FRIEZE ART FAIR

FRIEZE ART FAIR

Yearbook
2007–8

Published in 2007 by Frieze
3–4 Hardwick Street
London EC1R 4RB
UK
Tel +44 (0)20 7833 7270
Fax +44 (0)20 7833 7271
Email info@friezeartfair.com
www.friezeartfair.com

Frieze is an imprint of Frieze Events Ltd,
registered in England number 4429032

Frieze Art Fair Yearbook 2007–8
© Frieze
All images © the artists
All texts © Frieze and the authors

ISBN 978–0–9553201–2–5

A catalogue record of this book is available from the British Library

Editor: Rosalind Furness
Commissioning Editor: Anna Starling
Editorial Assistant: Andrew Bonacina
Copy-editor: Matthew Taylor
Advertising Sales: Molly McIver and Mareike Dittmer
Advertising Sales and Production: Marisa Futernick

Art Direction: Graphic Thought Facility, London
Printed by: Graphicom, Vicenza, Italy

Distributed outside North America by
Thames & Hudson Distributors Ltd
181a High Holborn
London WC1V 7QX
UK
Tel +44 (0)20 7845 5000
Fax +44 (0)20 7845 5050
Email customerservices@thameshudson.co.uk

Additional Distribution in North America by
DAP
155 Sixth Avenue, 2nd Floor
New York, NY 10013
USA
Tel +1 212 627 1999
Fax +1 212 627 9484

Contents

Participating galleries

ACME.
Air de Paris
Galería Helga de Alvear
Andersen_s Contemporary
Galerie Paul Andriesse
L'appartement 22
The Approach
Arndt & Partner
Art : Concept
Galerie Catherine Bastide
Galerie Guido W. Baudach
Marianne Boesky Gallery
Tanya Bonakdar Gallery
BQ
The Breeder
Broadway 1602
Gavin Brown's enterprise
Galerie Daniel Buchholz
Cabinet
Luis Campaña Galerie
Galerie Gisela Capitain
Galleria Massimo de Carlo
Casa Triângulo
China Art Objects Galleries
Galería Pepe Cobo
Sadie Coles HQ
Contemporary Fine Arts
Corvi-Mora
CRG Gallery
Galerie Chantal Crousel
Sorcha Dallas
Thomas Dane Gallery
Dicksmith Gallery
doggerfisher
Galerie Eigen + Art Leipzig/Berlin
The Fair Gallery
Konrad Fischer Galerie

Foksal Gallery Foundation
Galeria Fortes Vilaça
Marc Foxx
Carl Freedman Gallery
Stephen Friedman Gallery
Frith Street Gallery
Gagosian Gallery
Annet Gelink Gallery
Gladstone Gallery
Marian Goodman Gallery
Galerie Bärbel Grässlin
Greene Naftali
greengrassi
Galerie Karin Guenther
Studio Guenzani
Guild and Greyshkul
Jack Hanley Gallery
Hauser & Wirth Zürich London
Herald St
Hotel
Taka Ishii Gallery
Jablonka Galerie
Alison Jacques Gallery
Galerie Martin Janda
Johnen Galerie Berlin/Cologne
Annely Juda Fine Art
Iris Kadel
Casey Kaplan
Georg Kargl
Galleri Magnus Karlsson
Paul Kasmin Gallery
francesca kaufmann
Kerlin Gallery
KHOJ International Artists'
Association
Galerie Peter Kilchmann
Nicole Klagsbrun Gallery
Johann König
David Kordansky Gallery
Tomio Koyama Gallery
Andrew Kreps Gallery
Galerie Krinzinger

Galerie Krobath Wimmer
kurimanzutto
Yvon Lambert
Lehmann Maupin
Lisson Gallery
Luhring Augustine
maccarone
Kate MacGarry
Mai 36 Galerie
Giò Marconi
Matthew Marks Gallery
Metro Pictures
Galerie Meyer Kainer
Meyer Riegger
Massimo Minini
Victoria Miro Gallery
The Modern Institute/Toby Webster
Galerie Christian Nagel
Galerie Neu
Galleria Franco Noero
Galerie Giti Nourbakhsch
galerie bob van orsouw
Patrick Painter, Inc.
Maureen Paley
Peres Projects Los Angeles/Berlin
Galerie Emmanuel Perrotin
Friedrich Petzel Gallery
Galerie Francesca Pia
PKM Gallery
Galerija Gregor Podnar
Galerie Eva Presenhuber
Produzentengalerie
The Project
Galleria Raucci/Santamaria
Galerie Almine Rech
Regen Projects
Daniel Reich Gallery
Anthony Reynolds Gallery
Rivington Arms
Galerie Thaddaeus Ropac
Galleria Sonia Rosso
Salon 94

Galerie Aurel Scheibler
Galerie Rüdiger Schöttle
Gabriele Senn Galerie
Galerie Sfeir-Semler
Stuart Shave/Modern Art
Galeria Filomena Soares
Sommer Contemporary Art
Monika Sprüth, Philomene Magers
Standard (Oslo)
Store
Galeria Luisa Strina
Sutton Lane
Galerie Micheline Szwajcer
Taxter & Spengemann
Timothy Taylor Gallery
Team Gallery
Emily Tsingou Gallery
Vilma Gold
Vitamin Creative Space
Waddington Galleries
Galleri Nicolai Wallner
Galerie Barbara Weiss
Galerie Fons Welters
White Cube/Jay Jopling
Max Wigram Gallery
Wilkinson Gallery
Galleri Christina Wilson
XL Gallery
Zeno X Gallery
Zero...
David Zwirner

Art Fair Staff

Amanda Sharp, Director
Matthew Slotover, Director
Sara Le Turcq, Fair Manager
Kate Fisher, Associate Fair Manager
Neville Wakefield, Curator, Frieze Projects
Kitty Anderson, Associate Curator, Frieze Projects
Andrew Bonacina, Curatorial Assistant, Frieze
Projects
Camilla Nicholls, Head of Communications
Claire Hewitt, Marketing Manager
Nicola Harvey, Communications Assistant
Victoria Siddall, Head of Development
Eliana Facioni, Sponsorship Manager
Charlotte Nourse, VIP Manager
Kathrin Luz, VIP Consultant
Cristina Raviolo, VIP Consultant
Anne Thidemann, General Manager
Harriet Godwin, Assistant to the Directors
Ravinder Gill, Finance Manager
Josh O'Connor, Accountant

Introduction

Welcome to the Frieze Art Fair 2007. Now in its fifth year, and firmly established as one of the major international hubs for the contemporary art world, the fair features 150 of the world's most dynamic contemporary art galleries and over 1,000 artists.

There are several elements that make Frieze Art Fair unique. It remains the only fair to commission new projects by artists. Curated by Neville Wakefield, these projects, in his words, put some 'sand in the Vaseline', encouraging visitors to step back and question the very particular environment of the art fair. Amongst the commissioned artists this year are Richard Prince, Elín Hansdóttir and the recipient of The Cartier Award, Mario Garcia Torres.

The Frieze Talks programme continues to set the agenda, including three very special keynote lectures by Thierry de Duve, Dave Hickey and Roni Horn. Four new artists' films have been commissioned by Frieze Film from Oliver Payne and Nick Relph, Wilhelm Sasnal, David Shrigley and Kara Walker, which, thanks to a new collaboration with Channel 4, will be broadcast for the first time on national television during the week of the fair. Beyond Regent's Park, Frieze Music presents Glenn Branca, performing his symphony for 100 electric guitars at Camden's recently renovated Roundhouse.

We are grateful to the fair's main sponsor, Deutsche Bank, for their fourth year of support, and to our associate sponsor, Cartier, for their continued support of Frieze Projects. These companies share our deep and ongoing commitment to contemporary art, and as such have made ideal partners.

Amanda Sharp
Matthew Slotover

Sponsor's Foreword

In the short space of five years, the Frieze Art Fair has become a premiere event for art collectors and enthusiasts alike, and at Deutsche Bank, we look forward to this occasion, as it highlights our commitment to the arts.

Through our sponsorship, we endorse the organisers' aim: to make new art more accessible and to bring the most up-to-date ideas to the attention of today's discerning audience.

Over the past 30 years, Deutsche Bank has acquired more than 50,000 works of art, helping to launch the careers of many talented new artists. On display in our offices around the world, the Deutsche Bank Collection contributes to a stimulating working environment, an aspect we believe is highly important.

There are many parallels between the world of art and the financial industry. Artists creatively use pioneering techniques to express new ideas in their artwork, stimulating viewers' imagination. At Deutsche Bank, we focus on providing top quality, innovative products and services to our clients, distinguishing us in a world of competitive offers. Innovation and creativity are very much part of our corporate culture.

We are delighted to sponsor the Frieze Art Fair and particularly proud of the Deutsche Bank Education Space, which we introduced last year, as we would like families and young people from inner-city schools to have the opportunity to visit the Frieze Art Fair and participate in workshops. Thanks to the huge amount of visual art on display from around the world, creating a unique learning environment, we are confident this year's Frieze Art Fair will attract and inspire an expanded and enthusiastic audience.

Josef Ackermann

Chairman of the Group Executive Committee
Deutsche Bank AG

A Passion to Perform. Deutsche Bank

Frieze Art Fair wishes to acknowledge the generous support of the following companies and organizations:

Main Sponsor

Deutsche Bank

Associate Sponsor

Cartier

Media Sponsor

theguardian

Sponsors and Partners

H **THE HOSPITAL**

Simmons & Simmons

The Frieze Art Fair
Special Acquisitions Fund

This year marks the fifth anniversary of the successful collaboration between Frieze Art Fair and Tate. This unique partnership, based on the generosity of a group of London collectors, enables Tate to buy important works by emerging artists at the fair for the national collection. Over the last four years, with a fund of over £500,000, works by more than 35 significant international artists have been collected, including Trisha Donnelly, Thomas Hirschhorn, Zoe Leonard, Roman Ondák, Simon Starling and Christopher Williams.

A substantial fund of £150,000 should allow some of the best works of art in this year's fair to find a home in the Tate Collection. The works will be chosen by Udo Kittelmann (Director, Museum für Moderne Kunst, Frankfurt) and Lisette Lagnado (Chief Curator, 27th São Paulo Biennial) following guidelines provided by Ann Gallagher (Head of Collections, British Art, Tate) and Jessica Morgan (Curator of Contemporary Art, Tate). The acquisitions will be announced on 11 October at Tate Britain.

The Fund is organized and financed by Outset patrons and enjoys support from sponsors Laurent-Perrier. The donors all have a particular interest in enabling the Tate's acquisition of international contemporary art, and we are very grateful to all the participants for their generosity. We look forward to the Fund continuing in 2008.

Sir Nicholas Serota, Director, Tate
Amanda Sharp and Matthew Slotover, Directors, Frieze Art Fair
Candida Gertler and Yana Peel, Directors, Outset Contemporary Art Fund

Passion: Exceptional talent.
Performance: Exceptional support.

Deutsche Bank is proud to be the main sponsor of Frieze Art Fair for the fourth year running. Over this time we've seen it turn into a headline event, not only for collectors, enthusiasts, and established artists but also for new talent. This sponsorship is part of our ongoing commitment to the arts, which includes our corporate collection, now the largest in the world, of over 50,000 contemporary art pieces. We believe that supporting young artists today will make for a better art world tomorrow.

www.db-artmag.com

Frieze Art Fair
Regent's Park, London
11–14 October 2007
www.frieze.com

A Passion to Perform. Deutsche Bank

Today's art

The Art Fund is the UK's leading independent art charity, relying on the vision and support of like-minded individuals to help acquire great works of art for museums and galleries. The Art Fund Patrons' Circle is at the heart of our activity, building collections to include contemporary works by artists such as Anish Kapoor, Frank Auerbach and Olafur Eliasson.

This inspired philanthropy deserves its rewards and our Patrons enjoy exclusive viewings of exhibitions, artists' studios and private collections usually closed to the public.

If you feel able to support our work at an entry level of £1,000, please call Willa Beckett on 020 7225 7843 or write to her at *wbeckett@artfund.org*

for tomorrow's great collections

Anish Kapoor, *Turning the World Inside Out*, 1995, cast 1997, Cartwright Hall Art Gallery, Bradford
Art**Funded 1997**

Registered charity 209174

THE ART OF SELF-EXPRESSION

DEPUIS **1812** SINCE

Laurent-Perrier

CHAMPAGNE

FRIEZE
ART
FAIR

OFFICIAL CHAMPAGNE

*Grand Siècle
by Jean-Baptiste Huynh*

Stockists: Majestic, Oddbins, Harrods,
Harvey Nichols, Selfridges, Fortnum & Mason

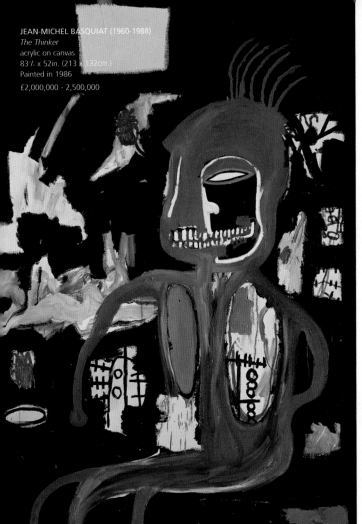

JEAN-MICHEL BASQUIAT (1960-1988)
The Thinker
acrylic on canvas
83⅓ x 52in. (213 x 132cm.)
Painted in 1986
£2,000,000 - 2,500,000

Auction
14 October 2007
8 King Street

Viewing
10-14 October
85 Old Brompton Road

Enquiries
Anthony McNerney
amcnerney@christies.com
+44 (0) 20 7389 2253

London
8 King Street
SW1Y 6QT

Catalogues
+44 (0)20 7389 2820

christies.com

10.07 THE CONTEMPORARY SALE
THE ITALIAN SALE
POST-WAR & CONTEMPORARY ART SALE

THE CONTEMPORARY SALE

LONDON, 14 OCTOBER 2007

CHRISTIE'S

Simmons & Simmons

Understanding context is vital...

Simmons & Simmons is more than just an international law firm. At the heart of our business is a culture that fosters initiative and embraces creativity.

We have been collecting contemporary art for more than 15 years and are delighted to support Frieze Art Fair for the fifth year running.

Like our firm, our art collection has grown increasingly international. Yet we remain true to our original objective of supporting young artists, early in their careers, by acquiring significant work.

View our collection online at www.simmonscontemporary.com

Auction
15 October 2007
8 King Street

Viewing
10-15 October
8 King Street

Enquiries
Mariolina Bassetti
mbassetti@christies.com
+39-06-686-33-30

London
8 King Street
SW1Y 6QT

Catalogues
+44 (0)20 7389 2820

christies.com

OCT.07
THE CONTEMPORARY SALE
THE ITALIAN SALE
POST-WAR & CONTEMPORARY ART SALE

THE ITALIAN SALE
LONDON, 15 OCTOBER 2007

THE PROPERTY OF A
PRIVATE ITALIAN COLLECTOR

LUCIO FONTANA
(1899-1968)
Concetto spaziale,
Teatrino
signed and titled
'L. Fontana
"Concetto spaziale"'
(on the reverse)
waterpaint on canvas
with laquered wood
39⅜ x 39⅜
(100 x 100cm.)
Painted in 1966
£180,000 - 250,000

CHRISTIE'S

THE ROYAL PARKS FOUNDATION

Deckchair Dreams

sponsored by **Bloomberg**

25 DECKCHAIRS TRANSFORMED BY 25 CELEBRITY ARTISTS

PUBLIC VIEW

Hyde Park, Regent's Park,
St James's Park and The Green Park
From June-October 2007

BUY ONE AND HELP A TREE
deckchairdreams.org

Deckchair Dreams

deckchairdreams.org

The Royal Parks Foundation is a registered charity, number 1097545
Photography by Heiko Prigge

Auction
16 October 2007
8 King Street

Viewing
10-16 October
85 Old Brompton Road

Enquiries
Jeremy Goldsmith
jgoldsmith@christies.com
+44 (0) 20 7389 2171

London
8 King Street
SW1Y 6QT

Catalogues
+44 (0)20 7389 2820

christies.com

OCT.07
THE CONTEMPORARY SALE
THE ITALIAN SALE
POST-WAR & CONTEMPORARY ART SALE

POST-WAR AND
CONTEMPORARY ART
LONDON, 16 OCTOBER 2007

KEITH HARING
(1958-1990)
Untitled
vinyl paint on tarpaulin
96 x 94¹/₄in.
(244 x 240cm.)
Executed in 1986
£400,000 – 600,000

CHRISTIE'S

BEST
KEPT SECRET

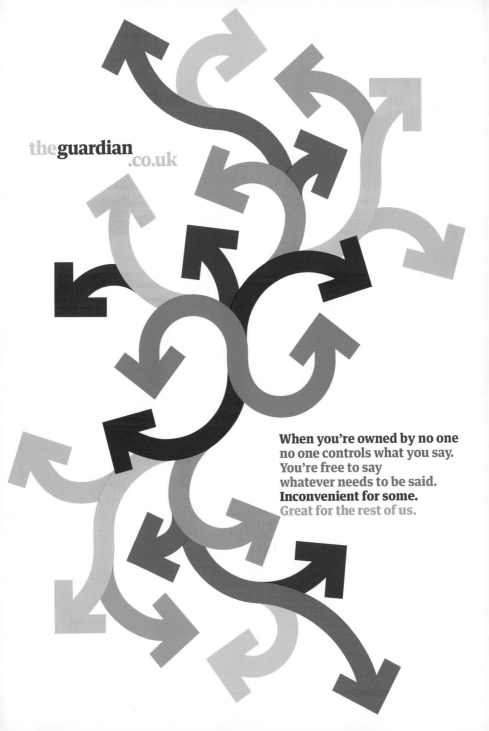

theguardian
.co.uk

When you're owned by no one
no one controls what you say.
You're free to say
whatever needs to be said.
Inconvenient for some.
Great for the rest of us.

THE HOSPITAL

Home To The Arts Community

More than London's most dynamic member's club serving delicious food and cocktails in beautiful surroundings, The Hospital also has a TV studio, music studio, screening room and gallery.

Recent public shows in our gallery at The Hospital include The End Begins; selected work from the Lodeavans collection and Warhol vs Banksy.

The Hospital is delighted, for the second year, to be at the Frieze Art Fair. We look forward to welcoming you at the VIP Room.

The Hospital, 24 Endell Street, London WC2H 9HQ

What you can't see won't hurt you, (Detail Shot), Diann Bauer, 2007

QUINTESSENTIALLY ART

Quintessentially – the world's leading private members' club and concierge service – provides indispensable insider knowledge and access to the very best hotels, clubs, gyms, spas and restaurants in the world.

As part of our complete lifestyle management service, our specialist team of art advisors will help you build up your own private collection, making it easier to buy and own art. They will handle everything from finding and sourcing extraordinary works and completing all negotiations, to assistance with transport, storage, valuation, insurance, framing and installation.

At City Inn you never have to go far to find a moment of inspiration.

In fact you don't even have to leave the hotel.

Every City Inn hotel is designed and purpose built especially for our guests' comfort and enjoyment, which is why we exhibit a rolling programme of contemporary art in all our hotels. Whether it's a behind the scenes view of up-and-coming artists or jazz on our al fresco terrace, make the most of the arts with City Inn.

Some of the reasons we were voted 'Best Business Hotel Brand'* 2007, 2006.

City Inn Westminster, Official Partner Hotel, Frieze Art Fair 2003 – 2007.

Corbett PROJECTS and City Inn presents Tom Leighton in Urbo Vida October – December 2007.

Custom made hotels in London, Birmingham, Bristol, Glasgow and now Manchester.

www.cityinn.com

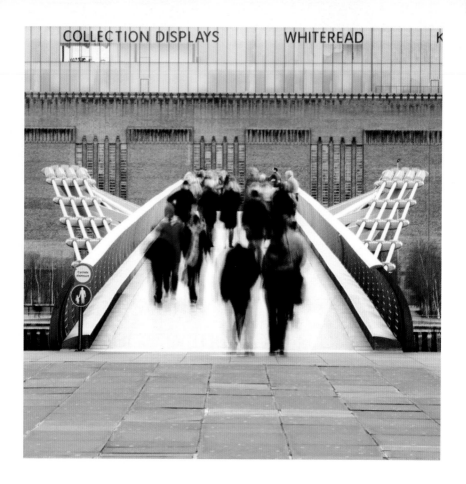

SUPPORTING THE UK'S INTERNATIONAL CONTEMPORARY ART FAIR

Wine, Dine and Recline at The Landmark...

...moments from Regents Park

SELFEXPRESSIONISM

outset.

Supporting New Art

www.outset.org.uk
Registered Charity no.1101476

Sponsors
Laurent Perrier
McLaren
Tiffany & Co.

Production partners
Rattan Chadha
Lydia & Miles d'Arcy Irvine
Tania & Fares Fares
Wendy Fisher
Candida & Zak Gertler
Jolana Leinson & Petri Vainio
Jennifer Moses & Ron Beller
Katy & Maurice Ostro
Yana & Stephen Peel
Catherine & Franck Petitgas
Barrie & Emmanuel Roman
Inna Vainshtock
Shirly & Yigal Zilkha
Mercedes Zobel &
Robin Halwas

Patrons
Ghazwa & Walid Abu Suud
Carrie & Steve Bellotti
Micaela & Christopher Boas
Bettina & Philippe Bonnefoy
Christina Boothe
Silvia Bruttini
Lady Sharon &
Sir Ronald Cohen
Blake & Michael Daffey
Chantal Defay & Jim Sheridan
Yelena & Kimbell Duncan
Mala Gaonkar &
Oliver Haarman
Jaime & Raquel Gilinski
Mark Glatman

Jacqui & Chris Goekjian
Jane & Max Gottschalk
Lorenzo Grabau
Rhian-Anwen &
Michael Hamill
Maria & Stratis Hatzistefanis
Sam & Brian Heyworth
Leili Huth
Kate & Matt Jones
Elizabeth & Boris Jordan
Karen & Tom Kalaris
Donna M. Lancia &
Jeffrey E. Brummette
Natalie & Ian Livingstone
Amalie &
Guillaume Molhant Proost
Elena Marano
Mary Moore
Kirsten & Dwight Poler
Jenny Halpern Prince &
Ryan Prince
Lynn Pryor
Laurel & John Rafter
Maya & Ramzy Rasamny
David Roberts
Robin Saunders & Matt Roeser
Melanie & Michael
Sherwood
Lulu & Ed Siskind
Cindy & David Soter
Carol & Rick Sopher
Tiziana & Ramez Sousou
Maria & Malek Sukkar
Adi & Micky Tiroche
Kerstin & Stephen Traube
Monica & Amir Weissfisch
Blathnaid Woodall

Annual Supporters

Friends
Miel de Botton Aynsley &
Angus Aynsley
Lauren & Mark Booth
Candice Breitz
Rosemary & Jake Chapman
Tiphaine de Lussy &
Dinos Chapman
Nigel Cooke
Jeremy Deller
Lady Elena &
Lord Norman Foster
Penny Govett
Siobhan Hapaska
Susanne & Anish Kapoor
Pauline Karpidas
Emily King &
Matthew Slotover
Fatima & Eskander Maleki
Daria Martin
Petra & Joachim Muehling
Roman Ondák
Vicken Parsons &
Antony Gormley
Grayson Perry
John Rushworth & Pentagram
Muriel & Freddy Salem
Amanda Sharp
Walter Smerling
Keith Tyson
Nicole Wermers
Jane & Louise Wilson
Anita & Poju Zabludowicz

And those who wish to
remain anonymous

'Passage', 2004, foil installation, Roman Ondák.

Subodh Gupta *Curry* 2005 © Subodh Gupta 2005

Artes Mundi

Wales International Visual Art Prize and Exhibition

Artes Mundi 3 2008 Artist Shortlist now available
Visit **www.artesmundi.org**

Selectors: Isabel Carlos and Bisi Silva

Artes Mundi 3 Exhibition
15 March - 8 June 2008 National Museum Cardiff, Wales

Artes Mundi 1 2004 Janine Antoni Tim Davies Jacqueline Fraser Jun Nguyen-Hatsushiba
Lee Bul Michal Rovner Berni Searle Fiona Tan Kara Walker Xu Bing

Artes Mundi 2 2006 Eija-Liisa Ahtila Thomas Demand Mauricio Dias and Walter Riedweg
Leandro Erlich Subodh Gupta Sue Williams Wu Chi-Tsung

2.5 GRAMS OF **HERBS** IN EVERY FIREFLY

FIREFLY

wake up

Peach & Green Tea

FIREFLY

de-tox

Lemon, Lime & Ginger

FIREFLY

sharpen up

Grapefruit, Passionfruit & Yerba Maté

PREIS DER NATIONALGALERIE FÜR JUNGE KUNST

ONE OF THE MOST IMPORTANT COMPETITION – SHOW ON YOUNG ARTISTS

14. SEPTEMBER – 4. NOVEMBER 2007
HAMBURGER BAHNHOF – MUSEUM FÜR GEGENWART – BERLIN

Jeanne Faust, Ceal Floyer, Damián Ortega, Tino Sehgal

www.preis2007.de

EINE AUSSTELLUNG DER NATIONALGALERIE, STAATLICHE MUSEEN ZU BERLIN.
ERMÖGLICHT DURCH DEN VEREIN DER FREUNDE DER NATIONALGALERIE.

S M
B Nationalgalerie
Staatliche Museen
zu Berlin

GEFÖRDERT DURCH

Wild AT *Heart*

Wild At Heart is the name in London for all things floral. From hand tied bunches and house flowers to large scale events and corporate contracts, we believe flowers should enrich our surroundings through sight and smell; and draw inspiration from the environment around us.

For flowers call 020 7727 3095
For events, contracts and all other enquiries call 020 7229 1174
www.wildatheart.com

The New Art Gallery Walsall

World class

Temporary exhibitions ■
The Garman Ryan collection ■
Interactive Discovery Gallery ■
Free events ■
Café ■
Shop ■
Art library ■

To find out what's on, join our mailing list or subscribe to our free e-bulletin for information about exhibitions and events, visit **www.artatwalsall.org.uk** and click on Contact Us.

The New Art Gallery Walsall
Gallery Square
Walsall
WS2 8LG

T: +44(0)1922 654400
F: +44(0)1922 654401

Free admission

www.artatwalsall.org.uk

 Walsall Council

Koenig Books
in London

Koenig Books
at the Serpentine Gallery

Kensington Gardens
London W2 3XA

TEL 020. 7706. 4907
FAX 020. 7706. 4911
MAIL info@koenigbooks.co.uk
WEB www.koenigbooks.co.uk

and

Koenig Books

80 Charing Cross Road
London WC2H 0BD

TEL 020. 7240. 8190
FAX 020. 7706. 4911
MAIL info@koenigbooks.co.uk
WEB www.koenigbooks.co.uk

art**press 2**

LONDON August / September / October 2007

ARTINFO

ART+
AUCTION

MODERNPAINTERS

GALLERYGUIDE
EUROPE

WE MAKE THE ART WORLD CLICK.

WWW.ARTINFO.COM

Original

i-D since 1980. www.i-dmagazine.com

Jessica Stam, detail. The New Dawn issue No247. September 2004. Photography by Richard Burbridge
Sarah Stockbridge, detail. The Holiday issue No50. August 1987. Photography by Nick Knight

Artprice Images: Your access to past, present and upcoming auction catalogues from 2,900 auction houses worldwide

Search auctioned art works and browse sales catalogues

In addition to the information given by the artprice.com databases, you can now find the catalogue announcing the work's sale. You can bring up its picture, leaf through the entire catalogue and put the sale in context: a high profile sale, auction house and place of sale, origin, number of lots, presence of masterpieces, the quality of the participants,

and all the information on the auction house. By having access to the entire contents of catalogues, you finally have the key to understanding an artwork's price.

With Artprice Images, for the launch price of £33/year* (€49 instead of €99) you get access to the largest art auction library of 290,000 catalogues spanning from 1960 to the present days.

artprice™

THE WORLD LEADER IN ART MARKET INFORMATION

Tel +800-2780-0000 or +33 (0)4 72 42 17 06 - *payment in €, price in £ indicative only - see full sales terms and conditions of use at www.artprice.com - Artprice is listed on Eurolist by Euronext Paris (PRC-ARTF)

ARTUPDATE.COM/

FRIEZE ART FAIR

Frieze Foundation

Frieze Commissions, Frieze Talks and Frieze Film 2007

Frieze projects sponsors:

Education and Culture

Culture 2000

ARTS COUNCIL ENGLAND

LOTTERY FUNDED

Frieze films sponsors:

A&B
Arts & Business *working together*

Do art fairs have an influence over the kind of art that is made, as well as how it is sold? Some critics have claimed that fairs promote a certain type of art-making – one that implicitly repudiates the process-driven, anti-market, Conceptual legacy of the 1960s and '70s. Whether or not this is the case, fairs have undeniably taken their place alongside biennials and other international events as sites of artistic opportunity. That the precepts of the past no longer apply may yet prove to be an entryway into new structures of cultural exchange and development. Now, after five years of commissioning artists' projects, Frieze Art Fair can be seen as a bellwether of this trend, reflecting the current mood but also intimating its future direction.

The ambition of Frieze Projects is to engage with these conditions, whether by throwing sand into the Vaseline-slick commercial presentation of art, or by taking the spectacle of art out of the white space empyrean and into the forgotten back-lots of the city. For in the new republics of acquired taste we inhabit, we have become familiar with art that is presented and sold according to models that have as much in common with the car dealerships of Detroit as with the boutiques of Bond Street. And, as in any time of plenty, obsolescence is a natural by-product of this glut, and creative evolution tends to favour incremental developments over paradigm shifts.

With this in mind it makes perfect sense that Richard Prince would elect to present an inverse form of readymade: a unique hand-fabricated copy

of an assembly-line Dodge Challenger from 1970. Amid the smoke, sex and mirrors of a trade-show display it is clearly a vehicle designed to inspire, although the precise nature of that inspiration remains suitably ambiguous. A driverless car aspiring to the condition of artless art, its continued function begs the question of what exactly we are buying into and why? And if, as Prince seems to suggest, the extreme fetishization of movement leads only to display-stand immobility, it also perhaps begs the question of whether the road of the market ever leads to homes other than those of the rich.

The complete absence of spectacle in Kris Martin's project allows him to address similar issues from the perspective of absolute immateriality. Consisting of nothing more than an announcement over the fair's PA system, Martin's call for a minute's silence raises questions about art and art-making at both local and global levels. No reason is given for the silence: what we are being asked is whether art's traditional claims to gravitas can still be heard above the clamour of social networking and commerce. And in the end it is only our response to Martin's proposal — whether the silence is observed and unremitting momentum of trade is brought to a temporary halt — that will ultimately determine its attribution: will the work be a commemoration of art's significance or a mourning for its loss?

Other projects take the form of variously explicit or implicit responses to the conditions, visible or otherwise, of the fair itself. Entering the fair, you pass through the ethereal shadow play of Elín Hansdóttir's light installation. Here human presence is registered as interruption, as the white light of the entranceway splinters into its constituent realms of red, green and blue. Reversing the procedure by which RGB streams coalesce in colour-image projection, Hansdóttir's transformations suggest a

world of component reality and divisible illusion. Inside the fair, Gianni Motti interrogates notions of security. Determining that threat is implicit in the promise of defence, Motti has insisted that, alongside his regular duties, one of the policemen patrolling the fair should also practise yoga. Stress and insecurity are a perennial presence in contemporary society, whether related to public, private or – of particular relevance given the hot-house nature of the fair's economy – financial concerns. By promoting the search for inner harmony, Motti calls for an interruption to avarice and a relaxation of the codes governing our perceptions of safety and protection.

Lara Favaretto embraces the innate theatricality of the fair as a means of rendering tangible an unrealizable fantasy. By inviting a member of the royal family to attend the fair – an invitation all but certain to be refused – she creates an aura of anticipation around an arena from which the central protagonist is absent. Applause marks both the end of the day and the end of each act in a five-day play on the spectacle of absence. Similarly discreet in presence, Janice Kerbel's print project draws a comparison between the spectacle of the fair and the carnivalesque atmosphere of 19th-century circus and freak shows. Like Favaretto's absent protagonist, Kerbel's printed announcements, distributed throughout the fair, conjure a cast of phantom characters that become vividly etched onto visitors' imaginations.

The Cartier Award goes this year to Mario Garcia Torres. Challenging the form that these projects have taken in the past, Garcia Torres has chosen to present his work as a lecture given by the mythical film-world figure of Allen Smithee. Disrupting expectations regarding the content of the talks programme where his presentation will

be given, which necessarily favours information over art, as well as dissolving distinctions between fact and fiction, Garcia Torres presents Smithee, who under the Directors' Guild of America became a figurative catch-all for films that for reasons of content or politics were disowned by their creators, as the singular architect of a large and diverse body of work. Torres' interrogation of authorship also examines authority – an inquiry that, within the context of the fair, rebounds with questions relating to the provenance and legitimacy of the art that surrounds us.

The topics addressed in Frieze Talks also take the fair and the conditions it can potentially generate as their departure point. Keynote speakers include Dave Hickey, Thierry de Duve and Roni Horn. Each speaker reflects in very different ways on the manner in which we come to understand art, its presentation and its market. Drawing on his own past experiences as an art dealer, Hickey's lecture takes its cue from Ed Ruscha's rhetorical question of how one can sell art without selling out. De Duve's purview is broader, considering, as it does, the theory and paradigms of Modernism. In the case of artist Roni Horn, whose work is often physically remote from the main centres of commerce and their attendant art markets, the discussion of site-specificity is a take on the venues and audiences encouraged by art fairs.

Accompanying these keynote talks, and serving as an introduction to the topics debated in them, are the panel discussions. Although the themes are wide-ranging, they aim to address four key issues: 'The Expanded Gallery' considers the cultural or commercially driven emergence of film, industrial and graphic design as a gallery staple; 'Custodians of Culture' explores the relationship of the museum to the market; 'Theory & Practice' examines the

vocational role of the art school; and 'Cultural Cartography' considers the question raised by international events such as fairs and biennials as to whether art can speak across cultural and political borders. The talks are once again being broadcast live at the fair by Resonance104.4fm, returning for the fourth year as the fair's resident radio station. We are also pleased to welcome Frankfurter Kunstverein as our partner institution this year. They will be offering a dynamic representation of the organization's activities through talks, discussions and screenings, held in a specially commissioned structure by artist Tobias Putrih.

Building on the success of The Artists Cinema, this year Frieze Film is taking a different direction: adopting a new format and aiming to reach out to an even wider audience through the medium of television. The commissions – by Oliver Payne & Nick Relph, Kara Walker, Wilhelm Sasnal and David Shrigley – range in content from a morbidly trenchant commentary on life to a hilarious inquisition into its origins. Each film will be premiered in the on-site auditorium at Frieze Art Fair and broadcast daily on Channel 4 in the 3 Minute Wonder slots from 8 to 11 October 2007. The collaboration with Channel 4 offers the commissions the opportunity to reach a nationwide audience for the first time, and promises to bring some of the most challenging and provocative art into the living-rooms and lives of those who least expect it.

More, we hope, than the sum of its parts, Frieze Projects aims to realize its artistic ambitions in relation to a fair that has always been more than the sum of its sales.

Neville Wakefield
Frieze Projects Curator

Participating artists and organizations

Richard Prince
Elín Hansdóttir
Kris Martin
Gianni Motti
Lara Favaretto
Janice Kerbel
The Cartier Award:
Mario Garcia Torres
Oliver Payne & Nick Relph
Wilhelm Sasnal
David Shrigley
Kara Walker
Frankfurter Kunstverein
Resonance 104.4fm

Richard Prince
Untitled (Original)
2007
Courtesy the artist

Richard Prince
Untitled (Original)

'I was thinking about one more car. I'd found a '69
Charger, a kind of sister to the Challenger. The one
I'd found had just 9,000 miles on the clock. The
tyre size, scribbled in yellow crayon at the assembly
line, was still inside the trunk lid. Next to the size
was another note, scrawled in the same yellow
crayon, probably by the same worker: "Pavement
pachyderms reign in the asphalt jungle." Weird. I
looked up "pachyderm" in the dictionary. Odd. It
said: "Any thick-skinned, non-ruminant mammal,
especially the rhino."'

Richard Prince, *Richard Prince*, Barbara Gladstone
Gallery, 1988

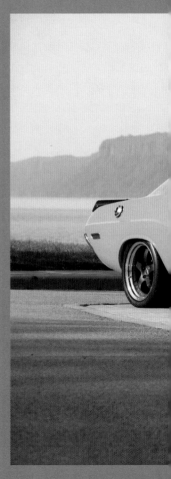

Richard Prince will present a unique installation
that is intended as simultaneously critical and
laudatory of the art of commerce, offering the
ultimate vehicle in which to pursue the combined
fantasies of upward and lateral mobility. Road to
nowhere or stairway to heaven, Prince's restless
invocation of travel is equal parts pulp fiction
sculpture and glorified, assembly-line product.

Much of Prince's work draws on automotive culture
and American abstraction. Recently, the artist has
begun to re-attach his painted car hoods to the
formal structures of the chassis from which they
were originally taken. The resulting sculptures speak
the language of painting in the form of the car.
Prince's readymade for Frieze draws this process
to its logical conclusion, resulting in a work that
challenges our preconceptions about art fairs, and
proving that what you see is not necessarily what
you get.

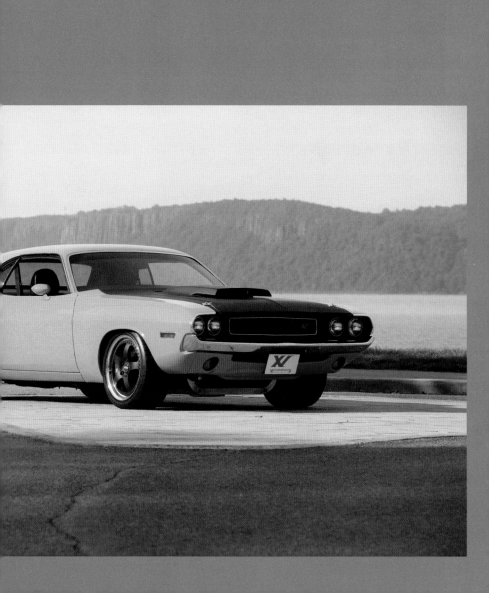

Elín Hansdóttir
PERIPHERAL
2007
Courtesy the artist

Elín Hansdóttir
PERIPHERAL

'The space is lit up with white light, which consists
of red, green and blue light in equal parts. The idea
of the project is to introduce an element of surprise,
to alter people's expectations of this apparently
ordinary space by way of the multi-coloured
shadows that appear when you move through
it. I'm interested in the act of paying attention, in
the moment when the mind takes possession, as
William James defined it in *The Principles of Psychology*
(1890), of "several simultaneously possible trains of
thought". There is a connection between action and
perception – perception is a creative receptivity.'

Elín Hansdóttir, June 2007

Elín Hansdóttir's architectural interventions turn
traditional spaces of display and social interaction
into sensorial environments that challenge
the viewer's expectations and perceptions. Her
lyrical, site-specific installations, which are often
barely perceptible, frame the nebulous space of
engagement between the work and the spectator,
and demonstrate Hansdóttir's belief that 'art doesn't
exist without the viewer'.

Hansdóttir presents a light installation that
transforms the entrance to the fair. The neutral
white light with which art works are customarily
illuminated will be broken down into its spectral
elements and this simple passageway lent the form
of a modern-day Plato's cave.

Kris Martin
Mandi XVI

'One minute to read:
Fifty-nine, fifty-eight, fifty-seven, fifty-six, fifty-
five, fifty-four, fifty-three, fifty-two, fifty-one, fifty,
forty-nine, forty-eight, forty-seven, forty-six, forty-
five, forty-four, forty-three, forty-two, forty-one,
forty, thirty-nine, thirty-eight, thirty-seven, thirty-
six, thirty-five, thirty-four, thirty-three, thirty-
two, thirty-one, thirty, twenty-nine, twenty-eight,
twenty-seven, twenty-six, twenty-five, twenty-four,
twenty-three, twenty-two, twenty-one, twenty,
nineteen, eighteen, seventeen, sixteen, fifteen,
fourteen, thirteen, twelve, eleven, ten, nine, eight,
seven, six, five, four, three, two, one, zero.

One minute of silence for no reason. For nobody.
For nothing.
Just one minute for yourself. One minute to gain or
to lose, to spill or to use. Up to you.'

Kris Martin, June 2007

Kris Martin's appeal to maintain a minute's silence
during the fair is an act that engages every visitor
and participant. Unspecified as to who or what
it commemorates, the call aims to induce the
audience to embrace a moment of reflection, and
also aspires to succeed in temporarily stilling the
wheels of commerce.

Morbid and absurd, Martin's works describe the
form of particular kinds of possibility, the outcomes
of which are always uncertain. Like *Mandi III*
(2003), a departure board whose ever-changing
black plates promise information they never deliver,
or *100 years* (2004), a bomb set to explode in 2104,
Martin's time-based sculpture is simultaneously
tangible and unknowable.

Kris Martin
100 years
2004
Courtesy Sies + Höke
Photograph: Achim Kukulies

Gianni Motti
Blitz
2003
Intervention at the 1st Prague
Biennial
Courtesy the artist

Gianni Motti
Pre-emptive Act

'The threat of terrorism, physical or psychological,
has given rise to a collective stress in society. Even
the police are affected and this particular stress is
referred to as the "Police Paradox".'

Gianni Motti, July 2007

Working within the varied arenas of sport, finance,
media, international politics, parapsychology
and, now, an art fair, Gianni Motti sets out to put
himself, as he defines it, 'in the wrong place at the
right time'. Previously, he has hi-jacked a busload of
Japanese tourists and taken them to an art opening,
organized a national telepathy event in Bogotá
urging President Ernesto Samper to resign, and
seated himself in the VIP box of the French Open
tennis tournament with a bag over his head, in a
curious evocation of the images from Abu Ghraib.
Without ever sermonizing, Motti's improbable
actions contain lessons about the freedoms we take
for granted.

Continuing his examination of institutions of
authority and issues of security, both perceived
and real, Motti will engage the security presence
at the fair, not in a demonstration of force, as one
might expect, but in the act of maintaining inner
peace though the practice of yoga. In our times
of proliferating terrorism and great national and
personal insecurity, Motti presents a humanist
response to these circumstances with an image of
calm.

No More Reality
1991
Cibachrome
64×80cm
Courtesy Air de Paris

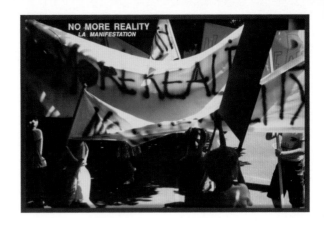

Selected Bibliography

2007 *Comic Abstraction: Image Breaking, Image Making*, Roxana Marcoci, Museum of Modern Art, New York

2006 *All Hawaii Entrées/Lunar Reggae*, ed. Philippe Parreno, Edizioni Charta, Milan

2006 *dontstopdontstopdontstop*, Hans Ulrich Obrist, Sternberg, New York/Berlin

2006 *Traité du combat moderne* (Treaty of Modern Combat), Jordi Vidal, Allia, Paris

Selected Exhibitions

2007 'Stories are Propaganda', Friedrich Petzel Gallery, New York

2007 'What do you believe: your eyes or my words?', Haunch of Venison, London

2007 'Le cri ultrasonic de l'écureuil', Air de Paris

2006 'Performance #3 (Le cri ultrasonic de l'écureuil)', Studio 28/Air de Paris

2006 'Briannnnnn & Ferryyyyyy/Law and Creativity', Konsthall, Malmö

Philippe **Parreno**
Born 1964
Lives Paris

Perhaps unsurprisingly for an artist whose practice is heavily characterized by collaboration, Philippe Parreno has stated that 'a good image is always a social moment'. Concerned with the overlapping territories of reality, its commentary and its representation, Parreno creates work in which one thing often gives rise to another – a description of a party producing a temporary exhibition (*Snow Dancing*, 1995), for example, or a film calling a building into being (*Boy from Mars*, 2005). For Parreno art lives and breathes in the dynamic spaces that link pre-production, production and post-production. As David Lynch said of contemporary cinema, 'images are no longer beautiful, but chains are'. (TM)

Shown by Air de Paris E5, Friedrich Petzel Gallery B2

Untitled
2006
Acrylic and oil paint on canvas
119×80cm
Courtesy the artist and Sutton Lane

Sean **Paul**

Born 1978
Lives New York

The abstraction of Sean Paul's untitled paintings of 2006 is washed out: shuddering grey planes of paint parody the pale palette of Postmodernism. Where representation does occur, it consists either of the stock-in-trade of meaningful subjects – flags, buildings with pediments – or unadulterated banality – red polka-dotted kitchenware, for instance. Yet Paul does not deal in exhausted endgames: rather than evacuating his subjects of meaning, he inverts the process of significance, monumentalizing mugs while making the paraphernalia of patriotism inane. The employment of spray-paint in *Pouvoir/Devoir* (To Be Able, To Be Obliged, 2007) confirms this anarchic streak: dead flowers and black need not speak only of death. (BB)

Shown by Sutton Lane G1

Selected Bibliography

2007 *Conditions of Display*, ed. Gean Moreno, The Moore Space/Locust Projects, Miami

2007 'Sean Paul', Marcia Vetroq, *Art in America*, March

2007 *For the People of Paris*, Sutton Lane, Paris

2006 'Michael Krebber and Sean Paul', Nicolas Bauche, *Paris-Art. com*, June

2006 'Under Pressure', Judicaël Lavrador, *Les Inrockuptibles*, October

Selected Exhibitions

2007 Sutton Lane, London

2007 'For the People of Paris', Sutton Lane, Paris

2007 'Conditions of Display', The Moore Space, Miami

2007 'Art Premiere', Art 38 Basel

2006 'Sean Paul and Michael Krebber: I NEVER SAID YES: AMBITIOUS SOMETHINGS THAT DIDN'T WORK OUT THE TASTE KING KONG AIR GUITAR FUN & MONEY', Sutton Lane, Paris

Lo spazio della scultura (Pelle di cedro)
(The Sculpture Room, Skin of
Cedar)
2001
Bronze, leather
130×700×800cm
Courtesy Konrad Fischer Galerie

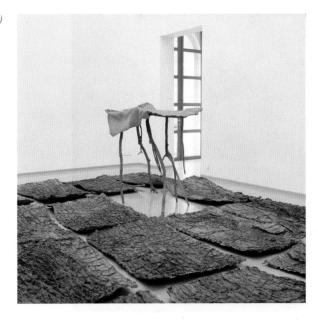

Selected Bibliography

2006 *Die Augen umkehren: Schriften 1968–2004* (To Reverse One's Eyes: Publications 1968–2004), Giuseppe Penone, Museum Kurhaus, Kleve

2004 *Giuseppe Penone*, Catherine Grenier, Centre Georges Pompidou, Paris

1989 *Giuseppe Penone*, Germano Celant, Electa, Milan

Selected Exhibitions

2007 Italian Pavilion, 52nd Venice Biennale

2006 Museum Kurhaus, Kleve

2004 'Penone: Retrospective', Centre Georges Pompidou, Paris

2004 'Giuseppe Penone: Retrospectiva', CaixaForum, Fundació la Caixa, Barcelona

1973 Galleria Sperone-Fischer, Rome

Giuseppe **Penone**

Born 1947
Lives San Raffaele

Of all the artists associated with the Arte Povera movement, Giuseppe Penone remains perhaps the most concerned with the processes and forms of the natural environment in relation to those of his own body. His 'Soffio' (Breath) series from the late 1970s comprised large vase-like terracotta vessels based on the imagined effect of the artist blowing onto piles of leaves. Other works exhibit a similar desire to summon sculptural behaviours at the interface of positive or negative volumes, or of invisibility – not least his iconic *Rovesciare i propri occhi* (To Reverse One's Eyes, 1970), a photograph of Penone wearing mirrored contact lenses. (MA)

Shown by Galerie Paul Andriesse H8, Konrad Fischer Galerie A5, Frith Street Gallery C1, Marian Goodman Gallery F14

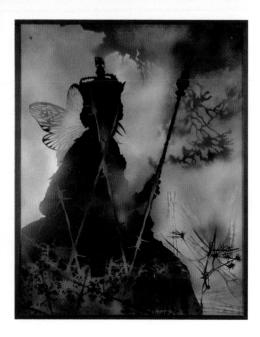

New Dawn Fades
2007
Spray-paint on glass, framed
82×66×4cm
Courtesy Sadie Coles HQ

Simon **Periton**

Born 1964
Lives London

Simon Periton's Steam-Punk doilies, lanterns and filigreed curtains suggest both leisured luxury and the painstaking process of making art. There is something almost hobbyist about these delicate constructions, reminiscent as they are both of home tapestry kits and of hormone- and rage-fuelled music fanzines. Intricate, speckled with anarchy logos, barbed wire and icons such as Iggy Pop, they prod craft into unfamiliar places where it falls on its backside and laughs a self-deprecating laugh. Eschewing the academic politics of the handmade decorative object (connected with anthropology, women's studies and Marxian theories of kitsch), Periton's work is concerned with the persistence of its own fragile yet far from defenceless beauty. (TM)

Shown by Sadie Coles HQ C9, The Modern Institute/Toby Webster B11

Selected Bibliography

2003 *Simon Periton*, Will Bradley, Sadie Coles HQ, London/ Inverleith House, Edinburgh/ The Modern Institute, Glasgow/ Verlag Walter König, Cologne

2003 'Simon Periton: Premonitions', Michael Kimmelman, *The New York Times*

1998 *Simon Periton*, Isabella Blow and Adam McEwen, Camden Arts Centre, London

1997 *Target Doilies*, David Bussel, British Council/ Window Gallery, Prague

1990 *A Summerplace*, Stuart Morgan, Salama Caro Gallery, London

Selected Exhibitions

2007 'Sordide Sentimental', Vacio 9, Madrid

2007 'The Anti-Room of the Mae Queen', Victoria and Albert Museum, London

2004 'The Edge of the World', Sadie Coles HQ, London

2003 'Mint Poisoner', Inverleith House, Royal Botanic Garden, Edinburgh

1999 'Barroquade: Simon Periton', Hayward Gallery, London

43 fiorito
(Flowering 43)
2006
Oil on canvas
100×70cm
Courtesy Studio Guenzani

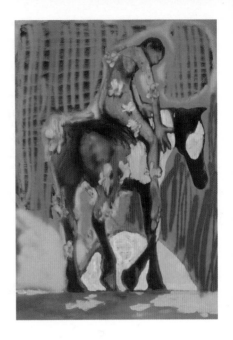

Alessandro **Pessoli**

Born 1963
Lives Milan

Selected Bibliography

2006 'Alessandro Pessoli', Cecilia Alemano, *Artforum*

2006 'Alessandro Pessoli', Ilaria Bonacossa, *contemporary*, 83

2005 'Alessandro Pessoli', Melissa Gronlund, *frieze*, 94

2004 'Alessandro Pessoli', Massimiliano Gioni, *Boiler*, 5

2003 'Alessandro Pessoli', Roberta Smith, *The New York Times*

Selected Exhibitions

2007 'Bruciatore', greengrassi, London

2006 'Il caduto', Studio Guenzani, Milan

2006 'Fuga verde', Anton Kern Gallery, New York

2005 'Baracca's time', Chisenhale Gallery, London

1997 'One Day To Live', The Drawing Center, New York

Alessandro Pessoli's fantastical gouaches and lumpen maiolica statuettes describe states of metamorphosis: trees that become rivers, six-legged horses and clown-like men. His fluid and imaginative style was apparent in the animated short *Caligola* (Caligula, 2002), which transferred thousands of works on paper onto film. The work presaged Pessoli's recent flamboyant reinterpretations of the life of Italian fighter pilot and World War I hero Francesco Baracca. An exhibition of colourful painted maiolica sculptures and some 50 drawings on this theme was entitled 'Baracca's Time' (2005). Recently Pessoli created a life-size reconstruction in wood, metal and ceramics of Baracca's combat aircraft *Il Caduto* (The Fallen, 2006), festooned with embroidered fabric and hand-painted silk. (SL)

Shown by Marc Foxx A1, greengrassi D8, Studio Guenzani E9

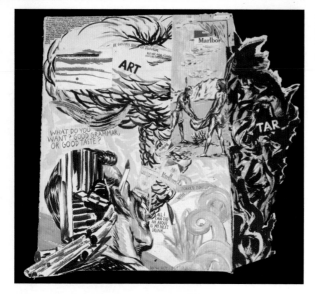

No Title (I cannot form)
2007
Pen and ink collage on paper
77.5×82.5cm
Courtesy Regen Projects

Raymond **Pettibon**

Born 1957
Lives Hermosa Beach

Although he first made his name as the creator of
scurrilous zines aimed at the West Coast Punk
crowd and as sleeve artist for bands such as Black
Flag, the Minutemen and Sonic Youth, Raymond
Pettibon soon revealed more rarefied tastes: his
cryptic, cartoon-like drawings are laced with
quotations from, and allusions to, such literary
exquisites as Marcel Proust, John Ruskin and
Walter Pater. But as well as setting out his
aestheticist stall, Pettibon peddles odds and ends of
Pop culture in laconic profusion; his art, says critic
Robert Storr, is a 'remainder-table of the mind'.
(BD)

Shown by Sadie Coles HQ C9, Contemporary
Fine Arts D2, Hauser & Wirth Zürich London C6,
Galerie Meyer Kainer F2, Regen Projects C10,
David Zwirner C8

Selected Bibliography

2007 *Raymond Pettibon: V–Boom*,
Aaron Rose and Francisco Javier
San Martin, Kestner Gesellschaft,
Hanover

2006 *Raymond Pettibon*, Aaron
Rose et al., Centro de Arte
Contemporáneo, Málaga

2006 *Whatever It Is You're Looking
For You Won't Find It Here*, Gerald
Matt et al., Kunsthalle, Vienna

2005 *Turn to the Title Page*,
Raymond Pettibon, Museum of
Modern Art, New York

Selected Exhibitions

2007 'Raymond Pettibon: V–
Boom', Kestner Gesellschaft,
Hanover

2007 'Raymond Pettibon:
Whatever It Is You're Looking For
You Won't Find It Here',
Kunsthalle, Vienna

2006 Centro de Arte
Contemporáneo, Málaga

2006 Whitney Museum of
American Art, New York

2006 Regen Projects, Los Angeles

Four Horsemen of the Apocalypse (25)
2006
Fugiflex digital C–print
122×161.5cm
Courtesy The Project

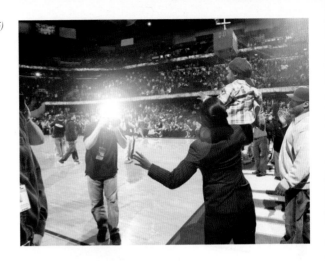

Selected Bibliography

2007 'Paul Pfeiffer MC Kunst',
Micol Hebron, *Flash Art
International*

2006 *Vitamin Ph: New Perspectives
in Photography*, T.J. Demos,
Phaidon Press, London

2006 'Fantastic Frameworks:
Architectural Utopias + Designs
for Life', Brian Grison, *Focus*

2006 'Paul Pfeiffer', Julie
Boukobza, *L'Officiel Hommes*

2003 *Paul Pfeiffer*, Dominic
Molon, Museum of Contemporary
Art, Chicago

Selected Exhibitions

2007 'Live From Neverland', The
Project, New York

2007 'Jerusalem', ArtAngel,
London

2006 'Full House: Views of the
Whitney's Collection at 75', The
Whitney Museum of American
Art, New York

2006 MC, Los Angeles

2006 'The Gold Standard', PS1
Contemporary Art Center, New
York

Paul **Pfeiffer**

Born 1966
Lives New York

Digital images are metaphor as much as material for
Paul Pfeiffer. Rigorous but multivalent, including
allusions to art-historical touchstones, sporting
events, cinema and biblical themes, his works in
various media explore the subjective states that are
obscured or made possible by contemporary image
production. In *Fragment of a Crucifixion (After
Francis Bacon)* (1999), a looped shot of basketball
player Larry Johnson, the star appears to howl in
anguish rather than victory. Other resonant
subjects have included a dancing Michael Jackson,
with his head removed and his torso amorphous, in
Live Evil (Bucharest) (2004), and real-time footage
of wasps building a nest, in *Empire* (2004). (KJ)

Shown by Thomas Dane Gallery E1, The Project
H1

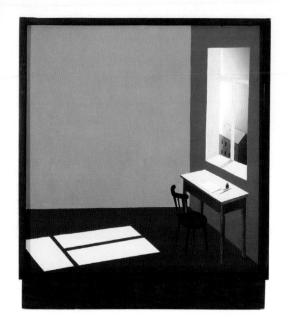

Empty Room
1995
Oil on fibreboard, wood, electric bulb
75×66×15cm
Courtesy XL Gallery

Viktor **Pivovarov**

Born 1937
Lives Prague

A key figure, alongside Ilya Kabakov and Eric Bulatov, in the 1970s' school of Moscow Conceptualism, Victor Pivovarov examines elements of the world around him with an almost childlike sense of curiosity. His formative work from the 1960s includes a number of 'albums', similar to those produced by Kabakov, in which elaborate narratives are constructed through the interplay of text and image, a style Pivovarov also exercised in the children's books he illustrated for over 20 years. His series of 'Cut Paintings' (2003) depicts dreamlike environments populated by objects and figures playfully bisected in ways that render each a playground of surreal reverie. (AB)

Shown by XL Gallery E13

Selected Bibliography

2006 *Sublime Pivovarov*, Milena Orlova, XL Gallery, Moscow

2003 *Moskauer Konzeptualismus* (Moscow Conceptualism), Schulze Altcappenberg, Verlag Walther König, Cologne

2001 'Logik der Fantasie' (The Logic of Fantasy), Jähne Svoboda, *Neues Deutschland*

2000 'Zwei Agenten: Viktor Pivovarov + Pavel Pepperstein' (Two Agents: Viktor Pivovarov + Pavel Pepperstein), Peter Deutschmann, *Kulturzentrum bei den Minoriten*, 5

1997 *Viktor Pivovarov at the Leopold-Hoesch-Museum*, Frank Frangenberg, Kunst-Bulletin, Duren

Selected Exhibitions

2006 'Lemon Eaters', Museum of Modern Art, Moscow

2004 'Steps of the Mechanic', State Tretyakov Gallery, Moscow

2004 'The Dark Rooms', XL Gallery, Moscow

2001 'Philemon', IFA, Berlin

1997 'Sonja and the Angels', Musée d'Art Moderne, Saint-Étienne

The Polis or the Garden or Human Nature
1998–2005
Painted onions on shelf (aged for two months), mirror, custom-built shelf
Dimensions variable
Courtesy Thomas Dane Gallery

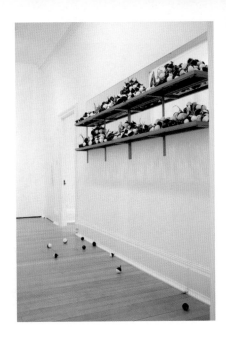

Selected Bibliography

2007 *Trophy Room*, Sabine Folie and Gerad Matt, Kunsthalle, Vienna

2006 *Exhausting Dance: Performance and the Politics of Movement*, André Lepecki, Routledge, New York/London

2005 'Profile: Tapping the Energy of Predicament', Lauri Firstenberg, *contemporary*

2005 'Letter to a Young Artist', William Pope L., *Art on Paper*, July/August

2004 'Ain't No Such Thing As Superman', James Trainor, *frieze*, 83

Selected Exhibitions

2007 'The Void Show', MC, Los Angeles

2006 'Trophy Room', Kunsthalle, Vienna

2004 'The Big Nothing', Institute of Contemporary Arts, Philadelphia

2002 Whitney Biennial, New York

2001 'Hole Theory', The Project, New York

William **Pope L.**

Born 1955
Lives Lewiston

William Pope L. is best known for his street performances – most notably a continuing project in which he crawls on his hands and knees down a city street dressed in a business suit or a Superman costume. The self-proclaimed 'Friendliest Black Artist in America' repeatedly stages his own clownish degradation in his work – eating the *Wall Street Journal* while perched on a toilet-throne, portraying a drunken Santa Claus or creating grotesque, scatological spectacles involving mayonnaise, hot dogs and peanut butter. Both literally and politically messy, Pope L.'s absurdist enactments of abjection are designed to force confrontation. (SS)

Shown by Galerie Catherine Bastide E12, The Project H1

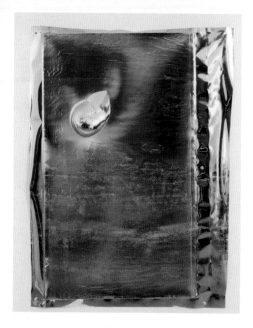

Untitled
2006
Vacuum-formed, high-impact
polystyrene
114.5×67.5cm
Courtesy Friedrich Petzel Gallery

Seth **Price**

Born 1973
Lives New York

The random delights generated by Internet searches provide Seth Price with a mind-bending array of material for his film and music works: dancing cats jostle for space alongside vacuum-formed objects, grated cheese and manipulated videos of Richard Serra interviews. *Untitled Film, Right* (2006) stretches a seconds-long downloaded loop of an ocean swell to 14 minutes, cycling from grey through to psychedelic Technicolor and back again. Elsewhere, the artist's series of mix CDs 'Title Variable' (2001–5) forms an impossible archive, constantly varied and reordered to thwart any attempt at categorization. Channelling Marcel Broodthaers' preoccupation with distribution and dispersion, Price's often disturbing Google-driven pranks and samples are an ongoing act of post-production. (ST)

Shown by Galerie Gisela Capitain D11, Friedrich Petzel Gallery B2

Selected Bibliography

2007 'Seth Price', Maurizio Cattelan, *Flash Art International*, January/February

2006 'Reviews: Seth Price', Andrea K. Scott, *Time Out New York*

2006 'Review: Seth Price', Megan Ratner, *frieze*, 103

2006 'Art in Review: Seth Price', Roberta Smith, *The New York Times*, 29 September

2005 'Seth Price', Elizabeth Schambelan, *Artforum*, May

Selected Exhibitions

2007 Galerie Gisela Capitain, Cologne

2007 Modern Art, Oxford

2006 Friedrich Petzel Gallery, New York

2006 Electronic Arts Intermix, New York

2004 Reena Spaulings Fine Art, New York

The Second Sentence of Everything I Read Is You: Mourning Sex
2005–7
Installation view
Dimensions variable
Courtesy Galerie Gisela Capitain

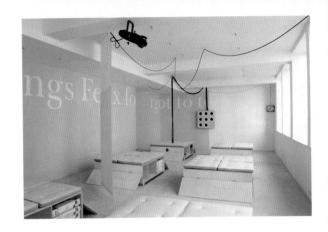

Selected Bibliography

2006 'Cologne as Mythic Hot Spot (Cue the Background Music)', Roberta Smith, *The New York Times*

2002 'An Interview with Stephen Prina', Beatrice von Bismarck, *Texte zur Kunst*

2000 'Don't Lose That Number', Diedrich Diederichsen, *Texte zur Kunst*, June

1992 *It was the best he could do at the moment*, Museum Boijmans Van Beuningen, Rotterdam

1989 *Stephen Prina: Monochrome Painting*, Stephen Prina, Renaissance Society, University of Chicago

Selected Exhibitions

2007 'The Second Sentence of Everything I Read is You', Galerie Gisela Capitain, Cologne

2000 'Departures: 11 Artists at the Getty', J. Paul Getty Museum, Los Angeles

1998 'Stephen Prina: Monochrome Painting', Musée d'Art Moderne et Contemporain, Geneva

1997 'Sunshine & Noir: Art in Los Angeles 1960–1997', Louisiana Museum of Modern Art, Humlebaek

1996 'Retrospection Under Duress: Reprise', DAAD Galerie, Berlin

Stephen **Prina**

Born 1954
Lives Los Angeles/Harvard

In 1999, in an apparent bid to resist easy definition as a 'crossover' artist, Stephen Prina released an album, *Push Comes To Love*, and opened an eponymously titled but otherwise unrelated exhibition that created a coded web of references between the artist's monochrome paintings and Marcel Broodthaers' *Musée d'Art Moderne, Déparment des Aigles* (1968). However, Prina's recent installation *The Second Sentence of Everything I Read Is You: Mourning Sex* (2005–7) marks a return to the sound installations he pursued in the 1980s: a modish pop song containing Felix Gonzalez-Torres-related quotes becomes the focus of a miniature road show, fully equipped with a multi-channel speaker system and cushioned seating. Prina's work invests seemingly distanced statements with empathy and seemingly opaque structures with meaning. (JöH)

Shown by Galerie Gisela Capitain D11, Friedrich Petzel Gallery B2, PKM Gallery G2

Rob Pruitt's Flea Market
2000
40 artists, designers, performers and
secret celebrity superstars exhibit
and sell their wares
Courtesy Gavin Brown's enterprise

Rob **Pruitt**

Born 1964
Lives New York

During the early 1990s, as one half of artist duo
Pruitt & Early, Rob Pruitt documented the residue
of male teen culture in works that included stacked
beer cans embellished with bad-boy-style decals.
Working solo, he has mined more rarefied terrain
with glittery paintings and playfully interactive
post-Conceptual projects such as *101 Art Ideas You
Can Do Yourself* (1999). More recently he's made
paintings of tabloid princess Paris Hilton, and
others that channel Abstract Expressionist bravura
but exchange macho cool for a froufrou pink and
scarlet palette and an engagement with current
events. He's exhibited these *faux* Action paintings
– with no shortage of irony – alongside a bevy of
cement-filled jeans. (KJ)

Shown by Air de Paris E5, Gavin Brown's
enterprise G14

Selected Bibliography

2007 'In the Pink: Rob Pruitt',
Christopher Mooney, *ArtReview*

2005 'Purple News', Alison
Gingeras, *Purple Fashion*

2004 'Interview', Christopher
Bollen, *V Man*

2000 'Back in the Arms of the Art
World', Mia Fineman, *The New
York Times*

2000 'A Man, a Plan, a Panda',
Tim Griffin, *Time Out New York*

Selected Exhibitions

2006 'The Gold Standard', PS1
Contemporary Art Center, New
York

2002 Le Consortium, Dijon

2001 'The Americans: New Art',
Barbican Art Gallery, London

2000 'Flea Market', Gavin
Brown's enterprise, New York

2000 'Protest and Survive',
Whitechapel Art Gallery, London

Program
2006
16mm colour film, optical sound,
looped
Production still
Courtesy Galerie Daniel Buchholz

Florian **Pumhösl**

Born 1971
Lives Vienna

Modernism – its unfulfilled promises and ambiguous manifestations – is the subject of Florian Pumhösl's investigations. In his installation *Humanist and Ecological Republic* (2000) he displayed modular architectural elements taken from the grammar of global Modernism so as to reveal the uncanny affinities between the Unesco-type spirit of postwar internationalism and the colonization of the globe through the architectural logic of instrumental reason. In recent works Pumhösl has focused on photogrammetry, questioning modern visual technology's claim to objective representation. For him the myth of objectivity becomes opaque as the image turns into a mute trace of the bare facticity of its subject. (JV)

Shown by Galerie Daniel Buchholz C4, Galerie Krobath Wimmer E22

Selected Bibliography

2007 'Die Befreiung aus der Gefangenschaft des Marktes' (Liberation from Market Ties), Thomas Wagner, *Frankfurter Allgemeine Zeitung*, 16 June

2007 *Various Small Fires*, Coline Milliard, Royal College of Art, London

2006 'Florian Pumhösl', Luca Cerizza, *tema celeste*, May/June

2006 'Florian Pumhösl', Brigitte Huck, *Artforum*, March

2005 'Future Greats: Florian Pumhösl', *ArtReview*, December

Selected Exhibitions

2007 UAG/Room Gallery, University of California, Irvine

2007 documenta 12, Kassel

2007 'Various Small Fires', Royal College of Art, London

2006 27th São Paulo Biennial

2005 Galerie Daniel Buchholz, Cologne

Are You Me
2007
Oil on canvas
200×200cm
Courtesy Contemporary Fine Arts

Tal **R**

Born 1968
Lives Copenhagen

It is perhaps not wise to attempt to pin down Tal R's subject matter, because he can gain a purchase on any image. Referencing everything from Bas Jan Ader to The Beatles, Tal R has a non-discriminating approach to cultural reference. He does, however, employ identifiable techniques, tropes and design tics – perhaps passing through a phase in which a painterly palette of pink, yellow and brown predominates, or having a temporary penchant for small collages or bronze casts of cruddy found-object assemblages. All are buoyed, though, by a child-like crudeness that shrieks of enthusiasm for the tactility of the medium. (SO'R)

Shown by Contemporary Fine Arts D2, Victoria Miro Gallery G6

Selected Bibliography

2006 *Fruits*, Rudi Fuchs, Contemporary Fine Arts, Berlin

2005 *House of Prince*, Jorg Heiser, Contemporary Fine Arts, Berlin

2004 *Figur*, Contemporary Fine Arts, Berlin

2004 *Tal R: Arcade*, P.E. Toejner, Bawag Foundation, Vienna

2002 *Tal R: Fruitland*, Museum Abteiberg, Munchengladbach

Selected Exhibitions

2007 Skulptur 4, Cologne

2007 Kunsthalle, Mannheim

2007 Louisiana Museum of Modern Art, Humlebaek

2006 'Fruits', Contemporary Fine Arts, Berlin

2005 'House of Prince', Contemporary Fine Arts, Berlin

immortality
2006
Acrylic and thread on canvas
190×240cm
Courtesy The Approach

Selected Bibliography

2005 *show*, Alison M. Gingeras
and Caoimhin Mac Giolla Leith,
Scalo, Zurich

2004 *forevernevermore*, Michael
Raedecker, Kunstverein, Salzburg

2002 *instinction*, Michael
Raedecker, Museum für
Gegenwartskunst, Basel/Centro
Nazionale per le Arti
Contemporanee, Rome

2001 *Post-Nature: Nine Dutch
Artists*, Frederic Paul, Van
Abbemuseum, Eindhoven

1999 *Michael Raedecker: extract*,
Edwina Ashton, Van
Abbemuseum, Eindhoven

Selected Exhibitions

2006 'up', Andrea Rosen Gallery,
New York

2005 'show', Hauser & Wirth,
Zurich

2004 'forevernevermore',
Kunstverein, Salzburg

2002 'sensoria', The Approach,
London

2002 'instinction', Centro
Nazionale per le Arti
Contemporanee, Rome

Michael **Raedecker**

Born 1963
Lives London

It is hard to know, with the paintings of Michael Raedecker, precisely what sort of realm is being represented: it could be a space (perhaps real, perhaps imaginary), but it might also be the time of thought, dream, intuition. The confusion is nowhere as clear as in *ah* (2005), a pair of portraits of Adolf Hitler exhibited on opposite walls so that you can't see both at once. While Raedecker's earlier paintings, with their succession of murky dwellings and obscurely embroidered canvases, made one flit nervously between subject and surface, the Hitler paintings stage an endlessly dizzying dialectic: how to reconcile image and execution, history and fantasy? Could a painting of Hitler ever be 'just' a painting? (BD)

Shown by The Approach D10, Hauser & Wirth Zürich London C6

Hinterland
2007
Embroidery on organdy
220×352cm
Courtesy White Cube/Jay Jopling

Jessica **Rankin**

Born 1971
Lives New York

On the reverse side of embroidered cloth, stitches connect in untidy criss-crosses; flipping the fabric over is like spying on the messy bedroom of a straight-A student. It would be worth bribing someone to see the back of Jessica Rankin's embroidered works on organdy: the large-scale *Ripple* (2007), which evokes starry-night beauty in precise, perfectly circular bubbles, or the Glenn Ligon-esque *Passage (Dusty Humming)* (2007), in which the chaos of Concrete poetry is rendered in neat capital letters. Operating knowingly in the lineage of women's work as well as that of the visual use of text, Rankin presents façades of perfect order that barely cover the turbulence of the traditions on which she draws. (MG)

Shown by The Project H1, White Cube/Jay Jopling F13

Selected Bibliography

2007 *Jessica Rankin*, Sarah Kent, White Cube/Jay Jopling, London

2007 'Gallery', *American Craft*, February/March

2005 'Jessica Rankin', Frances Richard, *Art in America*, January

2005 'Jessica Rankin at The Project', Guy Matthew Nichols, *Art in America*, March

Selected Exhibitions

2007 White Cube, London

2006 'The Measure of Every Pause', PS1 Contemporary Arts Center, New York

2005 Franklin Artworks, Minneapolis

2004 The Project, New York

1999 First Floor Gallery, Melbourne

Kartoon
2006
Mixed media on paper
45×45cm
Courtesy the artist

Hani **Rashed**

Born 1975
Lives Cairo

Hani Rashed's monochrome paintings of humanoid creatures hang within large installations peopled by odd figures clambering up walls and hanging from strings. Occasional mirror-writing gestures towards an arcane narrative, while something sinister lurks behind the ramshackle assemblages and painted smiles on these cumulatively overwhelming small-scale works. An insect revolution is assembled from meandering pencil lines and hair-clips in Rashed's pint-sized folk art, intimations of domesticity grimly mixing the fairy-tale with the kitchen-sink. (ST)

Shown by L'appartement 22 F34

Selected Bibliography

2003 *Tamass*, Catherine David, Fundació Antoni Tàpies, Barcelona

Selected Exhibitions

2007 1st Thessaloniki Biennial

2007 Cape Town Biennial

2006 Mashrabia Gallery, Cairo

2006 DAK'ART Biennial

2006 '48byfourEgyptians', Gallery B21, Dubai

Passenger (Urban Bourbon)
1992
Acrylic on enamelled aluminium
124.5×119.5cm
Courtesy Waddington Galleries

Robert **Rauschenberg**

Born 1925
Lives Captiva Island

Robert Rauschenberg once remarked that 'a picture is more like the real world when it's made out of the real world'. In his 'combines', which incorporate fragments of reality such as tyres and taxidermied animals, found objects retain individual force. The artist has approached photographic imagery similarly, relishing its connection to the world while marrying it with painting, much as the 'combines' join sculpture and painting. Solvent-transfer works such as those in his series 'Short Stories' (2000–01) – each of which includes a page and paragraph number in its title, suggesting a larger narrative – show his still keen eye for colour and composition. Radiant and almost cinematic, Rauschenberg's series 'Scenarios' (2005–6) strikingly activates negative space. (KJ)

Shown by Waddington Galleries F15

Selected Bibliography

1999 *Robert Rauschenberg*, Sam Hunter, Rizzoli, New York

1997 *Robert Rauschenberg: A Retrospective*, Walter Hopps and Susan Davidson, Guggenheim Museum Publications, New York

1990 *Rauschenberg: Art and Life*, Mary Lynn Kotz, Harry N. Abrams, New York

1987 *Rauschenberg: An Interview*, Barbara Rose, Vintage Books, Random House, New York

1980 *Robert Rauschenberg: Work 1950–1980*, Lawrence Alloway, Staatliche Kunsthalle, Berlin

Selected Exhibitions

2006–7 'Robert Rauschenberg: Combines 1953–1964', Centre Georges Pompidou, Paris

1997–8 'Robert Rauschenberg: A Restrospective', Guggenheim Museum, New York

1966 The Museum of Modern Art, New York

1964 'Robert Rauschenberg: Paintings, Drawings and Combines 1949–1964', Whitechapel Gallery, London

1963 The Jewish Museum, New York

Cake
2005
Framed C-print on aluminium
45×57cm
Courtesy Air de Paris

Selected Bibliography

2006 *Torbjørn Rødland: White Planet, Black Heart*, Gil Blank et al., steidlMACK, London

2006 'Torbjørn Rødland. Special Focus: Norway', Melissa Gronlund, *Profile*, 3

2004 'Torbjørn Rødland', Martin Herbert, *contemporary*, 66

2003 *Torbjørn Rødland: Grave with a View*, Astrup Fearnley Museet for Moderne Kunst, Oslo

2002 *Clockwise*, NIFCA, Helsinki

Selected Exhibitions

2007 'More Whenever Minutes', Standard, Oslo

2006 'Trobjørn Rødland and Olaf Breuning', Galeria Leyendecker, Santa Cruz de Tenerife

2006 'The Exorcism of Mother Teresa', Art Center, Rochester

2006 '132 BPM', PS1 Contemporary Art Center, New York

2006 'Fantasies Are Facts', Kodama Gallery, Tokyo

Torbjørn **Rødland**

Born 1970
Lives Hafrsfjord

In his photographs and videos Torbjørn Rødland searches for 'something of importance that's been lost under layers of banality'. This displaced aspect may be an authentic relation to nature (as in Rødland's photographic updates from the early 1990s of Caspar David Friedrich's paintings, featuring the artist communing with wild Nordic landscapes), a pre-Christian theism (as emblemized by his 2001 studies of Death Metal musicians in gloomy woods) or romantic credulity in monsters such as the eponymous subject of his languorous video *Blues for Bigfoot* (2005). The question that haunts Rødland's poised, thematically open-ended art – whether such qualities are recoverable – appears particularly timely in *Taking Liberties* (2006), a side-view of the Statue of Liberty. (MH)

Shown by Air de Paris E5, Standard (Oslo) F25

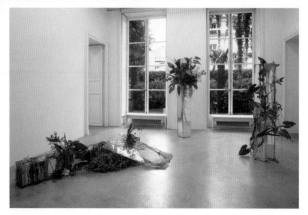

Cristina Lei **Rodriguez**

Born 1974
Lives Miami

One of a clutch of artists to benefit from Miami's rise and rise in contemporary art, Christina Lei Rodriguez is best known for her lush gardens of plastic, Perspex, paint and epoxy resin. Constructed as personal shrines, her installations are set with rhinestones, festooned with plastic jewellery and inundated with hot wax that glistens on the surfaces like a sexual secretion. The rank over-exuberance of her baroque forms suggests that Rodriquez' assemblages are not so much a depiction of life as a Frankensteinian displacement of it. (AJ)

Shown by Team Gallery G23

Selected Bibliography

2006 'Reviews: Cristina Lei Rodriguez', Elisa Turner, *Art News*

2006 'Futurism', Ossian Ward, *Wallpaper**

2006 'Review of Exhibitions: The Garden Party', Edward Leffingwell, *Art in America*

2006 'Young at Art: Miami's Emerging Visual Arts Scene Draws Young Pros from More Established Cities', Elisa Turner, *The Miami Herald*

2006 'How Young Europeans View America's Uncertain State', Benjamin Genocchio, *The New York Times*

Selected Exhibitions

2007 Team Gallery, New York

2006 'Endless Autumn', Galerie Emmanuel Perrotin, Miami

2006 'The Garden Party', Deitch Projects, New York

2005 'New Works', Rocket Projects, Miami

2005 'Uncertain States of America', Astrup Fearnley Museum of Modern Art, Oslo

get / up / girl / a / sun / is / running / the / world
2006
Cast aluminium, white enamel
470×350×320cm
Courtesy Sadie Coles HQ

Selected Bibliography

2006 *zero built a nest in my navel*, Andrea Tarsia et al., Whitechapel Gallery, London

2003 *Ugo Rondinone: Roundelay*, Gaby Hartel and Christine van Assche, Centre Georges Pompidou, Paris

2003 *Our Magic Hour*, Russell Storer, Elizabeth Ann MacGregor and Ugo Rondinone, Museum of Contemporary Art, Sydney

2002 *Ugo Rondinone: No How On*, ed. Gerald Matt, Kunsthalle, Vienna

1999 *Guided By Voices*, Beatrix Ruf et al., Kunsthaus Glarus/ Galerie für Zeitgenossiche Kunst, Leipzig/Hatje Cantz Verlag, Ostfildern Ruit

Selected Exhibitions

2007 Arario, Seoul

2006 'My endless numbered days', Sadie Coles HQ, London

2006 'zero built a nest in my navel', Whitechapel Art Gallery, London

2003 'Roundelay', Centre Georges Pompidou, Paris

2002 'No How On', Kunsthalle, Vienna

Ugo **Rondinone**

Born 1964
Lives New York

In his 2006 solo show at the Whitechapel Gallery, Ugo Rondinone managed to flummox more or less everyone. Confounding expectations, which were mostly pinned on the appearance of his signature multicoloured target paintings and transgender photographic self-portraits, he instead installed a monochromatic array of heterogeneous objects. Masks, a Samuel Beckett-like conversation between a couple breaking up and a central configuration of black Perspex colonnades hung together by virtue of their stylized artifice and a pervading atmosphere of playful melancholy. The progression between Rondinone's works is, it seems, erratically associative. (SO'R)

Shown by Sadie Coles HQ C9, Galerie Krobath Wimmer E22, Matthew Marks Gallery C5, Galerie Eva Presenhuber C3, Galleria Raucci/Santamaria G4, Galerie Almine Rech G7, Sommer Contemporary Art F18

8 images
Installation view
2007
Mixed media
Courtesy Luis Campaña Galerie

Matthieu **Ronsse**

Born 1981
Lives Brussels

Matthieu Ronsse's installations, such as *Picture This!* (2007) – containing figurative paintings in ill-fitting frames, guitars, piles of random stuff and even his laundry – are placed and hung throughout rooms divided by temporary constructions, some held together with masking tape or clamps. Is it all just coming together or falling apart? The repeated presence of a reproduction of Edouard Manet's *Bunch of Asparagus* (1880), whose questionable provenance Hans Haacke famously traced in his work *Manet-Projekt '74* (1974), and the Haacke monograph *Framing and Being Framed* (1975) hint that we should pay as much attention to that which underpins what we see as to that which is right under our noses. (VR)

Shown by Luis Campaña Galerie F24

Selected Exhibitions

2007 'Seb Koberstädt, Takeshi Makishima, Matthieu Ronsse, Chris Lipomi, Keegan McHargue', Luis Campaña Galerie, Cologne

2007 3rd Prague Biennial

2007 'Women and Fluids', Museum Dhondt-Dhaenens, Belgium

2006 'THE END (of a couple of versions to move the home sick)', Luis Campaña Galerie, Cologne

Untitled
2007
Oil on canvas
228.5×381cm
Courtesy Marianne Boesky Gallery

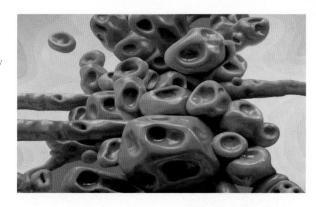

Selected Bibliography

2006 'Color and Texture as Playthings', David Pagel, *The Los Angeles Times*

2005 'World Piece', Andrea Scott, *Time Out New York*

2005 'Alexander Ross', Ken Johnson, *The New York Times*

2004 *Disparities and Deformations: Our Grotesque*, Robert Storr, Site, Santa Fe

2003 'Mighty Graphitey', Roberta Smith, *The New York Times*

Selected Exhibitions

2007 'Renaissance Court Wall', Worcester Art Museum

2006 'Twice Drawn', The Tang Museum at Skidmore College, Saratoga Springs

2006 'Remote Viewing', Whitney Museum of American Art, New York

2005 'Recent Paintings and Drawings', Feature, Inc., New York

2005 'Realism and Abstraction: Six Degrees of Separation', Nelson-Atkins Museum of Art, Kansas City

Alexander **Ross**

Born 1960
Lives New York

Alexander Ross' pictorial universe is a vast green alien garden in which clusters of cells, coiled shapes and organic blobs flourish. Ross starts out by sculpting Plasticine into various forms, which he photographs and then renders as paintings. His restrained palette – shades of blue-green on cool or warm creamy backgrounds – and Hyperrealist attention to detail smack of obsession. Yet while the repertoire may seem limited, shape and scale shift from one canvas to the next, and Ross' fascinating imagery starts to resemble life from the depths of the ocean, the furthest reaches of space or the darkest corners of the mind. (VR)

Shown by Marianne Boesky Gallery F7

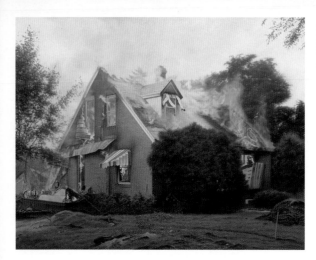

House Fire
2007
Oil on linen
107×137.5m
Courtesy The Project

Peter **Rostovsky**

Born 1970
Lives New York

Try telling Peter Rostovsky that the Sublime died
in the 19th century. Among other things, the artist
makes meticulous miniature dioramas depicting
human figures enthralled by the grandeur of
nature. Consciously referring to a continuum of
transcendentalism that links Caspar David
Friedrich, *Close Encounters of the Third Kind* and the
latest SUV ad, Rostovsky's figurines are tiny Ralph
Waldo Emersons or Henry Thoreaus enjoying
equally miniaturized epiphanies. While he some-
times models his figures on TV characters, in
works such as *Epiphany Model 4: The Meteor Shower*
(2004) Rostovsky's protagonists seem to be
ordinary Gore-Tex-clad eco-tourists, glorying in
perfect, if culturally constructed, moments of
recreational incomprehension. (JT)
Shown by The Project H1

Selected Bibliography

2006 *Exceeding Paint/Expanding
Painting*, Karen E. Jones, Pratt
Institute, New York

2006 *Painting Codes*, ed. Andrea
Bruciati and Alessandra Galasano,
Galleria Communale d'Arte,
Monfalcone

2006 'Peter Rostovsky at The
Project', Edward Leffingwell, *Art
in America*

2005 'Swallowing Seattle', Grant
Mandarino, *Artnet*

2002 *Vitamin P: New Perspectives in
Painting*, Barry Schwabsky,
Phaidon Press, London

Selected Exhibitions

2006 'Landscape for Another',
The Project, New York

2006 'Dark Places', Museum of
Art, Santa Monica

2004 ArtPace, San Antonio

2004 'Deluge', The Project, New
York

2003 'Peter Rostovsky/Kori
Newkirk', The Project, Los
Angeles

Death Cult / Lunar Mouse
2007
Lambda print with plexi mount
152×122cm
Courtesy Marc Foxx

Selected Bibliography

2006 'Sterling Ruby: Long Live the Amorphous Law', Richard Hawkins, *Flash Art International*, October

2006 'Shape Shifter', Holly Myers, *ArtReview*, December

2006 'Sterling Ruby', Michael Ned Holte, *Artforum*, December

2006 *Orange County Biennial*, Kristin Chambers et al., Museum of Art, Orange County

2006 'Introducing: Sterling Ruby', Catherine Taft, *Modern Painters*, December

Selected Exhibitions

2007 'Superoverpass', Foxy Productions, New York

2007 'Killing the Recondite', Metro Pictures, New York

2007 2nd Moscow Biennial of Contemporary Art

2006 'Interior Designer', Marc Foxx, Los Angeles

2006 'Supermax', Galerie Christian Nagel, Cologne

Sterling **Ruby**

Born 1972
Lives Los Angeles

Sterling Ruby moves fluidly between media – from ceramics and weaving to video and Minimalist sculpture. Some of his installations are viscous and dense, featuring oversized dream-catchers and cubes dripping with primordial goo. Others, such as his Minimalist-inspired *Superoverpass* (2007), appear more reserved but still feature unlikely combinations of vandalism and geometry, craft and formalism. Graffiti figures prominently in his 'Inscribed Monoliths' and 'Supermax Wall' series (both 2006), the surfaces of which are defaced by smears and scrawled writings, as well as in his 'Anti-print Posters' series (2007), which includes a work that declares 'Geometry ends life' spray-painted over with the words 'This won't last'. (CL)

Shown by Marc Foxx A1, Metro Pictures C11, Galerie Christian Nagel E3

jpeg nt03
2007
C-print, diasec-face
250×188cm
Courtesy Mai 36 Galerie

Thomas **Ruff**

Born 1958
Lives Dusseldorf

Rising to prominence in the 1980s with his monumentally sized portraits, Thomas Ruff shot in colour film when it was still unfashionable, and helped reintroduce the medium into German photography. Since then he has trained his particular, distanced eye on nearly every genre – from stars in the night sky to his famous series of pixelated 'Nudes' (1999–2005) taken from pornographic websites. In his more recent series 'Jpeg' (2004– ongoing) he enlarges images from the Internet to the point at which the visual information lost through their digital compression becomes the subject of the photograph: we struggle to discern more details, but they no longer exist. (CL)

Shown by Johnen Galerie Berlin/Cologne F10, Mai 36 Galerie C12, Galerie Rüdiger Schöttle E10, David Zwirner C8

Selected Bibliography

2006 *Click/Doubleclick: Das dokumentarische Moment* (Click/Doubleclick: The Documentary Moment), Thomas Weski, Verlag Walther König, Cologne

2005 *Thomas Ruff: m.d.p.n.*, Fabrizio Tramontano et al., Edizioni Charta, Milan

2005 *Art Now*, Eva Kernbauer, Taschen, Cologne

2005 *Flashback: Eine Revision der Kunst der 80er Jahre* (Flashback: Another Look at Art from the '80s), Philipp Kaiser, Hatje Cantz Verlag, Ostfildern Ruit

2002 *Thomas Ruff: Fotografien 1979–heute* (Thomas Ruff: Photography 1979–present), Matthias Winzen, Verlag Walther König, Cologne

Selected Exhibitions

2007 'Thomas Ruff: Das Sprengelprojekt', Sprengel Museum, Hanover

2006 'The Grammar of Photography', Fondazione Bevilacqua la Masa, Venice

2006 'Click/Doubleclick: Das dokumentarische Moment', Haus der Kunst, Munich

2005 'Flashback: Eine Revision der Kunst der 80er Jahre', Museum für Gegenwartskunst, Basel

2003 'Thomas Ruff: Fotografien 1979-heute', Museu Serralves, Porto

Keep illusion for the end
(detail)
2005
Aluminium, concrete, brass,
copper, oak
250×140×216cm
Courtesy BQ

Selected Bibliography

2006 *To what extent should an artist
understand the implications of his or
her findings*, ed. Sarah Glennie and
Grant Watson, Project Arts Centre,
Dublin/Niland Gallery, Sligo

2005 *1954*, BQ, Cologne

2005 *Une Heureuse Régression*
(Happy Regression), Daniel
Kurjakovic, Kunstverein, Munich

2002 *La quête du sens joue entre la
verticalité humaine et l'horizon où se
perd le chemin* (The Quest for
Meaning Lies between Human
Verticality and the Horizon where
the Path Disappears), Maria Barnas,
Centre d'Art Contemporain,
Brétigny

2002 *Spirit of Versatility and
Inclusiveness*, BQ, Cologne

Selected Exhibitions

2007 Museo d'Arte Moderna,
Bologna

2007 BQ, Cologne

2007 BAWAG Foundation,
Vienna

2006 'Strange I've Seen That Face
Before', Museum Abteiberg,
Munchengladbach

2006 'The Secret of Drawing:
Dislocation & Indirection in
Contemporary Drawing', The
Drawing Room, London

Bojan **Sarcevic**

Born 1974
Lives Berlin

At the 2003 Venice Biennale Bojan Sarcevic's
Where the hand doesn't enter, heat infuses, an elegant
curved construction composed of Perspex and
steel, arched across a corner of the exhibition space
like a quarter-section of a greenhouse dome: a
translucent cave reserved for dreams of a perfect
retreat. In 2006, at the Kunstverein Heilbronn, the
artist's small delicate sculptures made from fine
brass rods protruded from the wall like broken
fragments of the building's architectural
framework, as though Fred Sandback's string
outlines of empty volumes had resurfaced in an
antique shop. Berlin-based Sarcevic re-invests
Modernity's clinical objects and spaces with what
they were often built to exclude: historicity, poetry
and playfulness. (JöH)

Shown by BQ B5

Yehudit **Sasportas**

Born 1964
Lives Berlin/Tel Aviv

Yehudit Sasportas' meticulously executed black and white ink drawings of looming trees and scraggy forests, and her stripped-down room installations are at once utterly silent and impenetrable – hers is a still world largely devoid of colour – and full of barely suppressed emotional life. The daughter of Moroccan Jews who emigrated to Israel before she was born, Sasportas takes her uncertain familial and national situation as the foundation for a meditation on the universal desire for roots in a world seemingly beyond our control. Her elusive forests beckon, but their hidden paths and tantalizing clearings merely open onto further networks of dense lines and pooling shadows. (CG)

Shown by Galerie Eigen + Art Leipzig/Berlin F5, Sommer Contemporary Art F18

Selected Bibliography

2007 *The Guardians of the Threshold*, Galerie Eigen + Art, DuMont Literatur/Kunst Verlag, Cologne

2006 *Kunststation Berlin* (Berlin Art Now), Ulf Meyer zu Küingdorf, Knesebeck Verlag, Munich

2005 *The Cave Light*, Christoph Tannert, Galerie Eigen + Art, Leipzig/Berlin

2004 *Rohkunstbau*, Arvid Boellert, Hans Schiler Verlag, Berlin

2003 *Yehudit Sasportas by the River*, Galerie Eigen + Art Leipzig/Berlin, University of California, Berkley Art Museum and Pacific Film Archive, San Francisco

Selected Exhibitions

2007 Israeli Pavilion, 52nd Venice Biennale

2006 'The Guardian of the Pearl Shadow', Sint-Lukas Galerij, Brussels

2005 'The Pomegranate Orchard', Galerie Eigen + Art, Berlin

2004 'Drawing Today', Centro de Arte Contemporáneo, Málaga

2002 'By the River', Berkeley Art Museum, San Francisco

A Day with Sohail and Mariyan
2004
Single-channel video with sound
Courtesy the artist

Selected Bibliography

2007 *Presence Through Absence and the Art of Slowing Down*, Yasmin Canvin, Sainsbury Centre for Visual Arts, UEA, Norwich

2007 *The Garden of Forking Paths: Recent Works by Gigi Scaria*, Gayatri Sinha, Palette Gallery, New Delhi

2007 'The Self, Out There', Shruti Ravinsran, *Outlook*, 26 June–2 July

2007 'Reading Painting', Ramesh Kumar, *Fine Art*, March

2005 *Are We Like This Only?*, Vidya Shivadas, Vadehra Gallery, New Delhi

Selected Exhibitions

2007 'Absence of an Architect', Palette Gallery, New Delhi

2006 'Impossible India', Kunstverein, Frankfurt

2006 'Ghost in the Machine and Other Stories', Apeejay Media Gallery, Delhi

2005 'Where are the Amerindians?', Inter America Space, Trinidad

2005 'Double–Enders', Jehangir Art Gallery, Mumbai

Gigi **Scaria**

Born 1973
Lives New Delhi

Gigi Scaria's art explores the politics of migration by drawing parallels between his own experiences as a peripatetic artist and those of itinerant labourers. In *A Day with Sohail and Mariyan* (2004), his video portrayal of two teenage scavengers, Scaria finds an unlikely beauty in piles of rags, plastic sheets and packing materials, the distance of documentary faltering until subject and artist become akin. More recent works focus on urban dynamics: *Panic City* (2007) filmed from a minaret on Delhi's principal mosque, Jama Masjid, peels back the strata of people and places to reveal the ancient alongside the new. Scaria provokes a dialogue between people and their environments that chips away boundaries, both social and physical. (BB)

Shown by Khoj International Artists Association F33

Low Sweetie # Omega Haus
Installation view
2006
Mixed media
Dimensions variable
Courtesy the artist and
Produzentengalerie

Thomas **Scheibitz**

Born 1968
Lives Berlin

Thomas Scheibitz' paintings comprise interlocking jagged fields and lines, while his sculptures take the form of compositions that emulate constellations. *Head* (2007), for example, consists of a grey MDF box on a low table: a black square just about suggests an eye, turning a steel ball stuck next to it into a bulbous 'nose'. It's as though the icons and forms that Scheibitz develops from material noted in his sketchbooks have been jumbled into a semiotic shaker and then allowed to spill out again. These are works that deal just as much with what they aren't as with what they are: embracing the ambiguity of meaning, Scheibitz reveals the beauty of the irreconcilable. (JöH)

Shown by Tanya Bonakdar Gallery E8, Produzentengalerie Hamburg H8, Monika Sprüth Philomene Magers B10

Selected Bibliography

2006 *Artist's Book: Negative Day*, Thomas Scheibitz, Diamondpaper, Berlin

2005 *Film, Music and Novel*, Thomas Scheibitz, Other Criteria, London

2004 *ABC – I II III: Sculptures 1998–2003*, Verlag Walther König, Cologne

2001 *Ansicht und Plan von Toledo* (View and Plan of Toledo), Kunstmuseum, Winterthur/ Museum für Bildende Künste, Leipzig

Selected Exhibitions

2007 'The Artist's Dining Room', Tate Modern, London

2007 Irish Museum of Modern Art, Dublin

2007 Skulptur 4, Cologne

2007 'Imagination Becomes Reality', ZKM Centre for Art and Media, Karlsruhe

2005 German Pavilion, 51st Venice Biennale

Stone Woman
2006
Oil on canvas
81×65cm
Courtesy Sommer Contemporary
Art

Netally **Schlosser**

Born 1979
Lives Tel Aviv

In the paintings of Netally Schlosser even apparently straightforward subjects are made morbid. *The Pig* (2006), for instance, is an animal akin to a portly politician, with a faint trace of a smug smile and folds of fat under its chin. The grim humour of these scenarios is rivalled only by the application of the paint itself: *Books in Her Hair* (2004) presents a sunless depiction of a furious woman, yet despite her oddly distended limbs the predominance of rich, oily browns ensures that the strange sensuality of the figure is preserved. Through an unlikely alliance of a baleful eye and a sumptuous technique, Schlosser dramatizes the pernicious potential of paint. (BB)

Shown by Sommer Contemporary Art F18

Selected Bibliography

2005 'New Exhibitions', Dana Gilerman, *Ha'aretz*

Selected Exhibitions

2007 'Paintings', Tel Aviv Museum of Art

2006 'Mixed Emotions', Haifa Museum of Art

2005 Sommer Contemporary Art, Tel Aviv

2005 'Sommer in Berlin', Christian Ehrentraut Project Room, Berlin

Ada and her Daughters in the Garden
2005
Oil on canvas
188×137cm
Courtesy Maureen Paley

Maaike **Schoorel**

Born 1973
Lives London

Every image is in some way involved with the process of remembering. Maike Schoorel's paintings, often based on old family photographs, make this visible while harnessing the visceral advantages that paint has over negatives or pixels. Creamy grounds, muted tones, blurs, stains and sketchy details take her compositions to the edge of abstraction – leaving them to hover somewhere between emerging into full view and just fading away. The light and airy nature of Schoorel's paintings suggests that the past is to be found not by peering into dark recesses, but rather by staring into the glare of an imagined sun. (DE)

Shown by Maureen Paley D5

Selected Bibliography

2007 'Maaike Schoorel: Magic Eyes', Pablo Lafuente, *Flash Art International*, March/April

2007 'Must See Art', Amra Brooks, *The Los Angeles Times*

2006 'Bathing dining garden father daughters beach bed: Maaike Schoorel's Shadow Play', Ingrid Commandeur, *Metropolis M*

2006 *Just in Time*, Maxine Kopsa, Stedelijk Museum, Amsterdam

2005 'London: Critics' Picks', Brian Sholis, *Artforum.com*

Selected Exhibitions

2007 'Stilleven, Portret, Schutterstuk', Marc Foxx, Los Angeles

2007 'Very Abstract and Hyper Figurative', Thomas Dane Gallery, London

2006 'Bathing dining garden father daughters beach bed', Maureen Paley, London

2006 'Just in Time', Stedelijk Museum, Amsterdam

2006 'Le Nouveau Siècle', Museum van Loon, Amsterdam

Lara Favaretto
Project for Some Hallucinations

'It is not important to know whether the Queen will
come to the fair or not because, once the news of
my inviting her spreads, the image of her visit will
already be implanted in people's minds. It is like
when one listens to the relating of an idea that is so
powerful it ultimately does not matter if it is ever
realized, since there is already enough substance by
which to visualize it. I imagine this to be like living
surrounded by the empty set of a show, from which
the main character is missing, when the end of the
show is announced by an unexpected applause
thanking all the participants.'

Lara Favaretto, July 2007

The playful, celebratory visual language employed
by Lara Favaretto in her sculptures, installations
and performances is often wilfully undercut by
a simultaneous resignation to failure. Whether
inviting a group of friends to try and make a
donkey fly, or borrowing and suspending in mid-air
a caravan belonging to a community of gypsies, the
artist's enigmatic choreographies gesture towards a
theatre of the absurd.

Favaretto draws on the spectacle of the fair to give
concrete form to an empty or unfulfilled dream.
Ceremony is used to create a stage of expectation,
as we gradually become aware that the main
character may be missing. The applause that marks
the end of each day signals an intermission in an
extended theatrical production.

Janice Kerbel
Remarkable

'*Remarkable* is a print-based work that announces
the achievements of a range of extraordinary
beings imagined in response to the context of the
fair. In the tradition of printed broadsides and
fairground ephemera *Remarkable* employs hyperbolic
language and un-illustrated texts to conjure these
unique individuals. Produced to be distributed
daily throughout the fair, the work acts to alert
visitors to the potential presence of these anomalous
attractions.'

Janice Kerbel, July 2007

Remarkable is a continuation of Janice Kerbel's
fascination with deception in all its forms, the
outcomes of which range from plausible but
impractical plans for a bank heist to a cheat's pack
of playing cards and a town designed specifically for
ghosts. The artist's understanding of the visual codes
that surround these activities allows her work to
exist in its own reality, between thought and action,
where suggestion and expectation flourish.

Kerbel's print project takes 19th-century fairground
posters as its inspiration, and heralds the arrival of
a series of remarkable characters. Building on her
interest in predicting events, each print evokes a
figure created in response to a specific detail relating
to the fair.

THE

REGURGITATING

LADY

THIS truly remarkable being, who by her emetic power alone has excited the imagination of all those who have loved and lost, makes a long-awaited return—

A GOLD WISHBONE
A PORCELAIN FIGURINE
A DOG CALLED MAGGIE

BEHOLD Engraved Heirlooms Returned To Once-Careless Daughters; WITNESS Boys' Treasured Baseballs United With The Hands Of Grown Men; SEE Lost Letters Delivered, Snatched Handbags Recovered, Family Fortunes Restored. This DIVINE ACT of FATE & POSSESSION Will Bring Up The PAST And Give Back ALL That ESCAPES Us—

Things LOST, Things STOLEN, Things MISPLACED
& Things VANISHED

COME ONE COME ALL.

Allen Smithee
*The Corroboration Of My Existence
As A Filmmaker*
Overexposed Negatives
1969–2007
Courtesy the artist

Mario Garcia Torres
Cartier Award 2007:
How I Made a Flop Out of a Strike (or The Other Way Around)

'Can a long history of mistakes and disappointments be turned into a productive buzz when transposed to the art system? In a highly competitive environment in which art works must vie for attention, and where their immediate fate is greatly amplified, my project will try to bring into perspective the politics of authorship, reappraisal, promotion and success.

Taking as a starting point the legend of a discredited filmmaker, this oral intervention will attempt to deconstruct what happens to be a collectively created body of work by considering whether consistency need necessarily be defined by a chronological production or a unique style.

Conceived as a means of consigning the particular endorsement I received for this project, and any potential significance it may temporarily acquire, to an apparently uncertain existence, the work will try to redefine the limits of the scenario that facilitates its being.'

Mario Garcia Torres, June 2007

Mario Garcia Torres reframes the body of work of film auteur Allen Smithee, who will deliver a keynote lecture as part of the Frieze Talks programme in which he elaborates the complex relationship between his public persona and the filmography for which he has become known.

Tobias Putrih
*A Proposal for Frieze Art Fair
2007: A Modern Structure Made of
Wooden Sticks*
2007
Pencil on paper
Courtey the artist

Frankfurter Kunstverein
A Delicious Feeling of Confidence

'Operating within the context of the fair, this project aims to address the notions of "trust" and "pleasure" in relation to contemporary art production today. Within our entertainment-driven society, art fairs constitute what we might call a "pleasure zone": can they also provide a legitimate arena in which the spectator can not only view art but also reflect on contemporary culture today? Can criticality be achieved in this social celebration of art and the art market?

Our specially commissioned 'space unit' by artist Tobias Putrih offers viewers the opportunity to familiarize themselves with the mission of the Frankfurter Kunstverein: to promote curiosity about, and foster trust in, artistic practices that fall a little outside the territory of the commonsensical. The space's key objective is to provide access: to our activities in Frankfurt, and the philosophy that drives them; to our guest speakers and their first-hand accounts of their working practices; to films, videos and databases of art and curating… This is architecture that aspires to promote free exchange, operating from the premise that every one of us needs to invest some time in exploring a universe of projects, images, words and sounds. The Frankfurter Kunstverein's project is, quite simply, an experimental district inside the artificial city of Frieze.'

Chus Martínez, June 2007

Resonance104.4fm

For the fourth consecutive year London's art radio
station, Resonance104.4fm, is broadcasting live
from the fair. The Frieze Talks programme will be
aired alongside specially commissioned radio art
projects and feature interviews with artists and art
professionals in and around the fair. Visitors to the
fair will be able to watch the Resonance team at
work and contribute to the debates.

Log on to www.resonancefm.com worldwide.
Tune in to 104.4 fm in central London.

Oliver Payne and Nick Relph
Stop!
2007
Courtesy Gavin Brown's
enterprise and Herald Street

Oliver Payne &
Nick Relph

British artists Oliver Payne and Nick Relph
manipulate a range of visual material to create
films that meld contemporary culture and artists'
video, referencing documentary film, music video
and surveillance footage. Their subject matter is
frequently drawn from their antagonistic relation-
ship to the social and physical architecture of
London. Bleak, gritty and laden with teenage angst,
their work is often both elegiac and wryly amusing.

Wilhelm Sasnal
The Ranch
2007
Super-8 film transferred to DVD
Courtesy the artist

Wilhelm Sasnal

The paintings of Polish artist Wilhelm Sasnal focus
on the details of the drab and often overlooked
landscapes that surround us, articulating emotional
analogues to moments that linger longer in the
mind than they do in reality. His subjects often
interrogate the way in which we inhabit the liminal
spaces that lie between public and private spheres,
and the ways in which music and image infiltrate
our interior landscapes. Sasnal attributes his interest
in painting to music, which also consistently plays
a key part in his films, providing the narrative
structure for an abstract language of sensation fed
by social and political events.

David Shrigley
Untitled
2007
Courtesy the artist

David Shrigley

British artist David Shrigley has worked in a
variety of media, though he is perhaps best known
for his mordantly humorous cartoons describing
various states of ineptitude and the utterly bizarre.
Referencing Outsider art, his work often focuses
on the infiltration of violence and the effects
of morbid curiosity on the mundane. His films,
which have included music videos for Bonnie
Prince Billy and Blur, are animations of the
narratives implicit in the drawings. These tales
of curiosity and misadventure and their deadpan
humour stay with the viewer long after the last
frame has disappeared.

Kara Walker
*...calling to me from the angry surface
of some grey and threatening sea. I
was transported.*
2007
Still from colour video with
sound; 5-part installation
Courtesy Sikkema Jenkins & Co.

Kara Walker

American artist Kara Walker tackles issues of black
history, race, gender and stereotype. Adapting the
silhouette, a medium more readily associated with
children's illustration, and turning it on its head,
Walker's unruly cut-paper characters fornicate
and inflict violence on one another. Recently
these works have developed into puppet-show
films enacting tragicomic scenarios of illegitimacy,
degradation and compulsive persuasion. Drawing
on the historical realism of slavery and the
fantastical realm of the romantic novel, Walker's
films present seductive, nightmarish fictions.

Artists' Biographies:
Frieze Commissions

Richard Prince (b. 1949) is an American artist based in upstate New York, with a host of international exhibitions to his name. Recent solo projects include the major exhibition 'Richard Prince: Canaries in the Coal Mine', Astrup Fearnley Museum, Oslo, Norway (2006). Recent group exhibitions include: 'In the darkest hour there may be light', Serpentine Gallery, London; 'Magritte and Contemporary Art: The Treachery of Images', Los Angeles County Museum of Art (both 2006); and 'Faces in the Crowd: Picturing Modern Life from Manet to Today', Whitechapel Art Gallery, London (2005). Prince recently opened his solo retrospective at the Guggenheim Museum, New York.

Elín Hansdóttir (b. 1980) is an Icelandic artist based in Reykjavik. Recent solo exhibitions include: 'Taking Time', Sequences Realtime Festival, Reykjavik; 'Book Space', Jugendbibliothek Zeisehalle, Hamburg (both 2006); and 'Untitled (Nafnlaust)', Reykjavik Arts Festival' (2005). Recent group exhibitions include: 'Between The Two Deaths', ZKM Karlsruhe (2007) and 'New Icelandic Art II', National Gallery of Iceland, Reykjavik (2005).

Gianni Motti (b. 1958) is an artist based in Geneva. Recent solo exhibitions include: La Salle de Bains, Lyon (2007); 'Vidéoclub #5', Palais de Tokyo, Paris (2005); and Centre pour l'Image Contemporaine, Geneva (2003). Recent group exhibitions include: 'Defamation of Character', PS1 Contemporary Art Center, New York (2006) and the Swiss Pavilion at the 51st Venice Biennale (2005).

Kris Martin (b. 1972) is a Belgian artist based in Ghent. Martin has recently participated in the group exhibitions 'Some Time Waiting', Kadist Art Foundation, Paris; 'Learn to Read', Tate Modern, London (both 2007); and 'Of Mice and Men: 4th Berlin Biennial for Contemporary Art' (2006).

Lara Favaretto (b. 1973) is an Italian artist based in Turin. Favaretto has had solo exhibitions at the Castello di Rivoli Museum of Contemporary Art, Turin (2005) and at the Gallery of Modern and Contemporary Art, Bergamo (2002). Recent group exhibitions include: 'Une seconde une année' (One Second, One Year), Palais de Tokyo, Paris (2006); 'Ecstasy: Recent Experiments in Altered Perception', Museum of Contemporary Art, Los Angeles; and the Venetian Pavilion, 51st Venice Biennale (both 2005).

Janice Kerbel (b. 1969) is a Canadian artist based in London. Recent solo exhibitions include: '1st at Moderna', Moderna Museet, Stockholm, and 'Deadstar', Locus +, Newcastle (both 2006). Recent group exhibitions include: the Montreal Biennial, Canada (2007); 'Around the World in 80 Days', South London Gallery (2006); and the British Art Show 6, BALTIC, Centre for Contemporay Art, Newcastle and touring (2005).

Mario Garcia Torres (b. 1975) graduated from the California Institute of the Arts in 2005 and lives and works in Los Angeles. Recent group exhibitions include the 2nd Moscow Biennial and 'Saturday Live: Actions and Interruptions', Tate Modern, London (both 2007). Garcia Torres was included in the 52nd Venice Biennale (2007) and has forthcoming solo exhibitions at the Stedelijk Museum, Amsterdam, and the Kadist Art Foundation, Paris.

Artists' Biographies:
Frieze Film Commissions

Oliver Payne (b. 1977) and **Nick Relph** (b. 1979) are artists based in London. Recent solo exhibitions include: Serpentine Gallery, London (2005), and Kunsthalle Zurich (2004). Recent group exhibitions include: the Tate Triennial, Tate Britain, London (2006); 'Greater New York', PS1 Contemporary Art Center, New York (2005); Carnegie International, Carnegie Museum of Art, Pittsburgh (2004); and 'Utopia Station', 50th Venice Biennale (2003).

Wilhelm Sasnal (b. 1972) is a Polish artist based in Kraków. Recent solo exhibitions include: Douglas Hyde Gallery, Dublin; Frankfurt Kunstverein (both 2006); and Camden Arts Centre, London (2004). Recent group exhibitions include: 'Infinite Painting: Contemporary Painting and Global Realism', Villa Manin Centre for Contemporary Art, Codroipo, Italy (2006); 'On Line', Louisiana Contemporary, Copenhagen; and 'Expanded Painting', 2nd Prague Biennial (both 2005).

David Shrigley (b. 1968) is an artist based in Glasgow. Recent solo exhibitions include Dundee Contemporary Arts (2006); Camden Arts Centre, London, and UCLA Hammer Museum, Los Angeles (both 2002). Recent group exhibitions include: 'Under God's Hammer: William Blake versus David Shrigley', Art Gallery of Western Australia, Perth, and 'The Compulsive Line: Etching 1900 to Now', Museum of Modern Art, New York (both 2006); and 'State of Play', Serpentine Gallery, London (2004).

Kara Walker (b. 1969) is an American artist based in New York. Recent solo exhibitions include: 'Kara Walker at the Met: After the Deluge', The Metropolitan Museum of Art, New York (2006), and 'Grub for Sharks: A Concession to the Negro Populace', Tate Liverpool (2004). Recent group exhibitions include: 'Global Feminisms', The Brooklyn Museum of Art, New York (2007); and 'Into Me/Out of Me' Kunst-Werke Institute for Contemporary Art, Berlin, and touring (2006). Walker currently has a major retrospective touring the Walker Art Center, Minneapolis; Musée d'Arte Moderne de la Ville de Paris/ARC, Paris; the Whitney Museum of American Art, New York, and the UCLA Hammer Museum, Los Angeles.

FRIEZE ART FAIR

Artists

Mino
2005
Oil on canvas
48×38cm
Courtesy Galerie Giti
Nourbakhsch and greengrassi

Tomma **Abts**

Born 1967
Lives London

Tomma Abts imposes a great many regulations on her practice, painting only with acrylic and oil, and on canvases that measure 48 x 38 cm. She layers many compositions one on top of the other until she considers the painting to have become 'congruent with itself', and then titles the work with a German forename. The textured surface of each small canvas becomes both a relic of this lengthy process and a strange entity in itself. Abts' characteristic use of repetitive geometrical forms also yields a variety of associations, such as the shattered glass or stars discernible in *Fewe* (2005) or the more curvilinear, planetary forms of *Loert* (2005). (SL)

Shown by Galerie Daniel Buchholz C4, greengrassi D8, Galerie Giti Nourbakhsch C2, David Zwirner C8

Selected Bibliography

2006 *Of Mice and Men: 4th Berlin Biennial for Contemporary Art*, Maurizio Cattelan, Massimiliano Gioni and Ali Subotnick, Hatje Cantz Verlag, Ostfildern Ruit

2006 'Terminally New', Tom Morton, *frieze*, 97

2006 'Konzentrierter Augentrug' (Concentrated Trick of the Eye), Boris Hohmeyer, *art*, December

2006 'Kunst der Langsamkeit' (The Art of Slowness), Julia Große, *ZEIT*, Hamburg, 30 November

2005 *Tomma Abts*, Adam Szymcyk, Kunsthalle, Basel

Selected Exhibitions

2006 Galerie Daniel Buchholz, Cologne

2006 Kunsthalle, Kiel

2005 greengrassi, London

2005 The Douglas Hyde Gallery, London

2005 Kunsthalle, Basel

Unrealizable Goals
2007
Single-channel video projection
with sound
Video still
Courtesy Lisson Gallery

Selected Bibliography

2006 *Land Mark*, ed. Frédéric Grossi, Akiko Miki and Marc Sanchez, Palais de Toyko/Paris Musées, Paris

2006 *Hugo Boss Prize 2006: The Ends of Art and the Right to Survival*, Yates McKee, Guggenheim Museum, New York

2006 *Artificial Light: Jennifer Allora & Guillermo Calzadilla: Growth (Survival)*, John B. Ravenal, VCUarts Anderson Gallery, VMFA MOCA, Richmond

2005 *Allora & Calzadilla*, ed. Sofia Hernández Chong Cuy, The Americas Society, New York

2004 *Common Sense?*, Yates McKee, Institute of Contemporary Arts, Boston

Selected Exhibitions

2007 Kunsthalle, Zurich

2007 'Wake Up', Renaissance Society, Chicago

2006 'Clamour', The Moore Space, Miami

2006 'Land Mark', Palais de Tokyo, Paris

2003 'Puerto Rican Light', The Americas Society, New York

Jennifer **Allora** & Guillermo **Calzadilla**

Born 1974/1971
Live Puerto Rico

Jennifer Allora and Guillermo Calzadilla have written that they 'deal with globalization because it's impossible not to'. In their first collaborative work, *Charcoal Dancefloor* (1997), a drawing of human figures was blurred into abstraction by gallery-goers' feet until nothing but their Nike-branded footprints remained. While in that work the mobility of people, capital and ideas intimated violence, in their video *Under Discussion* (2005) it is perhaps a more benign force. Here the son of a Puerto Rican civil disobedience movement leader travels to the disputed territory of Vieques in a boat made from an upturned conference table, bringing with him the hope, however absurd, of profitable debate. (TM)

Shown by Galerie Chantal Crousel D3, Gladstone Gallery D6, Lisson Gallery B8

Guide to Al Khan, an Empty Village in the City of Sharjah
2007
80 slides and edited guide
Courtesy Galería Pepe Cobo

Lara **Almarcegui**

Born 1972
Lives Rotterdam

The list of materials used to construct last year's Frieze Art Fair – which ran to the tune of 407.9 tonnes of aluminium and 338.5 tonnes of MDF – displayed in vinyl lettering at the fair entrance, may have been interpreted as a critique of art as a commodity-led industry. Considered within the context of Lara Almarcegui's ongoing practice, however, its connotations are more nuanced and socializing. Previous 'deconstructions' have involved borrowing the raw building materials required to rebuild an arts institution in Brussels, a gesture of potentiality that is intended to prompt the empowerment of collectivity rather than scepticism – themes that Almarcegui also unearths in the mundane acts of allotment-tending and wasteland preservation. (SO'R)

Shown by Galería Pepe Cobo H10

Selected Bibliography

2007 *Lara Almarcegui*, Fernando Francés and Juan Herreros, Centro de Arte Contemporáneo, Málaga

2006 *Lara Almarcegui*, David Perreau, Actes Sud/Atladis Prize, Arles

2005 'The Emancipation of Nowhere Land', Ole Bouman, *Pasajes de arquitectura y crítica*, February

2005 'Entropic Promise: Lara Almarcegui', Jean Marc Huitorel, *Art Press*, February

2002 *Lara arreglatodo* (Lara Fix-it-all), Santiago Cirugeda, Editions la Lettre Volée, Brussels

Selected Exhibitions

2007 'Lara Almarcegui: Materiales de construcción de la sala de exposiciones Espacio 2 CAC Málaga', Centro de Arte Contemporáneo, Málaga

2006 'How to Live Together', 27th São Paulo Biennial

2006 'Frieze Projects', Frieze Art Fair, London

2006 'The Unhomely: Phantom Scenes in Global Society', 2nd Seville Biennial

2005 'Removing the Floor of Room D4', Rijksmuseum, Amsterdam

Abram and Burus
2006
Bronze
33cm (height)
Courtesy Foksal Gallery
Foundation

Selected Bibliography

2006 *Pawel Althamer: Au Centre Pompidou* (Pawel Althamer: At the Pompidou Centre), ed. Anna Hiddleston and Francoise Bertaux, Centre Georges Pompidou, Paris

2006 'Pawel Althamer Talks about Fairy Tale', Claire Bishop, *Artforum* , May

2004 *Pawel Althamer: The Vincent Award 2004*, ed. Ineke Kleÿn, Hatje Cantz Verlag, Ostfildern Ruit

2003 *Sogenannte Wellen und andere Phäenomene des Geistes: Artur Zmijewski and Pawel Althamer* (So-called Waves and Other Phenomena of the Mind: Artur Zmijewski and Pawel Althamer), Rita Kersting, Kunstverein für die Rheinlande und Westfalen, Dusseldorf

2002 'The Annotated Althamer', Adam Szymczyk, *Afterall*, 5

Selected Exhibitions

2007 'Black Market', neugerriemschneider, Berlin

2007 'One of Many', Fondazione Nicola Trussardi, Milan

2007 Sculpture Projects 07, Munster

2006 Centre Georges Pompidou, Paris

2006 4th Berlin Biennial

Pawel **Althamer**

Born 1967
Lives Warsaw

From his early visceral wax-and-hair self-portraits to his recent naked depiction of himself in the form of a gigantic aerostat balloon, Pawel Althamer has constructed a whole mythology around his own body, multiplying and manipulating his corporeal identity as though it were an external adornment. His installations, performances and videos are also well known for their critical engagement with social and political questions concerning art institutions, and in particular the role and place of art in urban contexts. Althamer is one of the original practitioners of opening up gallery spaces to the wider public, whether inviting migrant workers to participate in his exhibitions or documenting the artistic activities of local residents. (AS)

Shown by Foksal Gallery Foundation E6

Kai **Althoff**

Born 1965
Lives Cologne

To encounter a work by Kai Althoff – which can include anything from painting, drawing and installation to writing and musical performance – is to intrude on a rarefied and carefully constructed world, riddled with oblique allusions to marginalized and deviant subcultures and to the artist's own childhood in 1970s' West Germany. While his delicate paintings of fraternal encounters queer the Expressionism of George Grosz, Gustav Klimt and Egon Schiele, Althoff's sprawling installations, such as the site-specific project *Von Mausen und Menschen* (2006) created with Lutz Braun for the 4th Berlin Biennial, act out altogether more wretched dramas, mingling art works (his own and those of others) with life's detritus, throwing sanitized domesticity into abject disarray. (AB)

Shown by ACME. D16, Gladstone Gallery D6, Galerie Christian Nagel E3, Galerie Neu B4, Gabriele Senn Galerie E24

Selected Bibliography

2005 'The Ties That Bind', Jordan Kantor, *Parkett*, 75

2004 'Kai Altoff', David Rimanelli, *Artforum*, September

2004 'Hometown of Utopia and Dissent', Holland Cotter, *The New York Times*, 23 July

2002 'The Drawing Board', Peter Schjeldahl, *The New Yorker*, November

2001 'Kai Althoff', Michael Kimmelman, *The New York Times*

Selected Exhibitions

2006 'Painting in Tongues', Museum of Contemporary Art, Los Angeles

2006 'Heart of Darkness', Walker Art Center, Minneapolis

2005 'Solo für eine befallene Trompete', ACME., Los Angeles

2004 'Kai No Respect', Institute of Contemporary Arts, Boston

2002 'Drawing Now: 8 Propositions', Museum of Modern Art, New York

Transa
2005
9 copies of album sleeve for
'Transa', Caetano Veloso, 1972
Dimensions variable
Courtesy Carl Freedman Gallery

Armando **Andrade Tudela**

Born 1975
Lives St Etienne

Focusing on the complex systems of translation and transference, Armando Andrade Tudela explores the various manifestations of broader cultural ideas within the localized context of South America. *Transa* (2005), a sculpture made from copies of Tropicalia musician Caetano Veloso's eponymous 1974 album – recorded on his return to Brazil from self-imposed exile in London, following his arrest by the military junta – gives literal form to notions of belonging, the transmigration of style and corollaries between politics and aesthetics. *Inka Snow* (2006), a book and architectural model of a hedonistic community built within giant lines of cocaine, alludes to the ancient geoglyphs in Peru's Nazca Desert, now scarred by trucks driving across them: detail and nuance are lost in a blizzard of excess, migration and colonization. (DF)

Shown by Carl Freedman Gallery B1, Annet Gelink Gallery E21

Selected Bibliography

2006 'Armando Andrade Tudela', Dan Fox, *frieze*, 102

2006 *Vitamin Ph: New Perspectives in Photography*, T.J. Demos, Phaidon Press, London

2006 *The Drawing Book*, Tania Kovats, Black Dog Publishing, London

2006 *27th São Paulo Biennial: How to Live Together*, Lisette Lagnado and Adriano Pedrosa, Fundação Bienal de São Paulo

2004 *Camion*, Armando Andrade Tudela, Counter Gallery, London/Verlag Walther König, Cologne

Selected Exhibitions

2007 'Les signaux de l'âme', Annet Gelink Gallery, Amsterdam

2007 9th Lyon Biennial

2006 'Inka Snow', Carl Freedman Gallery, London

2006 6th Shanghai Biennial

2006 27th São Paulo Biennial

Girl from the Depths
2006
Chromogenic print
169×108cm
Courtesy Galerie Emmanuel
Perrotin and Blum and Poe

Chiho **Aoshima**

Born 1974
Lives Tokyo

In Chiho Aoshima's monumental, digitally generated mural *The Divine Gas* (2006) a giant, naked girl lies prostrate, surrounded by butterflies, in an apparently idyllic landscape – but clouds of pastel vapour and a green genie emerging from her rear suggest a darker scenario. Drawing on references that range from Edo scrolls to Japanese Pop, Aoshima's images limn a detailed, toxically seductive world in which nymphs navigate faintly diabolical, lushly cinematic situations: these waifs are tied to trees, revel in graveyards as pretty zombies and soak in hot springs under the stars while insects and reptiles crawl on their bodies. (KJ)

Shown by Galerie Emmanuel Perrotin F9

Selected Bibliography

2006 'Chiho Aoshima: Mr. and Aya Takano', Eve Sullivan, *contemporary*, December

2006 'Ecstasy: In and about Altered States', Erik Davis, *Artforum*, January

2005 'Chiho Aoshima', Jori Finkel, *Art in America*, October

2005 'The Murakami Method', Arthur Lubow, *The New York Times Magazine*, 6 April

2005 '54th Carnegie International', James Trainor, *frieze*, 88

Selected Exhibitions

2007 'City Glow', Museum of Fine Arts, Houston

2007 Galerie Emmanuel Perrotin, Paris

2006 BALTIC Centre for Contemporary Art, Gateshead

2006 Musée d'Art Contemporain, Lyon

2005 'Little Boy: The Arts of Japan's Exploding Subculture', Public Art Fund, New York

After Thought 1
2007
Aluminium
170×180×140cm
Courtesy Jablonka Galerie

Selected Bibliography

2005 *Ron Arad*, Issey Miyake et al., Barry Friedman Ltd., New York

2004 *Ron Arad*, Matthew Collings, Phaidon Press, London

1999 *Ron Arad*, Deyan Sudjic, Laurence King Publishers, London

1990 *Ron Arad*, Alexander von Vegesack, Vitra, Weil am Rhein

1989 *Restless Furniture*, Deyan Sudjic, Fourth Estate, London

Selected Exhibitions

2006 'The Dogs Barked', de Pury & Luxembourg, Zurich

2005 'Designs by Ron Arad', Museum of Contemporary Art, Indianapolis

2000 'Before and After', Victoria and Albert Museum, London

1994 'L'Esprit du Nomade', Fondation Cartier pour l'Art Contemporain, Paris

1987 documenta 8, Kassel

Ron **Arad**

Born 1951
Lives London

From welded and polished voluminous metal chairs to vases and lights grown from laser fused polyamide, Ron Arad's work combines the sculptural with sci-fi innovation. The undulating forms of his wittily titled limited-edition objects are often created using hi-tech computerized manufacturing processes: pieces in the 'Not Made By Hand Not Made In China' series (2000) were derived from handwriting rendered in three dimensions, while those in the well-known 'Oh-Void' series (2005–6), in inflated mirror polished aluminium, look like chairs from the set of some Brancusi-designed *Blade Runner*. Arad's objets d'art twist and polish past countless visions of the future imagined by other generations.

Shown by Jablonka Galerie D1

El vado
(The Passage)
2006
Colour photograph
80×100cm
Courtesy Galería Pepe Cobo

Ibon **Aranberri**

Born 1969
Lives Itziar-Deba

Ibon Aranberri's varied political practice encompasses public art works, photographic archives and interventions into the landscape of his native Spain. His works are best understood as failed monuments, or as monuments to failure. Modernism, with its romantic aura and frequently nationalist claims, is his material and subject. Recently Aranberri has investigated Francisco Franco's hydraulic policies, writing a history of the political management of water resources and their execution in a Brutalist aesthetic. In his redrawn maps, documentary films and found materials Aranberri calmly reveals the political exploitation of Modernism, replacing it with a cyclical narrative tied to the landscape itself. (MG)

Shown by Galería Pepe Cobo H10

Selected Bibliography

2006 'The Logic of Stories', Pip Day, *Afterall*, 14

2006 *Registros imposibles: el mal de archivo* (Impossible Registers: Archive Syndrome), Ibon Aranberri, Consejería de Cultura y Deportes, Madrid

2005 *Black Friday: Exercises in Hermetics*, Christoph Seller, Revólver

2004 'Ibon Aranberri', Peio Aguirre, *Flash Art International*, 234

2004 *No Trees Damaged*, Joseba Zulaika, Lars Bang Larsen and Peio Agirre, Sala Rekalde, Bilbao

Selected Exhibitions

2007 Galleria d'Arte Moderna, Bologna

2007 'Whenever It Starts It Is The Right Time: Strategies for a Discontinuous Future', Kunstverein, Frankfurt

2007 documenta 12, Kassel

2006 Baltic Art Center, Visby

2006 'Phantom', Charlottenborg Udstillingsbygning, Copenhagen

'Casa de Vidrio' Cuadro 1
('Glass House' Painting 1)
2006
Oil on wood
23×34cm
Courtesy Galeria Luisa Strina

Selected Bibliography

2006 *Romance (A Novel)*, Adriano Pedrosa, Galeria Cristina Guerra, Lisbon

2006 *27th São Paulo Biennial: How to Live Together*, Lisette Lagnado and Adriano Pedrosa, Fundação Bienal de São Paulo

2004 *Inéditos 2004 (Proyectos expositivos de arte emergente)* (New Faces 2004, Programme of Exhibitions for Emerging Art), Obra Social Caja, Madrid

2004 *Reanimation*, Madeleine Schuppli, Kunstmuseum, Thun/Museum für Gestaltung, Zurich/Grafiksammlung, Zurich

2003 *Cream3*, Phaidon Press, London

Selected Exhibitions

2007 Galeria Luisa Strina, São Paulo

2007 'Construction Time Again', Lisson Gallery, London

2006 Galería Elba Benítez, Madrid

2006 27th São Paulo Biennial

2003 'Obras recientes', Galería Sicardi, Houston

Juan **Araujo**

Born 1971
Lives Caracas

In 2005 Juan Araujo based a series of his small-format oil-on-wood panels, 'Reflejos en Coloritmos' (Reflections on Colour Rhythms), on the lustrous reflections perceived in the surfaces of the 'Coloritmos' paintings of the 1950s by Venezuelan artist Alejandro Otero, which hang in art collections in Caracas. In his ongoing series of 'Cuadros-Libros' (Painting-Books) Araujo creates *trompe-l'oeil* illusions of art history books – a monograph on Johannes Vermeer, for instance. Modern Venezuelan cultural heritage and the condition of art's reproducibility are spliced together in paint. (MA)

Shown by Galeria Luisa Strina F12

Life During Wartime
2007
Oil on wood panel
95×122cm
Courtesy Taxter & Spengemann

Wayne **Atkins**

Born 1977
Lives New York

The painter can become an omnipotent narrator by exploiting the sheer malleability of illusory space. He or she can overcome gravity, facilitate anachronisms and shunt together phenomena that might ordinarily never come into contact. Wayne Atkins uses this power to satirical ends, while also prompting more serious reflections on appropriation and the patricidal tendencies of the avant-garde. Placing canonical works by Marcel Duchamp, Josef Albers and others in improbable situations, he flexes his post-Structuralist muscles: Robert Rauschenberg's goat is liberated from its 'combine', only to be trapped in some bizarre cultish pulley system involving a Sol LeWitt star drawing and a headless bat. (SO'R)

Shown by Taxter & Spengemann F19

Selected Exhibitions

2007 Taxter & Spengemann, New York

2006 Taxter & Spengemann, New York

2006 'Clear the Room', California Institute of the Arts, Los Angeles

2005 'Los Angeles Biennial Juried Show', Municipal Art Gallery, Los Angeles

Ghost
2007
Aluminium foil castings
Dimensions variable
Courtesy Galerie Christian Nagel

Selected Bibliography

2006 'Génération Kader', *Lyon Capitale*, 4 July

2006 'Kader Attia: œil pour œil, dent pour dent' (Kader Attia: Eye for an Eye, Tooth for a Tooth), Maou Farine, *L'œil*, July/August

2006 'Attia: À double détente' (Attia: Double Release), Émilie Renard, *Beaux Arts*, December

2006 *Kader Attia*, Tami Katz-Frieman and Jean-Louis Pradel, jrp | ringier, Zurich

Selected Exhibitions

2007 Museum of Art, Haïfa

2007 Galerie Christian Nagel, Berlin

2007 Institute of Contemporary Art, Boston

2006 Musée d'Art Contemporain, Lyon

2006 'Tsunami', Magasin, Centre National d'Art Contemporain, Grenoble

Kader **Attia**

Born 1970
Lives Paris

Kader Attia raised eyebrows during the last Lyon Biennial with *Flying Rats* (2005), a flock of pigeons enclosed in a giant cage with child-sized mannequins made out of birdseed and dressed in kids' clothes: a powerful evocation of the simmering violence of the playground, or an exercise in animal cruelty? Attia's installations expose today's widespread conflicts by homing in on specific communities, habitats and icons. In *Fridges* (2006) he painted 172 abandoned refrigerators and arranged them to resemble the anonymous housing blocks of the Parisian suburbs. His work probes the contradictions born of the universal desire to maintain one's sense of self and yet simultaneously to belong. (VR)

Shown by Galerie Christian Nagel E3

Untitled (Theodora/Dorothea) /
Untitled (Mr Impossible)
2006
Jesmenite, acrylic, sheep's wool
Dimensions variable
Courtesy Galleria Sonia Rosso

Charles **Avery**

Born 1973
Lives London

Since 2005 Charles Avery's practice – which encompasses drawing, sculpture and texts – has been dedicated to describing the geography and cosmology of an imagined archipelago whose every feature posits a philosophical problem, question or, perhaps, solution. Recently mapped areas of this island group include its heaving market-place and the Plane of the Gods – a horizontal Olympus on which its collection of motley deities reside, presided over by an apparently bottomless hole into which, over the course of eternity, each of them is destined to fall. Combining elegant draughtsmanship with deft conceptual thinking, Avery's work resembles the cartographic findings of an explorer returned from a fantastical inland sea. (TM)

Shown by doggerfisher G19, Galleria Sonia Rosso A9

Selected Bibliography

2006 'Charles Avery', Tiziana Conti, *tema celeste*, July/August

2005 'Charles Avery', Tom Morton, *Frog*, October

2005 'Charles Avery, The Islanders', Mariuccia Casadio, *Vogue Italia*, September

2003 *The Art Atom*, Matthew Kneake, Tom Morton and Brian Dillon, Atopia Projects, Edinburgh

2003 'In the Beginning', Tom Morton, *frieze*, 75

Selected Exhibitions

2007 The Drawing Room, London

2007 52nd Venice Biennale

2007 9th Lyon Biennial

2007 1st Athens Biennial

2006 'The Plane of the Gods', Cubitt Gallery, London

Generale che incita alla guerra
(General Commanding his Troops
into Battle)
1961
Oil, collage, passementerie, fabric
decorations
146×114cm
Courtesy Giò Marconi

Selected Bibliography

1991 *Enrico Baj: The Garden of
Delights*, Donald Kuspit and
Umberto Eco, Fabbri Editori,
Milan

1989 *Milan in the 1950s: An
Authentic Avant Garde*, Jan van der
Marck, Marisa del Re Gallery,
New York

1985 *Enrico Baj: General Crisis.
The Large-scale Works 1964–1984*,
Jan van der Mark, Center for the
Fine Arts, Miami

1973 *Enrico Baj: Dada Impressionist*,
Herbert Lust, Giulio Bolaffi, Turin

1971 *Games Baj Plays*, Jan van der
Mark, Museum of Contemporary
Art, Chicago

Selected Exhibitions

2007 Friedrich Petzel Gallery,
New York

2002 'Enrico Baj: Opere 1951–
2001', Palazzo delle Esposizioni,
Rome

1971 Museum of Contemporary
Art, Chicago

1967 Gemeentemuseum, The
Hague

1964 31st Venice Biennale

Enrico **Baj**

Born 1924
Died 2003

The work of artist, writer and general dissenter
Enrico Baj never lost its sense of sardonic critique –
from his derisory series of found-object sculptures
from the 1960s, 'Generals', fashioned from scraps
of haberdashery and military medals, to the work
that is often considered his greatest, *Apocalypse*
(1978–83), in which he expressed his dismay at the
degeneracy of humanity and the destruction of the
planet. Acclaimed for his anti-institutional stance
by other artistic nonconformists such as Marcel
Duchamp and Asger Jorn, Baj also co-founded the
Movimento d'Arte Nucleare (the Art for the
Nuclear Age Movement) with Sergio Dangelo in
1951, proclaiming a desire to 'demolish all the isms
of painting, which inevitably lapse into academism,
whatever their origins may be'. (AB)

Shown by Giò Marconi F6

Selected Bibliography

2007 *Drawing Restraint: Volume 4*,
Matthew Barney, JMc/GHB
Editions, New York

2006 *Matthew Barney & Joseph
Beuys: All in the Present Must Be
Transformed*, Nancy Spector, Mark
Taylor and Christian Scheidemann,
Guggenheim Museum
Publications, New York

2005 *Drawing Restraint: Volume 1*,
Matthew Barney, Verlag Walter
König, Cologne

2002 *Matthew Barney: The
Cremaster Cycle*, Nancy Spector and
Neville Wakefield, Harry N.
Abrams/Guggenheim Museum
Publications, New York

1991 *Matthew Barney: New Work*,
San Francisco Museum of Modern
Art

Matthew **Barney**

Born 1967
Lives New York

Matthew Barney's strange, wondrous blends of
performance art, cinematic spectacular and tactile
exhibition display epitomize 1990s' art in their
ambition and excess. Demonstrating a creative
attitude towards biological nomenclature – and
gender – and a penchant for evocative, seamy
materials, Barney's epics create a mythology for the
hybrid species of his world: Lucite-legged sprites,
crusty giants and cross-dressing athletes. In works
such as the five-film *Cremaster* cycle (1994–2002)
or the long-running 'Drawing Restraint' series
(1987– ongoing) Barney uses himself as a point of
resistance, grounding his flights of fancy in a stark
appraisal of what it means to be human – or almost
human. (MG)

Shown by Sadie Coles HQ C9, Gladstone Gallery
D6, Regen Projects C10

Selected Exhibitions

2006 'All in the Present Must Be
Transformed: Matthew Barney and
Joseph Beuys', Deutsche
Guggenheim, Berlin; Peggy
Guggenheim Collection, Venice

2005 'Matthew Barney: Drawing
Restraint', 21st Century Museum
of Contemporary Art, Kanazawa;
Samsung Museum of Art, Seoul;
San Francisco Museum of Modern
Art

2002 'Matthew Barney: The
Cremaster Cycle', Solomon R.
Guggenheim Museum, New York;
Museum Ludwig, Cologne; Musée
d'Art Moderne de la Ville de
Paris/ARC

1991 'Matthew Barney: New
Work', San Francisco Museum of
Modern Art,

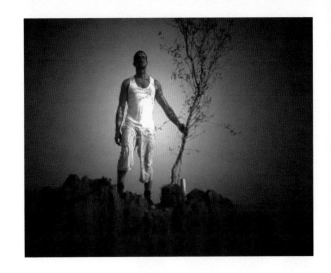

A Declaration
2006
One channel video and sound
installation
Courtesy Annet Gelink Gallery

Yael **Bartana**

Born 1970
Lives Tel Aviv/Amsterdam

Yael Bartana's photographs and videos explore the political, religious and social traditions of her native Israel, particularly as they manifest the conflict between individual choice and collective duty. Her best-known work, *Trembling Time* (2001), observes a highway in Tel Aviv on Memorial Soldiers' Day. At the sound of a siren the cars uniformly slow to a stop, and the drivers get out to stand in solidarity for the dead. After a few minutes they return to their cars and resume driving. Bartana's sloweddown view of an act of automatic collective remembrance forces us to question whether, in her words, such rituals 'strengthen the nation or whether they merely increase our loyalty to the state whilst undermining our ability to make an individual judgement'. (CG)

Shown by Annet Gelink Gallery E21, Sommer Contemporary Art F18

Selected Bibliography

2006 'How to Live Together', Maria Elvira Iriarte, *Art Nexus*, 63

2006 'Yael Bartana', Nina Montman, *Artforum*, October

2006 'Community Service', Nina Montman, *frieze*, 102

2006 *Yael Bartana: Videos & Photographs*, Galit Eilat and Charles Esche, Van Abbemuseum, Eindhoven

2005 'Future Greats', Victoria Lynn, *ArtReview*, December

Selected Exhibitions

2007 'Summer Camp', Annet Gelink Gallery, Amsterdam

2007 documenta 12, Kassel

2006 Stedelijk Van Abbemuseum, Eindhoven

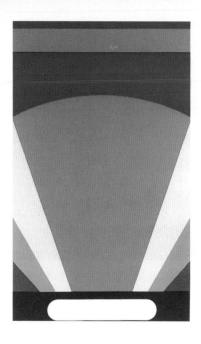

Dansamgam
1997
Acrylic on canvas
116×70cm
Courtesy Art : Concept

Francis **Baudevin**

Born 1964
Lives Geneva

Modernist geometric abstraction has long been employed in graphic design to indicate cleanliness, speed and efficiency. The pharmaceutical industry, in particular, conjures messages of efficacy through hard-edged logos and designs, with a visual syntax that rarely strays from rectangles or concentric circles in bold colours. For over 15 years now Francis Baudevin has repatriated these designs as art, removing all text from the packaging and enlarging the graphic motif to the scale of a painting. Such processes of appropriation, subtraction, inversion and resuscitation implicate the artist in a cycle of visual culture that renders the notion of the 'death of painting' somewhat simplistic. (SO'R)

Shown by Art : Concept G10

Selected Bibliography

2003 'Francis Baudevin', Fabrice Stroun, *frieze*, 75

2003 'Francis Baudevin', Vincent Pecoil, *Flash Art International*, 229

1995 'Francis Baudevin', Lionel Bovier, *Flash Art International*, 178

1995 *In Vitro/In Vivo*, Christophe Cherix, jrp | ringier, Zurich

1992 *Sens dessus dessous* (Upside Down), Katja Schenker, Kunsthalle, St Gallen

Selected Exhibitions

2007 'Zones de Productivités Concentrées', Musée d'art Contemporain du Val-de-Marne, Vitry sur Seine

2007 'Painting as a Fact', de Pury & Luxembourg, Zurich

2007 'Une question de génération', Musée d'Art Contemporain, Lyon

2006 'In den Alpen', Kunsthaus, Zurich

2005 'Lost and Found', Musée d'Art Moderne et Contemporain, Geneva

Teenage heart-randy
2006
Oil on canvas
150×130cm
Courtesy Galerie Peter Kilchmann

Selected Bibliography

2006 *Die anderen Bilder: Outsider und Verwandtes aus der Sammlung Hartmut Neumann* (The Other Pictures: Outsider and Related Works from the Hartmut Neumann Collection), Museum der Stadt, Ratingen

2006 *Faster Bigger Better*, Gregor Jansen and Andreas Beitin, ZKM Centre for Art and Media, Karlsruhe

2006 'Artist Edition: Michael Bauer', Uta M. Reindl, *Artist Kunstmagazine*

2005 *Michael Bauer: Das Kabinett* (Michael Bauer: The Cabinet), Annelie Pohlen, Galerie Hammelehle und Ahrens, Cologne

2001 *When We Were Kings*, Christian Krausch, Kunstverein, Heinsberg

Selected Exhibitions

2007 'Basho's Bar', Kunstverein, Bonn

2007 3rd Prague Biennial

2007 'Triumph of Painting: Germany', Saatchi Gallery, London

2007 'The Pack', Städtische Galerie, Helmenhorst

2006 'Faster! Bigger! Better', ZKM Centre for Art and Media, Karlsruhe

Michael **Bauer**

Born 1973
Lives Cologne

In Michael Bauer's paintings disembodied heads hover against neutral backgrounds like ornamented organic spacecraft: these are portrait busts that seem to have exploded onto the canvas, leaving their gory viscera trailing behind. Abstract pinwheel designs, dripping pipes and finger-like protuberances sprout from Bauer's painted heads. The faces of his clownish characters can barely be discerned, adorned as they are with what look like colourful feathers, pearl strands, handlebar moustaches or Native American head-dresses – like cynical or playful portraits of great leaders from another world. In his most recent series, 'Meditation Love Drawings' (2006–7), Bauer obsessively scrawls over these forms the word 'love'. (CL)

Shown by Jack Hanley Gallery A8, Hotel H2, Galerie Peter Kilchmann E2

Six Houses on Mound Street
2006
Oil on canvas
91.5×167.5cm
Courtesy the artist and Gladstone
Gallery

Selected Bibliography

2006 *Robert Bechtle*, Linda
Nochlin, Gladstone Gallery, New
York

2005 *Robert Bechtle: A Retrospective*,
San Francisco Museum of Modern
Art, University of California Press,
Berkeley

1994 *American Realism*, Edward
Lucie-Smith, Thames and Hudson,
London/Harry N. Abrams, New
York

1980 *Photo Realism*, Louis K.
Meisel, Harry N. Abrams, New
York

1974 *Sunshine Muse: Contemporary
Art on the West Coast*, Peter
Plagens, Praeger, New York

Robert **Bechtle**

Born 1932
Lives San Francisco

Robert Bechtle's paintings and charcoal drawings
take as their subjects the hard, flattening light of
the San Francisco Bay Area, the blandness of its
connective streets and the insignificance of
ordinary moments. Photographs of street scenes
and the interiors of family homes (including that of
the artist), often spliced, with elements rearranged
or subtracted, are interpreted in a painting style
that verges on Photorealism. Rather than
comprising deadpan studies of individuals or
objects, however, Bechtle's work seems more like
literary realism: a true representation of the
American middle classes. (SO'R)
Shown by Gladstone Gallery D6

Selected Exhibitions

2006 Gladstone Gallery, New
York

2005 'Robert Bechtle: A
Retrospective', San Francisco
Museum of Modern Art

2001 'Les Années Pop', Centre
Georges Pompidou, Paris

1999 'The American Century: Art
and Culture, 1950–2000', Whitney
Museum of American Art, New
York

1980 'Robert Bechtle: Matrix/
Berkeley 33', University of
California Art Museum, Los
Angeles

Stealing Beauty
2007
Colour video with sound
Courtesy Konrad Fischer Galerie

Selected Bibliography

2007 *Treehouse Kit: Guy Ben-Ner*, Gilles Godmer, Musée d'Art Contemporain, Montreal

2005 'Some Disassembly Required', Blake Gopnik, *The Washington Post*, 14 June

2005 'Man about the House: Guy Ben-Ner's Home Videos', Martin Herbert, *Modern Painters*, June

2005 *Guy Ben-Ner: Self-portrait as a Family Man*, Tom Gunning and Sergio Edelsztein, Israeli Pavilion, Venice Biennale

2005 'Guy Ben-Ner', Priya Bhatnagar, *contemporary*, 74

Selected Exhibitions

2007 Musée d'Art Contemporain, Montreal

2005 'Greater New York', PS1 Contemporary Art Center, New York

2005 Israeli Pavilion, Venice Biennale

2005 'Honey, I Shrunk the Kids', Contemporary Arts Center, Cincinnati

2004 Museum of Modern Art, New York

Guy **Ben-Ner**

Born 1969
Lives Berlin

Evidently in thrall to the films of Buster Keaton, Guy Ben-Ner transposes his deadpan approach to humorous filmmaking to a distinctly domestic space. His *Tree House Kit* (2005) is a guide to dismantling a tree made from furniture, in which the main protagonist is named after Daniel Defoe's Robinson Crusoe, while *Moby Dick* (2000) is a re-imagination of Herman Melville's novel that takes place in the artist's kitchen sink with the aid of a piece of rope. By appropriating the anarchic spirit of early cinema, Ben-Ner deftly forges a fantasy world that is both a part of and an escape from the family home. (BB)

Shown by Konrad Fischer Galerie A5

Selected Bibliography

2006 'Walead Beshty',
Christopher Bedford, *Artforum*,
May

2006 'Walead Beshty',
Christopher Balaschak, *frieze*, 96

2006 'Art in Review: Looking
Back, White Columns Annual',
Holland Cotter, *The New York
Times*, December 1

2006 *Interview with Walead Beshty*,
Aimee Chang, UCLA Hammer
Museum of Art, Los Angeles

2006 *Vitamin Ph: New Perspectives
in Photography*, T.J. Demos,
Phaidon Press, London

Walead **Beshty**

Born 1976
Lives Los Angeles

Walead Beshty's art reveals the prosaic assumptions
of photography. His images distil the way
photographs shape history, and how they are made
to perform meaning. At the UCLA Hammer
Museum in 2006, Beshty's camera was the staging
ground for political engagement, melding images
of the abandoned and dilapidated the Iraqi embassy
in the former East Berlin with photocopied
fragments of news from Iraq. Reflecting on the
absurdity of a reproduced world, Beshty's
installation opens our eyes to the medium's
complicity. (CB)

Shown by China Art Objects Galleries E19

Selected Exhibitions

2006 'The Maker and the Model',
Wallspace, New York

2006 'EMBASSY! (a dismal
science waiting room)', UCLA
Hammer Museum of Art, Los
Angeles

2006 California Biennial, Orange
County Museum of Art, Newport
Beach

2005 'Parks, Hotels and Palaces',
China Art Objects Galleries, Los
Angeles

2005 'The New City: Sub/Urbia
in Recent Photography', Whitney
Museum of American Art, New
York

Athos
2006
Wood, clay, wire, Polystyrene,
metal stud, acrylic paint
196×71×75cm
Courtesy the artist and Salon 94

Huma **Bhabha**

Born 1962
Lives Poughkeepsie, New York

Surrogates for bodies, body parts and architecture, Huma Bhabha's assemblages feel alien yet familiar. Skeletal pale tones combine with brownish or greyish substances that recall grime, ooze, excretions and man-made objects left to the elements. Crafted of traditional ingredients such as clay, wire and wax, as well as more motley ones such as animal bones or found construction materials, these works evoke dystopic science fiction and 'primitive' totems. Although formally dynamic, they gesture toward politics, religion and war, including the recent carnage in the Middle East. Unease also prevails in Bhabha's other-worldly ink-and-pencil drawings depicting huge heads rising from roiling seas. (KJ)

Shown by Salon 94 B13

Selected Bibliography

2007 'Ouverture', Merrily Kerr, *Flash Art International*, 252

2006 'Art in Review', Roberta Smith, *The New York Times*

2006 *USA Today*, Norman Rosenthal et al., Royal Academy of Art, London

Selected Exhibitions

2007 Salon 94, New York

2007 Greener Pastures Contemporary Art, Toronto

2006 'USA Today', Royal Academy of Arts, London

2006 ATM Gallery, New York

2006 'Remember Who You Are', Mary Boone Gallery, New York

Made's Warung
2006
Mixed media collage on wood
104×151×40cm
Courtesy the artist and Lehmann
Maupin Gallery

Ashley **Bickerton**

Born 1959
Lives Kuta

Sleek as racing cars, Ashley Bickerton's logo-plastered sculptures – and placeholders for paintings – succinctly addressed art's commodity status during the 'roaring '80s'. One piece incorporated an LED display that tracked the art work's increasing value. Later, his move to Bali in 1993 inspired figurative paintings rife with mordant imagery invoking contemporary ills from predatory tourism to toxic waste. His work has since been peopled by an often repellent, sometimes alluring, cast of characters, including an array of acid self-caricatures. Bickerton has always implicated himself along with the rest of us, recently modelling for the sinister being – sprouting flowers in a polluted tropical pool – in his digitally produced series 'Green Reflecting Heads'. (KJ)

Shown by Lehmann Maupin F16

Selected Bibliography

2007 'Tropic Zone', Marisa Fox, *Culture and Travel*, February/March

2006 'The World Tour Rolls into Town, Sprawling but Tidy', Holland Cotter, *The New York Times*, 10 March

2006 'Ashley Bickerton', Holland Cotter, *The New York Times*, 19 May

2006 'Top Ten 2006', Alison Gingeras, *Artforum*, December

2005 'For flashy 80s artist, a new palette', Sonia Kolesnikov-Jessop, *International Herald Tribune*, 4 August

Selected Exhibitions

2006 Lehmann Maupin / Sonnabend Gallery, New York

2006 Singapore Tyler Print Institute

2004 'Visions of America', Sammlung Essl, Klosterneuberg

1999 'Face to Face', Vancouver Art Gallery

1997 Palacete del Embarcadero: Autoridad Portuaria, Santander

'What kind of society isn't structured on greed? The problem of social organization is how to set up an arrangement under which greed will do the least harm; capitalism is that kind of system' Milton Friedman (Day Version)
2006
Acrylic, aluminium anti-rust paint on canvas
213×153cm
Courtesy The Breeder

Selected Bibliography

2006 *Marc Bijl: In Times Like These*, Jan Verwoert, The Breeder/Futura Publications, Athens

2005 'Marc Bijl: United Statements', Katerina Gregos, *Flash Art International*, 38

2005 *SUPERSTARS*, Ingried Brugger et al., Kunstforum, Vienna/Hatje Cantz Verlag, Ostfildern Ruit

2005 *Emergencies*, ed. Alfredo Jaar, Museo de Arte Contemporáneo, Castilla y León

Selected Exhibitions

2007 1st Athens Biennial

2007 'Left Pop', Museum of Modern Art at Petrovka, Moscow

2006 'Indy Structures', The Breeder, Athens

2006 'Dark', Museum Boijmans Van Beuningen, Rotterdam

2005 'Populism', Stedelijk Museum, Amsterdam

Marc **Bijl**

Born 1970
Lives Rotterdam

Political anxiety can push entire cultures into states of profound neurosis, ready to jump at the mere appearance of a word or sign. Marc Bijl exploits this fear of symbols in his work, which refers heavily to the Central European countercultures built around Goth and Punk. *One Living One Dead* (2003) features a skeleton in a hooded sweater and leather overcoat riding a life-size horse. The skeleton carries an anarchist flag emblazoned in Gothic lettering with the words 'Such as I was you are and such as I am you will be'. The work could be read as Agit-prop but is also a *memento mori*, a reminder of the radical incompatibility between true nihilism and political servitude. (AJ)

Shown by The Breeder E17

Composition I
2006
Wood, wool, leather, paint, clam
160×66×15cm
Courtesy BQ

Alexandra **Bircken**

Born 1967
Lives Cologne

Alexandra Bircken's witchy, feral assemblages are like the sticks-and-stones micro-worlds that kids make when left to play alone in the garden. Twigs form gnarled and weather-beaten trees that stand in freshly ploughed fields made of knitted wool, or support lumpen woollen tree houses in the crooks of their branches. *Big Klötz* (Big Block, 2005) is a table-top, Technicolor peak whose unassailably steep slopes are covered in a patchwork of fabric and leather. Through her homely craft techniques Bircken wraps protective arms around the fragile materials she uses, recognizing the tenderness of these intimate constructions which hang together, always on the verge of falling or floating away. (JG)

Shown by BQ B5, Herald St F1

Selected Bibliography

2006 *Klötze*, BQ, Cologne
2004 *Alexandra Bircken*, BQ, Cologne

Selected Exhibitions

2007 'Unmonumental', New Museum of Contemporary Art, New York
2007 'Um-Kehrungen', Kunstverein Brunswick
2007 'Holz', Gladstone Gallery, New York
2006 'Klötze', BQ, Cologne
2005 Herald St, London

Sculptcure
2007
Orange skin
Dimensions variable
Courtesy Art : Concept

Selected Bibliography

2007 'Michel Blazy: Sculpteur de vies' (Michel Blazy: Sculptor of Lives), Judicael Labrador, *Beaux-Arts Art Press*, 274

2006 'Michel Blazy', Valérie Da Costa, *Art Press*, January

2001 'Michel Blazy', Ralph Rugoff, *Artforum*, December

2001 'Michel Blazy: des formes de bonne volonté' (Michel Blazy: Forms of Good Will), Jean-Yves Jouannais, *Art Press*, October

2000 'Sensory Overflow', Heartney Eleanor, *Art in America*, October

Selected Exhibitions

2007 'Falling Garden', Kunstraum, Dornbirn

2007 'Post Patman', Palais de Tokyo, Paris

2007 'Airs de Paris', Centre Georges Pompidou, Paris

2006 'Vanity Case', Art : Concept, Paris

2002 CCA Wattis Institute for Contemporary Art, San Francisco

Michel **Blazy**

Born 1966
Lives Paris

Michel Blazy uses natural and synthetic foodstuffs and organic materials as the building blocks of his art, but the real architect of his sculptures, installations and films is time. A recent solo show ('Post Patman', Palais de Tokyo, Paris, 2007) featured stacks of silvery mould-covered orange peel, walls painted with flaking vegetable puree or increasingly sour-smelling yogurt, and nondescript objects overrun with wild curlicues of green sprouts. The dialectic between destruction and creation is at the heart of these experiments, in which the life of the art work, and the viewer's relationship to it, depend entirely on the dissolution, putrefaction and structural change that come with the passing of time. (VR)

Shown by Art : Concept G10

Echelon
2006
3-channel video projection
Courtesy XL Gallery

Bluesoup

Founded 1996
Based Moscow

The members of the Russian collective Bluesoup –
Alexei Dobrov, Daniil Lebdev, Valery Patkonen
and Alexander Lobanov – employ video as a means
of estranging their subject and, in turn, of
rendering video itself strange. *Black River* (2004)
examines the notion of the river as an ancient,
universal symbol signifying a boundary or an
obstacle. Bluesoup's interpretation is brought up to
date by the inclusion of a white hatchback car
precariously parked on the bank of a particularly
dank, blackened waterway, the whole set against an
incongruous but ethereal purplish haze of sky.
More recently, *Lake* (2007) also adopts water as its
subject matter, depicting an icy pool ringed by
leafless trees that gradually become enshrouded
with mist. (BB)

Shown by XL Gallery E13

Selected Bibliography

2007 *The third attempt of the Russian avant-garde, or urban formalism*, Evgenia Kikodze, Interros, Moscow

2006 *Russian Formalism Today*, Olesya Turkina, WAM Publishing, Moscow

2005 *Bluesoup*, Evgenia Kikodze, 1st Moscow Biennial of Contemporary Art, Moscow

Selected Exhibitions

2007 'Urban Formalism', Museum of Modern Art, Moscow

2007 'The Lake', XL Gallery, Moscow

2006 'Modus R', The Newton Building, Miami

2005 'Angels of History', MUHKA, Antwerp

2005 1st Moscow Biennale of Contemporary Art

Serenade
2006
Performance
Courtesy Foksal Gallery
Foundation

Selected Bibliography

2006 *Fragile*, ed. Cezary
Bodzianowski, Formigari Group
Delle Nogare, Bolzano

2005 *I love Paris*, ed. Anne-Marie
Bonnet and Cezary Bodzianowski,
Foksal Gallery Foundation,
Warsaw

2003 *Cezary Bodzianowski*, ed.
Joanna Mytkowska and Piotr
Uklanski, Foksal Gallery
Foundation, Warsaw

2003 *Hidden in a Daylight*, eds
Joanna Mytkowska, Andrej
Przywara and Adam Szymscyk,
Foksal Gallery Foundation,
Warsaw

Selected Exhibitions

2007 'Giulietta Project', Zero...,
Milan

2007 'Il teatro della vita', Galleria
Civica di Arte Contemporanea,
Trento

2006 Sorcha Dallas, Glasgow

2006 'The Exotic Journey Ends',
Foksal Gallery Foundation,
Warsaw

2005 Kunstverein, Cologne

Cezary **Bodzianowski**

Born 1966
Lives Lodz

The interventions of Polish *flâneur* and performance artist Cezary Bodzianowski recall the history of silent cinema as well as the stridency of the Situationists. Drawing on slapstick and the myth of Sisyphus, he uses his ineffectual but indefatigable *alter ego*, a moustachioed and overcoat-clad buffoon, to bring his theatre of the Absurd to an often ungrateful cosmopolitan West. In *Chapeau Beaux* (2006), for instance, he doffs his hat at the security cameras at a Glasgow underground station, his Chaplinesque presence transforming the other commuters into unwitting performers in a gentle slapstick comedy. (AJ)

Shown by Broadway 1602 G18, Foksal Gallery Foundation E6, Zero... G3

Study for 16mm Film (Synesthetic Object, Rotating View)
2006
Copperplate etching on Hahnemuhle paper
10×15cm
Courtesy greengrassi

Jennifer **Bornstein**

Born 1970
Lives Los Angeles

Jennifer Bornstein's etchings of friends and famous figures show the medium to be a match for the more mainstream documentary means – film, photography, sculpture – that she has employed elsewhere. Rather like one of her subjects, the anthropologist Margaret Mead, Bornstein scrutinizes the details of ritual to reveal the fabric of identity. *Study for 16mm Film (Margaret Mead in Hat)* (2005) is typically appealing, showing a faintly comical figure bedecked in tribal feathers. Although early photographic projects – in which, for example, Bornstein photographed herself hanging out with young boys in LA – attest to an interest in identity, it is within the composed curves of etching that Bornstein reveals the potential benevolence of documentation and representation. (BB)

Shown by Gavin Brown's enterprise G14, greengrassi D8

Selected Bibliography

2007 'Jennifer Bornstein', Joanna Kleinberg, *frieze*, 105

2006 'Jennifer Bornstein', Roberta Smith, *The New York Times*, 10 November

2006 'Jennifer Bornstein', Emily Speers-Meers, *Artforum*, October

2005 *General Ideas: Rethinking Conceptual Art 1987–2005*, Matthew Higgs, CCA Wattis Institute for Contemporary Art, San Francisco

1997 'Project: Jennifer Bornstein', Russel Ferguson, *Art/Text*, May/July

Selected Exhibitions

2006 Gavin Brown's enterprise, New York

2005 Museum of Contemporary Art, Los Angeles

2003 greengrassi, London

2000 'Greater New York', PS1 Contemporary Art Center, New York

1998 'L.A. Times: Arte da Los Angeles nella Collezione Sandretto Re Rebaudengo', Fondazione Sandretto Re Rebaudengo per l'Arte, Turin

In Time
2006
Pencil and watercolour on paper
11.5×11cm
Courtesy Zeno X Gallery

Selected Bibliography

2006 *Vitamin D: New Perspectives in Drawing*, Emma Dexter, Phaidon Press, London

2006 *Of Mice and Men: 4th Berlin Biennial for Contemporary Art*, Maurizio Cattelan, Massimiliano Gioni and Ali Subotnik, Hatje Cantz Verlag, Ostfildern Ruit

2005 'Enigma Variations', Jennifer Higgie, *frieze*, 89

2005 *Michaël Borremans: The Performance*, Michaël Borremans, Hatje Cantz Verlag, Ostfildern-Ruit

2004 *Michaël Borremans: Zeichnungen/Tekeningen/Drawings*, Anita Haldemann et al., Verlag Walther König, Cologne

Selected Exhibitions

2006 'The Good Ingredients', La Maison Rouge, Paris

2005 'The Performance', Parasol Unit, London

2005 'Hallucination and Reality', Museum of Art, Cleveland

2005 'An Unintended Performance', S.M.A.K., Ghent

2004 'Zeichnungen/Drawings', Museum für Gegenwartskunst, Basel

Michaël **Borremans**

Born 1963
Lives Ghent

Three figures gather around a table, on which sits a fourth, decapitated at the waist. A man indifferently forces branches up his nostrils. A gigantic Mae West materializes out of thin air. The quietly virtuosic Michaël Borremans is the latest inheritor of a strain of Belgian art devoted to cool, affectless renderings of the irrational; his, though, is a bleaker vision than that of, say, René Magritte. Borremans' muted palette suggests postwar austerity; his imagery feels traumatized. When not exploring obscure punishments, his art returns to a motif of figures intently engaged in unknowable empirical endeavours, as if determined to parse a world that makes sense only when not scrutinized. (MH)

Shown by Zeno X Gallery B3, David Zwirner C8

Carol **Bove**

Born 1971
Lives New York

Carol Bove assembles quotidian objects into an archaeology of burnt-out Utopias. Her *What the Trees Said* (2004) combines Herbert Marcuse's *Five Lectures* (1970), Germano Celant's *Arte Povera* (1967), Gaston Bachelard's *The Poetics of Space* (1958) and the *Kama Sutra*. The texts present a cross-section of the intellectual currents of the late 1960s, but their conjunction functions as a commentary on each: the *Kama Sutra* turns Marcuse into an excuse for hedonism, for example, while Bachelard's *Poetics* hints at the latent bourgeois tendencies of Arte Povera. Yet the humility of the objects in their domestic arrangements also tempts the viewer into empathy, reminding us of the present as a future that was. (AJ)

Shown by Hotel H2, Georg Kargl G16, maccarone B6

Selected Bibliography

2005 'Shelf Life', Barry Schwabsky, *Artforum*, January

2005 'Artists on the Verge of a Breakthrough', *New York Magazine*, March

2004 *Below Your Mind*, Yilmaz Dziewior, Kunstverein, Hamburg

2004 '(Re)Making History', Brian Sholis, *Flash Art International*, 238

2003 'Experiment in Total Freedom includes a variety of works', Martha Schwendener, *Artforum*, October

Selected Exhibitions

2006 Georg Kargl, Vienna

2006 Blanton Museum, Austin

2005 'Greater New York', PS1 Contemporary Art Center, New York

2004 'momentum 1: Carol Bove (The Future of Ecstasy)', Institute of Contemporary Art, Boston

2004 'Playlist', Palais de Tokyo, Paris

Nightmen
2007
Acrylic on canvas
275×193cm
Courtesy Peres Projects

Selected Bibliography

2007 'Art in Progress', Jason Schmidt, *V Magazine*

2006 'Down East', Stephen Maine, *Art in America*, May

2006 'Kurgan Waves. Art in Review', Ken Johnson, *The New York Times*, 17 February

2005 'New York's Finest', Roberta Smith, *The New York Times*, 22 May

Selected Exhibitions

2007 Peres Projects, Los Angeles/Berlin

2007 'The Triumph of Painting: Abstract America', The Saatchi Gallery, London

2006 'Kurgan Waves', PS1 Contemporary Art Center, New York

2005 'New York's Finest', CANADA, New York

2003 'Project Room', ConTEMPorary, New York

Joe **Bradley**

Born 1975
Lives New York City

Joe Bradley once wrapped a canvas in wool; he has made other Colour Field- and Minimalist-inspired paintings on flimsy MDF and named them after characters from the arcade game Space Invaders. Bradley's works give Minimalism a cartoonish feel, trading its high belief in the purity of medium and form for a quizzical presentation in which his forms attain human shape. In this way he unexpectedly anthropomorphizes his subjects, lending them pathos and agency, and drawing humility out of cold formalism. (MG)

Shown by Peres Projects Los Angeles/Berlin G22

Ulla **von Brandenburg**

Born 1974
Lives Paris/Hamburg

The translation of historical motifs into a
contemporary time frame and the parallel
transformation enacted by a shift in medium are
ongoing interests in Ulla von Brandenburg's films,
performances, drawings and installations. A wall-
size mural (*Untitled*, 2003) reproduces a 19th-
century photograph of a dying girl, but its
expanded scale and graphically stylized execution
lend it an estranged and eerily indeterminate
atmosphere. *Schlüssel* (Key, 2007), a black and
white film projection, is similarly enigmatic. An
ensemble of figures are frozen in a range of separate
dramatic poses that signal not just narrative
ambiguity but also the existential grey area
represented by the *tableau vivant*. (KB)

Shown by Art : Concept G10,
Produzentengalerie Hamburg H8

Selected Bibliography

2006 'Ulla von Brandenburg',
Jessica Morgan, *Artforum*, Summer

2006 *Ulla von Brandenburg*, Jens
Hoffmann, Phaidon Press, London

2006 *Again for Tomorrow*, Andrew
Bonacina, Royal College of Art,
London

2006 *Nr.3*, Ulla von Brandenburg,
Kunsthalle, Zurich

Selected Exhibitions

2007 'All the World's a Stage',
Tate Modern, London

2007 'Performa 07', 2nd Biennial
of New Visual Art Performance,
New York

2007 3rd Prague Biennial

2006 Kunsthalle, Zurich

2006 'Cinq Milliards d'Années',
Palais de Tokyo, Paris

Herbert Brandl
2005
Installation view
Courtesy Galerie Bärbel Grässlin

Selected Bibliography

2007 *Herbert Brandl: Austrian Pavilion of the Venice Biennale*, ed. Robert Fleck, Hatje Cantz Verlag, Ostfildern Ruit

2004 *Pintura: Herbert Brandl, Helmut Dorner, Adrian Schiess* (Painting: Herbert Brandl, Helmut Dorner, Adrian Schiess), Fundação de Serralves, Porto

2002 *Herbert Brandl: Chromophobie* (Herbert Brandl: Chromophobia), Peter Weibel and Günther Holler-Schuster, Neue Galerie Graz am Landesmuseum Joanneum/Hatje Cantz Verlag, Ostfildern Ruit

2002 *Painting on the Move: Ein Jahrhundert Malerei der Gegenwart (1900–2000)*, Kunsthalle, Basel/ Schwabe Verlag, Basel

1998 *Herbert Brandl: Secession*, Secession, Vienna/ Kunsthalle, Basel

Selected Exhibitions

2007 Austrian Pavilion, 52nd Venice Biennale

2005 Galerie Bärbel Grässlin, Frankfurt

2004 'Pintura: Herbert Brandl, Helmut Dorner, Adrian Schiess', Fundação de Serralves, Porto

2002 'Painting on the Move: Ein Jahrhundert Malerei der Gegenwart (1900–2000)', Kunstmuseum, Basel

1992 documenta 9, Kassel

Herbert **Brandl**

Born 1959
Lives Vienna

For over 20 years Herbert Brandl has created a painterly *oeuvre* that has marked out new possibilities for contemporary painting as it side-steps historically established styles and familiar practices. His work notably oscillates between abstraction and figuration (nature scenes, especially mountains, regularly recur), the contemplative and the dynamic, apparent carelessness and deliberate execution. Neither a starting-point nor an end-point, the figures in Brandl's paintings seem to have wandered in by chance, part of an unfolding process that sweeps across the canvas and suggests an unfinished, continuing movement. (AS)

Shown by Galerie Bärbel Grässlin D18

Stage (We're writing a play. It starts
with an orgy. With animals tearing
each others' guts out. With sounds of
breaking glass. Then it's tedious,
without direction. More boring than
uncomfortable. For like another hour.
There's no satisfaction. No closure. No
reward. You can leave after fifteen
minutes. It's called "HYENA.")
2007
Wood, metal, leather, silk screen
on canvas, ink on paper
Dimensions variable
Courtesy David Kordansky Gallery

Matthew **Brannon**

Born 1971
Lives New York

Although Matthew Brannon's elegant prints and
tapestries initially appear to epitomize the very
height of good taste, on closer inspection their
titles and footnotes send them reeling into salacious
revelations of cruelty, aspiration, submission and
resentment. Motifs such as eels, lobsters and chefs'
knives become emblems of brutality when upset by
addenda such as 'public break-up and career
backlash' or 'drunk baptism'. Drawing on specific
references to class and morality, Brannon implicates
both his audience and himself in his seductive but
barbed works. (JG)

Shown by David Kordansky Gallery F22,
Friedrich Petzel Gallery B2

Selected Bibliography

2007 'Material Muse for Some
Strange Bedfellows', Martha
Schwendener, *The New York
Times*, 6 April

2006 'Openings', Jan Tumlir,
Artforum, February

2006 'Mood Swings', Maria
Muhle, *Texte zur Kunst*, September

2005 'Matthew Brannon', Peter
Eleey, *frieze*, 90

2004 *Collection Diary*, Bob Nickas,
jrp | ringier, Zurich

Selected Exhibitions

2007 'Where Were We', Whitney
Museum of American Art at Altria,
New York

2007 'Try and Be Grateful', Art
Gallery of York University,
Toronto

2006 'Cum Together', Friedrich
Petzel Gallery, New York

2006 'Shoegazers &
Graverobbers', Art Statements, Art
37 Basel

2005 'Meat Eating Plants', David
Kordansky Gallery, Los Angeles

Untitled (Glove on Coat on Chair)
2007
Conté on cotton
137×178cm
Courtesy Mai 36 Galerie

Selected Bibliography

2006 *Day for Night: Whitney Biennial*, Johanna Burton, Whitney Museum of American Art, New York

2006 'Critic's Notebook', Peter Schjeldahl, *The New Yorker*, 20 Marche

2006 'Freezer Burn', Terry R. Myers, *Modern Painters*, May

2006 'Biennial 2006: Short on Pretty, Long on Collaboration', Michael Kimmelmann, *The New York Times*, 2 March

Selected Exhibitions

2007 Mai 36 Galerie, Zurich

2007 Magasin, Centre National d'Art Contemporain, Grenoble

2006 'The Downtown Show: The New York Art Scene 1974–1984', Grey Art Gallery, New York

2006 'Day for Night', Whitney Biennial, New York

2005 Friedrich Petzel Gallery, New York

Troy **Brauntuch**

Born 1954
Lives Austin/New York

In the essay accompanying his seminal 1977 exhibition 'Pictures' Douglas Crimp asserted that beneath every image 'there is always another picture'. Of all the artists in the show to which this semiological insight applied, Troy Brauntuch is perhaps the one whose work it most accurately described. Since then Brauntuch has continued to explore the way images evade attempts to define their 'truth': whether in his photographs depicting ambiguous, silent scenes (a cat on the roof, an empty swimming-pool) or in his conté drawings on black-dyed cotton, in which what at first seem monochromatic canvases on closer inspection reveal domestic scenes (shirts on a shelf, trainers on the floor) that resurface like memories from dark waters. (JöH)

Shown by Mai 36 Galerie C12, Friedrich Petzel Gallery B2

He spent almost 30years
struggling to be happy.
And then.
And then he landed
in the psychiatric
clinic.

He spent almost
2006
Print-out, graphite, typewriting on
paper
30×21cm
Courtesy Galerie Eigen + Art

Birgit **Brenner**

Born 1964
Lives Berlin

The red threads running through Birgit Brenner's installations suggest metaphorical links to feminism. Works such as *Sie lacht oft ohne Grund* (She Often Laughs for No Reason, 2003) typically combine dark, moody or disturbing photography and rambling texts covering walls or printed on sculptural elements. Banners for a street demo, for instance, depict emotionally dysfunctional and verbally impoverished relationships from the perspective of troubled female protagonists. Installations such as *All This Started with Love* (2003) are often designed to unfold like scenes from a film with a plot that is candidly emotional, macabre, melancholy or fretful – an exorcism of disappointment and doubt. (DE)

Shown by Galerie Eigen + Art Leipzig/Berlin F5

Selected Bibliography

2006 'Verstrickt ins eigene Leben' (To get caught up in Life), Markus Clauer, *art Kunstmagazin*, 7

2006 *Roman in grosser Schrift* (Novel in Large Type), Birgit Brenner, Virtuell-Visuell, Dortsen

2005 *Die besten Jahre* (The Best Years), Peter Herbstreuth, Galerie Eigen + Art, Leipzig/ Berlin

2004 'Tales of the Unexpected', April Lamm, *ArtReview*

2003 *Sie lacht oft ohne Grund* (She Often Laughs Without Reason), Birgit Brenner, Stadthaus Ulm, Leipzig

Selected Exhibitions

2007 Kunstverein, Paderborn

2007 'Into Me Out of Me', PS1 Contemporary Art Center, New York

2005 'Die besten Jahre', Galerie Eigen + Art, Leipzig

2004 'Poetische Positionen', Kunstverein, Kassel

2003 Sammlung Falckenberg, Hamburg-Harburg

Ideogram for Outdoor Dance
Performance with Five Dancers
2007
Ink and gouache on paper in
artist's frame
55×42cm
Courtesy Herald St

Pablo **Bronstein**

Born 1977
Lives London

Selected Bibliography

2007 'Pablo Bronstein', Martin Herbert, *Artforum*, February

2006 'Pablo Bronstein', Jonathan Griffin, *frieze*, 99

2006 'Pablo Bronstein', Gilda Williams, *Artforum*, Summer

2006 *Becks Futures*, Polly Staple, ICA Exhibitions, London

2006 *Tate Triennial*, Catherine Wood, Tate, London

Selected Exhibitions

2007 'Performa 07', Biennial of New Visual Arts Performance, New York

2007 Franco Noero, Turin

2007 Städtische Galerie im Lenbachhaus, Munich

2006 'Tour of London Postmodern Architecture', Frieze Projects, Frieze Art Fair, London

2006 '3rd Tate Triennial', Tate Britain, London

Pablo Bronstein adores Neo-Classical architecture and, guiltily, Postmodernism's maligned baubles – that's evident from his fluent drawings fusing the two styles. Yet his love isn't blind; tougher-minded works confirm Bronstein's interest in how each era's built environment has quietly policed the populace. He forbade audiences to step inside *Concept for a Public Square* (2005), a low, fence-like, gallery-dominating rectangle with Postmodernist detailing; he subliminally steered viewers across the crossed-box floor design of *Plaza Minuet* (2006) before dancers reclaimed it through gestural movement that cross-bred Renaissance *sprezzatura* with Bruce Nauman's studio performances. Referential pleasures aside, this is art as corrective: sleepwalk through the city, says Bronstein, and powerbrokers will determine your route. (MH)

Shown by Herald St F1, Galleria Franco Noero A2

Filth
2004
Oil on panel
133×94×3cm
Courtesy the artist and Gagosian
Gallery

Glenn **Brown**

Born 1966
Lives London

Glenn Brown's trademark is the flattened painterly gesture – Auerbach without the impastoed anguish, Rembrandt without the biographical gloom, Fragonard without the frivolity. Although his virtuoso handling of paint links the look of his paintings – hyperreal 'copies', or variations on a theme or detail of another painting – each one is different from the one that precedes it. Brown's technique, like all trademarks, only hints at the complexity of the finished product. These paintings are about the cyclical dreams of art history; the architecture of paint; the slippery relationship between time and the possibilities of representing it. There's no right way to look at or remember a painting, they seem to be saying. And they're right. (JH)

Shown by Gagosian Gallery D7, Patrick Painter, Inc. B14

Selected Bibliography

2006 'New Worlds for Old: The Fantastic Voyage of Glenn Brown', Trevor Smith, *Parkett*, 75

2005 'Coming Up Roses', Terry R. Myers, *ArtReview*, May

2004 *Glenn Brown*, David Freedberg, Gagosian Gallery, New York

2004 'You Take My Place in the Showdown', Ian MacMillan, *Modern Painters*, Autumn

2004 *Glenn Brown*, Alison M. Gingeras, Julia Peyton-Jones and Rochelle Steiner, Serpentine Gallery, London

Selected Exhibitions

2007 Gagosian Gallery, New York

2006 Galerie Max Hetzler, Berlin

2005 Patrick Painter, Inc., Santa Monica

2005 'Ecstasy: In and About Altered States', Museum of Contemporary Art, Los Angeles

2004 Serpentine Gallery, London

J.L.
2005
Wax, epoxy, wood, metal
113×110×55cm
Courtesy Hauser & Wirth
Private collection, New York

Selected Bibliography

2006 *Berlinde De Bruyckere: Der Schmerzensmann* (Berlinde De Bruyckere: Man of Pain), Gregor Muir and Ali Subotnick, Steidl Hauser & Wirth, London

2006 *Under cover/aus dem Verborgenen*, Ulricke Groos, Kunsthalle, Dusseldorf/ Verlag Walther König, Cologne

2005 *Berlinde De Bruyckere: One: 2002–4*, Harald Szeemann and Barbara Baert, De Pont Foundation, Tilburg/ La Maison Rouge, Paris

2002 *Berlinde De Bruyckere*, Hans Martens, Provinciebestuur van Oost-Vlaanderen, Ghent

Selected Exhibitions

2007 'Berlinde De Bruyckere: Der Schmerzensmann', Museum of Modern Art Kärnten, Klagenfurt

2006 'Schmerzensmann', Hauser & Wirth, London

2006 'Under Cover: Berlinde De Bruyckere and Martin Honert', Kunsthalle, Dusseldorf

2005 'Un', La Maison Rouge, Paris

2005 'Eén', De Pont Foundation for Contemporary Art, Tilburg

Berlinde **De Bruyckere**

Born 1964
Lives Ghent

Berlinde De Bruyckere's materials are emotive: horse skin and hair are fashioned together with wax, wood and wool to form bestial beings. *J.L.* (2006), a recumbent masculine form with a barely evolved upper body, is encased in a vitrine, an example of medical monstrosity. *Schmerzensmann IV* (Man of Sorrows IV, 2006) is one of a series of flayed skins that recall the martyrdom of Saint Bartholomew. By invoking 'Schmerzensmann', the eternal man of suffering, De Bruyckere tests humanism's limits: these husks cling to columns from which they appear to have slipped, desperate not to fall from grace. (BB)

Shown by Hauser & Wirth Zürich London C6, Yvon Lambert G5

Untitled (Borders)
2006
Cardboard
Dimensions variable
Courtesy The Fair Gallery

Michal **Budny**

Born 1976
Lives Warsaw

Michal Budny's is an art of obsessive reduction. Armed with cardboard, glue and a delicate touch, he crafts meticulous sculptural facsimiles of the unremarkable objects that populate our everyday surroundings. CD players, mobile phones and advertisements are stripped of colour and detail and reduced to form alone, inviting reconstruction in the mind of the viewer. Recently Budny has turned his transformative skills to less tangible subjects – meteorological phenomena such as fog and rain or, as in *Light* (2004), the contours of light as it filters through a window – lending tentative and makeshift form to nature's fleeting processes. (AB)

Shown by The Fair Gallery F21, Johnen Galerie Berlin/Cologne F10

Selected Bibliography

2006 *Das Radio empfiehlt* (The Radio Recommends), ed. Claudia Turtenwald, Kunstverein, Nuremberg

2006 *At the Very Center of Attention: Part 8*, Marcin Krasny, Center for Contemporary Art, Warsaw

2005 *Revenge on Realism: The Fictitious Moment in Current Polish Art*, Severin Dunser, Krinzinger Projekte, Vienna

2005 *Spojrzenia: II edycja*, ed. Jolanta Pienkos, Zacheta National Gallery, Warsaw

2004 *De ma fenêtre: des artistes et leurs territoires* (From My Window: Artists and their Territories), Ecole Nationale Supérieure des Beaux-Arts, Paris

Selected Exhibitions

2006 Centre for Contemporary Art, Warsaw

2006 Zacheta National Gallery of Art, Warsaw

2006 'Das Radio empfiehlt', Kunstverein, Bielefeld

2005 Prague Biennial

2004 'From My Window: Artists and their Territories', Ecole Nationale Supérieure des Beaux-Arts, Paris

Untitled
2007
Aluminium, mirror and stainless
steel
Sculpture: 30×22×34cm; pedestal:
50×50×100cm
Courtesy PKM Gallery

Selected Bibliography

2006 *The ICE Age*, Charles
Green, Govett-Brewster Art
Gallery, New Plymouth

2003 *Lee Bul: Monsters*, Jean-Louis
Potterin et al., Les Presses du
Réel/ Janvier, Paris

2002 'Les deux corps de
l'artiste' (The Two Bodies of the
Artist), Seung-duk Kim, *Art Press*,
279

2001 'Supernova in Karakoe
Land', Franck Gautherot, *Flash Art
International*, 217

Selected Exhibitions

2007 Fondation Cartier pour l'Art
Contemporain, Paris

2004 Museum of Contemporary
Art, Sydney

2002 New Museum of
Contemporary Art, New York

1999 Korean Pavilion, 48th
Venice Biennale

1997 'Projects', Museum of
Modern Art, New York

Lee Bul

Born 1964
Lives Seoul/New York

When Lee Bul began doing street performances in Korea, making sculpture and videos with a brazen post-feminist streak, she was virtually alone. Over the last 20 years her works have addressed Asian popular culture and social mores from a woman's perspective, with an emphasis on the body. In the early 1990s this led to a series of 'Cyborg' and 'Monster' sculptures that could be read as the fantasy outcomes of technological developments in genetics. More recently, her futuristic white 'Karaoke Pods', which cocoon individual viewers as they watch one of Lee's videos while listening to a specially selected soundtrack, explore notions of public and private. (DE)

Shown by Lehmann Maupin F16, PKM Gallery G2

From the series '1984 and Beyond'
2005–7
Black and white photograph
40.5×47.5×4cm
Courtesy the artist and Lisson
Gallery

Gerard **Byrne**

Born 1969
Lives Dublin

'A country road. A tree. Evening.' The opening
stage direction of Samuel Beckett's *Waiting for
Godot* (1952) describes a scene that could not
sound more anonymous. In Gerard Byrne's
photographic series 'A Country Road. A Tree.
Evening' (2006– ongoing) the sparse imaginary
landscape is given an absurd specificity among the
hills around Dublin that Beckett walked as a boy.
This is Byrne's preferred territory: fiction rendered
as fact, history as farce, fantasy as rigorous research.
In a video from his series '1984 and
Beyond' (2005–7) he restages a symposium of
science-fiction writers, speculating on the future,
originally published by *Playboy* in 1963:
anachronism is the motor of Byrne's profound
comedy. (BD)
Shown by Lisson Gallery B8

Selected Bibliography

2007 *The Present Tense through the
Ages: On the Recent Work of Gerard
Byrne*, Mark Godfrey, Lytle Shaw
and Catherine Wood, Lisson
Gallery, London/ Verlag Walther
König, Cologne

2007 'T.J. Demos on Gerard
Byrne', T.J. Demos, *Artforum*,
Summer

2006 'The World's a Stage', Dan
Fox, *frieze*, 103

2006 'Gerard Byrne: Once More
Without Feeling', Caoimhin Mac
Giolla Leith, *Parkett*, 77

2004 *Books, Magazines,
Newspapers*, George Baker, Lukas &
Sternberg, Berlin

Selected Exhibitions

2007 Irish Pavilion, 52nd Venice
Biennale

2007 Kunstverein, Dusseldorf

2007 9th Lyon Biennial

2006 '3rd Tate Triennial', Tate
Britain, London

2003 Kunstverein, Frankfurt

Untitled (Collier)
2007
Oil on linen on board
50×35cm
Courtesy Private Collection, New
York

Nicholas **Byrne**

Born 1979
Lives London

Nicholas Byrne's jewel-like canvases hover
somewhere between precisely rendered abstraction
and tentative figuration; the promiscuity of his
painterly surfaces, by turns airily translucent and
heavily impastoed, invokes both the esoteric
symbolism of Hilma af Klint and the volatile
brushwork of Francis Bacon. Diaphanous scrims of
paint periodically coalesce into recognizable forms:
a silhouetted head looms repeatedly, as does a
harlequin-like diamond motif, which the artist uses
both as surface pattern and in layered choreo-
graphies to suggest illusory depth. Fabric backdrops
and supporting wooden armatures in recent
installations lend Byrne's modest canvases a human
scale and explode his chromatic micro-worlds
beyond their enclosing frames. (AB)

Shown by Vilma Gold G26

Selected Exhibitions

2007 Vilma Gold, London

2007 'Tales of Song', Mark Foxx,
Los Angeles

2007 'Why We Are Ourselves',
W.S. Bartlett, London

2006 'the air line', The Reliance,
London

2006 'Toutes Composition
Florales', Counter, London

18.2 cm-tall Babel Tower
2004
A4 80g paper
18.2cm (height)
Courtesy Emily Tsingou Gallery

Peter **Callesen**

Born 1967
Lives Copenhagen

Peter Callesen is preoccupied with paper. *Castle* (2007), a fairy-tale abode conjured into life-size proportions, resembles a cake-top decoration, the size and solidity of which belie the fragility and mundanity of its material. *Cradle* (2004) reverses this formula, creating a diminutive coffin that brims with dainty paper trails of creepers from minimal means: a single sheet of A4. The romance of Callesen's practice is paralleled in his performances. The stated intention of *Infinity +1* (2003) was 'to put another star in the sky': by attaching a folded paper star to a helium balloon and letting it go, Callesen achieved his apparently impossible task. (BB)

Shown by Emily Tsingou Gallery A10

Selected Bibliography

2006 *Peter Callesen: Selected Works*, Pontus Kyander, Emily Tsingou Gallery, London

2006 'Out of the Shadows', Lupe Núñez-Fernández, *ArtReview*, March/April

2006 'Take a sheet of A4', Daniel Bates, *Metro*

2005 '100 Future Greats', *ArtReview*, December

2005 'Peter Callesen', Andrew Marsh, *Flash Art International*, 241

Selected Exhibitions

2007 'Fairy Tale: Contemporary Art and Enchantment', The New Art Gallery, Walsall; Chapter, Cardiff

2007 'Himmelrum', Kunsthallen, Brandts

2006 6th Shanghai Biennial

2004 Emily Tsingou Gallery, London

2004 'The Dying Swan', The National Gallery, Copenhagen

Untitled film poster
2007
Screen print on paper
93×63cm
Courtesy Hotel

Duncan **Campbell**

Born 1972
Lives Glasgow

Duncan Campbell's films re-invest reality with contradiction and interpretative possibility. Samuel Beckett and *cinéma vérité* converge in *Falls Burns Malone Fiddles* (2003), pieced together from hundreds of black and white archival photographs of young working-class people in Belfast in the 1970s and 1980s. Campbell employs an unreliable narrator, who veers between sociological explanation and existential self-interrogation, to sabotage the veracity of these historical documents. His latest film, *o Joan, no…* (2006), is even more enigmatic – a largely dark and silent composition interrupted by brief flashes of light (the flare of a streetlight, a glowing cigarette end) and bursts of disembodied sound (groans of pain or sexual pleasure, sighs and laughter). (SL)

Shown by Hotel H2

Selected Exhibitions

2007 Hotel, London

2007 'You Have Not Been Honest', Museo d'Arte Donnaregina, Naples

2006 'The Unnamable', Lux at Lounge, London

2006 'Art Now', Tate Britain, London

2003 'Falls Burns Malone Fiddles', Transmission Gallery, Glasgow

My Brain and Thought
2003–4
Freezer, ice, glass, aluminium
Dimensions variable
Courtesy francesca kaufmann

Gianni **Caravaggio**

Born 1968
Lives Milan

As though extending the existential vocabulary of the work of artists such as Giovanni Anselmo or Luciano Fabro, Gianni Caravaggio creates sculptures in which the synthesis of materials takes on the qualities of a cognitive proposition. *L'ignoto* (The Unknown, 2005–6) is a modest cube of white-veined black marble, one corner of which is extruded to a point with the addition of Vaseline. Elsewhere, meteorite-like aluminium forms or titles such as *My Brain and Thought* (2003) would seem to support the artist's declaration that he does not see himself as being 'within the universe, but outside it'. (MA)

Shown by Galerie Paul Andriesse H8, francesca kaufmann A7

Selected Bibliography

2006 'Becoming and Creating: Gianni Caravaggio', Andrea Bellini, *Sculpture*, May

2006 *Le Opere e i Giorni* (The Works and the Days), Achille Bonito Oliva, Skira, Milan

2006 *L'immagine del vuoto: Una linea di ricerca nell'arte italiana dal 1958 al 2006* (The image of emptiness: A line of research in Italian art from 1958 to 2006), Bettina della Casa, Marcello Ghilardi and Elena Volpato, Skira, Milan

2005 'Gianni Caravaggio', Marco Meneguzzo, *Artforum*, April

2005 'Gianni Caravaggio: l'intuizione dell'idea' (Gianni Caravaggio: The Intuition of the Idea), Guido Molinari, *Flash Art Italia*, 254

Selected Exhibitions

2007 'Already 38 years on this planet', Gallery Paul Andriesse, Amsterdam

2007 'Waste of Absolute Energy', francesca kaufmann, Milan

2007 'La Pescheria', Galleria d'Arte Moderna, Pesaro

2006 Castello di Rivoli, Turin

2001 'What Does Your Soul Look Like', Tomio Koyama Gallery, Tokyo

The Yellow Room
2005–6
Steel and cast iron, galvanized and
painted
186.5×230×180cm
Courtesy Annely Juda Fine Art,
London

Anthony **Caro**

Born 1924
Lives London

In 1960 Anthony Caro abandoned the figurative sculpture of his early career and began making abstract forms that were welded or bolted together from prefabricated I-beams and steel plates and set directly on the ground. His innovative attempt 'to make sculpture more real' led to his using vivid shades of household paint, notably the fire-engine red of *Early One Morning* (1962). From the 1980s Caro abandoned colour, instead varnishing and waxing the rusted steel used to construct pieces such as *Dream City* (1996), which effected a negotiation between sculpture and architecture. Since the same decade his work has also reflected a return to describing the human figure and narrative themes, as in *Achilles* (1993–4). (SL)

Shown by Annely Juda Fine Art G15

Selected Bibliography

2005 *Anthony Caro*, Paul Moorhouse, Tate Publishing, London

2004 *Anthony Caro: A Quest for the New Sculpture*, Ian Barker, Swiridoff Verlag, Künzelsau

Selected Exhibitions

2007 'Anthony Caro: New Galvanized Steel Sculptures', Annely Juda Fine Art, London

Valentin **Carron**

Born 1977
Lives Geneva

Valentin Carron's sculptures resurrect historically or ethnographically significant objects in a way that calls their authenticity into question. Somewhere between a relic and a ready-made, his life-size carving of a bear – from fake acrylic wood – sardonically refers to the craftsmanship of his native Switzerland. Carron doesn't just toy with his own Alpine culture: his series of stretched leather paintings (after Fernand Léger) imitates Native American folk crafts. He not only drains objects and art works of their traditional status as genuine articles but also shows how artistic production can itself be instrumental in this process. For him the term 'fabrication' can mean producing something as much as faking it. (CL)

Shown by Galerie Eva Presenhuber C3

Selected Bibliography

2006 *Valentin Carron*, Katya Garcia-Anton and Beatrix Ruf, jrp | ringier, Zurich

2006 'Valentin Carron', Eva Scharrer, *Artforum*, March

2006 'Valentin Carron', Cathérine Hug, *tema celeste*, January/February

2005 'Souvenirs de Suisse' (Swiss Souvenirs), Nicolas Trembly, *Numéro*, September

2004 *Cahiers d'Artistes* (Artist's Notebook), Valentin Carron, Pro Helvetia Arts Council of Switzerland, Bern

Selected Exhibitions

2007 Kunsthalle, Zurich

2006 'Déchéance, élégance, déhanchement', Swiss Institute, New York

2006 'Valentin Carron vs Mai-Thu Perret: Solid Objects', Chisenhale Gallery, London

2005 'Rellik', Galerie Eva Presenhuber, Zurich

2005 Centre d'Art Contemporain, Geneva

Partial Eclipse
(detail of performance)
1980/2004
Box with 35mm slides, compact
discs, choreography
Dimensions variable
Courtesy Galerie Giti
Nourbakhsch and Cabinet

Selected Bibliography

2007 *Celebration? Realife*, Tom
Holert, Afterall, London

2006 'Melancholischer
Bohémian', Philipp Meier, *Neue
Züricher Zeitung*, Zurich, 23 April

2006 'A Certain Simplicity of
Life', Catherine Wood, *Metropolis
M*, 6

2005 'Close Watch', Dan Fox,
frieze, 88

2005 *Marc Camille Chaimowicz*,
Anette Freudenberger, Kunstverein
für die Rheinlande und Westfalen,
Dusseldorf

Selected Exhibitions

2006 Migros Museum, Zurich

2005 Kunstverein für die
Rheinlande und Westfalen,
Dusseldorf

2005 'Concertina', Galerie Giti
Nourbakhsch, Berlin

2004 'Partial Eclipse', Galerie Giti
Nourbakhsch, Berlin

2004 'Jean Cocteau', Angel Row
Gallery, Nottingham

Marc Camille **Chaimowicz**

Born 1947
Lives London

During the 1970s, when art was expected to be bruisingly political, Marc Camille Chaimowicz distinguished himself through (in his words) his interest in the 'hint rather than [the] mind-fuck' and in 'the secret femininity in the most male of men'. Engaging at first with performance and then latterly with sculpture and environments featuring found objects and art works by himself and others, his practice is both melancholy and delicately camp. In love with the drama and humour implicit in transient things, Chaimowicz' art is closer to a whispered aside in a sun-dappled drawing-room than to a rousing speech from a podium. (TM)

Shown by Cabinet D14, Galerie Giti
Nourbakhsch C2

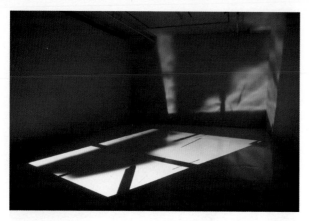

6th ~~Light~~
2007
Digital video projection
Courtesy Greene Naftali

Paul **Chan**

Born 1973
Lives New York

Paul Chan is an artist and political activist, and much of the conceptual depth of his work derives from the tension between these roles. He is best known for his haunting digital animations, made with redundant technology and featuring the detritus of everyday life. *1st ~~Light~~* (2005) depicts a trapezoid of light on a floor, as though cast by a window, past which bicycles, iPods and train carriages appear to float weightlessly up into the air while human bodies plunge down towards the earth, in a haunting reference to the events of 9/11. More overtly political is *Baghdad in no Particular Order* (2003), a collection of documentary photo-portraits of Iraqis, postered by volunteers across US cities in the lead-up to the Second Gulf War. (AJ)

Shown by Galleria Massimo de Carlo F3, Greene Naftali F4

Selected Bibliography

2006 'Embedded in the Culture: The Art of Paul Chan', Scott Rothkopf, *Artforum*, Summer

2006 'Picturing the Wreck, Writing the Disaster', Lilly Wei, *Art in America*, November

2005 'Paul Chan', Nell McClister, *BOMB*, Summer

2005 'Paul Chan', Johanna Burton, *Artforum*, January

Selected Exhibitions

2007 'The 7 ~~Lights~~', Serpentine Gallery, London

2007 Stedelijk Museum, Amsterdam

2006 Portikus, Frankfurt

2006 'Day for Night', Whitney Biennial, New York

Bat Opera
2006
Oil on canvas paper
15×20cm
Courtesy Herald St

Spartacus **Chetwynd**

Born 1973
Lives London

Lali Chetwynd adopted her new, gladiatorial name in 2006 – a move that endorsed her performative reinterpretations of childhood Pop-culture references, such as *Star Wars* (1977) and *Conan the Barbarian* (1982), and more distant sources, such as Hieronymus Bosch's *Garden of Earthly Delights* (1504). Chetwynd's collages, 'Bat Opera' painting series (2002– ongoing) and audacious live performances link together disparate examples of the grotesque. Her recent performance *The Fall of Man* (2006), staged with the assistance of some 20 friends and relatives, retold the problematic narratives of Genesis, John Milton's *Paradise Lost* (1667) and Karl Marx and Frederick Engels' *The German Ideology* (1845–6) through the jerky movements of home-made potato marionettes. (SL)

Shown by Herald St F1, Galerie Giti Nourbakhsch C2

Selected Bibliography

2007 *Spartacus Chetwynd*, Raphael Gygax, Migros Museum/ jrp | ringier, Zurich

2007 'Spartacus Chetwynd', Tom Morton, *frieze*, 107

2006 'Show Time', Neil Mulholland, *ArtReview*

2006 'Myth World', *Wallpaper*, 93

2006 *Tate Triennial*, Catherine Wood, Tate Publishing, London

Selected Exhibitions

2007 Migros Museum, Zurich

2007 'Stay Forever and Ever', South London Gallery, London

2007 'The Perfect Man Show', White Columns, New York

2006 'The Adamites', Art Basel Miami Beach

2006 '3rd Tate Triennial', Tate Britain, London

Sheba **Chhachhi**

Born 1958
Lives New Delhi

The recent discovery of a trove of ancient poetry by Indian female ascetics has had a lasting impact on the work of Sheba Chhachhi. With a self-proclaimed interest in women on the margins of society, she has followed modern-day ascetic communities to photographically document their everyday lives. In her honest but reverential images these extraordinary women, stripped of everything from their hair and clothes to their sexual identities, become emblems of transformation and power. In recent works, Chhachhi expands her photographic vocabulary into video-based sculptural environments and intricate kinetic tableaux such as those from 'The Jamuna Series' (2005) in which Chinese moving-image light boxes are adapted into mechanical dioramas staging metaphorically-charged confrontations between images of urban detritus and the lives of ordinary women in the city. (AB)

Shown by Khoj International Artists Association F33

Selected Bibliography

2007 *Women of the Cloth: Photographic Conversations*, Sheba Chhachhi, Nature Morte, New Delhi

2004 *Middle-Age Spread: Imaging India 1947–2004*, ed. Gayatri Sinha

2003 *body city: siting contemporary culture in India*, ed. Geeta Kapur, House of World Cultures/Tulika

2003 *Contemporary Indian Art: Other Realities*, ed. Yashodhara Dalmia, Marg Publications, New Delhi

2002 *Speaking Peace*, ed. Urvashi Butalia, Kali for Women, New Delhi/ Zed Books, London

Selected Exhibitions

2007 'Thermocline of Art: New Asian Waves', ZKM Centre for Art and Media, Karlsruhe

2007 'Indian Photography: Four Voices', Galleria Carla Sozzani, Milan

2006 'My Space Your Space', Walsh Gallery, Chicago

2006 1st Singapore Biennial

2005 'Indian Summer', Ecole Des Beaux Artes, Paris

www.tupacproject.it
2004
Concrete
178cm (height)
Courtesy Galleria Massimo Minini

Selected Bibliography

2006 'Paolo Chiasera', Angelo
Capasso, *Art in America*, October

2006 *Paolo Chiasera: Vincent,
Cornelius, Pieter*, Andrea Viliani,
Museo d'arte Moderna di Bologna,
Bologna

2005 'Paolo Chiasera: Coup de
Coeur, Turin', Hans Ulrich Obrist,
Domus, July/August

2005 'Beyond the Ego: Italiani
alla biennale di Mosca' (Beyond
the Ego: Italians at the Moscow
Biennial), Antonella Crippa, *tema
celeste*, January/February

2003 'Paolo Chiasera', Raimar
Stange, *Kunst Bulletin*, December

Selected Exhibitions

2007 'www.tupacproject.it',
Raines Foundation School and
Limehouse Arts Foundation,
London

2007 'I will never make it!', D21
Kunstraum, Leipzig

2006 'The Trilogy: Drawings',
Italian Academy at Columbia
University, New York

2006 'The Trilogy: Cornelius',
Museo d'Arte Moderna, Bologna

2006 'The Trilogy: Vincent',
Francesca Minini, Milan

Paolo **Chiasera**

Born 1978
Lives Florence

Paolo Chiasera's monumental sculpture of Hip-
Hop legend Tupac Shakur stands outside the
MARTa Herford museum, Germany, as an
unlikely tribute to a different kind of contemporary
artist. Chiasera frequently takes historical figures,
drains them of their mythical status and gives them
new identities within his Postmodern experiments.
In his series 'The Trilogy: Vincent, Cornelius,
Pieter' (2005–6), for example, he donned rubber
masks to imitate three seemingly incongruous art-
historical figures – Vincent van Gogh, M.C. Escher
and Pieter Brueghel – confronted with con-
temporary situations, while in *Young Dictators'
Village* (2003) Chiasera co-opted an Italian farm
and invited nine men to dress as dictators – from
Josef Stalin to Saddam Hussein – living in a
dubious 'collective' situation. (CL)

Shown by Galleria Massimo Minini F11

A short story about an unknown organism from Australia that is bent on infiltrating a given space as told by a geomancer (I'd like to die without feeling any pain)
2007
3000 self-adhesive stickers with off-set print, installed directly on wall
Dimensions variable
Courtesy Vitamin Creative Space

Heman **Chong**

Born 1977
Lives Singapore

The anxiety of influence is a key source of inspiration for Heman Chong, who since 2003 has staged re-enactments of landmark pieces by Ed Ruscha and John Baldessari, emptying the original works of significance and reducing them to the vacant familiarity of corporate trademarks. In *Akira* (2004) and *Happy Together* (2004) Chong renders the release dates of the eponymously titled films in the style of On Kawara's 'Date Paintings', collapsing filmic convention and signature style in a witty act of Postmodern shorthand. This ambivalent engagement with the narratives of cultural and artistic production demonstrates both an irreverence for the accepted canon and a captivation with it. (ST)

Shown by Vitamin Creative Space F28

Selected Bibliography

2007 *The Idea of the Journey*, Russell Storer, Vitamin Creative Space, Guangzhou

2005 *A Viewpoint*, Matthew Ngui, The Substation, Singapore

2004 *At Least Some Sleep Is Required*, Erden Kosova, Oda Projesi, Istanbul

2003 *Hypertexting (Of Rigour, Critiques and Remixes)*, Low Sze Wee, Singapore Pavilion, 50th Venice Biennale

2001 *Heman Chong's Molotov Cocktails*, Ahmad Mashadi, 10th India Triennial, New Delhi

Selected Exhibitions

2007 'Common People and Other Stories', Art In General, New York

2007 'The Sole Proprietor and Other Stories', Vitamin Creative Space, Guangzhou

2006 'Philip', Project Arts Centre, Dublin

2004 Busan Biennial

2003 Singapore Pavilion, 50th Venice Biennale

Constellation
2006–7
Household electrical appliances
Dimensions variable
Courtesy Vitamin Creative Space

Selected Bibliography

2006 *Love*, Karolin Timm-Wachter and Christine Hildebrandt, Siemens Arts Programme, Munich

2006 *Land, Art: A Cultural Ecology Handbook*, Max Andrews, Royal Society of Arts/Arts Council England, London

2005 *BEYOND: an extraordinary space of experimentation for modernization*, Hou Hanru, Wang Huangshen and Guo Xiaoyan, Guangdong Museum of Art, Guangzhou

2005 *Unspeakable Happiness*, Museo TAMAYO Arte Contemporáneo, Mexico City

2003 *The Fifth System*, He Xiangning Art Museum, Shenzhen

Selected Exhibitions

2007 'Smile of Matter', Vitamin Creative Space, Guangzhou

2006 'Love', Siemens VDO Automotive Co. Ltd., Huizhou

2005 2nd Guangzhou Triennial

2005 'Unspeakable Happiness', Museo TAMAYO Arte Contemporáneo, Mexico City

2003 50th Venice Biennale

Chu Yun

Born 1977
Lives Shenzhen

Significance lies in the gaps between, and the symbolic spaces around, Chu Yun's objects. Bars of soap have diminished through use by the artist's friends, and it is the differences between what they are now and how they once were that become a kind of portrait of the users. Chu savours the latent potency of over-familiar substances and situations, promoting the invisible or incremental to the status of monumental. The work *Love* (2006), for instance, comprises trees planted in pairs in the grounds of a Siemens factory in China – perhaps, once the title is forgotten, the trees will retreat from lyrical symbol to incidental banality. (SO'R)

Shown by Vitamin Creative Space F28

Sections of a Happy Moment
2007
Single-channel black and white
video projection, stereo audio
Courtesy David Claerbout and
Galerie Micheline Szwajcer

David **Claerbout**

Born 1969
Lives Antwerp/Berlin

In his formally rigorous video installations David
Claerbout brings together his interests in time (for
example, in 'deep time which can't be measured
by common time-keeping devices'), uncanny
realism and cinematic archetypes. *The Bordeaux
Piece* (2004), which runs for more than 13 hours,
shows 68 versions of a sequence of scenes in a
Rem Koolhaas villa – scenes that are identical
except for having been shot at different times of
the day. Claerbout's approach often recalls the
work of both Jeff Wall and David Lynch. In
American Car (2002–4) the two male characters are
'staking out' what appears to be a city street in the
rain, while a second video projection reveals the
car to be in the middle of nowhere. (DE)

Shown by Hauser & Wirth Zürich London C6,
Johnen Galerie Berlin/Cologne F10, Yvon
Lambert G5, Galerie Rüdiger Schöttle E10,
Galerie Micheline Szwajcer D9

Selected Bibliography

2007 *Imagination Becomes Reality:
An Exhibition on the Expanded
Concept of Painting. Works from the
Goetz Collection*, Ingvild Goetz et
al., Goetz Collection, Munich

2006 *Vitamin Ph: New Perspectives
in Photography*, T.J. Demos,
Phaidon Press, London

2006 *Brighton Photo Biennial*,
Gilane Tawadros, Photoworks,
Brighton

2004 *David Claerbout*, Susanne
Gaensheimer et al., Verlag Walther
König, Cologne

2004 *Visible Time: The Work of
David Claerbout*, David Green and
Joanna Lowry, Herbert Read
Gallery, Canterbury

Selected Exhibitions

2007 Centre Georges Pompidou,
Paris; MIT LIST, Boston;
Kunstmuseum, St Gallen; Morris
and Helen Belkin Art Gallery,
Vancouver

2005 Lehnbachhaus, Munich;
DAAD, Berlin; Van Abbemuseum,
Eindhoven; Contemporary Arts
Centre, Dundee

2004 Herbert Read Gallery,
Canterbury

2003 Centro Gallego de Arte
Contemporánea, Santiago de
Compostela

2002 Kunstverein, Hanover

Jonathan Velasquez
2003
Digital inkjet print
101×76cm
Courtesy the artist and Luhring
Augustine

Selected Bibliography

2003 *Punk Picasso*, Roth Horowitz
L.I.C., New York

1995 *KIDS*, Larry Clark, Grove
Press, New York

1993 *THE PERFECT
CHILDHOOD*, Larry Clark,
Scalo, Zurich

Selected Exhibitions

2006 Le Case d'Arte, Milan

2005 International Center of
Photography, New York

2004 'Punk Picasso', The Watari
Museum of Contemporary Art,
Tokyo; Luhring Augustine, New
York

1999 'Larry Clark: Retrospective',
Groninger Museum, Groningen

1998 'Kids', Luhring Augustine,
New York; Galleria Emi Fontana,
Milan; Galerie Nova Sin, Prague

Larry **Clark**

Born 1943
Lives Los Angeles/New York

American adolescence has been Larry Clark's
subject since his landmark photographic study of
his own druggy milieu, *Tulsa* (1971). While
increasingly classed as a filmmaker since *Kids*
(1995), Clark has long been a fixture in galleries
too, with a changeable aesthetic: his earlier epic
mixes of tattered press clippings, photographs and
videos, surveying wasted youth, have lately given
way to a focus on single individuals such as
Jonathan, a Hispanic skateboarder (and star of
Clark's 2006 film *Wassup Rockers*) whose life from
14 to 18 Clark traces in photographs. (MH)

Shown by Luhring Augustine B9

EZLN
2007
Digital C-print
20×25.5cm
Courtesy Broadway 1602

Martin Soto **Climent**

Born 1977
Lives Mexico City

Drink cans, hats, string, shoes, bottles, Venetian blinds and necklaces, discarded or lost in Mexico City, provide Martin Soto Climent with a vocabulary of forms that he elegantly combines in object poems. Forming simple relations between elements, drawing on both their associative meanings and their sculptural neutrality, he balances, leans, folds, clusters or levers things together, never fixing, gluing or bolting. In *Deep Heel 1* (2006) the toe of one stiletto shoe is tucked into the heel of another to form a spiked circle, like a caravan of wagons anticipating attack, drawing charm and value from the detritus of a careless urban society. (SO'R)

Shown by Broadway 1602 G18

Selected Bibliography

2007 'Martin Soto Climent', Quinn Latimer, *Modern Painters*, March

2006 'Un Rato de Existencia' (A Moment of Existence), Jimena Guarque, *Schock*, December

2001 *Papeles para Mirar Collection*, Babilonia Aula de Cultura, Valencia

Selected Exhibitions

2007 T293, Naples

2007 Vilma Gold, London

2006 Broadway 1602, New York

2005 'Other Objects', The Other Gallery, The Art Banff Center, Alberta

2004 'Throw Balls', The University Cultural Building, UNAM, Mexico City

Untitled (Figure Eight)
2007
Custom flexible skate-wheel
conveyor
Dimensions variable
Courtesy Le Confort Moderne,
Galerie Emmanuel Perrotin and
Andrew Kreps Gallery

Peter **Coffin**

Born 1972
Lives New York

Conceptual art is playfully open-ended and ideologically ecumenical in Peter Coffin's sculptures, photographs and installations. One work was a greenhouse where he invited musicians and sound artists to interact with the vegetation; between performances the plants listened to a soundtrack created for their enjoyment, while surrounding works invoked auras and other forms of pseudo-science. In Coffin's most recent New York solo show a squiggly neon sculpture depicted the path of an idea at the moment when a synapse is fired, and a painted bronze piece conflated Constantin Brancusi's *Endless Column* (1918) with Jack and the Beanstalk, suggesting that even iconic Modernist art works are susceptible to transformation by imaginative association. (KJ)

Shown by Herald St F1, Andrew Kreps Gallery C7, Galerie Emmanuel Perrotin F9

Selected Bibliography

2007 'Peter Coffin', Peter Eleey, *frieze*, 106

2007 'Peter Coffin', Raphael Gygax, *contemporary*, 91

2007 'Music for Living Entities', *Domus*

2007 'Grow Your Own', *Palais Magazine*

2007 'Various Wrong Times', ed. Maurizio Cattelan, Massimiliano Gioni and Ali Subotnick, *The Wrong Gallery*

Selected Exhibitions

2007 'The Idea of the Sun', Le Confort Moderne, Poitiers

2007 'Around, About Expanded Field', Herald Street, London

2007 'Music for Plants', Palais de Tokyo, Paris

2005 'Absinthe Drinker', The Wrong Gallery, New York

2004 'It Chooses You', Andrew Kreps Gallery, New York

Untitled (Birdshit #63, for Carlos)
2007
Oil on canvas
91.5×61cm
Courtesy Peres Projects

Dan **Colen**

Born 1979
Lives New York

Whether self-consciously romantic canvases featuring Disney-inspired cartoon candles or seemingly spray-painted (but carefully rendered) texts sputtering 'Holy Shit' or 'No Sex, No War, No Me', Dan Colen's paintings offer more than meets the eye. A preoccupation with youthful navel-gazing in his meticulous earlier works – which included images of a messy, empty bed and a tent's interior, visible through curtain-like flaps – has resurfaced in recent three-dimensional pieces, such as a wooden crate/hide-out replete with handcrafted beetle, boom-box and *faux* rock. The ersatz rock inspired his phallic papier-mâché monoliths blanketed in scribbles and graffiti, which cannily evoke both higher intelligence and its reverse: spectacular dumbness. (KJ)

Shown by Peres Projects Los Angeles/Berlin G22

Selected Bibliography

2007 'Share Your Feelings', Neville Wakefield, *i-D Magazine*, February

2007 'Chasing Dash Snow', Ariel Levy, *New York Magazine*, January

2006 'A Day in the Life of Dan Colen', Edward Helmore, *Modern Painters*, May

2005 'Work in Progress: Dan Colen', *V Magazine*

2003 'Dan Colen', Alex Poulson, *Dazed and Confused*, September

Selected Exhibitions

2006 'No Me', Peres Projects, Berlin

2006 'Secrets and Cymbals, Smoke and Scissors (My Friend Dash's Wall in the Future)', Deitch Projects, New York

2006 'USA Today', Royal Academy of Arts, London

2006 'Fantastic Politics', The National Museum of Art, Architecture and Design, Oslo

2006 'Day for Night', Whitney Biennial, New York

shady lane productions presents **the return of the real**
Press Conference, Café Royal, London, 22 November 2006
Courtesy the artist and Victoria Miro Gallery

Selected Bibliography

2007 *the world won't listen*, Bruce Hainley, Liz Kotz, Simon Reynolds and Suzanne Weaver, Yale University Press, New Haven

2007 *Ice Cream*, Sergio Edelsztein, Phaidon Press, London

2006 *Vitamin Ph: New Perspectives in Photography*, T.J. Demos, Phaidon Press, London

2005 *yeah... you, baby you*, Claire Bishop et al., Milton Keynes Gallery/ Shady Lane Publications, Hove

2003 *i only want you to love me*, Caoimhin Mac Giolla Léith, Sinisa Mitrovic, Andrew Renton, Photo Biennial/Photoworks, Brighton

Selected Exhibitions

2007 'Forum 59: Phil Collins', Carnegie Museum of Art, Pittsburgh

2007 'the world won't listen', Dallas Museum of Art

2006 'Turner Prize', Tate Britain, London

2005 9th Istanbul Biennial

2005 'yeah... you, baby you', Milton Keynes Gallery

Phil **Collins**

Born 1970
Lives Glasgow

For his video *They Shoot Horses* (2004) Phil Collins organized a seven-hour dance marathon for young Palestinians, held in a Ramallah gymnasium. As with many of his videos – shot in political hot spots ranging from Belfast to Baghdad – this work sees the artist turn his camera away from news-friendly scenes of suffering and towards a complex and perhaps ultimately affirmative vision of humanity. As we see the Palestinian kids boogie to Soft Cell, we are caught between disquiet at the Western capitalist hegemony that the music betokens and the memory of our own Pop epiphanies. For Collins the best our troubled world offers is the promise of 'Tainted Love'. (TM)

Shown by Tanya Bonakdar Gallery E8, Kerlin Gallery E11, Victoria Miro Gallery G6

The Senate Council
2002
Gold bronze
30×20×22.5cm
Courtesy Monika Sprüth
Philomene Magers

George **Condo**

Born 1957
Lives New York

George Condo's work marries Expressionism to the properties of the satirical cartoon. The universe described in his bold oil paintings is a grotesque one in which vile bodies cavort, clowns have vampire teeth and *Superman* (2006) is an inane lantern-jawed creature smoking cigarettes through his ears. A recurring protagonist in Condo's works of 'artificial realism' is Jean Louis, identifiable by his Cubist clown features and bow tie. Although there is a nonsensical aspect to Jean Louis and the miscellaneous cavewomen, Roman soldiers and corrupt cardinals that inhabit Condo's canvases, the artist's lewd scenarios are often metaphors for scandals in the 'real' world – as in the orgy scene entitled *The Last Days of Enron* (2004). (SL)

Shown by Luhring Augustine B9, Monika Sprüth Philomene Magers B10

Selected Bibliography

2006 *George Condo: Existential Portraits. Sculpture, Drawings, Paintings*, Luhring Augustine, New York

2005 *George Condo: One Hundred Women*, ed. Agnes Husslein-Arco and Thomas Kellein, Hatje Cantz Verlag, Ostfildern Ruit

2003 *George Condo: Sculpture*, Gallery Bruno Bischofberger/ Caratasch de Pury & Luxembourg, Zurich

2002 *The Imaginary Portraits of George Condo*, Power House Books, New York

1999 *George Condo: Portraits Lost in Space*, Pace Wildenstein Gallery/ Deitch Projects, New York

Selected Exhibitions

2005 Monika Sprüth Philomene Magers, Munich

2005 'One Hundred Women: Retrospective', Museum der Moderne, Salzburg

2002 'Garten-Landschaft', OstWestfalenLippe, Schlosspark Wendlinghausen, Dörentrup

Cover Potential
2007
Collage on paper
75×76cm
Courtesy China Art Objects
Galleries

Selected Bibliography

2007 'Must See Art: Bjorn Copeland@China Art Objects', Amra Brooks, *L.A. Weekly*, 23–29 March

2006 *Gore*, Dan Nadel, PictureBox, New York

2006 'One to Watch: Bjorn Copeland', H.G. Masters, *Artkrush*, 47

Selected Exhibitions

2007 'Archival K.O.', China Art Objects Galleries, Los Angeles

2007 'Panic Room: Works from the Dakis Joannou Collection', Deste Foundation Centre for Contemporary Art, Athens

2006 'Music is a Better Noise', PS1 Contemporary Art Center, New York

2006 'Sets', D'Amelio Terras, New York

2004 'California Earthquakes', Daniel Reich Gallery, New York

Bjorn **Copeland**

Born 1975
Lives New York

A relative newcomer to the gallery circuit, former Rhode Island School of Design student Bjorn Copeland has been making noise since 1997 as co-founder of the Indie Rock band Black Dice, which emerged out of the hard-hitting Providence, Rhode Island, music scene. Copeland's makeshift, found-object sculptures and his psychedelic mixed-media-on-paper collages are part Surrealist fetish object, part Pop icon and part Op-inspired formal exercise. Floating magazine-illustration body parts mingle with bold kaleidoscopic pen-and-ink patterns and bits of newspaper text to create eye-popping constellations that seem to dance to the beat. (CG)

Shown by China Art Objects Galleries E19

Work No. 641
2007
Marker pen on paper
29.5×21cm
Courtesy Johnen + Schöttle

Martin **Creed**

Born 1968
Lives London

A young woman walks into an empty white room, sticks her fingers down her throat and vomits a copious wash of purple over the pristine film set. Martin Creed's *Sick Film* (2006) is, in a sense, a lurid advance on the wry Conceptualism for which he is best known. But in truth Creed's characteristically skewed and subtle alterations to everyday space – his play with doorbells, light switches, metronomes and odd protrusions into ordinary interiors – has always been emotionally freighted. *Sick Film*, he says, is 'a good example of trying to get something from the inside out'. (BD)

Shown by Gavin Brown's enterprise G14, Galerie Hauser & Wirth Zürich London C6, Johnen Galerie Berlin/Cologne F10, Galerie Rüdiger Schöttle E10

Selected Bibliography

2004 *Martin Creed*, Kunsthalle, Bern

2004 *Martin Creed: the whole world + the work = the whole world*, Pawel Polit and Martin Creed, Centre for Contemporary Art Ujazdowski Castle, Warsaw

2000 *Martin Creed Works*, Godfrey Worsdale and Iona Spens, City Art Gallery, Southampton

Selected Exhibitions

2007 'Dogs', Sorry, We're Closed, Brussels

2006 'I Like Things', Fondazione Nicola Trussardi, Milan

2006 'Half the Air in a Given Space', Johnen Galerie, Berlin

2006 'Big Dogs', MC, Los Angeles

2006 'The Lights Off', Haubrokshows, Berlin

James Brown
2000
Ink, correction fluid on paper
32.5×40.5×2.5cm (framed)
Courtesy the artist, Paul Morris
and David Zwirner

Selected Bibliography

2005 *Experiencing Duration*, 8th
Lyon Biennial

2005 *Beautiful Losers*, Aaron Rose
and Christian Strike, Distributed
Art Publishers and Iconoclast, New
York

2005 *The R. Crumb Handbook*,
Texts by R. Crumb and Peter
Poplaski, MQ Publications,
London

2004 *Yeah, but is it Art? R. Crumb
Drawings and Comics*, Kasper König
et al., Ludwig Museum/Verlag
Walther König, Cologne

2004 *Experiencing Duration: 54th
Carnegie International*, Carnegie
Museum of Art, Pittsburgh

Selected Exhibitions

2007 David Zwirner, New York

2007 'R. Crumb's Underground',
Yerba Buena Center for the Arts,
San Francisco

2005 'Robert Crumb: A
Chronicle of Modern Times',
Museum Boijmans Van
Beuningen, Rotterdam

2004 'Masters of American
Comics', Museum of
Contemporary Art, Los Angeles

2004 Ludwig Museum, Cologne

R. **Crumb**

Born 1943
Lives Sauve

'Yeah, but is it art?' The cover of a recent R.
Crumb monograph asks a question that the art
market answered, affirmatively, long ago. Crumb's
jump from counterculture cartoonist – he's been
famous since the 1960s for such creations as bogus
guru Mr Natural and for his jaundiced take on
sexual relations – to full-blown 'artist' partly
reflects rampant cultural relativism. But it also
recognizes his superlative draughtsmanship and the
ethical challenge he presents to his audience. In
describing Crumb as a modern-day Pieter
Brueghel, Robert Hughes nailed him as a pioneer
chronicler of amoral times: few contemporary
artists confront human nature's uglier side with as
much honesty as Crumb; none with comparable
humour. (MH)

Shown by David Zwirner C8

Abraham **Cruzvillegas**

Born 1968
Lives Paris

Abraham Cruzvillegas' deadpan, mutable sculptures subject easily overlooked found objects – such as cactus leaves, sickles, feathers and fish bones – to a kind of alchemical transformation. They evoke art-historical antecedents while also generating their own odd formal and symbolic resonances. In *Horizontes* (Horizons, 2005) Cruzvillegas coated items from a soon-to-be-abandoned studio with pink enamel and matt green paint (alluding to the colours of the Rio samba club of which Hélio Oiticica was a member) and arranged them in a series of concentric circles. More recently he covered portions of a group of items with seemingly slender affinities – a poster, fruit crates, children's handmade paper masks – with black paint. (KJ)

Shown by kurimanzutto H3

Selected Bibliography

2007 *Los dos amigos* (The Two Friends), Abraham Cruzvillegas and Dr Lakra, A&R Press, Mexico

2007 *Collectif* (Collective), Caroline Bourgeois, Actes Sud, Arles

2006 'Found and Lost', Tom Morton, *frieze*, 102

2006 *Round de Sombra* (Shadow Round), Abraham Cruzvillegas, Conaculta, Mexico

Selected Exhibitions

2007 'Autoconstruction', Jack Tilton Gallery, New York

2006 'Ici', Château de Tours

2005 Atelier Calder, Saché

2005 'Los dos amigos', Museo de Arte Contemporáneo, Oaxaca

Hemisphere
1996
Ilfoflex photograph (from a set of 5
photographs)
24×30cm (framed)
Courtesy Galerija Gregor Podnar

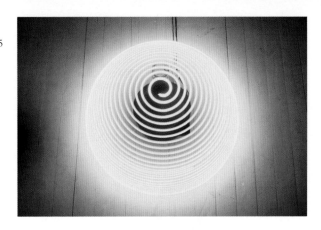

Selected Bibliography

2006 *Attila Csörgo*, ed. Riccardo
Caldura, Dario De Bastiani
Editore, Vittorio Veneto

2005 *Attila Csörgo*, Claudia Seidel,
Daimler Chrysler Collection,
Berlin

2004 *Attila Csörgo: Platonic love*,
Rob Tufnell, Kettle's Yard,
Cambridge

2001 *Les constructions d'Attila
Csörgo* (The Constructions of Attila
Csörgo), Barnabás Bencsik,
Histoires hungroises, Fresnoy/
Musée d'art moderne Lille
Métropole, Villeneuve d'Ascq

1999 *Tackling Techné*, János Sturcz,
Hungarian Pavilion, Venice
Biennale

Selected Exhibitions

2006 'Skin of Space', Galerija
Gregor Podnar, Ljubljana

2006 'Cosmogonies', La Galerie,
Noisy-le-Sec

2004 'Platonic love', Kettle's
Yard, Cambridge

2004 'Moving Parts', Kunsthaus,
Graz; Tinguely Museum, Basel

2003 8th Istanbul Biennial,

Attila **Csörgo**

Born 1965
Lives Budapest

Orange-Space (2003) is one indicator of the
perplexing nature of Attila Csörgo's burgeoning
oeuvre. The work consists of a sphere composed of
photographs that have been conjoined in the form
of a single peel of orange skin. In exhibition we see
the spread peel as well as the completed 'orange'.
As with many of Csörgo's works, there is a
disconnect between the two objects: the wonder
and amusement of imagining one entity becoming
another provides an engaging illustration of
technological illusion and metamorphic vision.
Csörgo's objects play with visual perception,
exposing the complexity of the most immaterial
and elemental modes of experience. (CB)

Shown by Galerija Gregor Podnar F20

José **Damasceno**

Born 1968
Lives Rio de Janeiro

José Damasceno's drolly hermetic installations seem to be working out a poetics of accumulation. Commonplace objects – hammers, pencils, chess pieces, chalkboard erasers, glass microscope slides – are massed together, forming flowing structures, grids, networks of information. The effect is often disorienting, as the viewer tries to reconcile two different notions of scale at the same time. Puzzling out the implied order in the seemingly chaotic groupings is a bit like exploring another world. As Damasceno himself says of his work: 'There is an unknown system of cause and effect, somewhat frightening yet also seductive.' (SS)

Shown by Thomas Dane Gallery E1, Galeria Fortes Vilaça E7, The Project H1

Selected Bibliography

2006 'José Damasceno', Anthony Downey, *Flash Art International*, 248

2006 'José Damasceno', Kim Dhillon, *frieze*, 99

2005 *The Experience of Art: Italian Pavilion*, María de Corral, 51st Venice Biennale

2002 *José Damasceno*, Márcia Fortes, Alexandra Gabriel and Riccardo Sardenberg, Galeria Fortes Vilaça, São Paulo

1998 *José Damasceno: Works 1992–1998*, Adriano Pedrosa, Galeria Camargo Vilaça, São Paulo

Selected Exhibitions

2007 Brazilian Pavilion, 52nd Venice Biennale

2006 Galeria Artur Fidalgo, Rio de Janeiro

2006 'Inframarket', Thomas Dane Gallery, London

2004 'Observation Plan', Museum of Contemporary Art, Chicago

2002 The Project, New York

*Vase of Flowers with Pocket Watch
(#6)*
2007
Oil on wood
41.5×29×3.5cm
Courtesy Marc Foxx

William **Daniels**

Born 1976
Lives London

William Daniels' canvases are derived from torn
paper tableaux of famous religious paintings from
the past – the kind of thing that a Renaissance
scholar might make out of paper napkins at a
lonely bistro table. Painted in shades of light grey,
they are graphically precise but also seem terribly,
terminally frail, as though on the brink of fading
into nothingness or of blowing away on the
slightest breeze. Art history, here, has a very
material death wish, which perhaps accounts for
the melancholy in Daniels' work. His is an act of
preservation that knows that it's perfidious but
which is unwilling to let the past slip out of sight.
(TM)

Shown by Marc Foxx A1, Vilma Gold G26

Selected Bibliography

2007 'Counterfacture at Luhring
Augustine', Roberta Smith, *The
New York Times*, 9 February

2005 'Emerging Artists: William
Daniels', Martin Herbert, *Modern
Painters*, January

2005 'William Daniels: Vilma
Gold', Helen Sumpter, *Time Out
London*

Selected Exhibitions

2007 Marc Foxx, Los Angeles

2007 'Counterfacture', Luhring
Augustine, New York

2005 Vilma Gold, London

Poured Lines: White Study
2005
Water-based paints on paper
114.5×84cm
Courtesy Waddington Galleries

Ian **Davenport**

Born 1966
Lives London

By drawing the parameters of production in tight around him, and to all intents and purposes eradicating illusory representation, it is as though Ian Davenport's practice has evolved in a Darwinian sense: through physical necessity. Having started by dripping paint vertically down canvas supports, Davenport has gradually harnessed the absolutism of gravity and the adherence of household gloss paint to configure stripes, zips, arcs and circles with almost mechanical exactitude. And yet the often contradictory qualities of medium and conditions, however, as well as chromatic interplay between acid yellows, sonorous blues and ripe greens, never quite maroon us in a wilderness of post-painterly abstraction. (SO'R)

Shown by Waddington Galleries F15

Selected Bibliography

2004 *Ian Davenport*, Jonathan Watkins and Tony Godfrey, Ikon Gallery, Birmingham

2003 *Ian Davenport: New Paintings*, David Batchelor, Waddington Galleries, London

2000 *Ian Davenport: Large Scale Paintings*, Michael Bracewell, Waddington Galleries, London

1999 *Ian Davenport: Paintings*, Jonathan Watkins, Contemporary Arts, Dundee

1993 *Ian Davenport*, Richard Shone, Waddington Galleries, London

Selected Exhibitions

2004 Ikon Gallery, Birmingham

2003 '2nd Tate Triennial', Tate Britain, London

2003 'Ian Davenport: New Paintings', Waddington Galleries, London

1996–8 'About Vision: New British Painting in the 1990s', Museum of Modern Art, Oxford

1991 'Turner Prize', Tate Gallery, London

S.T.
2007
Acrylic on canvas
226×226cm
Courtesy Galerie Francesca Pia

Selected Bibliography

2007 *Philippe Decrauzat*, Katya
Garcia-Anton et al., jrp | ringier,
Zurich

2007 'Philippe Decrauzat. Progress
Report', Daniel Baumann, *spike
Art Quarterly*, 11

2006 'Op-ed World: Philippe
Decrauzat', Vincent Pécoil,
contemporary, 82

2006 'Philippe Decrauzat', David
Velasco, *Artforum*, 10

2003 *Progress Report*, Fabrice
Stroun, jrp | ringier, Geneva

Selected Exhibitions

2007 'Undercover', Kunstraum
Walcheturm, Zurich

2006 Centre d'Art Contemporain,
Geneva

2006 'Plate 28', Swiss Institute,
New York

2006 'Cinq milliards d'années',
Palais de Tokyo, Paris

2005 'Komakino', Musée d'Art
Moderne et Contemporain,
Geneva

Philippe **Decrauzat**

Born 1974
Lives Lausanne

Philippe Decrauzat cuts Op art from its roots,
eviscerates it of its original meaning and represents
it as a sub-genre of Pop. *Flight Disc* (2002) recreates
the classic concentric circles of Op art but refers
them back to the Frisbee-style weapons used in the
1982 film *Tron* – the first mainstream movie to
employ digital imagery. The *Light-Space Modulator*
(2003) borrows its title from a work by László
Moholy-Nagy, but its appearance is based on the
hypnotizing machine from *Exorcist II: The Heretic*
(1977). By shearing out the Utopian promise and
phenomenological elements of Op, Decrauzat
foregrounds the endless historical circulation of
artistic genres from high avant-gardism to base
commerciality and back again. (AJ)

Shown by Galerie Francesca Pia H11

In Our Own Neighbourhood
2007
DVD projection (edition of 4)
Courtesy Giò Marconi

Nathalie **Djurberg**

Born 1978
Lives Berlin

Like cutting-room-floor out-takes too twisted
even for claymation legend Bruce Bickford,
Nathalie Djurberg's short films conjure up
deranged fables through the cruelly laborious
process of stop-frame Plasticine animation.
Melancholy, mutilation and molestation abound,
and a dramatis personae of lascivious tigers and
jailbait girls, wolves, bears, the walking dead and
executioners will morals to be malleable,
perversions to be plastic and realism to be magical.
Accompanying music by Hans Berg, with what
Helle Ryberg has described as an 'almost
psychopathically cheerful rhythm', make
Djurberg's dark materials all the more disquieting.
(MA)

Shown by Giò Marconi F6

Selected Bibliography

2007 *Nathalie Djurberg: Denn es ist schön zu leben* (Nathalie Djurberg: Because Living is Beautiful), Angela Stief, Kunsthalle, Vienna

2006 'Nathalie Djurberg', Roberta Smith, *The New York Times*

2006 'Emerging artists: Nathalie Djurberg', Barry Schwabsky, *Modern Painters*, September

2006 'Nathalie Djurberg. Naughty by Nature', Ali Subotnick, *Flash Art International*, 251

2005 'Bright Young Things', *ArtReview*, December

Selected Exhibitions

2007 Kunsthalle, Vienna

2007 Kunsthalle, Winterthur

2007 'Schmerz', Hamburger Bahnhof - Museum für Gegenwart, Berlin

2007 'EROS in Modern Art', Fondation Beyeler, Basel

Satin Operator (2)
2007
C-print
160×112cm
Courtesy the artist and Casey
Kaplan

Selected Bibliography

2006 'Trisha Donnelly', ed. Bice
Curiger, Jacqueline Burchkardt and
Cay-Sophie Rabinowitz, *Parkett*,
77

2006 *Of Mice and Men: 4th Berlin
Biennial for Contemporary Art*,
Maurizio Cattelan, Massimiliano
Gioni and Ali Subotnik, Hatje
Cantz Verlag, Ostfildern Ruit

2004 *54th Carnegie International*,
Laura Hoptman, Carnegie
Museum of Art and Carnegie
Institute, Pittsburgh

2003 *Moving Pictures*, Lisa
Dennison, Nancy Spector and Joan
Young, Guggenheim Museum,
Bilbao

2003 *Cream3*, Phaidon Press,
London

Selected Exhibitions

2007 Modern Art, Oxford

2007 Casey Kaplan, New York

2006 'Day for Night', Whitney
Biennial, New York

2005 'Trisha Donnelly:
CENTRAL Art Prize',
Kunstverein, Cologne

Trisha **Donnelly**

Born 1974
Lives San Francisco

As Jan Verwoert has written, Trisha Donnelly
employs 'gestures, ciphers and icons that articulate
and question the very conditions required for the
invocation of a physical epiphany'. At the
Kunstverein in Cologne in 2005 a recording of
grand organ music was played only during the first
and last minutes of the institution's opening hours.
The Redwood and the Raven (2004), meanwhile, is a
series of 31 silver gelatin prints, displayed individu-
ally in sequence over 31 days, of an elderly
woman making semaphore-like movements, like
some terpsichorean Theosopher. Often con-
founding the temporality and ceremony of an
exhibition, the artist's elusive works function like
fragmentary omens. (MA)

Shown by Air de Paris E5, Casey Kaplan A6,
Galerie Eva Presenhuber C3

Untitled
2006
Paper plates and glue
58.5×119.5×140cm
Courtesy Stephen Friedman
Gallery

Tara **Donovan**

Born 1969

Lives New York

Process and product are at odds in Tara Donovan's magisterial sculptures, made from found materials. Donovan calls her approach a 'mechanized process without the luxury of a machine', a statement that suggests the influence of Conceptualists like Sol LeWitt and Lawrence Weiner on recent installations such as *Haze* (2003) – two million drinking straws stacked perpendicularly across an entire wall – and *Untitled (Plastic Cups)* (2006), a 50 x 60 foot structure consisting of three million cups organized in regular rows of varying heights. What impresses in Donovan's artificial landscapes, however, is the sensual beauty behind the conceptual rigour, a sumptuousness that defies cynicism and restores faith in the transformative power of form. (CG)

Shown by Stephen Friedman Gallery D4

Selected Bibliography

2007 'The Emergent Artist', Jonathan T.D. Neil, *ArtReview*

2006 'Art in Review: Tara Donovan', Ken Johnson, *The New York Times*, 24 March

2006 'Tara Donovan', Rebecca Cascade, *Art + Auction*, 29

2006 'Tara Donovan', Edward Leffingwell, *Art in America*, June/July

2006 'Tara Donovan', Kevin Conley, *New Yorker*, 21 August

Selected Exhibitions

2007 Stephen Friedman Gallery, London

2007 The Metropolitan Museum of Art, New York

2006 'New Work', Pace Wildenstein, New York

2006 'Currents 98: Tara Donovan', Art Museum, St Louis

2004 'Hammer Projects', UCLA Hammer Museum, Los Angeles

Tuksiarvik 1
2006
Oil on linen
243.5×133cm
Courtesy Galerie Martin Janda and
Galerie Vera Munro

Selected Bibliography

2006 *Painting People: Figure Painting Today*, ed. Charlotte Mullins, Distributed Art Publishers, New York

2004 'Double Life', Tom Morton, *frieze*, 82

2003 'Milena Dragicevic at Artlab at Imperial', Mark Harris, *Art in America*

2003 'Reconstruction Isn't Easy', Jennifer Higgie, *frieze*, 73

2001 'Interview', Dobrochna Giedwidz, *Boiler Magazine*

Selected Exhibitions

2007 'the order of the present is the disorder of the future', De Hallen, Haarlem

2006 'The Supplicants', Galerie Vera Munro, Hamburg

2005 'Even a Stopped Clock Tells the Right Time Twice a Day', Institute of Contemporary Arts, London

2003 'Akrobatski', Galerie Martin Janda, Vienna

2003 'Skulptura [skoolp-too-ra]', Artlab 25, Imperial College, London

Milena **Dragicevic**

Born 1965
Lives London

Milena Dragicevic was born in Serbia but grew up in Canada. She is also a twin, and her paintings have often featured *doppelgängers*, but she's no glib analyst of personal or cultural division. Compositions such as *There is No Gardener, and He is Invisible* (2005) – intermingling crazily angled topiary, redundant public sculpture propping up a looming house, disembodied arms grasping for colourful, bouncing circles – clarify Dragicevic's overriding interest: painting itself. For her the medium enables intractable complexities, a space for dreaming and deferred conclusions. Her recent 'Supplicants' series, quasi-portraits with facial areas edited out or hauntingly replaced by aspects of Native American masks, hones that approach into a quietly thrilling pictorial austerity. (MH)

Shown by Galerie Martin Janda H6

Eine kleine Kantate
(A Little Cantata)
(In collaboration with Julian
Göthe)
1993
Mixed media
Dimensions variable
Courtesy Galerie Daniel Buchholz

Lukas **Duwenhögger**

Born 1956
Lives Istanbul

Lukas Duwenhögger paints life as a performance.
Frieda Sembach-Krone und ihre Favoritin Celeste
(Frieda Sembach-Krone and her Favourite Celeste,
2006) is a rhythm in blue: a greasy grey-blue
elephant, a cloud-studded sky and a cerulean fence.
The painting is a series of perplexing social codes:
the rearing animal, tusks akimbo, is disciplined by
an authoritarian old lady in floor-skimming black,
against the backdrop of a wind-whipped big top.
Duwenhögger's attention to detail suggests an
almost Pre-Raphaelite approach to symbolism, yet
his ciphers are always invested with an edge of
obscurity. By instigating a game of inference and
deduction Duwenhögger demonstrates that the
codes of life, and the circus, are synonymous with
those of art itself. (BB)

Shown by Galerie Daniel Buchholz C4

Selected Bibliography

2007 'Next to Kin', Manfred
Hermes, *frieze*, 104

2006 'Burgerlijke Reflexen', Arjan
Reinders, *Kunstbeeld*, 4

2006 'Projekt Migration',
Dominic Eichler, *frieze*, 97

2005 'The Undiscovered
Country', Terry R. Myers, *Modern
Painters*, December/January

2005 'Person, Place and Timing',
Raphael Rubenstein, *Art in
America*, January

Selected Exhibitions

2007 'A Year-in Review-Lamp-
Installation', Vilma Gold, London

2007 documenta 12, Kassel

2006 'Next to Kin', Galerie
Daniel Buchholz, Cologne

2006 'The Subversive Charm of
the Bourgeoisie', Van
Abbemuseum, Eindhoven

2005 9th Istanbul Biennial

Untitled
2006
Negro and colour pencil on paper
19×28cm
Courtesy galerie bob van orsouw

Ein klares Bild

Selected Bibliography

2007 'Was bisher geschah' (What happened so far), Till Briegleb, *ART Kunstmagazin*, 4

2006 *Marcel van Eeden: Celia*, Stephan Berg, Hatje Cantz Verlag, Ostfildern Ruit

2006 *Marcel van Eeden: K.M. Wiegand, Life and Work*, Massimiliano Gioni, Hatje Cantz Verlag, Ostfildern Ruit

2006 'Mind Games', Steven Henry Madoff, *Artforum*, September

2004 *Marcel van Eeden: Zeichnungen/Drawings*, Reinhard Spieler, Museum Franz Gertsch, Burgdorf

Selected Exhibitions

2007 'The Archaeologist. The Travels of Oswald Sollmann', Kunsthalle, Tübingen

2007 'The Death of Matheus Boryna', galerie bob van orsouw, Zurich

2007 'Made in Germany', Kestnergesellschaft, Hanover

2006 4th Berlin Biennial

2006 'Celia', Kunstverein, Hanover

Marcel **van Eeden**

Born 1965
Lives The Hague/Berlin

With a compulsiveness reminiscent of On Kawara's practice, Marcel van Eeden has made one drawing per day for the past 14 years, as part of an ongoing series he calls 'Encyclopaedia of My Death'. Unlike Kawara, however, Van Eeden draws on archival materials dating from 1920 to 1965 – the year of his birth – as the source for most of his imagery. The drawings, which are presented alongside incongruous texts, resemble squares stolen from comic books or storyboard frames. While some works picture ordinary moments, others are like stills from *films noirs*, suggesting a rendezvous underneath an awning in the rain or the echo of footsteps in an otherwise empty museum. (CL)

Shown by galerie bob van orsouw C12

*Tokyo Underworld (The Fast Times
And Hard Life Of An American
Gangster In Japan)*
2006
Acrylic paint on canvas
160×240cm
Courtesy Private collection and
Standard (Oslo)

Gardar Eide **Einarsson**

Born 1976
Lives New York

From Philip K. Dick to the Unabomber and the
American War of Independence the work of
Norwegian artist Gardar Eide Einarsson examines
the concept of the outsider and the notion of the
universal oppressor through historical and literary
examples. Einarsson uses painting, photography,
sculpture, wall texts and found objects as props in
theatrically arranged installations that are typically
strictly monochrome. Prison tattoos, corporate
logos, zine graphics, signage tactics and flags
constitute only a part of the vocabulary with which
he writes his paeans to paranoia, which aim to
articulate the ideas of marginal societies within an
art-world context. (AC)

Shown by Standard (Oslo) F25, Team Gallery
G23

Selected Bibliography

2007 'Gardar Eide Einarsson',
Staffan Boije af Gennas, *frieze*, 105

2007 'Gardar Eide Einarsson:
Remember Kids', Bob Nickas,
Purple Fashion, 6

2006 'Gardar Eide Einarsson', Ana
Finel Honigman, *tema celeste*,
September/October

2006 *A Problem of Style: Art vs.
Subculture*, Ina Blom and Tone
Hansen, Torpedo Press, Oslo

2005 'Gardar Eide Einarsson',
Michael Wilson, *Artforum*,
December

Selected Exhibitions

2007 'South of Heaven',
Kunstverein, Frankfurt

2007 Sculpture Center, New
York

2006 'Street: Behind The Cliché',
Witte de With, Rotterdam

2006 'Defamation of Character',
PS1 Contemporary Art Center,
New York

2006 'Theatre of Life: Rhetorics
of Emotions', Städtische Galerie im
Lenbachhaus, Munich

Holly
2006
Oil on canvas
122×152cm
Courtesy Galerie Krobath
Wimmer

Selected Bibliography

2006 *Anhauchen* (Breathing Out), Galerie Krobath Wimmer, Vienna

2005 *Uncensored*, Mark Taylor and Mario Testino, Visionaire, New York

2004 'First Take: 12 New Artists: Judith Eisler', Jeffrey Kastner, *Artforum*, January

2003 *The Lazarus Effect: New Painting Today*, Luca Beatrice et al., Prague Biennial

2001 'Judith Eisler', Friedrich Tietjen, *Flash Art International*, October

Selected Exhibitions

2007 'The Painting of Modern Life', Hayward Gallery, London

2007 'Counterparts: Contemporary Painters and Their Influences', Contemporary Art Center, Virginia

2006 'anhauchen', Galerie Krobath Wimmer, Vienna

2003 'Lazarus Effect: New Painting Today', Prague Biennial

Judith **Eisler**

Born 1962
Lives New York

The scenes Judith Eisler paints are familiar, but you may not have really seen them unless, like her, you watch arthouse movies with a finger on the pause button, magnetized by moments that are peripheral to the action. Here's Gena Rowlands, pictured waving from behind in John Cassavetes' *Love Streams* (1984); here's a shot of someone's knickers from Nicolas Roeg's *Bad Timing* (1980). They're not mnemonic images, and they are divorced from their sources still further by the artist's saturated colours, sensual blurring and sheeny surfaces. These pleasures, though, mask a deeper purpose: overtly contrasting painterly open-endedness with cinema's relentless linearity, Eisler reminds us of painting's potential as a training ground for autonomy. (MH)

Shown by Galerie Krobath Wimmer E22

17th to 21st Century Informal Exotic
2007
Oil on canvas
92×73cm
Courtesy galerie bob van orsouw

Armen **Eloyan**

Born 1966
Lives Amsterdam/Zurich

From a distance Armen Eloyan's large-scale paintings, with their gloomy colours, spatial disorder and sketchy gestural brushwork, appear explosively *Sturm und Drang*, but closer inspection reveals a cast of comic characters, which slightly alleviates their tone. *Disaster* (2006) shows a black-eared, black-footed mouse standing in a devastated green and grey landscape next to a white bunny shot through the heart with an arrow, whose face still registers shock and disappointment. *Bend Over* and *TV Room* (both 2006) are scenes featuring curious little figures in destroyed interiors with blank, glowing television screens. It looks as though everyone is up to no good in these deliciously mean-spirited critiques of mass-cultural mind waste. (VR)

Shown by galerie bob van orsouw C12

Selected Bibliography

2007 *Two feet in one shoe: Armen Eloyan*, Ziba de Weck Ardalan and Philippe Pirotte, Parasol Unit, London

2007 'Who Killed Bambi?', Wim Peeters, *contemporary*, 90

2006 'Armen Eloyan', Hans Rudolf Reust, *Artforum*, December

2006 'Überzeichnete Charakteren' (Overdrawn Characters), Oliver Kielmayer, *Kunst-Bulletin*, 10

Selected Exhibitions

2007 'Two feet in one shoe: Armen Eloyan', Parasol Unit, London

2007 'Peintures Aller/Retour', Centre Culturel Suisse (Project Room), Paris

2007 'Bad Dad', Objectif_ exhibitions, Antwerp

2006 'Comic-related Paintings', galerie bob van orsouw, Zurich

2006 'Villa Jelmini', Kunsthalle, Bern

The Color Wheel/Seven Keys to the Successful Making of a Picture About Keys
2006
Mixed media on paper
29×24cm
Courtesy the artist and Jack Hanley Gallery

THE COLOR WHEEL

Selected Bibliography

2007 *Whenever It Starts It Is The Right Time: Strategies for a Discontinuous Future*, Chus Martinez, Kunstverein, Frankfurt

2006 'Simon Evans at Jack Hanley Gallery', Glen Helfand, *art on paper*, January/February

2005 *Vitamin D: New Perspectives in Drawing*, Emma Dexter, Phaidon Press, London

2004 'First Take: 12 New Artists', Mathew Higgs, *Artforum*, January

Selected Exhibitions

2007 'Learn to Read', Tate Modern, London

2006 27th São Paulo Biennial

2005 'How to Get About', Aspen Art Museum

2005 'In the Country of Uncles', Jack Hanley Gallery, San Francisco

2003 'Your Shit's Stuff', Jack Hanley Gallery, San Francisco

Simon **Evans**

Born 1972
Lives Berlin

By redrawing things that should normally be printed – maps, graphs, food labels – Simon Evans undermines an overconfident, bullish world with his own sceptical and anxious reflections. His deeply personal drawings and collages are often lifted directly from notebooks, coalescing into lists and charts such as *Ideas for New Continents* (2003) or *The Color Wheel* (2006). Honesty occasionally seems to spill over into provocation before we realize the joke is on all of us: *100 Reasons Why I Hate the Irish* (2002) is a column of increasingly unhinged and hilarious invective ending in an advertisement offering a T-shirt with the word 'BIGGOT' emblazoned across the front. (JG)

Shown by Jack Hanley Gallery A8, Nicole Klagsbrun Gallery E23, Store F31

Matias **Faldbakken**

Born 1973
Lives Oslo

A best-selling author in his native Norway with his dyspeptic satire *The Cocka Hola Company* (2001), Matias Faldbakken also makes tough-minded art. He poeticizes the notion of underground culture resisting mainstream co-optation – sometimes advertizing content only to snatch it back, as in his photographs of empty DVD cases or sculptures made from unspooled videotape. *Slayer* (2007), featuring the Speed Metal band's name written repeatedly, and illegibly, on a wall in black electrical tape, was also designed to comment on Iraq, but Faldbakken's vehemence is best reflected by the title of his anarchist newspaper from 2005: *See You on the Front Page of the Last Newspaper Those Motherfuckers Ever Print*. (MH)

Shown by Standard (Oslo) F25

Selected Bibliography

2006 'Matias Faldbakken', Kjetil Røed, *contemporary*, 85

2006 'Matias Faldbakken: Top Ten List', Matias Faldbakken, *Artforum*, September

2006 'Upping the Anti', ed. Severin Dünser et al., *Mono.Kultur*, 07

2006 *Theatre of Life: Rhetorics of Emotions*, Susanne Gaenshaiemer et al., Städtisches Galerie, Munich

2005 *MF+MF*, Jennifer Allen, Moderna Museet, Stockholm/ Nordic Pavilion, Venice Biennale

Selected Exhibitions

2007 Midway Contemporary Art, Minneapolis

2007 'A Hideous Disease', Art Statements, Art 38 Basel

2007 'Memorial to the Iraq War', Institute of Contemporary Arts, London

2006 'Defamation of Character', PS1 Contemporary Art Center, New York

2006 'Theatre of Life: Rhetorics of Emotions', Städtische Galerie im Lenbachhaus, Munich

Maison du Peuple
(House of People)
2006
Oil on linen
112×102cm
Courtesy Galleri Magnus Karlsson

Selected Bibliography

2007 'Jens Fänges surrealistiska sagor' (The Surreal Stories of Jens Fänge), Frida Cornell, *Konstvärlden Disajn*, 2

2006 *Profane Illuminator*, Gertrud Sandqvist, Bokförlaget Langenskiöld and Jens Fänge, Stockholm

2006 *A Dandy in Present Tense*, Christian Viveror-Fauné, Bokförlaget Langenskiöld and Jens Fänge, Stockholm

2006 'Den döende dandyn' (The Dying Dandy), Magdalena Dziurlikowska, *Expressen*, Stockholm

2004 *Jens Fänge's Signature*, Anders Kreuger, Rhodes+Mann Gallery, London

Selected Exhibitions

2007 'Painting, Space & Society', Konsthall, Gothenburg

2006 'Maison du Peuple', Galleri Magnus Karlsson, Stockholm

2003 'Carnegie Art Award', The Royal Academy of Fine Arts, Stockholm

2002 'Flat, Baroque and Berserk', Schaper Sundberg Galleri, Stockholm

2001 Galleri Wang, Oslo

Jens **Fänge**

Born 1965
Lives Stockholm

Treasure chests, disembodied legs in striped socks and details from domestic scenes are all rose-tinted in the eyes of Jens Fänge. Yet, despite the predominance of pink in his painting, his works are never saccharine sweet. *Lampan* (Lamp, 2006), a picturebook perfect portrayal of a reclining dandy warming his hands on an abandoned doll's head, verges on the hallucinatory. By appealing to the more uncanny elements of childhood fantasies, Fänge's work falls far short of nostalgia, choosing instead to mine the rift between the phantasmic and the real in order to reveal that divide as illusory. (BB)

Shown by Galleri Magnus Karlsson G11

Untitled
2006
Cut mulberry paper on blue card
46×28cm (framed)
Courtesy greengrassi

Gretchen **Faust**

Born 1961
Lives Totnes

After making her name in the 1980s by incising ambiguous phrases directly into walls with an ice-pick, Gretchen Faust didn't exhibit for a decade; when she returned, in 2003, it was with a far more subdued and seemingly radically different aesthetic. Her delicate and petite paper cut-outs, neatly framed, at first resemble innocuous hobbyist distractions. Considered carefully, though, they reveal an absorbingly outlandish formal interplay on a reduced scale of events; small deviations from an apparent symmetry – created by virtuosic multi-axial folding – feel highly significant. The principle of perforation is consistent with Faust's earlier work, but the main thing her art now punctures is expectations. (MH)

Shown by greengrassi D8

Selected Bibliography

2003 'Gretchen Faust', Barry Schwabsky, *Artforum*, December

2003 'Gretchen Faust', Sally O'Reilly, *Time Out London*, 24 September – 1 October

1992 'Art in Review', Holland Cotter, *The New York Times*, 5 June

1991 'Gretchen Faust – Pat Hearn', Meyer Raphael Rubenstein, *Flash Art International*, March/April

1990 'Gretchen Faust', Kirby Gookin, *Artforum*, January

Selected Exhibitions

2004 'Reflections', Stadhuisplein, Belgium

2003 'Gretchen Faust', greengrassi, London

1994 'Outside the Frame: Performance and the Object', Center for Contemporary Art, Cleveland

1992 'Tattoo Collection', Andrea Rosen Gallery, New York

1990 Pat Hearn Gallery, New York

David head with scarf
Painted plaster
50cm (height)
Courtesy Hans-Peter Feldmann
and Galerie Micheline Szwajcer

Selected Bibliography

2006 *Liebe* (Love), Verlag Walter König, Cologne

2005 *Frauen im Gefängnis* (Women in Prison), Hans-Peter Feldmann and Klaus Hellmann, Verlag Walther König, Cologne

2004 *Bilder* (Pictures), Hans-Peter Feldmann, Verlag Walther König, Cologne

2004 *Das Kleine Mövenbuch* (The Little Seagull Book), Hans-Peter Feldmann, Verlag Walther König, Cologne

2002 *Vistas Desde Habitaciones de Hotel* (Views Out of Hotel Room Windows), Hans-Peter Feldmann, Ediciones Originales, Barcelona

Selected Exhibitions

2006 Bahnhof, Hamburg

2006 'Das Achte Feld: Geschlechter, Leben und Begehren in der bildenden Kunst seit 1960', Museum Ludwig, Cologne

2005 Galerie Barbara Weiss, Berlin

2003 Centre Nationale de la Photographie, Paris

2003 303 Gallery, New York

Hans-Peter **Feldmann**

Born 1941
Lives Dusseldorf

Although he also makes quirky sculptures from found objects, Hans-Peter Feldmann's main muse is the photographic image. Over many decades he has made series, in limitless editions, of plain but striking photographs, with motifs ranging from slept-in hotel beds and women's knees to the victims of the violent conflict between the German state and radical left-wing terrorist groups. An avid collector and collator of images – both his own snapshots and photographs taken from the mass media – Feldmann has published numerous artist's books, including a recent one in which he documents life in a women's prison. (DE)

Shown by Konrad Fischer Galerie A5, Johnen Galerie Berlin/Cologne F10, Galleria Massimo Minini F11, Galerie Francesca Pia H11, Galerie Micheline Szwajcer D9

Fire
2005
Silk yarn, steel armature, epoxy
244×366cm
Courtesy the artist and Lehmann
Maupin Gallery

Teresita **Fernández**

Born 1968
Lives New York

Sfumato (2005), Teresita Fernández' synthetic representation of natural phenomena, consists, quite literally, of smoke and mirrors – a wall-mounted cluster of reflective glass cubes seems to form a glittering cloud of smoke. The artist's sensuous brand of Conceptualism proposes her own interpretation of a single element from nature, as in the glittering curve of the plastic and aluminium *Waterfall* (2005). The artifice of Fernández' Minimalist constructions lies in the substitution of the real by the seductively realistic, obscuring the element of reference to give a purely artificial vision of the sublime. (ST)

Shown by Lehmann Maupin F16

Selected Bibliography

2007 'The Dazzle', Anne Stringfield, *US Vogue*, April

2007 *Olympic Sculpture Park*, Mimi Gates, Seattle Art Museum

2005 'In the Studio', Steven Wallis, *Art + Auction*

2003 'Teresita Fernández', Paula Harper, *Art in America*

2001 *Teresita Fernández*, Marcella Beccaria, Castello di Rivoli, Turin

Selected Exhibitions

2007 Lehmann Maupin Gallery, New York

2005 Centro de Arte Contemporáneo, Málaga

2002 'Outer City, Inner Space', Whitney Museum at Philip Morris, New York

2001 Castello di Rivoli, Turin

2000 'Hothouse', Museum of Modern Art, New York

Paradys
(Paradise)
2007
Wood
252×231×88cm
Courtesy Filomena Soares

Selected Bibliography

2007 *Maison Tropicale*, ed. Jürgen Bock, Instituto das Artes, Lisbon

2003 *No Place at All*, Pedro Lapa and Andrew Renton, Museu do Chiado/MNAC, Lisbon

2003 *Angela Ferreira's Zip Zap Circus School*, Jürgen Bock and Iain Low, Institute of Contemporary Arts, Cape Town

1999 *Casa Maputo: Um retrato íntimo* (Maputo's House: An Intimate Portrait), João Fernandes, Fundação de Serralves, Porto

1999 *Signs of Life*, Juliana Engberg, International Biennial, Melbourne

Selected Exhibitions

2007 'Afterlife', Michael Stevenson, Cape Town

2007 Portuguese Pavilion, 52nd Venice Biennale

2005 'Random Walk', Galeria Filomena Soares, Lisbon

2003 'No Place at All', Museu do Chiado - MNAC, Lisbon

1999 'Casa Maputo: Um retrato íntimo', Fundação de Serralves, Porto

Ângela **Ferreira**

Born 1958
Lives Lisbon

Although Ângela Ferreira's recent sculpture *Paradys* (Paradise, 2007) – an austerely linear wooden structure suggesting a drawing in space – references Carlo Scarpa's doors for the Gallerie dell' Accademia, Venice, the title pays tribute to Cape Town architect Gawie Fagan's second home of that name. Of dual nationality (Portuguese and South African), Ferreira works with sculpture, video, photography and performance to examine points of global exchange and to critique Modernist strategies, sometimes through the prism of Portuguese colonial history. Projects bridging temporal and geographical divides have included an installation for the exhibition 'Squatters' at Witte de With, which contrasted a 1920s' Rotterdam housing project with one built in Portugal during the 1970s. (KJ)

Shown by Galeria Filomena Soares H7

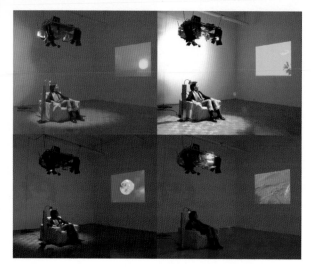

Choose Your Day
2005
Armchair, buttons, reflectors, data
projector, DVD player, audio,
ventilator, hair-dryer
Dimensions variable
Courtesy Galerija Gregor Podnar

Vadim **Fiškin**

Born 1965
Lives Ljubljana

Vadim Fiškin seems to channel the spirits of Willy
Wonka, Jules Verne and Stephen Hawking in
installations and inventions that display a
fascination with the space–time continuum,
creative kookiness and spectator perception.
Another Speedy Day (2005) used clock time and
light effects to reduce the 24-hour day to 12
minutes inside the gallery space, while *Lighthouse*
(1996) translated the artist's heartbeat from a sensor
attached to his chest into light pulsing under the
golden cupola of the Vienna Secession building.
However, it's not all hard science and
technological wizardry with Fiškin, whose machine
for catching angels and hot air balloon launched
inside a gigantic Slovenian cave appeal to the child
lurking inside all of us. (VR)
Shown by Galerija Gregor Podnar F20

Selected Bibliography

2007 *Vadim Fiškin: Orbit Edges*,
ed. Gregor Podnar, jrp | ringier,
Zurich / gurgur editions, Ljubljana

2005 'Slovenian Pavilion at the
Venice Biennale', Thomas
Wulffen, *Kunstforum*, 177

2003 *Imagining Prometheus*, Bonito
Oliva, Edizioni Charta, Milan

2003 'Kaplegraf 0G', Lívia Páldi,
Anomalie Digital_Arts, '*Space Art'*, 4

2000 *Fresh Cream: Contemporary
Art in Culture*, Viktor Misiano,
Phaidon Press, London

Selected Exhibitions

2005 'Twins Paradox', Galerija
Gregor Podnar, Ljubljana

2005 51st Venice Biennale

2005 'Joy', Casino Luxembourg -
Forum d'Art Contemporain,
Luxembourg

2002 'Centre of Attraction', Baltic
Triennial, Vilnius

1996 Manifesta 1, Rotterdam

Scipio and the Bear
2007
Watercolour and gouache on paper
151×303.5cm
Courtesy Paul Kasmin Gallery

Walton **Ford**

Selected Bibliography

2006 'A Tiger Roars in Brooklyn', Alix Finkelstein, *The New York Sun*, 2 November

2006 'Misadventures Along the Nature Trail', Robert Enright, *Border Crossings*, March

2005 'America the Beautifully Absurd', Annette Grant, *The New York Times*, 22 May

2005 'Built Ford Tough', Kevin Conley, *US Men's Vogue*, Autumn

Selected Exhibitions

2006 'Tigers of Wrath: Watercolors by Walton Ford', Brooklyn Museum, New York

2005 'Walton Ford: Watercolors', Paul Kasmin Gallery, New York

2004 'Bitter Gulf', Paul Kasmin Gallery, New York

2004 Museum of American Art, New Britain

Born 1960
Lives Berkshire County

Walton Ford's paintings are social commentary disguised as natural history. His meticulously rendered works refract the legacy of John Audubon through the satirical surrealism of Pieter Brueghel, Hieronymus Bosch and R. Crumb. A critique of colonialism and contemporary capitalism is apparent in many works, such as *Prodigy* (2004), a portrait of Fidel Castro as a wily-looking Cuban red macaw. *Falling Bough* (2002), one of Ford's most disturbing images, depicts a bough breaking under the weight of hundreds of carrier pigeons. These birds, once the most populous in America but now extinct, are shown fighting, copulating and eating their own young, oblivious to their imminent crash. (SL)

Shown by Paul Kasmin Gallery E14

Untitled
2007
Acrylic on canvas
140×150cm
Courtesy Galerie Bärbel Grässlin

Günther **Förg**

Born 1952
Lives Colombier

In a series of recent watercolours ('Untitled', 2006) Günther Förg demonstrates his faith in that most Modernist of tropes: the grid. Crossed lines become blurred in blue and pink but regain focus in black, suggesting the visual language of confinement. These works are not an exercise in form but a development of an earlier series in which he explored windows, some of them framing trees and others free-floating, that teeter between abstraction and figuration. The linear armature of Förg's painting is echoed in his architectural photographs, yet series such as 'Bauhaus Tel Aviv – Jerusalem' (2001) demonstrate that the artist's project reaches beyond the mere formal to embrace the cultural value of form. (BB)

Shown by Galerie Bärbel Grässlin D18

Selected Bibliography

2006 *Günther Förg: Fotografie* (Günther Förg: Photography), Kunsthalle, Bremen

2006 *Gazzetta dello Sport*, Galerie Bärbel Grässlin, Frankfurt

2004 *Günther Förg: Make it new*, Kunsthalle, Recklinghausen

2001 *Günther Förg*, Kunsthaus, Bregenz

1998 *Günther Förg*, Museo Nacional Centro de Arte Reina Sofia, Madrid

Selected Exhibitions

2006 'Günther Förg: Gazzetta dello Sport', Galerie Bärbel Grässlin, Frankfurt

2005 'Flashback: eine Revision der Kunst der 80er Jahre', Kunstmuseum/ Museum für Gegenwartskunst, Basel

2001 Kunsthaus, Bregenz

1998 Museo Nacional Centro de Arte Reina Sofia, Madrid

1992 documenta 9, Kassel

File under Sacred Music
2003
Video
Courtesy Kate MacGarry

Selected Bibliography

2007 'Back to the Future', Helen Sumpter, *Time Out London*

2006 'Silent Sound', Jonathan Griffin, *frieze*, 103

2006 'Music – Best of 2006', Iain Forsyth and Jane Pollard, *Artforum*

2006 'The Voice Within', Chris Mugan, *The Independent*

2005 'Iain Forsyth and Jane Pollard', Miria Swain, *Untitled*, Autumn

Selected Exhibitions

2006 'Silent Sound', A Foundation/Greenland Street and St George's Hall, Liverpool

2006 'Music for People', Contemporary Arts, Dundee

2006 'Street: Behind the Cliché', Witte de With, Rotterdam

2005 'Walking After Acconci (Redirected Approaches)', Kate MacGarry, London

2003 'File under Sacred Music', Institute of Contemporary Arts, London

Iain **Forsyth** & Jane **Pollard**

Born 1973/1972
Live London

The audiences at Iain Forsyth and Jane Pollard's performances often find themselves doubting the validity of their own responses. This was the case not only during their recent excursion into subliminal messaging, the spectacular *Silent Sound* (2007), but also at earlier recreations of legendary gigs by musicians including The Cramps and David Bowie. Theirs is an inquiry into the mechanics of performance, reception and recollection. By appropriating or adapting ready-made events, Forsyth and Pollard exploit their audiences' sense of recognition, allowing them to be swept up in an emotional response before inducing reflection on the shades of complicity between themselves, the performers and the artists pulling the strings. (JG)

Shown by Kate MacGarry E18

Drops
2007
Acrylic on canvas
213.5×152.5cm
Courtesy David Kordansky Gallery

Will **Fowler**

Born 1969
Lives Los Angeles

Looking like a mash-up between a graffiti-strewn wall and the crisp grids of Abstract Expressionism, Will Fowler's work attacks form, pushing vengefully against it with bright explosions of colour. He covers his canvases in grids, quoting, underneath, previous paintings of his own and works by other artists, such as, in his 2004 début solo show, El Lissitzky's exhibition model for a 1930 fur trade show. Fowler's paintings become assemblages of fragmentary images and motifs, chaotic references that are only slightly tamed by the repetition of shapes across the large canvases: squares, dots and jagged lines that bristle at having to share space with stories from elsewhere. (MG)

Shown by David Kordansky Gallery F22

Selected Bibliography

2007 'Will Fowler', Michael Ned Holte, *Artforum*, April

2006 '[Keep Feeling] Fascination', Katherine Satorius, *ArtWeek*, June

2006 'Los Angeles Elsewhere is Everywhere', Noellie Roussel, *Artpress*, April

Selected Exhibitions

2007 White Columns, New York

2007 David Kordansky Gallery, Los Angeles

2006 'Dereconstruction', Gladstone Gallery, New York

2006 'Concepts from Painting', AR/GE Kunst, Bolzano

OOOOOOOOOO
2007
Installation view
Courtesy Zero...

Selected Bibliography

2007 *Ambient Tour: Flavio Favelli,
Christian Frosi, Deborah Ligorio,*
Ilaria Bonacossa and Francesco
Bonami, Electa, Milan

2007 'Christian Frosi:
Riproduzione emotiva di un
esperimento scientifico' (Christian
Frosi: Emotional Recreation of a
Scientific Experiment), Gyonata
Bonvicini, *Flash Art Italia,*
February/March

2006 *Una sensibile differenza:
Conversazioni con artisti italiani di
oggi* (A Different Sensibility:
Conversations with Contemporary
Italian artists), Stefano Chiodi, Fazi,
Roma

2006 'Milan', Massimiliano Gioni,
Artforum, December

2005 *Premio Furla per l'arte.
Giovani artisti italiani* (Furla Prize
for Art. Young Italian Artists),
Charta, Milan

Selected Exhibitions

2007 'Ambient Tour', Fondazione
Sandretto Re Rebaudengo, Turin

2006 Galerie Rüdiger Schöttle,
Munich

2005 Isabella Bortolozzi Galerie,
Berlin

2005 'We Disagree', Andrew
Kreps Gallery, New York

2003 Zero..., Milan

Christian **Frosi**

Born 1973
Lives Milan

With his sculpture- and video-led installations
Christian Frosi creates environments that address
the potential of objects and images to lose their
meaning. A dismantled bike is packed into tubular
wooden forms for *New Title OOOO Bicycle* (2006),
while *New Title U05* (2006) presents a pair of shoes
belonging to Chris Dercon, director of Haus der
Kunst, Munich, on a Perspex wall pedestal. Frosi's
process-based works – tendentially ephemeral,
haphazard and playful – are often the result of
actions aimed at highlighting inconsistencies in our
own society. Buildings and trees can be submerged
with foam (*Foam,* 2003) or a gallery subsumed with
shifting sands, as in *Dune* (2007). (AC)

Shown by Zero... G3

Seven Intellectuals in Bamboo Forest, Part 4
2007
35mm black and white film
transferred to DVD
Courtesy the artist, Marian
Goodman Gallery and ShangART

Yang **Fudong**

Born 1971
Lives Shanghai

The films of Chinese artist Yang Fudong occupy a temporal limbo where contemporary characters, dressed frequently in old-fashioned clothes, engage in an inconclusive search for waylaid ideals or existential understanding. Blurry, atmosphere-drenched and often shot in black and white, with sparse dialogue and drifting narratives, they suggest a version of contemporary China that is more dream than analysis, illustrating Yang's concept of 'abstract cinema'. In the multi-channel video work *No Snow on the Broken Bridge* (2006), the (in-)action undergoes a further dislocation, spread across eight screens, to disorienting effect. (KB)

Shown by Marian Goodman Gallery F14

Selected Bibliography

2006 *No Snow on the Broken Bridge: Film and Video Installations by Yang Fudong*, Ziba de Weck Ardalan, Parasol Unit, London

2006 *Yang Fudong*, ed. Marcella Beccaria, Skira, Milan

2005 *Yang Fudong*, ed. Marcella Beccaria, Castello di Rivoli Museo d'arte Contemporanea, Turin

2005 *Yang Fudong*, ed. Sabine Folie, Kunsthalle, Vienna

2002 *Documenta_Platform 5*, ed. Heike Ander and Nadja Rottner, Hatje Cantz Verlag, Ostfildern Ruit

Selected Exhibitions

2007 52nd Venice Biennale

2006 'No Snow on the Broken Bridge', Parasol Unit, London

2005 'Yang Fudong: Recent Films and Videos', Stedelijk Museum, Amsterdam

2005 'Yang Fudong', Castello di Rivoli Museo d'Arte Contemporanea, Turin

2002 documenta 11, Kassel

Prostitute (Paramount Pictures Version)
2006
Oil on linen
61×46cm
Courtesy Carl Freedman Gallery

Selected Bibliography

2007 'Michael Fullerton', *The New Yorker*, 15 January

2004 'Futures and Pasts', Will Bradley, *frieze*, 82

2004 'Buried Treasures', Mark Sladen, *ArtReview*

2003 *Are You Hung Up?*, ed. Michael Fullerton et al., Transmission, Glasgow

2003 *The Cultural Devolution: Art in Britain in the Late 20th Century*, Neil Mulholland, Ashgate, London

Selected Exhibitions

2006 'Get Over Yourself', Greene Naftali Gallery, New York

2006 'Toutes Composition Florales', Carl Freedman Gallery, London

2005 'Art Now', Tate Britain, London

2005 'Suck on Science', Centre for Contemporary Arts, Glasgow

2003 'Are You Hung Up?', Carl Freedman Gallery, London

Michael **Fullerton**

Born 1971
Lives London

Best known for his Thomas Gainsborough-inspired paintings of notable public figures ranging from Carl Jung and Steve Jobs to Paddy Joe Hill, wrongfully convicted of an IRA bombing in 1974, Fullerton has trafficked in a range of objects and materials, including erased computer hard drives, radio microphones and sculptures made from ferrous oxide and urethane (used to coat audio and video tapes). The unifying feature? How information is generated and received. Fullerton takes style seriously, and his self-consciously anachronistic portraits affirm the mediation inherent in all forms of representation, be it 18th-century painting or contemporary media technology. (CG)

Shown by Carl Freedman Gallery B1, Greene Naftali F4

Characterised by conceptual rigour, visual simplicity and allusive text
2007
Hand-printed black and white photograph
110×82.5cm
Courtesy the artist and Store

Ryan **Gander**

Born 1976
Lives London

Storytelling need not comprise direct descriptions of people, places and events. Ryan Gander sketches narratives by tangentially lassoing historical figures, aesthetic tropes, over-specific objects and totally fabricated phenomena. His installations, publications and illustrated lectures are porous conglomerations that may draw on the legacy of Modernist architecture, incorporate a huge replica of a 1970s' doorbell cover or allude to the artist's great-aunt Deva. The chasms between appropriations, observations and inventions implore the audience to create a reading – Gander's intention is not to shirk the responsibilities of authorship but just to withhold the didactic elements. (SO'R)

Shown by Galleria Massimo de Carlo F3, Marc Foxx A1, Annet Gelink Gallery E21, Store F31

Selected Bibliography

2007 'Co-pilots', Dan Fox, *frieze*, 107

2007 'Denied Parole', Douglas Fogle, *Artforum*, February

2007 *Intellectual Colours: Ryan Gander*, Ryan Gander, Silvana Editoriale, Paris

2007 *Appendix Appendix*, Stuart Bailey and Ryan Gander, jrp | ringier, Zurich/Christoph Keller Editions, Amsterdam

2006 *Pure Associations*, Ryan Gander and Bart van der Heide, ABN-AMRO Art Award, Amsterdam

Selected Exhibitions

2007 'The Last Work', Stedelijk Museum, Amsterdam

2007 'A Short Cut Through the Trees', MUMOK, Vienna

2006 'Nine Projects for the Pavilon d'Espirit Nouveau', Museo d'Arte Moderna, Bologna

2006 'Is this guilt in you too (Cinema Verso)', Whitechapel Art Gallery, London

Sem Título
From the series 'Project to transform the political speech in facts, finally'
2005
Black and white photograph, thread, pins and stamps
125×175cm
Courtesy CIFO Collection, Miami

Selected Bibliography

2005 *Capablanca's Real Passion*, Gli Ori, Prato

2004 *La Misura di Quasi Tutte le Cose* (The Measure of Almost Everything), Gli Ori, Prato

2002 'Carlos Garaicoa', Holly Block, *BOMB Magazine*

2000 *Fresh Cream: Contemporary Art in Culture*, Victor Misiano, Phaidon Press, London

2006 'Carlos Garaicoa', Holland Cotter, *The New York Times*

Selected Exhibitions

2006 'Carlos Garaicoa: Carta a Los Censores', Fondation Prince Pierre de Monaco, Monte Carlo

2005 51st Venice Biennale

2005 'Capablanca's Real Passion', Museum of Contemporary Art, Los Angeles

2004 'Images Smugglers', 26th São Paulo Biennial

2002 documenta 11, Kassel

Carlos **Garaicoa**

Born 1967
Lives Havana

The urban decay of his native Havana has been the focus of Carlos Garaicoa's work since the early 1990s. The artist unearths the decrepit city's Utopian possibilities through imaginary architectural models and minor alterations in the landscape. In an ongoing series of photographs, for example, he uses coloured thread to add improvements or alternative meanings to old signage on decaying buildings. Through such projects Garaicoa hopes to illuminate, or perhaps even symbolically to repair, the gap between idealistic visions for the future of Cuba and the depressed living conditions of the present. (CL)

Shown by Galeria Luisa Strina F12

Mirror
2006
16mm film
Courtesy the artist and Yvon
Lambert

Anna **Gaskell**

Born 1969
Lives New York

Since the late 1990s Anna Gaskell has been making alluring, high-keyed colour photographs whose suspended narratives and manifest theatricality draw on cinematic conventions: exaggerated cropping, dramatic camera angles and lighting, variations in point of view and depth of field. References to the fairy-tale worlds of Lewis Carroll, the Brothers Grimm and E.T.A. Hoffmann prevail in Gaskell's haunting images of adolescent girls caught up in psychologically charged situations that appear to incarnate their own fantasies and nightmares. Less well known are Gaskell's films, the most recent of which (*Acting Lessons*, *Vermilion* and *Mirror*, all 2006–7) bridge the inner and outer worlds by taking as their focus the power, and fallibility, of memory. (CG)

Shown by Galerie Gisela Capitain D11, Galleria Massimo de Carlo F3, Yvon Lambert G5

Selected Bibliography

2004 *At Sixes and Sevens*, Israel Rosenfield and Massimiliano Gioni, Yvon Lambert, Paris

2001 *Half Life*, Matthew Drutt, The Menil Collection, Houston

2001 *Anna Gaskell*, Sheila Schwartz, Des Moines Art Center

1998 *Anna Gaskell*, Bonnie Clearwater, Museum of Contemporary Art, Miami

Selected Exhibitions

2007 'Paint your own pictures', Yvon Lambert, New York

2007 'Still Life', Vizcaya Museum and Garden, Miami

2006 'Everything that Rises', Second Street Gallery, Charlottesville

2003 Fondazione Sandretto Re Rebaudengo, Turin

2002 'Half Life', The Menil Collection, Houston

Omi
(Grandma)
2004
Mixed media
220×150×130cm
Courtesy Galerie Meyer Kainer

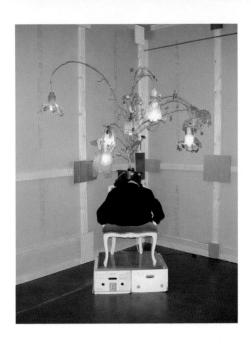

Selected Bibliography

2006 *gelitin: Chinese, Synthese, Leberkäse*, Eckhardt Schneider et al., Kunsthaus, Bregenz

2005 'Insert Object, and Out Comes an Artful Replica', Holland Cotter, *The New York Times*

2005 'Big, Dead, Rotting, Silly Rabbit', Meredith Kahn, *The New York Times*

2005 'gelitin: Hase', Christina Romano, *Domus*

2004 'gelitin: Risikobefriedigung', Meret Ernst, *Kunstforum*

Selected Exhibitions

2007 'Hamsterwheel', 52nd Venice Biennale

2007 'Das Kackabet', Gallery Nicola von Senger, Zurich

2007 'Die Künstlerinnen sind anwesend', Gallery Meyer Kainer, Vienna

2006 'In den Alpen', Kunsthaus, Zurich,

gelitin

Founded 1993
Based Vienna

A 60-metre knitted toy rabbit apparently discarded in an Italian alpine landscape, a load-bearing balcony covertly mounted on the exterior of the 148th floor of the former World Trade Center, and a toilet installed in an Austrian Kunsthaus that provides the periscopic possibility of watching your own urinal money shot, are typically tricksterish gelitin projects. The licentious and grotesque accent of much of what the four collaborators get up to chimes with Viennese Actionism, but any macho shamanism is tempered with a raucous, often self-deprecating humour that renders the outcomes more interventionist than spectacular. (SO'R)

Shown by Galleria Massimo de Carlo F3, Gagosian Gallery D7, Galerie Meyer Kainer F2, Galerie Emmanuel Perrotin F9

Everythingispossible...
2001
Vinyl text
Dimensions variable
Installation view 'Los Vinilos', El
Basilico, Buenos Aires, 2007
Courtesy Casey Kaplan

Liam **Gillick**

Born 1964
Lives New York/London

Liam Gillick's scenario-based installations are often triggered by playful, self-penned docu-fictional texts concerning shifts in society. His latest installation, *THE STATE ITSELF BECOMES A SUPER COMMUNE* (2006), took its cue from some Scandinavian workers who had returned to their recently closed car factory to discuss the possibility of, as a wall text posited, an 'economy of equivalence'. The text was accompanied by Gillick's elegant, Donald Judd-ian structures made from brightly coloured Perspex and aluminium, such as *Closed Reopened Closed Again (Uddevalla)* (2007). Gillick sends the easy opposition between the 'Conceptual' and the 'retinal' into the yawning gap he has opened up between opaque visuality and fractured meaning. (JöH)

Shown by Air de Paris E5, Corvi-Mora E4, Casey Kaplan A6, Galerie Meyer Kainer F2, Galerie Eva Presenhuber C3, Galerie Micheline Szwajcer D9

Selected Bibliography

2007 *Liam Gillick: Factories in the Snow*, Liam Gillick and Lilian Haberer, jrp | ringier/ Les Presses Du Réel, Zurich

2006 *Proxemics: Selected Writings (1988-2006)*, Liam Gillick, jrp | ringier/ Les Presses Du Réel, Zurich

2006 *Again the Metaphor Problem and Other Engaged Critical Discourses about Art*, John Baldessari et al., Springer, Berlin

2002 *The Wood Way*, Anthony Spira et al., Whitechapel Art Gallery/ PJ Print, London

Selected Exhibitions

2007 'The Shapes of Space', Guggenheim, New York

2006 '3rd Tate Triennial', Tate Britain, London

2005 'A short essay on the possibility of an economy of equivalence', Palais de Tokyo, Paris

2005 'McNamara Motel', Centro de Arte Contemporáneo, Málaga

2003 'Projects 79: Literally', Museum of Modern Art, New York

Untitled
2005–6
Aluminum leaf, oil and enamel
paint on cast lead crystal
12×11cm
Courtesy Matthew Marks Gallery

Selected Bibliography

2007 *Robert Gober: Sculptures and Installations 1979–2007*, Robert Gober and Elisabeth Sussman, Schaulager, Basel/ Steidl Verlag, Göttingen

2005 *A Robert Gober Lexicon*, Robert Gober and Brenda Richardson, Steidl | MM, Göttingen

2003 *Robert Gober: Werke von 1978 bis heute* (Robert Gober: Works from 1978 to the Present), Alexander Braun, Verlag Für Moderne Kunst, Nuremberg

1997 *Robert Gober*, Hal Foster and Paul Schimmel, Museum of Contemporary Art, Los Angeles/ Scalo Publishers, New York

1992 *Robert Gober*, Dave Hickey, Dia Center For the Arts, New York

Selected Exhibitions

2007 'Robert Gober: Work 1976–2007', Schaulager, Basel

2005 Matthew Marks Gallery, New York

2003 'Robert Gober: Displacements', Astrup Fearnley Museet for Moderne Kunst, Oslo

2001 United States Pavilion, 49th Venice Biennale

1999 'Robert Gober: Sculpture + Drawing', Walker Art Center, Minneapolis

Robert **Gober**

Born 1954
Lives New York

The strange gravity of Robert Gober's 'remade ready-mades' is as much down to their material transubstantiations (a slab of Polystyrene remade precisely in bronze) as to their unexpected fusion of contradictory elements (a Madonna statue pierced with a length of industrial drainage pipe). Even the most ordinary things (a crate of apples, a crumpled $5 receipt) appear uncanny, owing simply to the labour-intensive process of their recreation. These reticent objects, and the perplexing relationships between them, are loaded with narrative and symbolic allusion. Religion, family, sexuality and memory are recurrent themes, which knit together to form a complex reflection on the dualities implicit in the celebrated 'freedoms' of American society. (KB)

Shown by Matthew Marks Gallery C5

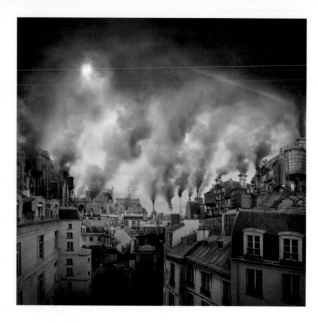

Smoke stack
2007
C-print (edition of 9)
140×152cm
Courtesy Aurel Scheibler

Anthony **Goicolea**

Born 1971
Lives New York

Anthony Goicolea is best known for his Photoshop-maestro photographic works featuring groups of identical feral schoolboys (played by the artist himself and digitally cloned) running riot in foppishly homoerotic rough-and-tumble. The seemingly frictionless alliance of such '*Lord of the Flies* scenarios', as critics have inevitably characterized them, with a 'David Lynch-meets-David LaChapelle' slick Surrealism, rather redoubles their provocation of rampant narcissism. The boys have now gone to ground (or into the woods, in the 'Shelter' series, 2004–5), and Goicolea has turned increasingly to drawing while allowing more murky allusions into his practice, specifically through references to survivalism and his Cuban roots. (MA)

Shown by Galerie Aurel Scheibler G17

Selected Bibliography

2007 *Behind Innocence*, Oliver Koerner von Gustorf, Gallery Hyundai, Seoul

2006 'Anthony Goicolea', *Snoecks 06*

2005 'To Thine Own Selves Be True', Linda Yablonsky, *ArtNews*, 11/12

2005 'Photos that Change Reality', Alan Riding, *The New York Times*, 19 November

2005 *Anthony Goicolea: Drawings*, Twin Palms Publishers, Santa Fe

Selected Exhibitions

2006 'The Septemberists', Aurel Scheibler, Berlin

2005 'Anthony Goicolea: Photographs, Drawings and Video', Arizona State University Museum of Art, Tempe

2005 'Outsiders: Photographs and Video', Cheekwood Museum of Art

2004 'Sheltered Life', Aurel Scheibler, Cologne

2003 Contemporary Center for Photography, Melbourne

Door
2006
Lambda print
122×99.5cm
Courtesy Galerie Catherine Bastide

Selected Bibliography

2006 *Vitamin Ph: New Perspectives in Photography*, T.J. Demos, Phaidon Press, London

2005 'Geert Goiris', Emily Hall, *Artforum*, November

2005 *Croiser des mondes* (Crossing Worlds), Régis Durand, Jeu de Paume, Paris

2005 'Geert Goiris', Daniele Balice, *Flash Art Italia*, 241

2005 'Concepts à l'oeuvre' (Concepts in Action), Dominique Bacque, *Art Press*, 310

Selected Exhibitions

2007 'Frontier', Galerie Catherine Bastide, Brussels

2007 'Private/Public', Museum Boijmans Van Beuningen, Rotterdam

2005 'Croiser des mondes', Jeu de Paume, Paris

2004 Art : Concept, Paris

2000 'Reconstruction', Museum for Photography, Anvers

Geert **Goiris**

Born 1971
Lives Anvers

Geert Goiris' photographs are irresistibly curious. His subjects include an albino wallaby, a stranded rhino and abandoned architectural anomalies. Despite this predilection for the alien, Goiris refuses the label 'Surrealist', preferring to describe his work as 'conceptual realism', exploring the bizarre within life. His interest in a collective consciousness is manifest in his exploration of how speed affects perception. Using long exposures to capture remote locations, Goiris states: 'I am interested in speed and stillness, and therefore time itself sometimes becomes the motif of a photo shoot.' Goiris coaxes the romance out of his landscapes to challenge the disquiet of his subjects, effectively restaging the trauma of the photograph. (BB)

Shown by Art : Concept G10, Galerie Catherine Bastide E12

Flower Arrangement
2007
Gouache on canvas
129.5×96.5cm
Courtesy Taka Ishii Gallery

Tomoo **Gokita**

Born 1969
Lives Tokyo

Tomoo Gokita first attracted the attention of the art world with his thick newsprint books of charcoal and ink drawings. His influences include 1950s' advertising, abstraction, soft porn and children's drawing, with allusions to traditional Japanese calligraphy. Recently Gokita has worked with black and white gouache on canvas, producing paintings such as *Mrs Drunko* (2006), which depicts a woman in a black négligé with what appears to be a pile of laundry in place of her head. The dense accumulation of abstract forms found in works such as *Bye, bye, baby* (2006) is reminiscent both of landfill sites and of the culture of channel hopping, reinterpreted as surreal monochromatic landscapes. (SL)

Shown by Taka Ishii Gallery G8

Selected Bibliography

2006 'Art in Revew: Tomoo Gokita', Roberta Smith, *The New York Times*

2005 'Stranger Town: Invading Genres Breach the Art World's Porous Borders', Roberta Smith, *The New York Times*

2001 *Oh Tengoku!*, Tomoo Gokita, Artbeat Publishers Inc., Tokyo

2000 *Lingerie Wrestling*, Tomoo Gokita, Little More Co., Ltd., Tokyo

Selected Exhibitions

2004 'Black Gainers', Art Zone, Kyoto

2003 'Oh! Tengoku', Nadiff, Tokyo

2000 'Lingerie Wrestling', Parco Gallery, Tokyo

Fromm
(Piously)
2007
Acrylic, graphite and tusche on
canvas
60×80cm
Courtesy Georg Kargl

Selected Bibliography

2005 *Evn Sammlung 95–05* (Evn
Collection 95-05), Edelbert Köb
and Thomas Trummer, Verlag
Walther König, Cologne

1998 *A visao austríaca* (The
Austrian Vision), MUMOK,
Vienna

1996 *Franz Graf, Herbert Brandl*,
Franz Graf, Herbert Brandl and
Patrizia Habsburg-Lothringen,
Vienna

1995 *Franz Graf*, Kunstverein,
Bonn

1994 *Franz Graf: W.C. Feminino,
W.C. Masculino* (Franz Graf:
Ladies' W.C., Men's W.C.), Franz
Graf, São Paulo Biennial

Selected Exhibitions

2006 Nylistasafnid - The Living
Art Museum, Reykjavik

2005 'Lovemydreams', Georg
Kargl, Vienna

1997 'The Austrian Vision',
Denver Art Museum; MUMOK,
Vienna

1995 Kunstverein, Bonn

1994 21st São Paulo Biennial

Franz **Graf**

Born 1954
Lives Vienna

The fact that the course Franz Graf teaches at the
Academy of Fine Arts in Vienna is entitled
'Extended Painterly Space' speaks volumes about
his interdisciplinary approach. His installations –
which interconnect and overlap various media,
including delicate, layered graphite drawings on
tracing paper, pen and ink wall texts, found
objects, and black and white photographs from his
archive – always have a direct relationship to their
environment and are more likely to appear in a
trendy fashion boutique or at a farmers' market
than in a gallery. Graf reassembles his materials to
create original narrative and associative connections
that deal with issues of language, ethics and
aesthetics in their political and social surroundings.
(AC)

Shown by Georg Kargl Fine Arts G16

*Cherries, Washington and North
Broad, New Orleans, 2006*
From the series 'A Shimmer of
Possibility'
2006
Colour coupler print mounted on
aluminium
Courtesy Antony Reynolds Gallery

Paul **Graham**

Born 1959
Lives New York

Distraction and displacement are at the vagrant heart of Paul Graham's photography. Influenced by the ravishment by colour in the work of William Eggleston, Graham confounded his first critics in the early 1980s by photographing dismal social security offices as formal, conceptual and documentary objects all at once. The uncertainties are still there in 'American Night' (2003): overexposed landscapes almost conceal lone figures in the distance; under-exposed street portraits show the poor retreating into shadow; only bright suburban homes are properly exposed. Graham mixes ideas, evidence and aesthetics to ambiguous ends. (BD)

Shown by galerie bob van orsouw C12, Anthony Reynolds Gallery F8

Selected Bibliography

2007 *A Shimmer of Possibility*, Paul
Graham, steidlMACK, London

2003 *American Night*, Paul
Graham, steidlMACK, London

1996 *Paul Graham*, Andrew
Wilson, Phaidon Press, London

1987 *Troubled Land*, Paul Graham,
Grey Editions, London

1986 *Beyond Caring*, Paul Graham,
Grey Editions, London

Selected Exhibitions

2004 Fundación Telefónica,
PhotoEspaña, Madrid

2003 'American Night', PS1
Contemporary Art Center, New
York

1995 'Empty Heaven',
Kunstmuseum, Wolfsburg

1993 'New Europe',
Fotomuseum, Winterthur

1979 Arnolfini, Bristol

Underworks
2007
Fireworks, polyurethane mould
Dimensions variable
Courtesy the artist and Yvon
Lambert

Selected Bibliography

2006 *End Extend*, Loris Gréaud
and Daniel Perrier, Editions HYX,
Orléans

2006 'Focus Paris', Sonia
Campagnola, *Flash Art International*,
249

2006 'Illusion is a Revolutionary
Weapon', Loris Gréaud, *Nuke*,
October

2006 'Illusion is a Revolutionary
Weapon', Francesco Stocchi,
Artforum, October

2006 'His Dark Materials', Skye
Sherwin, *ArtReview*, October

Selected Exhibitions

2007 'French May 2007', City
Hall, Hong Kong

2006 'Why is a Raven like a
Writing Desk?', Frieze Projects
Commission, Frieze Art Fair,
London

2006 'Devils Tower', Centre
Georges Pompidou, Paris

2005 'Silence Goes More Quickly
When Played Backwards', Le
Plateau - Frac Ile de France, Paris

Loris **Gréaud**

Born 1979
Lives Paris

Loris Gréaud's prolific and intriguing projects –
which have ranged from an electricity-generating,
three-hour solo drum set (*Silence Goes More Quickly
When Played Backwards*, 2005) to a mysterious, 11-
foot-high black mountain that was hauled by the
artist around the streets of Paris (*Devil's Tower*,
2006), and an underground fireworks
'display' (*Underworks*, 2007) – create parallel
universes of distorted perception and alternate
temporal flow filtered through the precision of a
scientific imagination. Collaborative without being
relational, Gréaud often works with architects,
writers, musicians and engineers in the
construction of his improbable artistic experiments.
(AS)

Shown by Yvon Lambert G5

PASSANGERS TO BE SEATED DURING THE VOYAGE

Passangers to be Seated During the Voyage
2007
Red text engraved on yellow Perspex plaque
42×34cm
Courtesy Galleria Sonia Rosso

Alice **Guareschi**

Born 1976
Lives Milan

Alice Guareschi is more interested in the temporal and physical spaces between things and images than in their actual construction. Her latest exhibition, 'Passangers to be Seated During the Voyage' (2007), transposes this conceptual procedure into three dimensions – the deliberate spelling mistake in the title hinting that the voyage is a mental rather than a physical one. A pile of books that cannot be opened, the white image of a labyrinth, a black and yellow spiral disk, and four little flags are hung or placed near a mirrored screen: the shattered fragments reflected in its surface hinder any straightforward reading of the signs. (VR)

Shown by Galleria Sonia Rosso A9

Selected Bibliography

2006 'In viaggio con Alice dalle Stelline a Parigi' (Travelling with Alice from the Stelline to Paris), Barbara Casavecchia, *La Repubblica*

2006 'Alice Guareschi', Marta Casati, *Flash Art Italia*, 257

2005 'Self-portrait', Alice Guareschi, *tema celeste*, September/October

2005 'Ouverture: Alice Guareschi' (Introducing: Alice Guareschi), Emanuela de Cecco, *Flash Art Italia*, 250

2005 'Il padiglione di sabbia e nebbia' (The Pavilion of Sand and Snow), Francesca Pasini, *Flash Art Italia*, 252

Selected Exhibitions

2007 'Passangers to be Seated During the Voyage', Galleria Sonia Rosso, Turin

2006 'Local Time at Destination', Centre Culturel Français, Milan

2005 'Objects Producing Interesting Shadows', Galleria Alessandro De March, Milan

2005 'The Final Cut', Palais de Tokyo, Paris

2005 'Aperto per lavori in corso', Padiglione Arte Contemporanea, Milan

Copan
2002
C-print
237×301cm
Courtesy Monika Sprüth
Philomene Magers

Selected Bibliography

2007 *Andreas Gursky*, ed. Thomas Weski, Haus der Kunst, Munich

2001 *Andreas Gursky*, Museum of Modern Art, New York

1998 *Andreas Gursky: Fotografien von 1984 bis heute* (Andreas Gursky: Photographs from 1984 to Today), Kunsthalle, Dusseldorf/ Schirmer & Mosel, Munich

1995 *Andreas Gursky: Images*, Tate Publishing, Liverpool

1994 *Andreas Gursky: Photographs*, Deichtorhallen, Hamburg/ De Appel Foundation, Amsterdam

Selected Exhibitions

2007 'Retrospektive 1984–2007', Haus der Kunst, Munich

2007 Monika Sprüth Philomene Magers, London

2001 The Museum of Modern Art, New York

1998 'Andreas Gursky: Photographs 1994–1998', Kunstmuseum, Wolfsburg

1998 'Andreas Gursky: Photographs from 1984 to the Present', Kunsthalle, Dusseldorf

Andreas **Gursky**

Born 1955
Lives Dusseldorf

Andreas Gursky's monumental colour photographs, rich in detail and often highly animated, offer an iconic representation of life under late capitalism, recalling in part the methodical approach of his teachers Bernd and Hilla Becher. Since the 1990s, Gurksy has trained his lens on industrial plants, hotel lobbies, parliaments, office buildings and other commercial and tourist sites, typically depicting them in sharp focus from a distant viewpoint. Whether it is the frenzied trading floor of an international stock exchange, the ecstatic revelries of late-night ravers or an almost unbelievably vast display of meticulously stacked consumer goods, the world Gursky represents is high-tech, fast-paced and well heeled, presenting us with an aesthetics of globalization. (AS)

Shown by Matthew Marks Gallery C5, Monika Sprüth Philomene Magers B10

Circle of Confusion
1997
Photographic print, repositionable glue, mirror
330×400cm
Courtesy the artists and CRG Gallery

Joana **Hadjithomas** & Khalil **Joreige**

Born 1969/1969
Live Beirut

The Beirut-based artists Joana Hadjithomas and Khalil Joreige navigate a city ravaged by war through the image of the ruin and its attendant nostalgia for another era. Using photography, film and video, the pair approach their subject through a range of genres, from fiction to documentary to appropriation. Snapshots taken by a man moments before his abduction and commercial photographs of tourist attractions from the 1960s, which have been manipulated to appear as though they've been bombed, become powerful indicators of the universal effect of war as well as its individual resonance. (SO'R)

Shown by CRG Gallery H5

Selected Bibliography

2007 'Joana Hadjithomas et Khalil Joreige exposant a la CRG de New York' (Joana Hadjithomas and Khalil Joreige on show at CRG New York), Sylviane Zehil, *L'Orient*, 10 May

2005 'Hysterical Repetition: Joana Hadjithomas and Khalil Joreige's A Perfect Day', Antonia Carver, *Bidoun*, Winter

2002 *Homeworks: A Forum on Cultural Practices in the Region*, Ashkal Alwan, Beirut

2002 *Fundamentalisms of the New Order*, Jean Charles Masera, Copenhagen

2002 'Tayyib Rah Farjik Shighil' (OK, I'll Show You My Work), *Magazine*, January

Selected Exhibitions

2007 'Circle of Confusion', CRG Gallery, New York

2007 'Whenever It Starts It Is The Right Time: Strategies for a Discontinuous Future', Kunstverein, Frankfurt

2007 'Ah, les belles images!', Fabienne Leclerc, Paris

2007 'Distorted Fabric', De Appel, Amsterdam

2006 'Out of Beirut', Modern Art, Oxford

After Eating Bad Horsemeat (macaroni style)
2006
Oil on canvas
37×47cm
Courtesy Sorcha Dallas

Charlie **Hammond**

Born 1979
Lives Glasgow

Faces and anthropomorphic features abound in Charlie Hammond's mixed-media practice, in which recognition seems chance-filled, canny and gratifying. Dark, inscrutable oil paintings become portraits by the simple addition of eyes or a mouth, or by the suggestion of a title, such as *Filmmaker (macaroni style)* or *Untitled (bread man)*, both from 2006. Cartoon faces are drawn over photographs, rendering the iconic as blobby caricature. Hammond's formidable work in ink on paper suggests visages of Francis Bacon-esque dread; the faces appear on the edge of slipping back into the marbled ink from which they emerged. (MG)

Shown by Sorcha Dallas F32

Rainer Werner Fassbinder
2007
Mixed media
170×230×85cm
Courtesy Greene Naftali

Rachel **Harrison**

Born 1966
Lives New York

How do you represent difference without making it a formal strategy? This is the question given and sustained by Rachel Harrison's brilliant and ungainly pieces, which she has been creating for the past 15 years. Her works sit somewhere between internally coherent sculpture and chaotic assemblages of found materials; they fold in images of Elizabeth Taylor, Ronald Reagan and Sigmund Freud alongside art-historical concerns – the difference between plinth-bound work and celebrity-conversant Pop art, for example. Harrison's work is never reduced to easy legibility or a quick-fix commentary on contemporary art: multiplying difference persists in each piece, shouting down the phone with its tetchy, sharp dissatisfaction. (MG)

Shown by Greene Naftali F4, Galerie Christian Nagel E3

Selected Bibliography

2007 'Rachel Harrison: If I Did It', Roberta Smith, *The New York Times*, 23 February

2006 'Just Past: Rachel Harrison's Lagerstatten', Johanna Burton, *Parkett*, 76

2005 'The Stuff: Rachel Harrison's Sculpture', Catherine Wood, *Afterall*, 11

2004 'Lakta/Latkas', John Kelsey, *Artforum*, November

2002 'Shelf Life', Saul Anton, *Artforum*, November

Selected Exhibitions

2007 'Voyage of the Beagle', Migros Museum, Zurich

2007 'If I Did It', Greene Naftali, New York

2006 'The Uncertainty of Objects and Ideas: Recent Sculpture', Hirshhorn Museum, Washington D.C.

2006 4th Berlin Biennial

2006 'Checking the Tyres, Not To Mention the Marble Nude', Galerie Christian Nagel, Cologne

Easily-removable people
2007
Acrylic on easily removable Scotch tape
Dimensions variable
Courtesy Galerie Fons Welters

Selected Bibliography

2007 'Shortlist Prix de Rome: Claire Harvey', Xandra de Jongh, *Kunstbeeld*, June

2005 *And It Looked Like This*, Wilma Süto, Galerie Fons Welters, Amsterdam

2004 'Stick to What You Know: Art by Claire Harvey', *TANK Magazine*, October

2004 'Een onbetaalbare ervaring' (A Priceless Experience), Sandra Smallenburg, *NRC Handelsblad*, 6 August

2004 'Claire Harvey at Store London', Chloe Kinsman, *tema celeste*, October

Selected Exhibitions

2007 'Easily Removable', Tate Modern, London

2007 'Prix de Rome', Witte de With, Rotterdam

2006 'Two Pictures and a Song', Store Gallery, Londen

2006 'Endless Summer', West London Projects, London

2005 'And It Looked Like This', Galerie Fons Welters, Amsterdam

Claire **Harvey**

Born 1976
Lives Amsterdam

Claire Harvey makes shadow installations using overhead projectors, and black and white drawings and paintings that are executed on a variety of supports, including easily removable Scotch Tape, Post-It notes, glass slides and transparencies. Her focus in all these works is on mundane scenarios and incidents that might easily be overlooked. In *Small Worlds* (2006), for instance, Harvey captures poignant details such as the tracks of a painted bird in miniature salt sand dunes and solitary figures lost in thought, while in the recent song 'Sorry' (2006) she sings about the demise of a fly on a wet canvas. (DE)

Shown by Store F31, Galerie Fons Welters G25

Grand Walk
2005
DVD projection
Courtesy Galerie Karin Guenther

Alexander **Heim**

Born 1977
Lives London

Alexander Heim mines the urban landscape for moments of poetic happenstance, reclaiming its detritus for ready-mades of simple and unexpected beauty. In *Untitled* (2006) five smashed car wing-mirrors, retrieved from the bottom of the River Thames in London and softened by the elements, are paraded as relics of an ancient civilization. In short videos such as *Grand Walk* (2005) and *Untitled* (2006) Heim artlessly trains his camera on nature's battle with urban sprawl, although images of a dog languishing in the middle of a busy road or of a gaggle of swans navigating a litter-strewn canal suggest the battle may already have been won. (AB)

Shown by doggerfisher G19, Galerie Karin Guenther G12

Selected Bibliography

2007 'Friedrich', Neil Mulholland, *ArtReview*, 8

Selected Exhibitions

2007 'Black & White', Ibid Projects, London

2007 'Inky Toy Affinitas', Cerealart, Philadelphia

2007 'Friedrich', doggerfisher, Edinburgh

2006 'Iduna Nova', Bibliothekswohnung, Berlin

2006 'Your Balance is £12.43', Fortescue Avenue/Jonathan Viner Gallery, London

Verse
2006
Crayon on paper
49×38cm
Courtesy Galerie Guido W.
Baudach

Thomas **Helbig**

Born 1967
Lives Berlin

Thomas Helbig makes unrecognizable the drab trappings of suburbia he discovers in flea markets. He smashes up and then recomposes innocuous garden ornaments and gnomes: the monstrously garbled busts that result, often manoeuvred towards coherence by coatings of gloss, evoke crude energies jittering within everyday civility. Subject to comparable overhaul are reproductions of Old Masters and what the artist calls '*Monarch of the Glen*-style portraits', faces blanked, blurred across abstraction's threshold by smudgy over-painting. Their bottomless blues and muted ochres recall European Romanticism; Helbig, you sense, is fashioning a vocabulary to accommodate huge and roiling forces that, although repressed, never went away. (MH)

Shown by Galerie Guido W. Baudach E20, China Art Objects Galleries E19, Galerie Rüdiger Schöttle E10

Selected Bibliography

2006 *Imagination Becomes Reality Part 4: From Rome to Rosenheim via Südseehausen: A Conversation with Thomas Helbig, Berlin, March 2006*, Katharina Vossenkuhl, Kunstverlag Ingvild Goetz, Munich

2005 *ROM: Thomas Helbig*, Berthold Reiß, Verlag H+K, Berlin

2004 *Sudseehausen: Leben im Stamm* (South Sea Houses: Life in a Tribe), Thomas Groetz, Verlag Heckler und Koch, Berlin

Selected Exhibitions

2007 'Homo Homini Lupus', China Art Objects, Los Angeles

2006 'Rings of Saturn', Tate Modern, London

2006 'Last World', Bortolami Dayan Gallery, New York

2005 Modern Art, London

2005 'Rom', Galerie Guido W. Baudach, Berlin

Adam **Helms**

Born 1974
Lives Tucson

Who could have predicted that the mythology of the American West would prove fertile ground for exploring the subversive appeal of extremist ideologies? In Adam Helms' eerily delicate graphite-and-gouache drawings, combatants in his fictional New Frontier Army pose almost genteelly – despite the horned buffalo masks many wear – as if for daguerreotypes. Helms' influences include Chechen rebel websites, heraldry, frontier art, iconic revolutionary images and wartime photojournalism. Some works depict structures resembling fortifications or sniper's nests, referencing the ragtag rebels' activities but also westward expansion and empire-building. *Untitled (48 Portraits)* (2006), a wall-size ink-on-Mylar grid that alludes to a Gerhard Richter work from 1971-2, offers a chilling gallery of hooded and masked faces. (KJ)

Shown by Marianne Boesky Gallery F7

Selected Bibliography

2007 'First Take', Bob Nickas, *Artforum*, January

2006 *Ordinary Culture: Heikes/Helms/McMillian*, Doryun Chong, Walker Art Center, Minneapolis

2005 'Fanciful to Figurative to Wryly Inscrutable', Holland Cotter, *The New York Times*, 8 July

2005 'On the Cover: Adam Helms', Lucy Raven, *Bomb*, Fall

2005 *Bridge Freezes Before Road*, Neville Wakefield, Barbara Gladstone Gallery, New York

Selected Exhibitions

2007 Marianne Boesky Gallery, New York

2007 'Rising Down', Sister, Los Angeles

2006 'Ordinary Culture: Heikes/Helms/McMillian', Walker Art Center, Minneapolis

2005 'You Are Here', The Ballroom, Marfa

2005 'Greater New York', PS1 Contemporary Art Center, New York

Que sepan todos
(Let Everybody Know)
2007
Cut red felt
Two parts: 160×125cm and
166×182cm
Courtesy Thomas Dane and
Sikkema Jenkins & Co.

Selected Bibliography

2007 *Arturo Herrera*, IKON Gallery, Birmingham

2007 'Arturo Herrera', Marcia E. Vetrocq, *Art in America*

2007 'Visions that Flaunt Cartoon Pedigree', Roberta Smith, *The New York Times*

2005 *Arturo Herrera*, Freidrich Meschede and Ingrid Schaffner, Centro Gallego de Arte Contemporánea, Santiago de Compostela

2002 *Vitamin P: New Perspectives in Painting*, Barry Schwabsky, Phaidon Press, London

Selected Exhibitions

2007 Thomas Dane Gallery, London

2007 IKON Gallery, Birmingham; Kettle's Yard, Cambridge

2005 DAAD Galerie, Berlin

2005 Centro Gallego de Arte Contemporánea, Santiago de Compostela

2001 'Hammer Project: Arturo Herrera', UCLA Hammer Museum, Los Angeles

Arturo **Herrera**

Born 1959
Lives Berlin/New York

Best known for mining the perverse morphology of Walt Disney cartoons, Arturo Herrera grounds his art in ambiguity, in works that range from dripping, cut-felt pieces to Rorschach-like, site-specific wall paintings. A series of recent large-scale collages draws on colouring-book images of a dwarf and an accordion-playing boy. Herrera had an illustrator render back-views of these characters and incorporated both sets of images into the works, conjuring the possibility of entering Pop-cultural spaces as though they were memories. Layered with patterned papers, lacy cut-outs and gestural marks, these works are unsettling palimpsests. In *58 BF5* (2006), for example, the boy partially assembles from collaged scraps like ghostly splinters against a smeary ground. (KJ)

Shown by Thomas Dane Gallery E1, Galleria Franco Noero A2

M.S,M.S
2006
Pigment and ink on canvas
51×46cm
Courtesy Friedrich Petzel Gallery

Charline **von Heyl**

Born 1960
Lives New York

Charline von Heyl's refined abstract canvases suggest an alert art-historical consciousness and an openness to painterly intuition and improvisation. In the past her compositions have included collage elements such as a gauze that, stuck over painted fields, mutes and veils the colour; in some works areas are over-painted in white, as though to suggest that the painted image's hold on a surface is tenuous or, at best, contingent. Her compositions unfold like a set of responses to visualized formal questions, the mental activity reflected directly in the vibrancy of her works' gaseous forms, taped and crossed lines and colour explosions. The painting *Lying Eyes* (2005), for instance, hurls vocal points and perspectives around the composition while painted threads connect abstract congestion points. (DE)

Shown by Galerie Gisela Capitain D11, Friedrich Petzel Gallery B2

Selected Bibliography

2006 'Der Länge Nach: Charline von Heyl' (Lengthwise: Charline von Heyl), Vito Acconci, *Texte Zur Kunst*, June

2006 'Sexism and the City', Jerry Saltz, *Modern Painters*, May

2005 *Concentrations 48: Charline von Heyl*, Suzanne Weaver, Dallas Museum of Art

2005 'Bold and Beautiful', Janet Kutner, *The Dallas Morning News*

2004 *Secession: Charline von Heyl*, John Kelsey, Secession, Vienna

Selected Exhibitions

2007 Galerie Gisela Capitain, Cologne

2006 Friedrich Petzel Gallery, New York

2006 'Make Your Own Life: Artists in and out of Cologne', Institute of Contemporary Art, Philadelphia

2005 Dallas Museum of Art

2004 Secession, Vienna

Fernand (Es regnet)
(Fernand (It's Raining))
2007
Cassette tape on canvas
270×184cm
Courtesy Galerie Almine Rech

Selected Bibliography

2007 'Kleb mir das Lied vom Tod' (Fix me to the Song of Death), Jan Kedves, *Monopol*

2006 *Unikate 0/6: 12 Statements aus Rheinland-Pfalz* (Unikate 0/6: 12 Statements for Rheinland-Pfalz), Kunstverein, Germersheim im Zeughaus

2005 *Jemand wird zuhören* (Someone Will Listen), Arsenal HKM1, Mainz/Galerie Pankow, Berlin

2003 *Dunst blauer Tage* (Blue Days Haze), Kunstverein, Eislinger

Selected Exhibitions

2007 'Zum Wohl der Tränen', Galerie Almine Rech, Paris

2007 'Dunkle Fahrt zu hellem Tag', Kunstverein, Ludwigshafen

2006 'B:1F-134', UBERBAU, Dusseldorf

2004 'Und dieses Wasser wird sich immer schwarz färben', Arsenal HKM1, Mainz

2003 'Dunst blauer Tage', Kunstverein, Eislingen

Gregor **Hildebrandt**

Born 1974
Lives Berlin

Gregor Hildebrandt's is an art of mirrors: black mirrors, to be precise. He hangs his works with strips of video and audio tape; the pristine and reflective (now also obsolete) substance may contain echoes of the image to which it is attached: Michelle Pfeiffer singing 'My Funny Valentine', for instance, or Isabella Rossellini performing the title song from David Lynch's *Blue Velvet* (1986). But we have to trust the image and the title: the glossy, unspoilt medium itself remains silent. At his most monumental, Hildebrandt drapes whole walls and even buildings with these blankly signifying strips, effecting a mute drapery that recalls the mourning livery of the 19th century. (BD)

Shown by Galerie Almine Rech G7

Übermass an Realität
(Excess of Reality)
2006
Mixed media
80×120×60cm
Courtesy Galerie Meyer Kainer

Siggi **Hofer**

Born 1970
Lives Vienna

Indeterminate spaces are the subject of Siggi Hofer's super-sized drawings and small-scale sculptures, which make liminal suburban plots and small provincial towns look like isolated experiments in urban planning. *Stadt IV (Der Knall)* (City IV (The Bang), 2005) is almost apocalyptic: outcrops of rock divide factory from tower block from shopping centre, as though an earthquake has fractured the regular layout of the land while leaving all the structures unscathed. Such unexpected topographical intrusions upset the harmony of Hofer's otherwise carefully composed works, giving a tantalizing glimpse of the artificial and imaginary, and of the instability at the core of all ordered society. (BB)

Shown by Galerie Meyer Kainer F2

Selected Bibliography

2007 *artcatalogue*, Hans-Peter Wipplinger, T-Mobile Austria/ art: phalanx, Vienna

2006 'Siggi Hofer: Preisträger des STRABAG Art Award' (Siggi Hofer: Winner of the STRABAG Art Award), Gerald Brod, *Vernissage*, June

2006 *Extension Turn*, Thomas Eller and Wolfgang Popp, Revolver, Frankfurt

2005 *Profiler*, Verena Kaspar and Christiane Krejs, Kunstraum Niederösterreich, Vienna

2003 *Panorama 03*, Marion Piffer Damiani and Letizia Ragaglia, Provincia Autonoma, Bolzano

Selected Exhibitions

2007 'I Forgot 1988', Meyer Kainer Gallery, Vienna

2006 'I'm Just a Girl Who Says What She Feels', Arge Kunst, Bolzano

2006 'Extension Turn 2', Eastlink Gallery, Shanghai

2005 'Profiler', Kunstraum NOE, Vienna; Kalin Studios, Prague

2005 'Weit und breit kein Ende', Gallery Eva Presenhuber, Zurich

Folk Music
2007
Fluorescent egg tempera, iron
oxide, lead antimonate, lead white,
ultramarine, gel, verdigris in oil on
board
91×62cm
Courtesy Annely Juda Fine Art

Sigrid **Holmwood**

Born 1978
Lives London

Sigrid Holmwood is as much an archivist as a visual
artist. Part of her project involves working with
historical re-enactors, principally those who adopt
the practices and authentic hand-stitched clothing
of 16th-century peasant life in an effort to combat
the mechanical nature of contemporary society.
Holmwood's equally historicist paintings employ
pre-industrial techniques and themes – her 16th-
century-derived genre scenes and 19th-century-
style landscapes are made with historical pigments
and period quill brushes – in a similarly ana-
chronistic gesture of resistance. Only her use of
fluorescent pigments acknowledges her inevitable
separation from the bygone world she painstakingly
invokes. (CG)

Shown by Annely Juda Fine Art G15

Selected Exhibitions

2006 'Past Times and Re-
creation', Transition, London

2006 'Self-sufficient', Forsterart
Space, London

2005 'The Jerwood Drawing
Prize', Jerwood Space, London

2004 'La Pittura Sale sugli Alberi',
42contemporaneo, Modena

2003 'Bloomberg New
Contemporaries', Cornerhouse,
Manchester

House Training #30
2006
Wool, leather, chicken wire,
wood, linen
64×114×84cm
Courtesy Galleria Massimo de
Carlo

Christian **Holstad**

Born 1972
Lives New York

Whether knitted, quilted, pasted, drawn, erased or produced through other methods, Christian Holstad's collages, installations, sculptures and performances are formally inventive and slyly anarchic. In 2003 Holstad, a Conceptualist and a connoisseur of textured nostalgia, exhibited reproductions of the images filed under 'Homosexual' in the New York Public Library's picture files. During a 2005 show in a Manhattan McDonald's, specially chosen juke-box songs played over the sound system. For *Leather Beach* (2006) Holstad blacked out a midtown deli's windows, stocking it with a delirious mix of hand-sewn S/M ephemera, deli staples and remnants of flower-child Utopianism. (KJ)

Shown by Galleria Massimo de Carlo F3, Daniel Reich Gallery F27

Selected Bibliography

2006 *Christian Holstad: The Terms of Endearment*, Museum of Contemporary Art, Miami

2006 'I Am An Outsider Who Got Let In', Maurizio Cattelan, *Flash Art International*, 251

2006 'The Ties That Bind', Christopher Bollen, *Artforum*, May

2004 *Dignity (Pressed Flowers)*, Christian Holstad and Steve Lafreniere, Snoeck-Ducaju/Zoon NV, Ghent

2004 'Christian Holstad', Christopher Miles, *frieze*, 85

Selected Exhibitions

2007 9th Lyon Biennial

2006 'The Terms of Endearment', Museum of Contemporary Art, Miami

2005 'The Area Known as The Grassy Knoll', Galleria Massimo de Carlo, Milan

2004 'A Dark Room in which to Stagger Sorrow', Whitney Biennial, New York

2004 'Gaity: Discovering the Lost Art (in Absentia)', Kunsthalle, Zurich

Riesen
(Giants)
2007
Styrodur, polyurethane-rubber,
horse hair, clothes, leather
300×100×80cm (edition of 3)
Courtesy Johnen + Schöttle

Selected Bibliography

2006 *Under cover/Aus dem Verborgenen*, Ulrike Groos, Georg Imdahl and Beate Sontgen, Verlag Walther König, Cologne/Kunsthalle, Dusseldorf

2004 *Martin Honert*, Verlag Walther König, Cologne/Matthew Marks Gallery, New York

1995 *Fliegendes Klassenzimmer* (Flying Classroom), Hatje Cantz Verlag, Ostfildern Ruit

1994 *Martin Honert*, Jean-Christophe Ammann, Museum für Moderne Kunst, Frankfurt

Selected Exhibitions

2007 Staatliche Kunstsammlungen, Dresden

2006 'Under Cover - aus dem Verborgenen', Kunsthalle, Dusseldorf

2005 Landesmuseum für Kunst, Munster

2002 Kunstverein, Hanover

2001 Johnen + Schöttle, Cologne

Martin **Honert**

Born 1953
Lives Dusseldorf/Dresden

Wandering among Martin Honert's works is like returning to a lost childhood memory. Working from his own recollections and dreams, the artist creates scale models of these unconsciously spawned apparitions. With a meticulous sense of craft and a patient, laborious production process, Honert produces installations, such as *A Model Scenario of the Flying Classroom* (1995), that commingle the workings of his own mind with widely recognizable images from Western culture. It is this that simultaneously repels us from and attracts us to the strange monstrous presences in his work: Honert's sculpture has a fidelity to reality that touches us and, although it is born of someone else's thoughts, in its presence we are seduced into its hallucinatory constellation. (CB)

Shown by Johnen Galerie Berlin/Cologne F10, Matthew Marks Gallery C5

Joy Eslava. Calle Arenal, Madrid.
Diciembre, 2006
2007
Cartoon for tapestry, ink print on
canvas
400×500cm
Courtesy the artist and Frith Street
Gallery

Craigie **Horsfield**

Born 1949
Lives London

Craigie Horsfield considers the photograph not as a
window but as a surface 'as vulnerable as skin'. His
evocative black and white photographs of scenes
from his life in the cities of London, Kraków and
Barcelona are both tender and corporeal, as are his
recent colour prints of rotting fruits and flowers.
Horsfield's interest in 'slow time' underpinned
both the intensely laborious printing process of his
early large-scale photographs and his deliberate
delay (of months or years) between taking
photographs and developing the film. Since the
mid-1990s he has worked on several collaborative
projects, such as the film *El Hierro Conversation*
(2002), which documents numerous discussions
with the inhabitants of the smallest of the Canary
Islands. (SL)

Shown by Frith Street Gallery C1

Selected Bibliography

2007 'Intimate Relations',
Sebastian Smee, *The Australian*, 7
April

2007 'La fotografía recupera al
individuo en la masa' (Photography
finds the individual in the crowd),
Javier Rodríguez Marcos, *El Pais*, 6
February

2006 *Craigie Horsfield: Relation*, ed.
Catherine de Zegher, Jeu de
Paume, Paris/ Fundação Calouste
Gulbenkian, Lisbon/ Museum of
Contemporary Art, Sydney

2004 'The Dilation of Attention',
Carol Armstrong, *Artforum*, January

1997 *La ciutat de la gent* (The City
of People), Manuel J. Borja-Villel
et al., Fundació Antoni Tàpies,
Barcelona

Selected Exhibitions

2007 'Relation', Museum of
Contemporary Art, Sydney

2007 'On History', Foundation
Santander, Madrid

2006 'In the Face of History',
Barbican Art Gallery, London

2004 Whitney Biennial, New
York

First Light
2006
Tuf-cal hemp, iron, clay, graphite
155×112×147.5cm
Courtesy The Modern
Institute/Toby Webster

Selected Bibliography

2007 'Jeder Penny für die
Kunst' (Every Penny for Art),
Daghild Bartels, *Parnass*, January

2007 'Future Greats: Thomas
Houseago', Skye Sherwin,
ArtReview, March

2006 'Place Matters: Los Angeles
Sculpture Today', Anne Rochette
and Wade Saunders, *Art in America*,
November

2005 *Both Ends Burning*, David
Kordansky Gallery, Los Angeles

Selected Exhibitions

2007 The Modern Institute,
Glasgow

2007 'Personal Belongings:
Contemporary Sculpture from Los
Angeles', Sabine Knust Galerie
Maximilian Verlag, Munich

2005 'Both Ends Burning', David
Kordansky Gallery, Los Angeles

2003 'I Am Here: Selected
Sculptures 1995–2003', S.M.A.K.,
Ghent

2002 'Amy Bessone & Thomas
Houseago', Xavier Hufkens,
Brussels

Thomas **Houseago**

Born 1972
Lives Los Angeles

Thomas Houseago's allegorical sculptures accrue
through the careful yet expressionistic use of
materials such as plaster, plywood, hemp, jute, steel
and graphite. From one vantage point his often
pale and usually masculine figures may appear
almost classical. From another perspective the
deliberately unfinished nature of their anatomies is
revealed. *Sitting Nude* (2006) is missing its head,
while one hand and one foot have been left
flipper-like, the pencil outline of the fingers and
toes traced but not yet dug out. The body of his
Standing Boy (2006) has also been half-coaxed into
being – the figure leans on undefined limbs, clad in
frozen drips of plaster, curiously lifelike in his
incompletion. (SL)

Shown by Herald St F1, David Kordansky
Gallery F22, The Modern Institute/Toby Webster
B11, Galerie Fons Welters G25

Mythography's boates #3
2007
120×80cm
Courtesy L'appartement 22 and the artist

Chourouk **Hriech**

Born 1977
Lives Marseille/Rabat

One of Chourouk Hriech's titles, *La nature n'aime pas le vide* (Nature Abhors A Vacuum, 2006), reveals much about the artist's approach to image-making. Her agglomerations of pictorial elements seem simultaneously to coalesce and to explode, creating carnivals of historical, geographical and personal reference points. Animals, folk costumes, ships and flags gather in the urban landscapes of the series 'Maroc' (Morocco, 2007), a body of work that reflects the frictional energy of contemporary Moroccan street life. Hriech's use of monochrome pen or gouache suits her paradoxically tidy graphic style, flattening the jumble of imagery and introducing a contemplative slowness, which in recent collages she juxtaposes with the instantaneity of photographs, on which the drawings float. (JG)

Shown by L'appartement 22 F34

Selected Bibliography

2005 'Chourouk Hriech', *Revue Mouevement*, January/February

2004 *Rendez-vous 2004*, Musée d'Art Contemporain, Lyon

2004 *The Pink Book*, Chourouk Hriech, Edition Villa St Clair, Sète

2003 *Les enfants du sabbat 4* (The Children of Sabbath 4), Pascal Beausse et al., Le Creux de l'Enfer, Thiers

Selected Exhibitions

2007 'Bendir: L'eau à la bouche', L'appartement 22, Rabat

2007 'La vitrine no.12', Villa St Clair, Sète

2007 'Projets Dessins', l'appartement 22, Rabat

2006 'Las cabras e las palabras', Can Filippa, Barcelona

2005 'Sliding/Lightning', Ateliers d'Artistes de la Ville de Marseille,

Thursday (Monte Pascoal, Brazil)
2005
Lambda print and blue fluorescent
tubes
180×300cm
Courtesy the artist and Max
Wigram Gallery

Marine **Hugonnier**

Born 1969
Lives London

Best known for her 'Three Continents' trilogy (*Ariana*, 2003; *The Last Tour*, 2004; *Travelling Amazonia*, 2006), in which she used 16 mm film to explore the social and physical singularities of places and the ethics of cinema, Marine Hugonnier recently shifted her focus to how real time impacts on still images. Her *Restoration Project* (2006) recreated an atelier in which a genuine restorer tended to damaged original landscape paintings from as early as the 17th century. This process, which sought not to make the works new but to imbue them with another layer of time and another narrative dimension, seems to sum up perfectly Hugonnier's approach to the places she films. (VR)

Shown by Max Wigram Gallery G20

Selected Bibliography

2007 'Double Feature', Celia McGee, *Elle Decor USA*, January

2006 'Keeping Distance', Martin Herbert, *Artforum*, September

2005 'Marine Hugonnier', Katerina Gregos, *Flash Art International*, 243

2003 'Best of 2003', Pamela M. Lee, *Artforum*, December

2003 'Marine Hugonnier', Mark Godfrey, *frieze*, 76

Selected Exhibitions

2007 S.M.A.K., Ghent

2007 Fondazione Sandretto Re Rebaudengo, Turin

2007 Museum of Art, Philadelphia

2007 Kunsthalle, Bern

2007 Musée d'Art Moderne et Contemporain, Geneva

Bright Eyes
2006
Acrylic on canvas
50×60.5cm
Courtesy Private Collection, New York

Thomas **Hylander**

Born 2007
Lives London

Thomas Hylander's stained and sparely detailed canvases are almost archaeological in their ambition to delve into the past, exhuming images from memory. In *Wallflower and Ornaments* (2006) the spectres of barely visible objects hover at the brink of decay or disappearance, with paint daubed on or scratched out to reveal the layered process of the piece's creation. Hylander's whimsical, quixotic search for lost time finds glimpses of wonder in the murk of memory. (ST)

Shown by Vilma Gold G26

Selected Exhibitions

2005 'It's Always Been Like That', Framework Gallery, London

2005 'London in Zurich', Hauser & Wirth, Zurich

2004-5 'Bloomberg New Contemporaries', Barbican Art Gallery, London

2004 'Lost and Found', Chambers Gallery, London

In a World Like This
2007
Light jet print on fuji crystal paper,
mounted on aluminium
100×187cm
Courtesy Kerlin Gallery

Selected Bibliography

2007 'In a World Like This',
Aileen Blaney, *Circa*, 119

2007 'Cooling Out', Caoimhin
Mac Giolla Leith, *frieze*, 105

2006 *Subjective Affinities...*, Declan
Long, Douglas Hyde Gallery,
Dublin

2005 *Dialogues: Women Artists from
Ireland*, Katy Deepwell, IB Tauris
& Co. Ltd., London

Selected Exhibitions

2006 'In a World Like This',
Model Arts and Niland Gallery,
Sligo

2005 'The Silver Bridge', Irish
Museum of Modern Art, Dublin

2005 'The Paradise', Douglas
Hyde Gallery, Dublin

2005 'Plans for Forgotten Works',
Henry Moore Institute, Leeds

2001 'Ivana's Answers', Delfina
Project Space, London

Jaki **Irvine**

Born 1966
Lives Dublin

There is a space between meaning and
comprehension that mainstream films try to ignore.
This, however, is precisely the space that Jaki
Irvine is interested in. Her seductive 16mm films
employ montage, voice-over and music to
approximate meaning, which the viewer cannot
resist attempting to complete. We try to make
sense of abstracted situations – a man meeting his
older self, a woman singing a love song to her dog,
the luminous dance of fireflies – as we would
optimistically speculate on the character of a new
lover. In this sense Irvine's slippages between
knowledge and anticipation are pure romanticism.
(SO'R)

Shown by Frith Street Gallery C1, Kerlin Gallery
E11

Empty C
2006
Graphite on paper
34×27.5cm
Courtesy Corvi-Mora

Colter **Jacobsen**

Born 1975
Lives San Francisco

Colter Jacobsen trawls the streets for lost photographs and discarded writings that speak of the sadness attending the tawdry business of desire. The 'Woods in the Watchers' series (2003) consists of 24 drawings of watch-wearing men reproduced from personal ads and vintage erotica. Created on used envelopes and other found ephemera, these works explore the delights of illicit passion and how easily it can be forgotten: Jacobsen allowed himself only one hour to draw each piece. As with the comic strips that the artist partially covers with correction fluid, Jacobsen's melancholic work wonders whether immediate gratification can ever be satisfactorily recalled or reconstructed. (ST)

Shown by Corvi-Mora E4, Jack Hanley Gallery A8

Selected Bibliography

2006 'Your Future', Johnny Ray-Huston, *San Francisco Bay Guardian*

2005 'Even a Little Space Can Hold an Abundance of Ideas', Roberta Smith, *The New York Times*

Selected Exhibitions

2007 Jack Hanley Gallery, San Francisco

2006 Corvi-Mora, London

2006 'Your Future', 4 Star, San Francisco

2005 'Open Walls', White Columns, New York

Painting
2006
Gouache on hemp
180×143cm
Courtesy White Cube/Jay Jopling

Selected Bibliography

2006 *La chambre de la peinture* (The Painting Room), White Cube/Jay Jopling, London

2006 'Pattern Recognition', Lisa Pasquariello, *Artforum*, Summer

2005 'Sergej Jensen at Galerie Neu', Arden Reed, *Art in America*, May

2003 *Sergej Jensen – Stefan Muller*, Karola Grasslin, Kunstverein, Brunswick

2002 *Urgent Painting*, Laurence Bosse, Musée d'Art Moderne de la Ville/ARC, Paris

Selected Exhibitions

2007 'Nomadic bags and bag faces', Douglas Hyde Gallery, Dublin

2006 4th Berlin Biennial

2006 'La chambre de la peinture', White Cube, London

2006 'Day for Night', Whitney Biennial, New York

2004 Galerie Neu, Berlin

Sergej **Jensen**

Born 1973
Lives Berlin

Sergej Jensen's canvases, such as a wavering grid of sewn-together, recycled linen money bags (*Tower of Nothing II*, 2004) or fabric covered with chemical stains and crudely painted marks, are bare and visually reticent. Titled with irony and self-deprecating wit – such as *Halbes Gehirn* (Half a Brain, 2003), a composition consisting of a semi-circle painted on raw cloth – they subscribe to a subversive meagreness. Jensen's works demand nothing more than attention to detail and nuance, while impurities and a controlled messiness or grubbiness lend his formalism grit. Unperturbed by painting's past and with a knowingly ambivalent attitude towards the present, his work is just as concerned with reframing as with image. (DE)

Shown by Galerie Neu B4, White Cube/Jay Jopling F13

Seven Intellectuals
(detail)
2007
Mineral pigments and ink on
mulberry paper
193×132.7cm
Courtesy Zeno X Gallery

Yun-Fei **Ji**

Born 1963
Lives New York

Although they seem to mimic the contemplative
qualities of traditional Chinese landscape painting,
Yun-Fei Ji's works on paper are rife with historical
turbulence and upended lives and draw on varied
aesthetic sources. Many works, including the series
'The Empty City' (2002–3), allude to the
catastrophic results of the Three Gorges Dam
project, which is sweeping away ancient
communities along the Yangtze River, displacing
thousands. Ji produces scroll-like, stratified
panoramas in a pale, carefully keyed palette,
creating transparent and opaque layers with ink
washes and coloured pigment on mulberry paper.
Ghosts and skeletons haunt the living in
apocalyptic, elegantly detailed, sometimes
ghoulishly humorous scenes. (KJ)
Shown by Zeno X Gallery B3

Selected Bibliography

2007 'Water Colored: Demons
and Detritus in Yun-Fei Ji's
Restive Landscapes', Francine
Prose, *Modern Painters*, March

2006 *Vitamin D: New Perspectives
in Drawing*, Emma Dexter, Phaidon
Press, London

2004 *Yun-Fei Ji: The Empty City*,
Shannon Fitzgerald, Contemporary
Art Museum, St Louis

2003 'Yun-Fei Ji: Moral Vistas',
Robert Knafo, *Art in America*

2003 *The Old One Hundred Names*,
Sarah Schmerler, Pratt Institute,
New York

Selected Exhibitions

2005 'Great news comes from the
collective farm', Zeno X Storage,
Antwerp

2004 'The Empty City',
Contemporary Art Museum, St
Louis

2004 'The East Wind', Institute of
Contemporary Art, Philadelphia

2003 'The Old One Hundred
Names', Zeno X Gallery, Antwerp

2002 Whitney Biennial, New
York

City on a Bombshell
2006
Mixed media on bombshell
37×122×38cm
Courtesy PKM Gallery

Selected Bibliography

2005 *Secret Beyond the Door*, Sun Jung Kim et al., Korean Pavilion, 51st Venice Biennale, Seoul

2005 'Festive Venice', Walter Robinson, *Artnet.com*

2003 'Asian Art Now', Fumio Nanjo, *Art Asia Pacific*, 37

Selected Exhibitions

2007 'Fast Break', PKM Gallery, Beijing

2006 'Bêtes de style', Musée de Design et d'Arts Appliqués Contemporains, Lausanne

2005 Korean Pavilion, 51st Venice Biennale

2005 'J'en rêve/Dream on', Fondation Cartier pour l'Art Contemporain, Paris

2004 'Aewan', PKM Gallery, Seoul

Ham Jin

Born 1977
Lives Seoul

Ham Jin credits the discovery of his preferred medium to the lonely hours he spent as a latchkey kid whiling away the time sculpting tiny figurines out of the clay earth. His minuscule anthropomorphic creatures – no bigger than the size of a fingernail – are developed from such mundane stimuli as a dead insect or a piece of chewed gum and turned into tiny marvels. His world is chaotic, passionate, grotesque, visceral and sometimes horrific; his microscopic figures make love, fight and generally mirror our own existence, aping and satirizing us, the crude Swiftian giants of Brobdingnag. (AC)

Shown by PKM Gallery G2

Still from Animated Video, Mill Office Scene
2007
Mixed media on canvas
66×81.5cm
Courtesy Nicole Klagsbrun Gallery

Ezra **Johnson**

Born 1975
Lives New York

Animation is the technical definition of Ezra Johnson's work, but it's not the most accurate. The artist is a painter turned animator: in his films static imagery jerks unsteadily into motion, cuts are quick, the aesthetics lo-fi and the subjects – an art heist in New York, a hunting expedition in the Hudson River Valley – smack of corruption, violence and stale genre plots. In a heady *mise en abyme* of film perspective, *What Visions Burn* (2006) depicts CCTV footage of burglars stealing paintings from a museum. The theft of painting: there is no better description of Johnson's practice than that given by his own film. (MG)

Shown by Nicole Klagsbrun Gallery E23

Selected Bibliography

2007 'Motion Pictures: Ezra Johnson', Shana Nys Dambrot, *ArtReview*

2007 *Ezra Johnson*, Jan Tumlir, UCLA Hammer Museum, Los Angeles

2006 'Ezra Johnson at Nicole Klagsbrun', *The New Yorker*

Selected Exhibitions

2007 Franklin Art Works, Minneapolis

2007 'What Visions Burn', UCLA Hammer Museum, Los Angeles

2006 'What Visions Burn/What Birds Remember if They Do Remember', Nicole Klagsbrun Gallery, New York

2006 Kantor Feuer, Los Angeles

2004 'Salad Days', Artists Space, New York

Watercolour of Endless Ice Sculpture
2007
Watercolour on paper
35.5×25.5cm
Courtesy Taxter & Spengemann

Selected Bibliography

2007 *The World is Round*,
Rochelle Steiner, The Public Art
Fund, New York

2006 'Focus on Los Angeles',
Sonia Campagnola, *Flash Art
International*, 246

2006 'Matt Johnson at Blum &
Poe: Daring to Tread on the Turf
of a Master', Christopher Knight,
The Los Angeles Times, 6 October

2005 *The Uncertain States of
America*, Hans Ulrich Obrist,
Daniel Birnbaum and Gunnar
Kvaran, The Astrup Fearnley
Museum for Modern Art, Oslo

2004 'An Artist Worms into Some
Nicely Dicey Territory', Jerry
Saltz, *The Village Voice*, 6 April

Selected Exhibitions

2007 'All About Laughter: Humor
in Contemporary Art', The Mori
Art Museum, Tokyo

2006 'The World is Round', The
Public Art Fund at MetroTech,
Brooklyn

2005 Taxter & Spengemann, New
York

2005 'Uncertain States of
America', The Astrup Fearnley
Museum of Modern Art, Oslo

2005 'Thing', UCLA Hammer
Museum, Los Angeles

Matt **Johnson**

Born 1978
Lives Los Angeles

Matt Johnson's *Breadface* (2004), a painted, cast-plastic crust of bread containing bite holes portraying a crude face, was received with such acclaim and inspired so many associations that the artist seemed almost to have reinvented Proust's madeleine. Historical and pop-cultural references mingle in works such as *Magic Eye* (2006), an 'all-over' acrylic painting composed of minuscule fragments of Michelangelo's *Creation of Adam* (c. 1511) that merge into a whole if you stare at the canvas long enough, or in his *Pietà* (2006), made out of cast-bronze silencers, exhaust pipes and wheel rims. Johnson shows what can be gleaned from the prosaic everyday, if you take time to look. (VR)

Shown by Taxter & Spengemann F19

Pedestrian
2007
Wood dowels, acrylic paint, wood
glue and steel
190.5×183×48cm
Courtesy Guild & Greyshkul

Ryan **Johnson**

Born 1978
Lives Brooklyn

Ryan Johnson crafts his life-size caricatured figures from painted pieces of paper, which are pasted together and held upright by wire scaffolding. *Brainstorm* (2005), for instance, is a sculpture of a slacker with untied shoelaces and wrinkled blue jeans standing tentatively on crumpling paper legs. Out of his head comes a funnel of wires with a tornado of torn and wind-blown papers caught within it. Often the fragility of Johnson's materials suggests his subjects' lack of self-confidence – as with the dazed man clutching his television remote in *Ghosting* (2005). The artist's most recent works reveal more black humour: a cat mesmerized by a television screen and, in *Cart* (2006), a spearheaded shopping trolley. (CL)

Shown by Guild & Greyshkul F19

Selected Bibliography

2006 'The Launch of Spaceship Columbia', Jessica Kraft, *contemporary*, 76

2005 'Higher Learning', Jenny Comita, *W Magazine*, March

2005 'Ryan Johnson and Aaron Spangler', *The New Yorker*

2005 'New Paper Sculpture', Merrily Kerr, *Art on Paper*, March/April

2005 *Greater New York*, Klaus Biesenbach, PS1 Contemporary Art Center/Museum of Modern Art, New York

Selected Exhibitions

2007 Kantor Feuer, Los Angeles

2007 Franco Soffiantino Arte Contemporanea, Turin

2006 '2006 Untitled (For H.C. Westermann)', The Contemporary Museum, Honolulu

2005 'Greater New York', PS1 Contemporary Art Center, New York

Spectral Poster (Evocation)
2007
Spray-paint on silkscreen print
102×72cm
Courtesy Wilkinson Gallery

Jacob Dahl **Jürgensen**

Born 1975
Lives London

Jacob Dahl Jürgensen puts formal investigations to the use of spiritualism. *Sigil Tag Placard (Green Triangle)* (2007), a black and white screen-printed poster of a performer, is transformed by Constructivist-style triangles of spray paint – two white and one green – which appear to hover on the surface of the work. A similarly sparing use of colour is extended to sculpture. *Folly (The Mysticals' Sphere)* (2006–7) consists of dimly lit, coloured light bulbs artfully draped on a geometric structure made from copper piping. In Jürgensen's hands what might otherwise look like re-constructions of Modernism appear as relics of an unspecified cult that discovered the true function of form. (BB)

Shown by Wilkinson Gallery E15

Selected Bibliography

2007 'Jacob Dahl Jürgensen's "Folly of the Mysticals"', Lupe Núñez-Fernández, *The Saatchi Gallery*, March

2007 'Jacob Dahl Jürgensen', Gabriel Coxhead, *Time Out*, April

Selected Exhibitions

2007 'The Folly of the Mysticals', Wilkinson Gallery, London

2007 'Curacion Geometrica', The Approach, London

2007 Rudiger Schöttle, Munich

2007 croy nielsen, Berlin

A Vicious Undertow
2007
Black and white Super-16mm film
transferred to DVD
Courtesy Galleri Christina Wilson

Jesper **Just**

Born 1974
Lives Copenhagen

Often conceived in trilogies, Jesper Just's short, polished opera–videos flirt with overwrought emotion and unrequited affairs. They track *noir*-ish, highly mannered scenarios – an arboretum, a courtroom and a roof-top, for example, in the case of *It Will All End in Tears* (2006) – in which a perpetually indecipherable relationship unfolds between a younger man (regularly played by the actor Johannes Lilleore) and older men. Just does not give his *dramatis personae* an easily intelligible theatric purpose; instead he sets up a crossfire of half-lit affiliations, stolen glances and loose ends. (MA)

Shown by Galleri Christina Wilson F26

Selected Bibliography

2006 'Jesper Just: Love, Desire and Impersonation', Ronald Jones, *frieze*, 100

2006 'Jesper Just: It Will All End in Tears', Jeffrey Kastner, *The New York Times*

2006 'Jesper Just', Jan Avgikos, *Artforum*, December

2006 'New York Tales: Chain Reactions', Andrea Bellini, *Flash Art International*, 246

2005 'Jesper Just', Michael Wilson, *Artforum*, March

Selected Exhibitions

2007 Miami Art Museum

2007 Kunsthalle, Vienna

2007 S.M.A.K., Ghent

2007 Witte de With, Rotterdam

2006 'Jesper Just: Something to Love', Stedelijk Museum, Amsterdam

Ada
(detail)
2004
Oil on canvas on board
244×86cm
Courtesy Timothy Taylor Gallery

Selected Bibliography

2005 'The Originals: Portraits for W', Alex Katz, *W Magazine*, 33

2005 *Alex Katz: Recent Paintings*, Fernando Huici and Vincent Katz, Centro de Arte Contemporáneo, Málaga

2003 *Alex Katz: Portraits*, Massimiliano Gioni, Vincent Katz and Angela Vettese, Fondazione Bevilacqua La Masa, Venice

2002 *Alex Katz: Small Paintings 1951-2002*, Timothy Taylor Gallery, London

1997 *Alex Katz: Twenty-five Years of Painting*, David Sylvester, The Saatchi Gallery, London

Selected Exhibitions

2007 Irish Museum of Modern Art, Dublin

2007 The Langen Foundation, Neuss

2006 'Alex Katz Paints Ada: 1957–2005', Jewish Museum, New York

2005 Centro de Arte Contemporáneo, Málaga

2004 Timothy Taylor Gallery, London

Alex **Katz**

Born 1927
Lives New York

In front of an Alex Katz painting, one forgets about his importance as a pioneer reconciler of abstraction and figuration, and the fact that he's inspired generations of artists – particularly the current one. Katz absorbs viewers in refinements of detail, nuance and mood: a smudge for a wearied eye's under-shadow; microscopic crimson blats curving a mouth's corners into reflective amusement; half a dozen mobile marks for saplings baroquely swaying in the upstate New York wind. This could be shockingly bourgeois stuff. It isn't, ever, thanks to Katz's consistent feel for irony and his gift for reducing reality to a few deft strokes. (MH)

Shown by Jablonka Galerie D1, Galerie Thaddaeus Ropac B12, Timothy Taylor Gallery G9

First Picture For a Show
2007
C-print
35×39cm
Courtesy Johann König

Annette **Kelm**

Born 1975
Lives Berlin

Annette Kelm treats portraits as though they were still lifes, and vice versa. A photographic portrait from 2007 of fellow artist David Lieske shows the latter posing with an umbrella; his expression is affectedly cool, yet in order to fit within the undersized frame of yellow background paper that Kelm has fixed to the wall he is obliged to crouch awkwardly, reduced to little more than a compositional element. By contrast, in an untitled work from 2005, a jute bag bearing the logo of a tourist steamboat, the *American Queen*, is set against a uniformly white background, as though allowing it to reveal its 'personality', its kitsch evocation of a Mark Twain South. Kelm bends the chain of linear representation into a garland of innuendo. (JöH)

Shown by Johann König D13

Selected Bibliography

2006 'Annette Kelm', Jessica Morgan, *ArtReview*, 4

2006 'Hawaii: ein Wunschbild' (Hawaii: an Ideal), Catrin Lorch, *Weltkunst Contemporary*, 3

2006 *Vitamin Ph: New Perspectives in Photography*, T.J. Demos, Phaidon Press, London

2006 *Annette Kelm: Errors in English*, Sabeth Buchmann, Michaela Meise and Jessica Morgan, König Books, London

2006 *Annette Kelms diskrete Kosmologien* (Annette Kelm's Discrete Cosmologies), Walead Beshty, Kunstverein, Hamburg

Selected Exhibitions

2007 Johann König, Berlin
2007 Marc Foxx Gallery, Los Angeles
2007 'Made in Germany', Sprengel Museum, Hanover
2006 'Gold Standard', PS1 Contemporary Art Center, New York

August Maria
2003
Oil on linen
250×200cm
Courtesy Galerie Paul Andriesse

Selected Bibliography

2007 *Natasja Kensmil: Hell's Angels*, Dominic van den Boogerd, Galerie Paul Andriesse, Amsterdam

2005 *Into Drawing: Hedendaagse Nederlandse Tekeningen* (Into Drawing: Contemporary Dutch Drawings), Arno Kramer, PS Items, Harderwijk

2003 *Natasja Kensmil: Universal Souvenir*, Ernst van Alphen, Boekhandel Broekhuis, Hengelo

2003 *Natasja Kensmil*, Rudi Fuchs, Philip Morris Holland B.V., Amstelveen

Selected Exhibitions

2007 'Sister Sledge: Marlene Dumas, Natasja Kensmil, Antonietta Peeters', Lieu d'Art Contemporain, Sigean

2006 'Singer 50 Years', Singer Museum, Laren

2006 'Into Drawing', Institute Néerlandais, Paris

2005 'Territoria', Centro per l'Arte Contemporanea Luigi Pecci, Prato

2003 Cobra Museum, Amstelveen

Natasja **Kensmil**

Born 1973
Lives Amsterdam

Natasja Kensmil's art has been described as a kind of exorcism. In her paintings and drawings she disinters imagery relating to dark corners of European history, then reburies it under scruffily impastoed surfaces or cages it behind bars of ink. The spectre of Tsar Nicolas II raises its head in a number of her recent works, as do hooded figures that bring to mind both the Ku-Klux-Klan and the prisoners of Abu Ghraib, as in *Desperate Land* (2004). Even her pastoral scenes, featuring swaying cypresses and winding streams, seem haunted by the threat of tragedy, hinting that the evils of the past are still lurking behind the trees. (JG)

Shown by Galerie Paul Andriesse H8

Home Climate Gardens: Launderette
2004
Inkjet on paper
83×118cm
Courtesy Galerie Karin Guenther

Janice **Kerbel**

Born 1969
Lives London

Janice Kerbel's mellifluous radio play *Nick Silver Can't Sleep* (2006) is the outcome of many months' research into insomnia. Findings from academic investigation and individual case studies, compressed into a swooning dialogue between nocturnal plants, convey the frustrating, enervating, even psychotic, depths of sleeplessness. Such expressions of desire recur throughout Kerbel's work. *15 Lombard Street* (2001), for instance, was an exhaustive manual on how to rob a particular branch of Coutts & Co. But, whether she's envisaging a bank job, a garden for agoraphobics, an imaginary Pacific island or a good night's sleep, Kerbel finds a form for each proposition that is never sullied by becoming physical fact. (SO'R)

Shown by Galerie Karin Guenther G12

Selected Bibliography

2007 'Nick Silver', Sally O'Reilly, *frieze*, 104

2007 *Deadstar*, Locus+, Newcastle

2006 'Nick Silver', Lucy Steeds, *Art Monthly*, December

2006 'Janice Kerbel', Mark Godfrey, *Artforum*, January

2000 *15 Lombard Street*, Bookworks, London

Selected Exhibitions

2007 Montreal Biennial

2006 '1st at Moderna', Moderna Museet, Stockholm

2006 'Janice Kerbel, Hilary Lloyd, Silke Otto-Knapp', Kunstverein, Graz

2006 'British Art Show 6', BALTIC Centre for Contemporary Art, Gateshead

2006 'Loveletter', Herald St, London

Butter Cave
2007
Foam, plaster and wax
61×152.5×91.5cm
Courtesy the artist and Hauser &
Wirth

Selected Bibliography

2003 *Fast Forward: Media Works from the Goetz Collection*, ed. Ingvild Goetz and Stephan Urbaschek, Munich

2002 *Art Now. 137 Artists at the Rise of the New Millennium*, ed. Uta Grosenick and Burkhard Riemschneider, Taschen, Cologne

2001 *Rachel Khedoori*, ed. Peter Pakesch, Schwabe, Basel

2001 'Rachel Khedoori', Hans Rudolf Reust, *Artforum*, October

Selected Exhibitions

2007 Hauser & Wirth, Zurich

2005 'Multiple Spaces. Film: Imagination and Illusion in Art', Staatliche Kunsthalle, Baden-Baden

2004 Villa Arson, Nice

2003 'Fast Forward. Media Art Sammlung Goetz', ZKM Centre for Art and Media, Karlsruhe

2001 Kunsthalle, Basel

Rachel **Khedoori**

Born 1964
Lives Los Angeles

Rachel Khedoori's work locates itself somewhere between architecture and film. In her uncanny and intelligent installations film projections haunt spaces that were once seemingly inhabited but are now vacant. This melding of the deserted domestic environment with the filmic locates the viewer in a curious non-place. We are left to make sense of our surroundings, and of the narrative permeating its bounds. Khedoori's work has the affect of estrangement; what at times appear almost as home movies become, in these settings, distant memories of unfamiliar lives. (CB)

Shown by Galerie Gisela Capitain D11, Hauser & Wirth Zürich London C6, David Zwirner C8

Anya **Kielar**

Born 1978
Lives New York

Anya Kielar's *Automaton* (2007) is a six-foot-tall black frame sculpture of a woman whose body is adorned with maple leaves, sunflowers, daisies and butterflies. Another work, *The Empress* (2007), stands 13 feet high and is made from stacks of wicker baskets that have been bound with rope. *Martha* (2007), meanwhile, crawls on her hands and knees carrying a torso made from a Martha Washington sewing box. Though Kielar's representations of women combine near-violent Constructivist forms with surreal flights of fancy, each of the figures portrayed is in fact modelled after her own body, creating a series of uncanny *doppelgängers* and psychological portraits. (CL)

Shown by Daniel Reich Gallery F27

Selected Bibliography

2007 'Art in Review: Anya Kielar', Holland Cotter, *The New York Times*

2007 'Anya Kielar', Roberta Smith, *The New York Times*, 6 April

2006 'The Year in Culture', Holland Cotter, *The New York Times*, 25 December

Selected Exhibitions

2007 'How to Build a Fire', Rivington Arms, New York

2007 'Lady', Daniel Reich Gallery, New York

2005 'Anya Kielar, Michael Phelan', Daniel Reich Gallery, New York

2004 'Past Perfect', Kantor Gallery, New York

2004 'Recent Alumni: Careers in Progress', La Guardia Gallery, New York

Untitled
2007
Courtesy the artist and Taka Ishii
Gallery

Selected Bibliography

2006 *You May Attend a Party
Where Strange Customs Prevail*, Yuki
Kimura, Taka Ishii Gallery, Tokyo

2003 *Reflex: Contemporary Japanese
Self-Portraiture*, Mark Sanders,
Fumiya Sawa and Kyoichi Tsuzuki,
Trolley Limited, London

2003 'Yuki Kimura', Charles
LaBelle, *frieze*, 74

2002 *Sensation*, Patrick Remy,
Steidl Verlag, Göttingen

2001 'Yuki Kimura', Holly
Meyers, *The Los Angeles Times*

Selected Exhibitions

2006 'Slow Tech', Museum of
Contemporary Art, Taipei

2004 'Sokoni nani ga mieru?',
Hamada Children's Museum of
Art, Shimane

2004 'Roppongi Crossing', Mori
Art Museum, Tokyo

2002 'A Second Talk', National
Museum of Contemporary Art,
Seoul

2001 'Surface: Contemporary
Photography and Video from
Japan', Netherlands Photo
Institute, Rotterdam

Yuki **Kimura**

Born 1971
Lives Kyoto

In his *Camera Lucida* (1980) Roland Barthes is
prompted by a photograph to ponder his own
existence: 'Why is it that I am alive here and now?'
Yuki Kimura takes this question, which runs
through photography like a sad underground
stream, and siphons it to the surface. Couples and
the act of coupling are important motifs in her
work, as are smiles and mortal remains. But while
Kimura's photos insist on the omnipresence of
death, they also point to the dogged persistence of
life. The artist's exhibition 'You May Attend a
Party Where Strange Customs Prevail' at Taka Ishii
Gallery, Tokyo, in 2006 saw her mingle found
photographs with her own pictures and sculptures,
furthering her exploration of the extraordinary
accident of being. (TM)

Shown by Taka Ishii Gallery G8

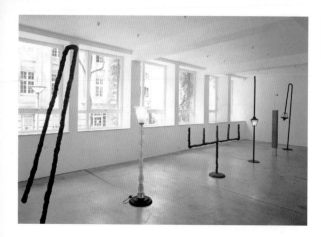

Selected Bibliography

2006 *Martin Kippenberger: Einer von Euch, unter Euch* (Martin Kippenberger: One of You, among You, with You), Jessica Morgan and Doris Krystof, Tate Modern, London/K21, Dusseldorf

2003 *Nach Kippenberger/After Kippenberger*, Eva Meyer-Hermann and Susanne Neuburger, MUMOK, Vienna/Van Abbemuseum, Eindhoven

1997 *Kippenberger leicht gemacht* (Kippenberger Made Easy), Musée d'Art Moderne et Contemporain, Geneva

1991 *I Had a Vision*, San Francisco Museum of Modern Art

1987 *Peter*, Galerie Max Hetzler, Cologne

Martin **Kippenberger**

Born 1953
Died 1997

For two hyperactive decades Martin Kippenberger mocked conservatism and cant wherever he found it – and in the art world he found it in spades. Refusing a signature style, he mocked those of others, painting glue-splattered parodies of neo-Expressionism and, in sardonic homage to Joseph Beuys, scattering giant pills around an indoor forest of tree trunks. He delegated Photorealist canvases to artisans, photographed himself beaten up, and sculpted himself red-faced, head bowed and disgraced in a corner. But Kippenberger became a hero anyway; this iconoclastic gadfly and post-medium pioneer is now hailed as an inspiration and respected by the institutions that rejected him in his lifetime. One wonders whether he'd have appreciated the irony. (MH)

Shown by Galerie Gisela Capitain D11, Gagosian Gallery D7, Galerie Bärbel Grässlin D18, Metro Pictures C11

Selected Exhibitions

2006 Tate Modern, London; K 21, Dusseldorf

2003 'Nach Kippenberger/After Kippenberger', MUMOK, Vienna; Van Abbemuseum, Eindhoven

1997 'Respektive 1997–1976', Musée d'Art Moderne et Contemporain, Geneva

1994 'The Happy End of Franz Kafka's "Amerika"', Museum Boijmans Van Beuningen, Rotterdam

1986 'Miete Strom Gas', Hessisches Landesmuseum, Darmstadt

Untitled
2005
Oil on canvas
140×350cm
Courtesy Annet Gelink Gallery

Selected Bibliography

2005 *Carla Klein: Scape*, Johanna Burton and Heidi Zuckerman, Veenman Publishers, Rotterdam

2005 'Lege gelaagdheid' (Empty Stratification), Hans den Hartog Jager, *Het Parool*, Amsterdam

2002 'Carla Klein', Jeffrey Uslip, *Flash Art International*, 132

2002 *Vitamin P: New Perspectives in Painting*, Barry Schwabsky, Phaidon Press, London

2000 *Carla Klein*, Carla Klein, Veenman Publishers, Rotterdam

Selected Exhibitions

2007 Tanya Bonakdar Gallery, New York

2006 'Radar: Selections from the Logan Collection', Denver Art Museum

2006 'Carla Klein/Matrix 218', Art Museum and Pacific Film Archive, Berkeley

2005 Annet Gelink Gallery, Amsterdam

Carla **Klein**

Born 1970
Lives Rotterdam

Non-places, sites of transition or departure, landscapes, corridors, Modernist interiors, airports, stairways, stadiums, blank televisions, suspension bridges, swimming-pools, empty factories, museum display cases and pet shop terrariums have all been the subjects of Carla Klein's paintings. Using her own snapshots as a basis, along with found and collected photographs, she paints her expansive canvases in a style of controlled imperfection and a blue-green and grey palette. Her compositions, such as *Untitled* (2003), which depicts unnervingly slanted stairs, are generally devoid of the figure, leaving her viewers alone in a scenic geometry of horizon lines and vanishing-points. (DE)

Shown by Tanya Bonakdar Gallery E8, Annet Gelink Gallery E21

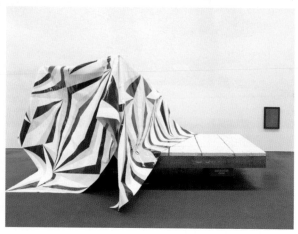

ES WIRD NIE WIEDER GUT
(It's Never Going To Be Good
Again)
2007
Washed-out concrete flagstones,
wood, beer crates, lacquered paper
250×350×180cm
Courtesy Luis Campaña Gallery

Seb **Koberstädt**

Born 1977
Lives Dusseldorf

A dark, ivy-covered, U-shaped MDF tunnel leading nowhere – it seems purpose-built for a hermit devotee of Minimal art and skateboarding (*Untitled*, 2000) – and a ramp-roofed room-within-a-room constructed of found materials, housing a lamp that can only be viewed through a trapdoor opening (*Dying to Live*, 2005) are among Seb Koeberstädt's recent sculptures and installations. His works delineate a speculative, context-specific space in which his viewers are asked to negotiate a reconstituted present infiltrated by an art-historical past. (DE)

Shown by Luis Campaña Gallery F24

Selected Exhibitions

2006 'Stay Gold', Luis Campaña Gallery, Cologne

2006 'My Home Is My Castle', Parc Heintz, Luxembourg

2005 'Compilation II', Kunsthalle, Dusseldorf

2004 'Deutschland sucht', Kunstverein, Cologne

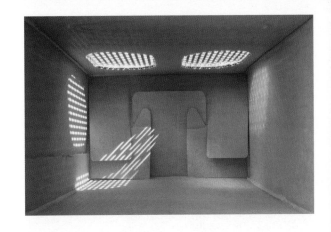

Dois Vinhos
(Two Wines)
2003
Photograph
300×400cm
Courtesy Casa Triângulo

Selected Bibliography

2005 *More Than This! Negotiating Realities*, Sara Arrhenius, International Biennial for Contemporary Art, Gothenburg

2005 'Aktion und Widerstand in der globalen Ära' (Action and Resistance in the Global Era), Miguel von Hafe Pérez, *Springerin*, XI, 3

2004 *Entre Pindorama: Contemporary Brazilian Art and Antropofagia*, Ruby Sircar, Elke Aus Dem Moore/Giorgio Ronna, Stuttgart

2003 *Poetic Justice*, Felipe Chaimovich, Foundation for Culture and Arts, Istanbul

2000 *El Espacio como Proyecto, El Espacio como Realidad* (Space as Project, Space as Reality), Maria de Corral, Deputación de Pontevedra

Selected Exhibitions

2006 27th São Paulo Biennial

2006 'Matemática Espontânea', Torre Malakoff, Recife

2005 3rd Gothenburg Biennial

2003 8th Istanbul Biennial

2001 'Squatters/Ocupações', Museu de Serralves, Porto

Lucia **Koch**

Born 1966
Lives São Paulo

Working relatively to a given architectural situation, Lucia Koch imposes schemes of transparency, pattern and colour to produce aesthetic experience. A large photograph, a window-filling patterned screen or a perforated sculptural structure may act as a light corrective to the room, introducing tessellated patterns of shadow or stained-glass-like designs. Although Koch sometimes speaks of the work in logical terms, considering space as topological and colour as 'a relational attribute', the installations nonetheless create socializing encounters in which atmospheric impressions and decorative pleasure are paramount. (SO'R)

Shown by Casa Triângulo F23

Rising (small version)
2006
Acrylic on canvas
40.5×50.5cm
Courtesy Galerie Daniel Buchholz

Jutta **Koether**

Born 1958
Lives New York

Jutta Koether's artistic practice is influenced as much by her complementary roles as musician and writer as it is by her move from Cologne (home to German 'Bad Painting') to New York (home to Experimental Noise rock). Her paintings exhibit a modesty of means and execution: with faint swirls, sketchy schematic faces and a washed-out palette, or snippets of theoretical text, they suggest an unencumbered personal investigation into the possibilities available to painting. Recent canvases laden with a Heavy Metal detritus of chains, skulls and badges, or black paintings installed on silver walls, play with clichés of an art/rock crossover, without ever denying its potency. (KB)

Shown by Galerie Daniel Buchholz C4, Galerie Francesca Pia H11

Selected Bibliography

2007 'Jutta Koether', Stefan Wagner, *Flash Art International*, 253

2007 'Use Me Up', Jan Verwoert, *Metropolis M.*

2006 *Jutta Koether*, Martin Prinzenhorn et al., Kunstverein, Cologne/Kunsthalle, Bern

2006 'Cross Platform: Jutta Koether', Lina Dzuverovic, *Wire*

1996 'Kairos', Jutta Koether, *Texte zu Kunst und Musik*

Selected Exhibitions

2007 'Bastard Creature', Palais de Tokyo, Paris

2007 'Shandyismus. Autorschaft als Genre', Secession, Vienna

2006 'Änderungen aller Art', Kunstverein, Cologne; Kunsthalle, Bern

2006 'Day for Night', Whitney Biennial, New York

2002 'Black Bonds (collaboration with Steven Parrino)', Swiss Institute – Contemporary Art, New York

Art of Awakening
2005
DVD still
Courtesy Dicksmith Gallery

Selected Bibliography

2007 'Meiro Koizumi', Sally O'Reilly, *Time Out*

2007 'Meiro Koizumi', Conrad Ventur, *Useless Magazine*

2006 'Miami Art Fairs', Roberta Smith, *The New York Times*

2006 'Meiro Koizumi', Arjan Reinders, *Kunstbeeld*

2004 'Frieze Art Fair', Adrian Searle, *The Guardian*

Selected Exhibitions

2007 'XXX: Trilogy', Dicksmith Gallery, London

2007 'It is not a question...', Frye Art Museum, Seattle

2006 The Bakery, Annet Gelink Gallery, Amsterdam

2005 Galeria Luisa Strina, São Paulo

Meiro **Koizumi**

Born 1976
Lives Japan

Meiro Koizumi's video installations use repetition and awkward timing to oscillate the viewer between hilarity and distress. *Art of Awakening* (2005) features an off-screen voice that asks: 'Do you want to feel the Freedom of Spirit?' before a stuffed doll fashioned from plastic bags is poked with a stick by three men in succession. The men's faces betray emotions ranging from self-conscious scepticism to quasi-religious ecstasy, and, although the motive for their curious activity is never explained, through duration and association it becomes freighted with meaning. (AJ)

Shown by Dicksmith Gallery F30

Pokr(a)covanie a, b (U.F.O.)
1982
Black and white photographs
49×32cm each
Courtesy Galerie Martin Janda

Július **Koller**

Born 1939
Lives Bratislava

Július Koller enacts his 'Anti-Happenings' in the guise of a 'U.F.O.-naut'. His numerous projects have entailed comparing the process of democratic communication to ping-pong, adopting the question mark as an emblem of 'the individual's relationship to the collective' and creating a gallery on a ledge of the High Tatra mountains in his native Slovakia that was only accessible to expert climbers. Yet despite investigating alienation, Koller's Conceptualism is marked by humanism: *Universal Futurological Question Mark* (1978) commemorated the tenth anniversary of the 'Prague Spring' by arranging schoolchildren on a hillside in the shape of his ubiquitous question mark as a demonstration of his mission to 'resolve the discrepancy between Utopia and real life'. (BB)

Shown by The Fair Gallery F21, Galerie Martin Janda H6

Selected Bibliography

2006 *Kontakt: Works from the Collection of Erste Bank Group*, Georg Schöllhammer, Verlag Walther König, Cologne

2004 'Július Koller', Tom Holert, *Artforum*

2003 *Univerzálne Futurologické Operácie* (Universal Futurological Operation), Vit Havránek et al., Verlag Walther König, Cologne

1999 *Július Koller*, Aurel Hrabušický, SOGA, Bratislava

Selected Exhibitions

2007 'Learn to Read', Tate Modern, London

2007 Galerie Martin Janda, Vienna

2003 50th Venice Biennale

2003 'Július Koller Univerzálne Futurologické Operácie', Kunstverein, Cologne

2001 'Ausgeträumt…', Secession, Vienna

SPATIUM
2006
Neon, Perspex
120×100×100cm
Courtesy Galerie Krobath
Wimmer

Selected Bibliography

2007 *Brigitte Kowanz*, Riccardo Caldura, Galleria Contemporaneo, Mestre

2006 *Brigitte Kowanz: MORE L978T*, Markus Brüderlin et al., Universität für Angewandte Kunst, Vienna

2004 *Brigitte Kowanz: L_D_M/Light Darkness Movements*, Christa Häusler et al., Galerie der Jenoptik, Jena

2002 *Brigitte Kowanz: Another time another place*, Christa Häusler et al., Wolfgang Häusler, Munich

2001 *Brigitte Kowanz: Zeitlicht-Lichtraum/Time-Light-Lightspace*, Rainer Fuchs, Hatje Cantz Verlag, Ostfildern Ruit

Selected Exhibitions

2006 'Lichtkunst aus Kunstlicht', ZKM Centre for Art and Media, Karlsruhe

2005 'Temporale Volumina (Temporary Volumes)', Galerie Krobath Wimmer, Vienna

2001 'Austrian Contemporary Art Exhibition', Shanghai Art Museum

2000 'Zeitwenden', MUMOK, Vienna

1995 46th Venice Biennale

Brigitte **Kowanz**

Born 1957
Lives Vienna

Brigitte Kowanz' principal medium is light. She creates free-standing sculptures, such as the pyramid-shaped *Exit* (2006) and the aquarium-like *Coincidence* (2006), which capitalize on the reflective interplay of fluorescent tubes manipulated into squiggles, mirrors and glass. Works with titles such as *Flow* (2005), *Energy* (2006) or *Motion and Change* (2006) evoke the physical and perceptual transformations that are essential to her process and to our reception of the linguistic elements that she often includes in her work, either as script or in Morse code. Her objects are smaller-scale pendants to architectural interventions where artificial and natural light, windows and glass partitions, trouble our perception of surface and depth, and so our access to space. (VR)

Shown by Galerie Krobath Wimmer E22

Katastrofen
(The Catastrophy)
2007
Stoneware
38×50×55cm
Courtesy Galleri Magnus Karlsson

Klara **Kristalova**

Born 1967
Lives Norrtälje

Apparently culled from her own experiences, the scenarios depicted by Klara Kristalova's ceramic figurines suggest a particularly ill-fated lifestyle. *The Catastrophy* (2007) befits its title; a long liquorice-like tongue lolls out of the mouth of an ashen-faced female figure submerged in a puddle of unidentifiable black liquid. Perhaps the most horrifying incident of all is *Days and Nights* (2007), in which a female face is almost obliterated by terrifyingly tenacious moths crawling into every orifice. Each piece is not quite autonomous: usually arranged together on a table, her works seem interchangeable, and, connected to each other, they testify to an existence that is a rearranged narrative of horror. (BB)

Shown by Galleri Magnus Karlsson G11

Selected Bibliography

2007 *Den Meningsfulla Igelkotten* (The Meaningful Hedgehog), Anders Olofsson, Galleri Magnus Karlsson, Stockholm

2007 'Kristalova spränger skulpturens ramar' (Kristalova Breaks the Limits of Sculpture), Anna Brodow, *Svenska Dagbladet*, Stockholm

2007 'Nytt allvar: utan ironi' (New Seriousness: Without Irony), Camilla Hammarström, *Aftonbladet*, Stockholm

2007 *Med Fingrarna i Bladverket* (Fingers in the Foliage), Jessica Kempe, Galleri Magnus Karlsson, Stockholm

2002 'Vardagstingens magi' (The Magic of Everyday Objects), Jessica Kempe, *Dagens Nyheter*, Stockholm

Selected Exhibitions

2007 'Two Black Holes and Other Stories', Galerie Emmanuel Perrotin, Miami

2007 'Catastrophes and Other Everyday Events', Galleri Magnus Karlsson, Stockholm

2006 '20 years', Bonniers Konsthall, Stockholm

2004 'Talking to Me?', Baltic Biennial, Rauma

2001 'The World of Flash', The Nunnery, London

Reforma Fiscal 2007
(Tax Reform 2007)
2007
Painted chipboard, weatherproof
roofing roll, silicone and assorted
objects and materials
242×1200×244cm
Courtesy the artist and
kurimanzutto

Gabriel **Kuri**

Born 1970
Lives Brussels

Gabriel Kuri explores what might be called
'commercial ephemera' – items left over from
commercial exchanges (crumpled up receipts,
carrier bags, newspaper wrapping). His material
fluctuates from the everyday to the artisanal, which
he poses in direct opposition to mass production.
Superama (2005) is an elaborate Gobelin tapestry
whose design is based on a supermarket receipt.
Wads of colourful chewing-gum stuck to a tree
trunk become, in Kuri's photographic docu-
mentation, a record of time's passing (*Tree with
Chewing Gum*, 1999). Kuri mines the residue of
social exchange to show that nothing ever really
disappears – and that everything lies waiting for a
better purpose. (MG)

Shown by kurimanzutto H3, Galleria Franco
Noero A2

Selected Bibliography

2007 *Suggested Taxation Scheme*,
Jessica Morgan, Roma
Publications, Amsterdam

2006 *En Cuenta* (Into Account),
Imschoot Publishers, Brussels

2005 *Compost Index*, Gabriel Kuri,
Roma Publications, Rotterdam

Selected Exhibitions

2007 'Reforma Fiscal',
kurimanzutto, Mexico

2006 'And Thanks in Advance',
Govett-Brewster, New Plymouth

2006 'Dato Duro, Dato Blando,
Dato Ciego', Galleria Franco
Noero, Turin

2004 'Calorie Counting', Galleria
Franco Noero, Turin

Dots Obsession
2005
Mixed media
Dimensions variable
Courtesy the artist, Ota Fine Arts
and Victoria Miro Gallery

Yayoi **Kusama**

Born 1929
Lives Tokyo

Although she has been described as a Minimalist, a Pop Surrealist and a performance artist, Yayoi Kusama prefers to describe her art as a safeguard against suicide. For 50 years she has channelled her obsessional neurosis into 'driven images' of her characteristic motifs: polka dots and phalluses. Kusama's 'self-obliterating' urge connects her early 'Infinity Net' paintings with later hallucinogenic environments such as the mirrored room *Endless Love Show* (1966). In the late 1960s Kusama attracted notoriety through her nude Happenings, but recent years have seen a reassessment of both her innovation and her influence. Many of her most arresting new works are 'impossible' objects, such as a pair of golden *Shoes* (1998) sprouting gleaming protuberances. (SL)

Shown by Arndt & Partner G21, Studio Guenzani E9, Victoria Miro Gallery G6

Selected Bibliography

2000 *Yayoi Kusama*, Robert Nickas, Steidl Verlag, Göttingen

2000 *Yayoi Kusama*, Laura Hoptman, Phaidon Press, New York

1998 *Love Forever: Yayoi Kusama 1958–1968*, Lynn Zelevansky et al., Los Angeles County Museum of Art

Selected Exhibitions

2007 'Dots Obsession', Haus der Kunst, Munich

2004 Mori Art Museum, Tokyo

1999 'American Century', Whitney Museum of American Art, New York

1998 'Love Forever: Yayoi Kusama 1958-1968', The Museum of Modern Art, New York

1993 45th Venice Biennale

Rehearsal
2006
Oil on canvas
80.5×100cm
Courtesy Tomio Koyama Gallery

Selected Bibliography

2007 *Women Living by the Sea*, Toru Kukwakubo, Junghwa Ryu, doART Gallery, Seoul

2007 *Portrait Session*, Minoru Shimizu, Daiwa Radiator Factory, Hiroshima

2005 'Geijutsu Shincho', *Shinchosha*, Tokyo, 1 April

2004 'Art Headquarters', *Bijutsu Techo*, 56

2004 'Five Artists in the Next Generation', Megumi Fukumitsu, *Asahi Shinbun Weekly AERA*, Tokyo, 20 September

Selected Exhibitions

2007 'Women Living by the Sea', doART Gallery, Seoul

2007 'Portrait Session', City Museum of Contemporary Art, Hiroshima

2006 'Illusion of the Sea Ebbing Away', Galerie Davide Gallo, Berlin

2005 'The Flower of Hole in the Sand', Tomio Koyama Gallery, Tokyo

2005 'BLOOMFIELD', Wonder Site Shibuya, Tokyo

Toru **Kuwakubo**

Born 1978
Lives Kanagawa

When Toru Kuwakubo exhibited at the fifth GEISAI art fair in Tokyo in 2004, he did so under the pseudonym of Kuwoud Bonet, a portmanteau of the names Kuwakubo, Claude Monet and Pierre Bonnard and a statement of his reverence for the latter two painters. Kuwakubo's work is characterized by a thickly applied, almost edible impasto, but unlike his Impressionist and Post-Impressionist forebears Kuwakubo's styled mannerism is loaded with irony and reflective distance. His *A Woman with Seaweed on her Hair* (2007) captures all the technical finesse of *plein-air* painting but gently mocks its earnestness by having its model pose with an absurd black mass balanced on her head. (AJ)

Shown by Tomio Koyama Gallery A3

Amanda as Andy Warhol's Liz Taylor
2002
Colour photograph
61×51cm (edition 9/10)
Courtesy Jablonka Galerie

David **LaChapelle**

Born 1969
Lives Los Angeles

Glam pornographer, Postmodern iconographer, favourite portraitist of the stars – the ecstasy of the infinitely flat and endlessly plastic is the dominant affect in the photography of Andy Warhol protégé David LaChapelle. His massive monograph bears the fittingly Baudelairean title *Artists and Prostitutes* (2005), and his practice has branched out in recent years to include music videos, theatrical events and documentary film. *Rize* (2005) is noteworthy for its departure from LaChapelle's signature Photoshop manipulations: documenting the dance craze coming out of south central Los Angeles, it seemed as though reality itself had finally caught up with the artist's highly stylized aesthetic. (AS)

Shown by Jablonka Galerie D1

Selected Bibliography

2006 *Heaven to Hell*, David LaChapelle, Taschen, Cologne

2006 *Artists & Prostitutes 1985–2005*, David LaChapelle, Taschen, Cologne

2005 (1996) *LaChapelle Land*, David LaChapelle, Edition Skylight, Zurich

2001 *David LaChapelle*, Davide Faccioli, Photology, Milan

1999 *Hotel LaChapelle*, David LaChapelle, Bulfinch Press, New York/ Time Warner Group, Boston

Selected Exhibitions

2006 'Heaven to Hell', Jablonka Galerie, Berlin

2005 'Artists and Prostitutes', Deitch Gallery, New York

2002 Barbican Art Gallery, London

2002 'All American', Tony Shafrazi Gallery, New York

2000 'Femmes plus que femmes', Museu de Arte Brazileira, São Paulo

Ohne Titel
(Untitled)
2005
Three wax houses on wood shelf
60×140×50cm
Courtesy Galerie Thaddaeus
Ropac

Selected Bibliography

2006 *Freundschaftsspiel* (Friendship Game), Norman Rosenthal, Galerie Thaddaeus Ropac, Salzberg

2005 *Wolfgang Laib*, Katharina Schmidt et al., Hatje Cantz Verlag, Ostfildern Ruit

2003 *Wolfgang Laib: Durchgang–Ubergang* (Wolfgang Laib: Run–Transition), Tohru Matsumoto, The National Museum of Modern Art, Tokyo

2002 *Wolfgang Laib: A Retrospective*, Klaus Ottman, Hatje Cantz Verlag, Ostfildern Ruit

Selected Exhibitions

2007 'Wolfgang Laib: Where Are You Going?', Galerie Thaddaeus Ropac, Salzburg

2005 'Retrospektive', Fondation Beyeler, Basel

2005 Kunstmuseum, Bonn
2001 'A Retrospective', Dallas Museum of Art

Wolfgang **Laib**

Born 1973
Lives Hochdorf Bei Biberach

The secret spaces of Wolfgang Laib's pollen pieces, beeswax rooms and rice houses quietly gesture towards a monastic solitude and austerity. In spring Laib gathers pollen from the flowers and pines near his rural south German home, withdrawing the sticky grains from their natural cycle of generation and reordering them into geometric abstractions influenced by Minimalism, while never forgetting their provenance. A hazy light or luminescence, reminiscent of Mark Rothko, pulses from Laib's floor-based installations and sculpted wax chambers. His pollen squares are less formalist objects than a pantheist vision, a pastoral manifesto of community and simplicity. (ST)

Shown by Galerie Chantal Crousel D3, Konrad Fischer Galerie A5, Galerie Thaddaeus Ropac B12

Blow Up
2007
Acrylic on canvas
220×165cm
Courtesy Andersen_s
Contemporary

Malene **Landgreen**

Born 1962
Lives Copenhagen

Form and colour are the main concerns of Malene Landgreen's *oeuvre*. Refreshingly devoid of rhetoric or a complicated conceptual challenge, she attacks canvases and huge expanses of wall alike to create abstract works that encourage active engagement rather than static contemplation. Locations for her site-specific pieces range from vast bustling factories to hushed museums. In 2005 at the Statens Museum for Kunst, Copenhagen, the Danish artist's work was put in dialogue with that of Henri Matisse, who once stated that art should be 'soothing and calming for the intellect, like a good armchair you can rest in'. Landgreen's work is a welcome pause indeed. (AC)

Shown by Andersen_s Contemporary F17

Selected Bibliography

2006 *Nybrud: dansk kunst i 1990'erne* (The New Break: Danish Art in the 1990s.), Rune Gade and Camilla Jalving, Aschehoug, Copenhagen

2006 *Overblik: 63 danske samtidskunstnere* (Overview: 63 Danish Contemporary Artists), Michael Jeppesen, Politikens Forlag, Copenhagen

2005 *Matisse &*, Tine Nygaard, The Danish National Gallery, Copenhagen

2003 *Her own place: in situ projekter* (Her own place: in situ projects), Tine Nygaard, Copenhagen

Selected Exhibitions

2007 'Jade', Andersen_s Contemporary, Copenhagen

2005 'Matisse &', The Danish National Museum of Art, Copenhagen

2005 'Passion beyond Reason', Wall str.1, Berlin

2004 'Libertine Appearance and Disappearance', DCA Galley, New York

2003 'Kunsträume im Norden', Bayer AG, Leverkusen

During My Lifetime
2006–7
Cibachrome
100.5×81.5cm
Courtesy the artist and Metro
Pictures

Selected Bibliography

2006 *Twice Untitled and Other Pictures (looking back)*, Helen Molesworth, MIT Press, Cambridge

2004 *Louise Lawler and Others*, Philipp Kaiser, Hatje Cantz Verlag, Ostifildern Ruit

2000 *An Arrangement of Pictures*, Douglas Crimp and Johannes Meinhardt, Assouline, New York

1998 *Louise Lawler: A Spot on the Wall*, Hedwig Saxenhuber, Oktagon Verlag, Cologne

Selected Exhibitions

2007 documenta 12, Kassel

2007 'Sequence 1', Palazzo Grassi, Venice

2006 'Twice Untitled and Other Pictures (looking back)', Wexner Center for the Arts, Ohio State University, Columbus

2005 'In and Out of Place: Louise Lawler and Andy Warhol', Dia: Beacon, New York

2004 'Louise Lawler and Others', Museum für Gegenwartskunst, Basel

Louise **Lawler**

Born 1947
Lives New York

Louise Lawler's particular brand of institutional critique – often involving affectionate photographic appropriation – suggests theory relayed as literature: her photographs, texts, objects and installations tend to shimmer with lucidity and wit. They have included: texts and riddles printed on matchbooks, drinking glasses and other mundane objects; art works photographed in museum storage rooms or as 'arranged' by collectors in their homes; glass paperweights enclosing images of art works in institutions; and shots of her New York gallery's space while it was being renovated. More recently Lawler has exhibited a series of photographs addressing the dissemination of information in the context of the occupation of Iraq. (KJ)

Shown by Studio Guenzani E9, Yvon Lambert G5, Metro Pictures C11, Monika Sprüth Philomene Magers B10

Shades of Destructors
2005
Video still
Courtesy Gavin Brown's enterprise

Mark **Leckey**

Born 1964
Lives London

Taken directly from the uproarious Viz comic, with the booze-soaked script read and retched through by Mark Leckey and fellow artist Steve Claydon, *Drunken Bakers* (2005) lauds the underbelly of a binge-drinking society. Its wholesale appropriation and downbeat delivery, though, is unusual for Leckey, whose works are generally constructed as frenetic paeans to popular culture. In *Parade* (2003), for instance, Leckey himself features in a decadent montage of high-street label fetishism and dandyesque posing, while *Londonatella* (2002) relates a fictional flaneur's passage through the London night which, like the audio-sculptural soundstacks of *Soundsystems – Dubplate* (1999), collages together the acoustic output of the city's style-conscious inhabitants. (SO'R)

Shown by Gavin Brown's enterprise G14, Galerie Daniel Buchholz C4, Cabinet D14

Selected Bibliography

2006 'Mark Leckey', Emily Speers-Mears, *Artforum*

2006 'Mark Leckey', Roberta Smith, *The New York Times*

2004 *7 Windmill Street W1*, Migros Museum, Zurich/ jrp | ringier/Verlag Walther König, Cologne

2004 'Horror Vacui', Catherine Wood, *Parkett*, 70

2002 'Openings', Matthew Higgs, *Artforum*

Selected Exhibitions

2006 '3rd Tate Triennial', Tate Britain, London

2004 'Faces in the Crowd', Whitechapel Art Gallery, London

2003 Migros Museum, Zurich

2003 'The Fourth Sex: The Extreme People of Adolescence', Pitti Imagine, Florence

2002 'Remix', Tate Liverpool

Light-Space Module (Laszlo Moholy-Nagy, 1928–30)
2007
16 mm film projection
Courtesy Galerie Rüdiger Schöttle

Selected Bibliography

2006 'Tim Lee', Michael Wilson, *Artforum*

2006 'Lee's Way: The Comic Art of Tim Lee', Lee Henderson, *Border Crossings*

2005 'Tim Lee', Clint Burnham, *Flash Art International*, 240

2005 *Perform*, Jens Hoffmann and Joan Jonas, Thames & Hudson, London

Selected Exhibitions

2007 Presentation House, Vancouver

2007 Galerie Rüdiger Schöttle, Munich

2007 'All About Laughter', Mori Art Museum, Tokyo

2006 Lisson Gallery, London

2006 Cohan & Leslie, New York

Tim **Lee**

Born 1975
Lives Vancouver

Tim Lee revisits radicalism and samples slapstick. The artist himself is the deadpan role-player in his photographs and performance videos as he mimes, covers and fuses, for example, moments of Hip-hop history, comic genius and the Conceptual art canon. Marx Brothers' visual humour is in the mix with a Dan Graham double-take, Steve Martin sight gags and Bruce Nauman's early studio actions. 'How can one make polemical art that does not look or appear to be overtly polemical?', Lee has asked. 'Comedy just seemed to offer itself as the most willing example.' (MA)

Shown by Lisson Gallery B8, Galerie Rüdiger Schöttle E10

Condition Subsequent
2006
Acrylic on board
134.5×48.5cm
Courtesy the artist and Sutton Lane

Daniel **Lefcourt**

Born 1975
Lives New York

Daniel Lefcourt's paintings and wall-based sculptures revel in taking one idea and pushing it to create an apparent contradiction or a false resolution. The long black strips of painted wood lining the walls in *Breach of Contract (Total Nonperformance)* and *Apparent Misconduct* (both 2006) represent lines of blocked-out newspaper text that Lefcourt came across in a photograph. The text told the murky story of a financial scandal that the paper decided to censor – making the black lines a literal cover-up. *Optimism is a Force Multiplier* (2006) is a taxonomic collage of images of the artist's studio tools, each photographed from a single-point perspective, which leaves Lefcourt's 'photographic' depiction floating somewhere between hyperreal and *trompe-l'oeil* representation. (MG)

Shown by Sutton Lane G1

Selected Bibliography

2007 'Daniel Lefcourt', Katie Stone Sonnenborn, *frieze*, 104

2006 'Daniel Lefcourt', Emily Hall, *Artforum*, November

2006 'Art in Review: Daniel Lefcourt', Roberta Smith, *The New York Times*

2005 'Like a Rock', Jerry Saltz, *The Village Voice*

2005 'Do You Like Stuff?', Adam E. Mendelsohn, *Art Monthly*, October

Selected Exhibitions

2007 Sutton Lane, Paris

2007 'For the People of Paris', Sutton Lane, Paris

2006 Taxter & Spengemann, New York

2006 'The Gold Standard', PS1 Contemporary Art Center, New York

2005 'Do You Like Stuff?', The Swiss Institute, New York

Sorte que foge
Installation view (detail)
(Fleeting luck)
2004
Fitted carpet, carpet fluff
800×1000×20cm
Courtesy the artist and CRG
Gallery

Selected Bibliography

2007 *Tonico Lemos Auad*, Alex
Farquharson, Andrea Schlieker and
Heidi Zuckerman Jacobson, Aspen
Art Press/Galeria Luisa Strina, São
Paulo

2004 'Adapting and Constructing
In a Dizzily Changing World', Ken
Johnson, *The New York Times*, 24
September

2004 *Adaptive Behaviour*, The New
Museum of Contemporary Art,
New York

2004 *Becks Futures*, Institute of
Contemporary Arts, London

2003 *Tonico Lemos Auad*, Galeria
Luisa Strina, São Paulo

Selected Exhibitions

2007 Aspen Art Museum

2007 Galeria Luisa Strina, São
Paulo

2006 'The British Art Show 6',
BALTIC Centre for
Contemporary Art, Gateshead

2002 Galerie Wieland, London

2002 'Lyric Underground',
Gasworks Gallery, London

Tonico **Lemos Auad**

Born 1968
Lives London

Although Tonico Lemos Auad works with such
diverse materials as collage, photography and even
sculpted carpet, the logic he ascribes to his work is
that of drawing. The artist describes his fitted
carpet pieces, such as *Peppercorn Carpet* (2000) – a
winsome carpet-fluff squirrel – as '3-D drawings in
space where the viewer actually enters the work'.
Lemos Auad's previous projects include dropping
jewellery around a space for anyone to find (*Lost
Gold*, 2002) and crafting delicate gold-studded
grape stems (*Skull Grapes*, 2004–5). By embracing
the ephemeral, Lemos Auad demonstrates that an
economy of means does not equal a frugality of
meaning. (BB)

Shown by CRG Gallery H5, Galeria Luisa Strina
F12

Atelier **van Lieshout**

Founded 1995
Based Rotterdam

Atelier van Lieshout (AVL) is a multidisciplinary group that produces works that bridge art, design and architecture. In 2001 the creative team established AVL-Ville, a 'free state' in the port of Rotterdam where it manufactures pieces ranging from simple four-square furniture and mobile homes to works of art that can be used for a self-sufficient and independent lifestyle. Examples include *The Technocrat* (2003), a biogas installation, with an industrial alcohol production unit and bunk beds for at least 1,000 people. Recently AVL has issued a series of more decorative works: polyester sculptures of human figures in various postures, such as *Woman on Stand* (2005). (SL)

Shown by Tanya Bonakdar Gallery E8, Galerie Krinzinger D17, Giò Marconi F6, galerie bob van orsouw C12, Galerie Fons Welters G25

Selected Bibliography

2007 *Atelier van Lieshout*, Jennifer Allen et al., NAi Publishers, Rotterdam

2005 *Atelier van Lieshout: Der Disziplinator* (Atelier van Lieshout: The Disciplinator), Peter Noever, Elisbeth Schweeger and Bettina Busse, MAK, Vienna

2002 *Atelier van Lieshout: 25th Bienal de São Paulo 2002. Representation for the Netherlands*, Jennifer Allen, Mondrian Foundation, Amsterdam

1998 *Atelier van Lieshout: The Good, The Bad & The Ugly*, Peter Hoefnagels et al., NAi Publishers, Rotterdam

1997 *Atelier van Lieshout: A Manual*, Bart Lootsma et al., Hatje Cantz Verlag, Ostfildern Ruit

Selected Exhibitions

2007 'The Technocrat', MACRO Hall, Rome

2005 'Der Disziplinator', MAK, Vienna

2004 'Zwang', Galerie Krinzinger, Vienna

2002 25th São Paulo Biennial

2001 'AVL-Ville' Rotterdam

Untitled
1978
Photomontage
18×23.5cm
Courtesy Stuart Shave/Modern Art

Selected Bibliography

2007 'The Working Class Goes to Paradise', Catherine Wood, *Untitled*, 40

2007 'Post Punk: the Secret Public', Skye Sherwin, *ArtReview*

2006 'Linder: Works 1976-2006', Louise Gray, *The Wire*, September

2006 *Linder: Works 1976-2006*, ed. Lionel Bovier, jrp | ringier, Zurich

2004 'Go Ahead, Punk, Make My Day!', Linder Sterling, *The Independent on Sunday*, London, 6 June

Selected Exhibitions

2007 PS1 Center for Contemporary Art, New York

2007 Stuart Shave/Modern Art, London

2007 'The Secret Public: The Last Days of the British Underground 1978–1988', Institute for Contemporary Art, London

2007 'Panic Attack! Art in the Punk Years', Barbican Art Gallery, London

2006 '3rd Tate Triennial', Tate Britain, London

Linder

Born 1954
Lives Heysham

In one photomontage a layer cake replaces the face of a naked woman in a food-filled kitchen. In another – which became an iconic Buzzcocks album cover – toothy smiles on the breasts of an iron-headed nude taunt the viewer like threatening eyes. Musician, performance artist and collagist Linder has long been an underground star, co-founding the post-Punk band Ludus and creating (with Jon Savage) the zine *Secret Public*. Her photomontages skewer sexism and consumerism; an early performance featured a dildo and raw-meat dress. At Tate Britain she recently restaged her durational music and dance extravaganza *The Working Class Goes to Paradise* (2000-6), inspired by the 18th-century Shaker Ann Lee. (KJ)

Shown by Stuart Shave/Modern Art D12

Untitled
2006
Papier mâché, plaster, steel, acrylic,
river sediment and debris
365.5×122×61cm
Courtesy Tanya Bonakdar Gallery

Selected Bibliography

2006 *The Uncertainty of Objects and Ideas: Recent Sculpture*, Johanna Burton and Anne Ellegood, Hirshhorn Museum and Sculpture Garden, Smithsonian Institution, Washington

2005 *Charles Long: More Like a Dream than a Scheme*, Vesela Stretenovic and Gregory Volk, Brown University, Providence

1998 *Peculiar Autonomy: Works by Charles Long*, Mark Linder and Charles Long, Gian Enzo Sperone, Rome

1997 *Performance Anxiety*, Amada Cruz and Robert Nickas, Museum of Contemporary Art, Chicago

1996 *Young Americans: New American Art in the Saatchi Collection*, Jeffrey Deitch, The Saatchi Gallery, London

Charles **Long**

Born 1958
Lives Los Angeles

Best known for marrying grotesque biomorphic form with retro-futuristic Modernist design, in such works as *The Amorphous Body Study Center*, made in 1995 in collaboration with the band Stereolab, Charles Long's recent work has taken a less Space-Age and more folksy turn. Inspired by the drawings of his young son, assemblages such as *Direction of My Home* (2003–4) and *A Slave Chemist* (2004) have an improvised quality, almost redolent of the intuitive processes of amateur science. Still juxtaposing the solidity of plastics and metals with the softer textures of plaster and papier mâché, his sculptures exude a sense of gawky playfulness that attractively offsets more serious formal concerns. (DF)

Shown by Tanya Bonakdar Gallery E8

Selected Exhibitions

2007 'Merce Cunningham: Dancing on the Cutting Edge Part 1', Museum of Contemporary Art, Miami

2007 '100 Pounds of Clay', Wexner Center for the Arts, Columbus

2006 'The Uncertainty of Objects and Ideas: Recent Sculpture', Hirshhorn Museum and Sculpture Garden, Smithsonian Institution, Washington D.C.

2006 'Gone Formalism', Institute of Contemporary Art, Philadelphia

2005 'More Like a Dream than a Scheme', David Winton Bell Gallery, Brown University, Providence; SITE, Santa Fe

Vanguardism Series #1, Image #1
2007
Digital print in bronze aluminium
frame
37×27.5cm
Courtesy Dicksmith Gallery

George Henry **Longly**

Selected Bibliography

2007 'That Sanitation Truck Parked on the Pier? It's Part of the Show', Holland Cotter, *The New York Times*

2007 'Ice Trade Exhibition Review', David Shariatmadari, *frieze*, 106

2006 *George Henry Longly*, Bernard Walsh, Dicksmith Gallery, London

2006 'George Henry Longly', Martin Coomer, *Time Out*

Selected Exhibitions

2007 'The Ice Trade', Chelsea Space, London

2007 'George Henry Longly & Rupert Norfolk', Galerie Chez Valentin, Paris

2006 G39 Gallery, Cardiff

2006 Dicksmith Gallery, London

2006 'The title taken from reading that book', Elisabeth Kaufmann Galerie, Zurich

Born 1978
Lives London

George Henry Longly's minimal installations proceed from a period of intensive research, as in his recent works informed by the history of measurement and images from the Army Physical Training Corps Museum in Aldershot. However, Longly is equally concerned with aesthetics, meaning that pieces such as *Little Wars and Floor Games* (2006) can be legitimately interpreted both as formalist sculpture and as an envisaging of the obscure pastime H.G. Wells developed for his two sons, and described in an unillustrated book, *Floor Games* (1911). Similarly, multicoloured bars propped up in a corner, *I do not know...* (2006), refer to the outmoded learning aids known as Cuisenaire rods but also possess a pure abstract quality. (SL)

Shown by Dicksmith Gallery F30

Sleep of Ulro
Installation view
2006
Mixed media installation
Courtesy A Foundation/Greenland
Street and Kate MacGarry

Goshka **Macuga**

Born 1967
Lives London

If Goshka Macuga's art is about taxonomic systems, it is also about curiosity and what happens when we put together things that aren't supposed to fit. Creating cod-museological installations of books, art (her own and others'), souvenirs, scientific implements and unnameable historical gee-gaws, she is perhaps as much a curator as an artist, albeit one who's happily swapped academic 'good practice' for unabashed poeticism. If data, in Macuga's work, are things not so much to be understood and used as to be felt, so much the better. Museums, after all, are where we house memories, and memories rarely come accompanied by a catalogue number or curt explanatory note. (TM)

Shown by Andrew Kreps Gallery C7, Kate MacGarry E18

Selected Bibliography

2007 'Goshka Macuga', Michael Wilson, *Artforum*, April

2006 'Focus: Goshka Macuga', Jonathan Griffin, *frieze*, 100

2005 'Goshka Macuga', Peter Suchin, *frieze*, 92

2004 'I am a Curator', Paul O'Neill, *Art Monthly*, April

2004 'Goshka Macuga', Sacha Craddock, *contemporary*, 64

Selected Exhibitions

2007 'Objects in Relation', Art Now, Tate Britain, London

2006 27th São Paulo Biennial

2006 'Sleep of Ulro: The Furnace Commission', A Foundation/ Greenland Street, Liverpool

2006 'Mathilda is Calling', Institut Mathildenhöhe, Darmstadt

2006 'The British Art Show 6', BALTIC Centre for Contemporary Art, Gateshead

Untitled
2006
Oil on canvas
45.5×38×5.5cm
Courtesy Galleri Christina Wilson,
Hiromi Yoshii Gallery

Selected Bibliography

2007 'Keisuke Maeda: When',
Sara Hatla Krogsgaard,
Kunstkalenderen

2007 'Fødselsdag hos Galleri
Christina Wilson' (Birthday at
Galleri Christina Wilson), Trine
Ross, *Politiken*, Copenhagen

2006 'Dette er maleri' (This is
Painting), Trine Ross, *Politiken*,
Copenhagen

Selected Exhibitions

2007 'When', Galleri Christina
Wilson, Copenhagen

2007 '5 Years: Anniversary Show',
Galleri Christina Wilson,
Copenhagen

2007 Galerie Diana Stigter,
Amsterdam

2006 'Art@Agnes', Agnes Hotel
and Apartments, Tokyo

2005 'Recent Works by Gallery
Artists', Hiromi Yoshii Gallery,
Tokyo

Keisuke **Maeda**

Born 1972
Lives Tokyo

If his untitled series of drawings and oil paintings
from 2005–6 is any indication, Keisuke Maeda
really seems to have it in for fairies. These works
depict a colouring-book page decorated with the
thick black outlines of a fairy perched on a
blossoming branch. Innocuous enough. But the
page is then repeatedly burnt, scribbled on,
crumpled and subjected to all sorts of abuse, which
Maeda preciously renders in eerie Hyperrealism.
Despite the child-like subject matter, it is tempting
to see Maeda's Photorealist painted depictions of
printed pages as *trompe-l'oeil* images, and so as
commentaries on the very nature of truth in
representation. (VR)

Shown by Galleri Christina Wilson F26

Disponha
(Dispose)
2001
Photograph (diptych)
110×108cm (each)
Courtesy Casa Triângulo

Rubens **Mano**

Born 1960
Lives São Paulo

A place is shaped by the everyday movements of its inhabitants. Rubens Mano makes simple interventions in the humdrum life of major Brazilian cities, temporarily suspending the patterns of activity that define a metropolis. Since 1984 he has focused on light as his primary tool. In *Detector of Absences* (1999) he used powerful lamps to create new spaces, the quiet interruption radically affecting the behaviour of passers-by on a dark street. In a similar vein to Rirkrit Tiravanija, Mano uses these open-ended modes of addressing the audience to prompt new interpersonal relations. (ST)

Shown by Casa Triângulo F23

Selected Bibliography

2007 *100 Latin American Artists*, Osvaldo Sánchez, Exit Publicaciones, Madrid

2006 *Espaço Aberto/Espaço Fechado: Sites for Sculpture in Modern Brazil*, Stephen Feeke, Henry Moore Institute, Leeds

2004 'An Art of Space and its Productions', Laymert Garcia dos Santos, *Parachute*, 116

2002 *Rubens Mano*, Ivo Mesquita, Bienal Iberoamericana de Lima

2000 *A cidade não mais como obstáculo: a produção de Rubens Mano* (The City No Longer as Obstacle: The Work of Rubens Mano), Tadeu Chiarelli, Casa Triângulo, São Paulo

Selected Exhibitions

2006 'Espaço Aberto/Espaço Fechado: Sites for Sculpture in Modern Brazil', Henry Moore Institute, Leeds

2006 '10 Defining Experiments', Cisneros Fontanals Art Foundation, Miami

2005 'inSITE', Tijuana/San Diego

2004 14th Sydney Biennial,

2002 25th São Paulo Biennial,

Demonstration
2006
Steel, black patina, wooden crate
Sculptures: 69×44.5×44.5cm
(each); Crate: 90×107×58.5cm
Courtesy Galerie Eva Presenhuber

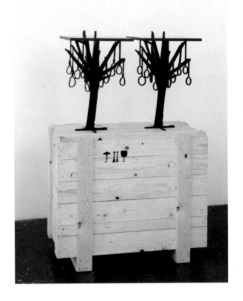

Selected Bibliography

2006 'Hugo Markl: Shrug',
Antonietta Fulvio, *Exibart.com*

2006 'Shrug: l'arte negata e messa
al muro' (Shrug: Art Negated and
Turned to the Wall), Anita Pepe,
Roma Cultura

2006 'Le sculture e i segni di
Markl il demolitore' (The
Sculptures and Signs of Markl the
Destroyer), Daniela Ricci, *Il
Mattino*

2005 'Art in Review: Interstate',
Roberta Smith, *The New York
Times*

2001 *THE BIRTH OF peter builts
AND THE DEATH OF hugo
markl BECAUSE I NO LONGER
AM I AM EVERYBODY I AM
EVERYTHING*, Rainer Fuchs,
Peter Builts, Zurich

Selected Exhibitions

2007 'The Third Mind', Palais de
Tokyo, Paris

2006 'Calcium', André
Schlechtriem Temporary, New
York

2006 'Shrug', Galleria
Raucci/Santamaria, Naples

2006 'Brown', Galerie Eva
Presenhuber, Zurich

2003 'Peter Builts Offene
Rechnung', Gruppe
Österreichische Guggenheim,
Vienna

Hugo **Markl**

Born 1964
Lives New York

Hugo Markl has stated that his art is not concerned
with 'philosophical questions and theoretical
answers': instead he seeks a directness and intensity
of image or form with every work. 'Brown' (2004)
is a series of 59 photographic reproductions of
collages, each titled after a US state or territory,
that deploys a constellation of magazine fragments
– lingerie, shoes, disembodied hairstyles, models'
abdomens or sullen interiors, for example.
Meanwhile *Vertikales Erdarmloch* (Vertical Earth
Armhole, 2006) is a black bronze form – an
upturned cast of the negative space of a roughly
excavated hole in the ground that was just big
enough for the artist's arm. (MA)

Shown by Galerie Eva Presenhuber C3

Untitled
2007
Graphite, acrylic, spray-paint on paper
41.5×35.5cm
Courtesy Galerie Neu

Nick **Mauss**

Born 1980
Lives New York

Nick Mauss' works on paper have the appearance of diligently executed notes on the everyday. Yet their union of faint shadowy figures within fields of abstraction indicate a curious quotidian. The apparent relation between the works' formal attributes is memory; the manner in which one forgets the banal yet recalls even the slightest ornamental detail. The figures in Mauss' work are inter-polated within this sea of adornment. They are languid creatures, awaiting fulfilment from without. Mauss portrays the void of a bourgeois subject wanting to be complemented by the opulent visual world around it. (CB)

Shown by Galerie Neu B4

Selected Bibliography

2007 *One Season in Hell*, Nick Mauss and Ken Okiishi, Gavin Brown's enterprise, New York

2007 *balcon/HOLD THE COLOUR*, Ingvild Goetz, Jan Seewald and Stephan Urbaschek, Sammlung Goetz, Munich

2006 'Between the Lines', Holland Cotter, *Art in Review*, March

2005 *Nick Mauss and Elizabeth Peyton*, Glenn Horowitz Booksellers, New York

Selected Exhibitions

2007 Galerie Neu, Berlin

2007 'Nick Mauss and Ken Okiishi', Gavin Brown's enterprise, New York

2006 'Between the Lines', Hotel Chelsea, New York

2005 'Words: The Formal Presence of Text in Modern and Contemporary Works on Paper', Andrea Rosen Gallery, New York

2005 'Nick Mauss and Elizabeth Peyton', Glenn Horowitz Booksellers, New York

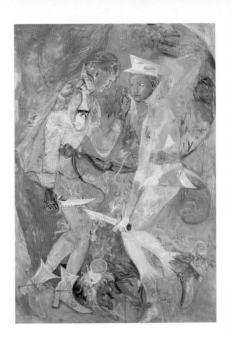

2525
2007
Oil on canvas
205×175cm
Courtesy Gabriele Senn Galerie

Hans-Jörg **Mayer**

Born 1955
Lives Berlin

Hans-Jörg Mayer is known for his works reproducing familiar media images – one Photorealistic painting recreates an image of a winged Victoria's Secret model – but he often abandons media critique to work in a radically different mode. Painterly, somewhat Neo-Classical canvases deploy delicate hues and fractured space to depict enigmatic women with names such as *Forestgirl* (2006) or *Female Worker in Psychic Landscape* (2005). These recall Balthus' erotic reveries or Weimar-era scenes but have their own troubling resonance, sometimes evoking fascism or communism. Gamines clasp hands while brandishing knives; a femme fatale exposes herself in a mountainous landscape; a woman observed by a cat holds a net in one hand, a fish in the other. (KJ)

Shown by Galerie Christian Nagel E3, Galerie Giti Nourbakhsch C2, Gabriele Senn Galerie E24

Selected Bibliography

2003 *Hans-Jörg Mayer*, Galerie Christian Nagel, Cologne

1995 *Pittura/Immedia: Malerei in den 90er Jahren* (Pittura/Immedia: Painting in the '90s), Peter Weibel, Neue Galerie am Landesmuseum Joanneum, Graz

1992 *Hans-Jörg Mayer*, Kunstraum Daxer, Munich

Selected Exhibitions

2007 Gabriele Senn Galerie, Vienna

2006 'Zen Touch', Galerie Giti Nourbakhsch, Berlin

2002 'MAYERus: Letzte Tage', neugerriemschneider, Berlin

Small Naples Morning
2006
Oil on canvas
50×75cm
Courtesy Kerlin Gallery

Stephen **McKenna**

Born 1939
Lives Bagenalstown

Stephen McKenna imbues the mundane and the pedestrian with an idealized other-worldliness. In paintings of Bagenalstown, Ireland, where he keeps a studio, the walls of buildings take on the smoothness of ideas and the simplicity of models. McKenna acknowledges his debt to Impressionism through multi-hued Mediterranean shadows, while Giorgio de Chirico's influence stalks through his starkly lit interiors. Recent works draw on time spent in Italy, a natural magnet for a painter whose complex relationship to the history of European painting and Classical mythology gives an ageless insight into contemporary life. (JG)

Shown by Kerlin Gallery E11

Selected Bibliography

2003 *Et in Arcadia Ego*, John Hutchinson and Stephen McKenna, Douglas Hyde Gallery, Dublin

2000 *Stephen McKenna*, Anna Krems and Stephen McKenna, Bahnhof Rolandseck, Bonn

1993 *Stephen McKenna: Paintings 1985–1993*, Ian Jeffrey, Irish Museum of Modern Art, Dublin

1986 *Stephen McKenna*, Jürgen Harten, Städtische Kunsthalle, Dusseldorf

1986 *Falls the Shadow: Recent British and European Art*, ed. Irena Oliver, Arts Council of Great Britain, London

Selected Exhibitions

2003 'Et in Arcadia Ego', Douglas Hyde Gallery, Dublin

2000 'Hans und Sophie Taeuber Arp Foundation', Bahnhof Rolandseck, Bonn

1993 Irish Museum of Modern Art, Dublin

1986 'Turner Prize', Tate Gallery, London

1982 documenta 7, Kassel

Gravesend
2007
35mm film transferred to HD
video
Courtesy the artist, Marian
Goodman Gallery and Thomas
Dane Gallery

Selected Bibliography

2003 *Speaking in Tongues*, Steve
McQueen, Paris Musées

2002 *Carib's Leap/Western Deep*,
Steve McQueen and James
Lingwood, Artangel, London/
Fundaçao de Serralves, Porto/
Fundació Antoni Tapies, Barcelona

2001 *Steve McQueen*, ed. Doris
Krystof, Kunsthalle, Vienna

1999 *Steve McQueen*, Okwui
Enwezor, Michael Newman and
Robert Storr, Institute of
Contemporary Arts, London/
Kunsthalle, Zurich

1997 *Steve McQueen*, Steve
McQueen and Barbara J. London,
Museum of Modern Art, New
York

Selected Exhibitions

2007 52nd Venice Biennale

2007 'For Queen and Country',
Central Library, Manchester

2005 Fondazione Prada, Milan

2003 Musée d'Art Moderne de la
Ville/ARC, Paris

2002 documenta 11, Kassel

Steve **McQueen**

Born 1969
Lives Amsterdam/London

Formalist and laconic, with references to the
cinema of Andy Warhol and the Nouvelle Vague,
Steve McQueen's absorbing video works are
equally characterized by a deep sensuality and
painterly composition – see, for example, his elegy
to the creative act in *Girls, Tricky* (2001), or his
methodically erotic and somehow other-worldly
nipple manipulation in *Cold Breath* (2000). Most
recently he has stirred controversy with *For Queen
and Country* (2007), a series of imitation Royal
Mail stamps commemorating British soldiers killed
in the Iraq War. McQueen's work squarely
confronts the imposed invisibility and media
control that have marked this disastrous conflict.
(AS)

Shown by Thomas Dane Gallery E1, Marian
Goodman Gallery F14

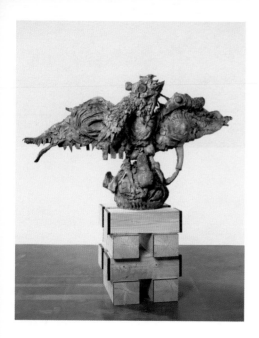

ErzAdler, fischiges Reptilbaby beim Ablaichen
(ArchEagle, Fishy Reptile Baby During Spawning)
2006
Bronze (edition of 3)
221×121×93cm
Courtesy Contemporary Fine Arts

Jonathan **Meese**

Born 1970
Lives Berlin/Hamburg

In 2006 a major survey exhibition at the Deichtorhallen, Hamburg, provided Jonathan Meese with the opportunity to redisplay his Caligula-meets-Kubrick installations from the late 1990s (scattered dens of collected images such as *Wunderkammern*, 1999) next to his more recent bronze sculptures (such as *Mutter Parzival*, 2004, which brings out the Smurf in Richard Wagner). While Meese's invocations of emblematic detritus from the scrapheap of Teutonic myth may be perceived either as a genuine endeavour or as hot air, few can fail to be convinced by his forceful, trance-like performances. In *The Geometrical God* (2006), carried out on a slowly revolving stage, Meese raged against the mechanisms of art education – with occasional interjections from his 77-year-old mother. (JöH)

Shown by Contemporary Fine Arts D2, Galerie Krinzinger D17, Stuart Shave/Modern Art D12

Selected Bibliography

2007 *Mama Johnny: Retrospective*, Yves Aupetitallot et al., Verlag Walther König, Cologne

2006 *Die Peitsche der Erinnerung: Jonathan Meese and Daniel Richter* (The Whip of Memory: Jonathan Meese and Daniel Richter), Kunsthaus, Stade

2005 *General Tanz: Drei Streifen für ein Halleluja* (General Dance: Three Steps for a Hallelujah), Contemporary Fine Arts, Berlin

2004 *Saalschlacht Paracelsus* (Paracelsus Hall Fight), Contemporary Fine Arts, Berlin

2002 *Young Americans*, Contemporary Fine Arts, Berlin

Selected Exhibitions

2007 'Jonathan Meese: Fräulein Atlantis', Sammlung Essl, Klosterneuburg

2007 'Dr. Rockford (Don't call me back, please)', De Appel, Amsterdam

2007 'Sei lieb, Mumin. (Tanz De Deputy)', Staatliche Kunsthalle, Karlsruhe

2006 'Mama Johnny', Deichtorhallen, Hamburg; Magasin, Centre National d'Art Contemporain, Grenoble

2006 'Johnny Come Home', Contemporary Fine Arts, Berlin

Albanische Garderobe
(Albanian Wardrobe)
2005
Enamel on metal
32.5×203cm (3 part installation)
Courtesy Meyer Riegger

Meuser

Born 1947
Lives Dusseldorf

Meuser's sculptures could be easily subsumed under the bracket of 'Minimalism' if it weren't for his choice of materials and the incorporation of language into his works. His use of heavy metals contradicts the maxim of practicability proposed by Donald Judd and Robert Morris, yet it doesn't comply with Richard Serra's rhetoric of rawness either. Rather, weightiness is countered by lightness: Meuser, who studied with Joseph Beuys, often uses bright colours, wall-hung installations that suggest canvases, or deadpan titles: two large steel monoliths − one painted white, one black − are entitled *With the Best Will in the World, I Can't See the Hoover in This* (2002), as though Martin Kippenberger and Jeff Koons had been consulted to cure the sobriety of Minimalism. (JöH)

Shown by Galerie Bärbel Grässlin D18, Meyer Riegger C7

Selected Bibliography

2004 'Meuser', Catrin Lorch, *Frankfurter Allgemeine Zeitung*, 3 July

2003 *Gibt's mich wirlich vier Räume aus der Sammmlung Schürmann* (Do I Really Exist? Four Rooms from the Schürmann Collection), Meuser, K21 Kunstsammlung Nordrhein-Westfalen, Dusseldorf

2003 *Meuser*, Kunstverein, Oldenburg

1991 *Meuser*, Verlag Walther König, Cologne/Kunsthalle, Zurich

1986 *Meuser*, Kunstraum, Munich

Selected Exhibitions

1992 documenta 9, Kassel

1991 Kunsthalle, Zurich

1986 Kunstraum, Munich

1979 Kippenbergers Büro, Berlin

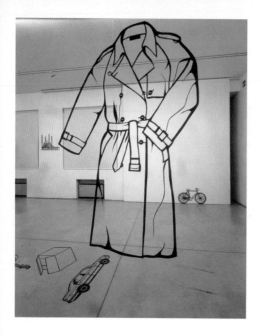

Vocabolario
(Dictionary)
2002
Installation view
Drawings cut into black cardboard
and taken from dictionaries
Dimensions variable
Courtesy Galleria Massimo Minini

Sabrina **Mezzaqui**

Born 1964
Lives Bologna

Sabrina Mezzaqui's art demonstrates how a stitch in time might work: her repetitive crafted objects and images seem at first sight still, peaceful things. On closer inspection the investment of hours in their making causes a ripple to pass over the unified surface of the work. Mezzaqui cut the dust-jacket of an edition of Homer's *Odyssey* into thin ribbons, then wove these together again, redressing the book in a slightly pixelated version of the original cover, entitled *Odissea* (2006). Similarly, the white felt-tip on acetate drawing *Tende* (Curtains, 2000), when mounted on two glass panels, becomes a floating lace curtain, a delay between interior and exterior worlds. (SL)

Shown by Galleria Massimo Minini F11

Selected Bibliography

2006 'Sabrina Mezzaqui', Alessandra Pioselli, *tema celeste*, September/October

2006 'Sabrina Mezzaqui', Chiara Canali, *Flash Art International*, August/September

2006 'Sabrina Mezzaqui', Cathryn Drake, *Artforum*, April

2006 *Sabrina Mezzaqui: C'è un tempo* (Sabrina Mezzaqui: There is a Time), Elena Volpato, Mariangela Gualtieri and Sabrina Mezzaqui, Hopefulmonster, Turin

2002 *Sabrina Mezzaqui*, Carolyn Christov-Bakargiev et al., Gli Ori, Siena

Selected Exhibitions

2007 'Apocalittici e integrati', MAXXI, Rome

2006 'Quando le parole atterrano', Galleria Massimo Minini, Brescia

2006 'C'è un tempo', Galleria Civica d'Arte Moderna, Turin

2005 One Severn Street, Birmingham

2005 'Sottolineature', Galleria Continua, San Gimignano

Restless Stillness
1991
Mixed media
51×196×105cm
Courtesy Meyer Riegger

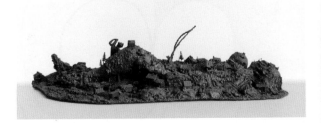

Selected Bibliography

2006 'Portfolio: John Miller', Bob Nickas, *Artforum*, April

2004 *The Middle of the Day: 1994–2004 (Volumes 1, 2, 3)*, John Miller, Cabinet des Estampes du Musée d'Art et d'Histoire, Geneva

1999 *Economies Paralleles/Parallel Economies*, ed. Yves Aupetitallaut and Lionel Bovier, Magasin, Centre National d'Art Contemporain, Grenoble

1992 *Rock Sucks, Disco Sucks*, Dennis Cooper et al., DAAD Galerie, Berlin

1991 'John Miller in New York', Jutta Koether, *Texte zur Kunst*, Winter

Selected Exhibitions

2006 'Hyperlinks for Global Dead Links', City Museum of Contemporary Art, Hiroshima

1999 'Parallel Economies', Magasin, Centre National d'Art Contemporain, Grenoble

1992 'Rock Sucks, Disco Sucks', DAAD Galerie, Berlin

1991 Whitney Biennial, New York

1982 White Columns, New York

John **Miller**

Born 1955
Lives New York

During the 1980s John Miller covered dolls and miniature suburban homes in brown 'faecal' impasto, thus treating fetish objects with the brutish playfulness of Pop vernacular. The artist continues to explore mass culture in a recent series of works in which online-dating ads are superimposed onto photographs of real places from the area of West Hollywood where the would-be lovers live: a self-confessed 'Viagra guinea pig' is matched with a dilapidated outdoor jacuzzi, for example. Meanwhile, in Miller's current sculptural works the brown impasto has been replaced by cornucopian aggregations of plastic fruit, which symbolize the 'excremental' side of consumer society even more graphically. (JöH)

Shown by Metro Pictures C11, Meyer Riegger C7, Galerie Christian Nagel E3, Galerie Barbara Weiss G13

Two Circles
2006
Oil, acrylic, graphite and ink on panel
122×152.5cm
Courtesy ACME.

Allison **Miller**

Born 1972
Lives Los Angeles

As though doodles had unexpectedly acquired substance and seriousness, Allison Miller's large-scale abstract paintings on wood panels – which have been compared to ballpoint-pen sketches – have a surprising, off-kilter solidity. Her limited yet unconventional palette often includes tan, navy, grey and wan beiges and pinks; metallic shades also intermittently appear. Wedges, wavy triangles and rectangles, as well as radiating or bending lines, intersect with and lean against one another on white grounds, like absurd architectural structures. Miller's tendency to combine disparate materials such as oil, acrylic and ink parallels formal disjunctions in her work. (KJ)

Shown by ACME. D16

Selected Bibliography

2006 'Painting à la sculpting, drafting', David Pagel, *The Los Angeles Times*

2006 'Allison Miller', Michael Ned Holte, *Artforum*, October

2006 'Allison Miller at ACME.', Charlene Roth, *Artweek*, October

Selected Exhibitions

2007 'Something about Mary', Orange County Museum of Art, Newport Beach

2007 'New Paintings', ACME., Los Angeles

2006 '25 Bold Moves', House of Campari, Venice, California

2006 'Paintings', ACME., Los Angeles

2001 'Cal's Art: Sampling California Painting', University of North Texas Art Gallery, Denton

Sparkle Freckle
2007
Enamel on metal
61×61cm
Courtesy the artist and Salon 94

Selected Bibliography

2007 'Beauty and Desecration', Barry Schwabsky, *Art in America*, March

2007 *Marilyn Minter*, Johanna Burton et al., Gregory R. Miller Publishers, New York

2006 'Marilyn Minter', Carol Kino, *Art + Auction*

2006 *Whitney Biennial: Day for Night*, Chrissie Iles and Philippe Vergne, Whitney Museum of American Art, New York

1996 'Solitary Refinement: Marilyn Minter's "Coral Ridge Towers"', Bruce Hainley, *Artforum*, January

Selected Exhibitions

2007 'Sparkle Then Fade', Museum of Art, Tacoma

2007 'Les Rencontres d'Arles Photographie', Arles

2006 'Day for Night', Whitney Biennial, New York

2006 Salon 94, New York

2005 San Francisco Museum of Modern Art

Marilyn **Minter**

Born 1948
Lives New York

Since the 1970s Marilyn Minter has been creating both realist paintings and painterly photographs that mine the imagery of glamour and beauty. A darker, more disturbing side is revealed through her tightly cropped, close-up images exposing the cracks in an otherwise perfect façade: a fleshy mouth choking on jewels or a pedicured foot in a mud-spattered stiletto. The high sheen of her enamel-on-metal paintings emulates glossy fashion pages, while the photographs are like the behind-the-scenes of the shoot. Minter's images cross-breed painting with photography, fine art with commerce and fashion with pornography, and cause the viewer to reflect on the issues of gender, sexuality and desire raised in our seductive visual culture. (AC)

Shown by Salon 94 B13

Science Teacher
2007
Cotton lab coat, Marlborough
cigarettes, ballpoint pen, wood,
metal
Dimensions variable
Courtesy Daniel Reich Gallery

Futoshi **Miyagi**

Born 1981
Lives Brooklyn

Futoshi Miyagi's art seems to oscillate between a
desire to reveal everything and the need to
withhold something. In some works the artist
pretends to reveal himself but instead presents us
with surrogates: the flip side of a portrait taped to a
mirror, lyrics of songs he once listened to, portraits
of himself made on over-exposed film. But in
those works in which he does appear he is
remarkably forthright: in the photographic series
'Strangers' (2005–6) he poses in intimate positions
with men he met through the Internet. These
photographs have the immediacy of Nan Goldin's
shots of friends gathered in dimly lit New York
apartments, but the participants remain at a 21st-
century remove from each other. (CL)

Shown by Daniel Reich Gallery F27

Selected Bibliography

2007 'Futoshi Miyagi', David
Velasco, *Artforum*, January

2006 'When Fathers Fail', Joseph
R. Wolin, *Time Out New York*, 19
October

2006 'When Fathers Fail', Darin
Klein, *Artillery Magazine*,
November

2006 'Strangers by Futoshi
Miyagi', Sean Kennedy, *Nerve
Magazine*, September

2006 'Futoshi Miyagi', Holland
Cotter, *The New York Times*, 1
December

Selected Exhibitions

2006 'Brief Procedures', Daniel
Reich Gallery, New York

2006 'When Fathers Fail', Daniel
Reich Gallery, New York

2005 'Group Exhibition', Green
Street Gallery, New York

Untitled (Höhere Wesen befahlen...
Blue)
(Higher Beings Ordered... Blue)
2007
Acrylic on canvas
150×120cm
Courtesy Galleri Nicolai Wallner

Höhere Wesen befahlen: rechte obere Ecke schwarz
malen!

Selected Bibliography

2007 *One in one hundred (child)*,
Jonathan Monk, Paris

2006 *Yesterday Today Tomorrow
etc.*, Stephan Berg, Revolver,
Frankfurt

2006 *Until Then... If Not Before*,
ed. Frederic Paul, Domaine De
Kerguehennec

2006 *Continuous Project Altered
Daily*, ed. Jens Hoffmann and
Claire Fitzsimmons, Institute of
Contemporary Arts, London

2003 *Jonathan Monk*, Lisson
Gallery, London/ Galerie Yvon
Lambert, Paris

Selected Exhibitions

2007 'New Works', Galleri
Nicolai Wallner, Copenhagen

2006 'Yesterday today tomorrow
etc.', Kunstverein, Hanover

2005 'Continuous Project Altered
Daily', Institute of Contemporary
Arts, London

2005 'Family of Man', Centre
d'art Contemporain Domaine de
Kerguéhennec, Bignan

2003 'Time and or Space', The
Swiss Institute, New York

Jonathan **Monk**

Born 1969
Lives Berlin

Jonathan Monk's playful practice lovingly 'kidnaps'
art works, particularly from the *oeuvres* of the
Conceptual, Arte Povera or Minimal artists of the
1960s and '70s. In works such as the acrylic on
canvas *This painting should be hung on the same wall
as an Alighiero e Boetti* (2005) or the film loop *A
Cube Sol LeWitt photographed by Carol Hueber using
nine different light sources and all their combinations front
to back back to front forever* (2001), already canonized
recent art history is correspondingly 'ransomed',
we could surmise, to scare up a supplement of
personal significance for the artist or a revitalized,
ambivalent interpretation. (MA)

Shown by Casey Kaplan A6, Yvon Lambert G5,
Lisson Gallery B8, Meyer Riegger C7, Galleria
Sonia Rosso A9, Galleri Nicolai Wallner A4

Caseys Pink Sleep
2007
Acrylic and plastic mesh on canvas
46×38cm
Courtesy Stuart Shave/Modern Art

Katy **Moran**

Born 1975
Lives London

Katy Moran's canvases often suggest the idyllic 18th-century paintings of Watteau and Fragonard blurred into dreaminess: their hazy smears of blue, green, pink and grey suggestive of silk, swings and summertime skies. If those colour-cued subjects aren't there, it's hard to say what is: Moran gets her images from Google, then inverts them for instant abstraction, suspending her painterly improv when a recognizable scene begins to bloom. The results are populated by phantoms, but nostalgia isn't Moran's bag: probing the points where binaries collapse into each other, her art queries the rationalities that underlie taste's thin divisions. It's also a magic trick, compounding *démodé* approaches into lush quasi-abstracts that threaten to free-fall into kitsch but, disarmingly, never do. (MH)

Shown by Stuart Shave/Modern Art D12

Selected Bibliography

2007 'Top Ten', Katy Moran, *Artforum*, XLV, 6

2007 'Katy Moran', Martin Herbert, *ArtReview*, 9

2006 *Katy Moran*, Modern Art, London

2006 'Reviews: Matthew Monahan, Katy Moran', Martin Herbert, *Time Out*

2005 'London MA Graduates: Katy Moran', Charlotte Edwards, *The Art Review 25*

Selected Exhibitions

2007 Anthony Meier Fine Arts, San Francisco

2007 Andrea Rosen Gallery, New York

2006 Stuart Shave/Modern Art, London

2006 'A Broken Arm', 303 Gallery, New York

2006 'New Contemporaries', Club Row, London; Coach Shed, Liverpool

Untitled (#05-06)
2006
Oil and spray-paint on canvas
219×203cm
Courtesy Galerie Barbara Weiss

Rebecca **Morris**

Born 1969
Lives Los Angeles

There are those who say that it is no longer possible to make an abstract painting, only a painting *of* an abstract painting. Rebecca Morris would seem to bear this out as her canvases chase down the quotable elements of the zenith of 20th-century abstraction. A family of fundamental shapes, often referred to as 'sticks and stones', charged permutations of colour and tone, and the splatter, wobble and pucker of paint become High Modernist moments to be identified and reassessed in relation to the very career of abstract quotation itself, from savvy contemporary painting to bandwagoning civic design. (SO'R)

Shown by Galerie Barbara Weiss G13

Selected Bibliography

2005 *Rebecca Morris: Paintings 1996–2005*, Diedrich Diederichsen and Stephen Westfall, The Renaissance Society, University of Chicago

Selected Exhibitions

2007 Karyn Lovegrove Gallery, Los Angeles

2007 'Abstract', Mitchell-Innes & Nash, New York

2006 'Rebecca Morris: Straight to Hell', Samson Projects, Boston

2006 'Rebecca Morris: For Abstractionists and Friends of The Non-Objective', Galerie Barbara Weiss, Berlin

2005 'Rebecca Morris: Paintings 1996–2005', The Renaissance Society, University of Chicago

Untitled
1988
Mixed media on canvas
140×160cm
Courtesy the artist, maccarone and
archives Muehl

Selected Bibliography

2006 *Otto Muehl: la scene des
profondeurs* (Otto Muehl: Scene of
Depths), Maud Benayoun,
Bookstorming, Paris

2005 *Wiener Aktionismus*, Julius
Hummel, Vienna

2005 *Water without you I'm not*,
Edizioni Charta, Milan/ Fundacion
Bienal de las Artes, Valencia

2004 *Otto Muehl
Leben/Kunst/Werk, Aktion Utopie
Malerei: 1960–2004* (Otto Muehl
Life/Art/Oeuvre, Action Utopia
Painting: 1960–2004), Peter
Noever, Cologne

2004 *Otto Muehl: lettres de prison
1991–1997* (Otto Muehl: Letters
from Prison 1991–1997), Otto
Muehl, Les Presses du Reel, Dijon

Otto **Muehl**

Born 1925
Lives Faro

Otto Muehl is notorious for the founding role he
played in the Viennese Actionist group, which
staged extreme and visceral rituals focusing on the
defilement of the human body. After violently
attacking painting in the 1960s, Muehl has
nonetheless returned to the medium time and
again in a striking range of works that explore
gesture, colour and usually libertine subject matter.
Muehl is a proponent of total societal trans-
formation, and his current practice is indistin-
guishable from his radical experiments in
communal living, which at one point led to a
seven-year prison sentence, and from his
unwavering belief that life itself is nothing less and
nothing more than a work of art. (VR)

Shown by Galerie Krinzinger D17, maccarone B6

Selected Exhibitions

2006 MC Kunst, Los Angeles

2006 'Otto Muehl Summlung
Hummel', MUMOK, Vienna

2005 'Jenseits von Zucht und
Ordnung: 1960–2005',
Kulturstiftung Phoenix Art,
Falckenberg Collection, Hamburg

2004 'Otto Muehl: Leben,
Retrospective 1960–2004', MAK,
Vienna

1998 'Otto Muehl: 7', MAK,
Vienna

Untitled (Pavilion)
2006
Bulletin board, 23 pieces
245×976×245cm
Courtesy Georg Kargl and Mai 36
Galerie

Selected Bibliography

2007 *Matt Mullican: That Person's Workbook*, Ulrich Wilmes, Matt Mullican and Vicente L. de Moura, Ridinghouse/ MER Paperkunsthalle, London

2006 *Matt Mullican: Model Architecture*, Stella Rollig, Lentos Kunstmuseum, Linz

2005 *DC: Matt Mullican Learning from that Person's Work*, Ulrich Wilmes, Museum Ludwig, Cologne

2000 *Matt Mullican: More Details from an Imaginary Universe*, Vincente Todoli, Kerry Brougher and Nuria Enguita Mayo, hopefulmonster, Turin

Selected Exhibitions

2006 'Matt Mullican: talking the talk, walking the walk', Mai 36 Galerie, Zurich

2005 'Two Rooms Learning from that Person's Work', Museum Ludwig, Cologne

2005 'Matt Mullican: Model Architecture', Lentos Kunstmuseum, Linz

2001 'More Details from an Imaginary Universe, Five Worlds: Banners and Flags 1972–2001', Fundació Antoni Tàpies, Barcelona; Kunstmuseum St Gallen; Kunstmuseen, Krefeld; Museion, Bolzano

2000 Georg Kargl, Vienna

Matt **Mullican**

Born 1951
Lives New York

Active since the 1970s, Matt Mullican makes art that is at heart concerned with the relationship between perception and reality, and with the pitfalls of the taxonomic project. Employing a wide variety of media – including drawings, rubbings, light-boxes, banners, bulletin boards and performances carried out under hypnosis – his dense, sometimes visually overwhelming work is threaded through with a personal cosmology that we might nevertheless imagine being adopted (perhaps unwisely) by our planet's every inhabitant. Alive to the complex worlds contained in the smallest particle of information, Mullican has commented: 'People say I'm trying to put everything in the universe into one of my shows. I'm just trying to diagram what we have in us.' (TM)

Shown by Galleria Massimo de Carlo F3, Georg Kargl G16, Mai 36 Galerie C12

Flower Ball (3-D) Kindergarten
2007
Acrylic and silver gold leaf on
canvas, mounted on board
100.5cm (diameter)
Courtesy Gagosian Gallery

Selected Bibliography

2007 *Comic Abstraction*, Roxana
Marcoci, Museum of Modern Art,
New York

2005 *Little Boy: The Arts of Japan's
Exploding Subculture*, Takashi
Murakami, Yale University Press,
New Haven and London

2004 *Fondation Cartier pour l'Art
Contemporain*, Larry Kazal,
Fondation Cartier pour l'art
Contemporain, Paris

2001 *Takashi Murakami summon
monsters? Open the door? Heal? Or
die?*, Takashi Murakami, Museum
of Contemporary Art, Tokyo

1999 *Takashi Murakami, The
Meaning of the Nonsense of Meaning*,
Amanda Cruz, Midori Matsu and
Dana Friis-Hansen, Harry N.
Abrams, New York

Takashi **Murakami**

Born 1962
Lives Tokyo/Saitama

Routinely described as an 'art superstar', Takashi
Murakami's output includes a prolific body of
painting, sculpture and, most recently, feature-
length *anime* film. He has also curated exhibitions
of Japanese art and culture, founded an art fair in
Tokyo, launched his own television and radio
show, and forged a lucrative collaboration with
fashion giant Louis Vuitton. His slick, studio-
produced paintings feature a cast of 'super-flat'
smiling flowers and *manga* characters, while new
multi-panel canvases show brow-furrowed,
goggle-eyed portraits of Zen Buddhism founder
Daruma, adding a further dimension to
Murakami's cross-cultural crusade. (KB)

Shown by Gagosian Gallery D7, Tomio Koyama
Gallery A3, Galerie Emmanuel Perrotin F9

Selected Exhibitions

2007 'Takashi Murakami:
Tranquility of the Heart Torment
of the Flesh - Open Wide the Eye
of the Heart, and Nothing is
Invisible', Gagosian Gallery, New
York

2007 Museum of Contemporary
Art, Los Angeles

2007 'Comic Abstraction',
Museum of Modern Art, New
York

2006 'The Pressure Point of
Painting', Galerie Emmanuel
Perrotin, Paris

2002 'Kaikai Kiki: Takashi
Murakami', Fondation Cartier
pour l'Art Contemporain, Paris;
Serpentine Gallery, London

Once in the XX Century
2004
Video Betacam SP film transferred
to DVD
Courtesy The Fair Gallery

Selected Bibliography

2006 *This is not what you see*, Maria Anna Potocka et al., Bunkier Sztuki, Krakow

2006 *Once in the XX Century*, ed. Martin Clark, Arnolfini, Bristol

2003 *The Role of a Lifetime*, Paul Barratt, Teresa Gleadowe and Jan Verwoert, Art & Sacred Places, Brighton

2003 *Déplacements*, Jennifer Allen, Musée d'Art Moderne de la Ville de Paris/ARC

2001 *Lithuanian Pavilion*, Lolita Jablonskiene et al., 49th Venice Biennale

Selected Exhibitions

2007 'Among The Things We Touched', Secession, Vienna

2007 'Revisiting Solaris', DAAD, Berlin

2007 Sculpture Projects 07, Munster

2006 'Plug in', Van Abbemuseum, Eindhoven

1998 Manifesta 2, Luxembourg

Deimantas **Narkevicius**

Born 1964
Lives Vilnius

Deimantas Narkevicius' probing and poetic films raise questions about the nature of memory and collective identity while extending the Modernist critique of documentary and the limits of representation. The arresting *Legend Coming True* (1999), narrated by one of the few survivors from the Jewish ghetto in Vilnius, places the desire to reconstruct the lost identity of Lithuania following the disintegration of the USSR alongside the disappearance of the country's Jewish population during the Holocaust. *Once in the 20th Century* (2004) questions the veracity of documentary evidence by playing found footage backwards: we become witness to the ironic spectacle of a crowd in Vilnius cheering not the dismantling but the erecting of a statue of Lenin. (AS)

Shown by The Fair Gallery F21

Bachelor Machines, Part 1
2007
16mm film projection
Dimensions variable
Courtesy Picture This and
Chisenhale Gallery

Rosalind **Nashashibi**

Born 1973
Lives London

Rosalind Nashashibi's films and videos explore the patterns and rhythms of the everyday, the non-event or the seemingly inconsequential, in Palestine, Scotland or the USA. Except in the titles she gives her works, her intentions are never made explicit and, despite their duration, none of her films has a real beginning or end. Importantly, Nashashibi never translates or subtitles. In an age of overdetermined art experiences, pretentious explanations and dramatic news footage her work appeals to those aspects of our intelligence that are fuelled by empathy and recognition of common ground, despite geographical, cultural or linguistic differences. (JH)

Shown by doggerfisher G19, Store F3

Selected Bibliography

2007 'Rosalind Nashashibi', Helen Sumpter, *Time Out London*

2007 'This Precious Stone, Set in a Silver Sea', Laura Cumming, *The Observer*, 22 April

2007 *Scotland & Venice*, Phil Long, National Galleries of Scotland, Edinburgh

2006 *British Art Show*, Alex Farquarson and Andrea Schleiker, Hayward Gallery, London

2006 'Rosalind Nashashibi', Mark Godfrey, *Artforum*, December

Selected Exhibitions

2007 'Scotland and Venice', 52nd Venice Biennale

2007 'Bachelor Machines: Part 1', Chisenhale Gallery, London

2007 'Pensée Sauvage', Kunstverein, Frankfurt

2006 'British Art Show 6', BALTIC Centre for Contemporary Art, Gateshead

2004 'Over In', Kunsthalle, Basel

Amnesiac Beach Fire
1999
Wood and plastic
25×120cm
Courtesy Galleria Franco Noero

Selected Bibliography

2006 *Mike Nelson: Lonely Planet*, Rebecca Coates, Australian Centre for Contemporary Art, Melbourne

2005 '8th Istanbul Biennial', Peter Eleey, *frieze*, 80

2004 *Triple Bluff Canyon*, Suzanne Cotter, Modern Art Oxford

2003 *Capp Street Project: 20th Anniversary*, Matthew Higgs and Ralph Rugoff, CCA Wattis Institute for Contemporary Arts, San Francisco

2001 *Mike Nelson: A Forgotten Kingdom*, Will Bradley, Institute of Contemporary Arts, London

Selected Exhibitions

2007 'Breaking Step/U Raskoraku', Museum of Contemporary Art, Belgrade

2007 Galleria Franco Noero, Turin

2007 'Lonely Planet', Australian Centre for Contemporary Art, Melbourne

2006 'Amnesiac Shrine or Double Coop Displacement', Matt's Gallery, London

2005 'Monuments to the USA', CCA Wattis Institute for Contemporary Arts, San Francisco

Mike **Nelson**

Born 1967
Lives London

Mike Nelson creates spaces that offer the possibility of getting lost. Sometimes, as in the case of his labyrinthine installation *The Coral Reef* (2000), this disorientation is literal; at other times, such as in his recent *Mirror Infill* (2006), a series of photographic dark-rooms hidden in the centre of the Frieze Art Fair, the visitor's sense of displacement is due to the incongruity and verisimilitude of the place that he describes. In recreating decrepit corridors, back rooms and storage spaces, Nelson builds psychologically charged environments in which genres and cultural references bump up against one another with the paranoid realism of a waking dream. (JG)

Shown by Galleria Franco Noero A2

Jacob and Esau
2006
Colour photograph
100×130cm
Courtesy Sommer Contemporary
Art

Adi **Nes**

Born 1966
Lives Tel Aviv

Best known for his sensual photographic studies of young Israeli men in military service, Adi Nes has focused in his recent work on the contemporary restaging of biblical narratives by way of well-known paintings from the history of art. In his *Ruth and Naomi Gleaners* (2006) two ragged-clothed women pick up abandoned fruit from the dusty ground of a rubbish-strewn market-place, their poses recalling the stooping serfs in Jean-François Millet's *The Gleaners* (1857). For all the desperation of the scene, it is, like the Old Testament story it references, a celebration of ingenuity, of the pursuit of sustenance and of that precious place, home, against almost insuperable odds. (TM)

Shown by Sommer Contemporary Art F18

Selected Bibliography

2007 *Adi Nes: Less the Horror than the Grace*, Doreet Le Vitte Harten, Tel Aviv Museum of Art

2006 *Adi Nes: Portrait of the Artist as Political Philosopher*, Joel Schalit, Tikkun, Tel Aviv

2005 'Dreaming Art Dreaming Reality', Ellen Ginton, *Tel Aviv Museum of Art*

2005 *Highlights from the Tel Aviv Museum of Art*, ed. Mordechai Omer, Tel Aviv Museum of Art

Selected Exhibitions

2007 'Biblical Stories', Tel Aviv Museum of Art

2005 'The New Hebrews', Martin Gropius–Bau, Berlin

2004 'Between Promise and Possibility: The Photographs of Adi Nes', Fine Arts Museums of San Francisco Legion of Honor

2003 'Saint Sebastian: A Splendid Readiness for Death', Kunsthalle, Vienna

2003 'Revelation: Representations of Christ in Photography', Israel Museum, Jerusalem

Untitled
2006
Lycra tulle, nylon stockings, glass
beads, Polystyrene
450×750×550cm
Courtesy Tanya Bonakdar Gallery

Selected Bibliography

2006 'Ernesto Neto, Olaf Nicolai
and Rebecca Warren', Yuko
Hasegawa, Paolo Herkenhoff and
Philip Ursprung, *Parkett*, 78

2006 *Ernesto Neto: The Malmö
Experience*, Lars Grambye and
Markus Wagner, Malmö Konsthall

2006 *Leviathan Thot*, Franck
Leibovici, Ernesto Neto and Jean
Marc Prevost, Editions du Regard,
Paris

2002 *Ernesto Neto: o corpo, nu
tempo* (Ernesto Neto: The Body, in
Time), Miguel Fernández-Cid et
al., Xunta de Galicia, Centro
Gallego de Arte Contemporánea,
Santiago de Compostela

1999 *Ernesto Neto: naves, céus,
sonhos* (Ernesto Neto: Naves, Skies,
Dreams), Adriano Pedrosa, Galeria
Camargo Vilaça, São Paulo

Selected Exhibitions

2007 Museum of Contemporary
Art, San Diego

2006 'Leviathan Thot', Panthéon:
35th Festival d'Automne, Paris

2006 'Forum 57: Luisa Lambri and
Ernesto Neto', Carnegie Museum
of Art, Pittsburgh

2006 'Ernesto Neto: The Malmö
Experience', Konsthall, Malmö

2005 Museum of Art, Indianapolis

Ernesto **Neto**

Born 1964
Lives Rio de Janeiro

There is an unmistakable familiarity to Ernesto
Neto's forms. They are welcoming. The artist's
amorphous shapes and soft, pliable materials (as
well as the occasional rush of vibrant colour)
arouse the senses and seduce the viewer. Moving
beyond the ethereal light and space installations of
James Turrell and Robert Irwin, Neto's works
invite the body itself. Earlier pieces such as *It
happens when the body is the anatomy of time* (2000),
overwhelmed our sense of smell, but his work has
evolved to overwhelm our desire to touch. In
works such as *Leviathan Thot* (2006) Neto extends
the art object into the viewer's interior being, fully
encasing us in tactile phenomena. (CB)

Shown by Tanya Bonakdar Gallery E8, Galeria
Fortes Vilaça E7, Tomio Koyama Gallery A3,
galerie bob van orsouw C12

London, December 2001
(detail)
2006
C-print (31 photographs)
14×21cm each
Courtesy Stephen Friedman
Gallery

Rivane **Neuenschwander**

Born 1967
Lives Belo Horizonte

An earthier Hanne Darboven, Rivane Neuenschwander clocks time's passing with food, spices, flowers and found objects that variously disintegrate and disappear. She created a calendar out of the 'sell-by' dates on food packaging; another was created from still-lifes that she found at street markets. A 2003 exhibition consisted of walls of ribbons to be taken away by gallery visitors; the practice was inspired by the Bahian superstition that the wishes would come true once the ribbons disintegrated. Her practice's double inscription of *memento mori* – works in the process of deterioration which themselves represent deterioration – contrasts poignantly and adeptly with its often playful appeal. (MG)

Shown by Tanya Bonakdar Gallery E8, Galeria Fortes Vilaça E7, Stephen Friedman Gallery D4

Selected Bibliography

2007 'Rivane Neuenschwander', Kristin M. Jones, *frieze*, 105

2007 *Comic Abstraction: Image-Breaking, Image Making*, Roxana Marcoci, Museum of Modern Art, New York

2006 'Other Stories and Stories of Others', Roberta Smith, *The New York Times*, 22 September

2005 *Ici lá-bas, aqui acolá* (Here and There), Rivane Neuenschwander, Rona Editora, Rio de Janeiro

2003 'Feast for the Eyes', Daniel Birnbaum, *Artforum*, May

Selected Exhibitions

2007 Galeria Fortes Vilaça, São Paulo

2006 Tanya Bonakdar Gallery, New York

2004 'Currents 04: Rivane Neuenschwander', Art Museum, St Louis

2003 'Superficial Resemblance', Palais de Tokyo, Paris

2002 'To/From: Rivane Neuenschwander', Stephen Friedman Gallery, London

Untitled
2006
Graphite, calcium sulphate (plaster)
and animal glue on cedarwood
55.5×55.5cm
Courtesy the artist and Galerie
Chantal Crousel

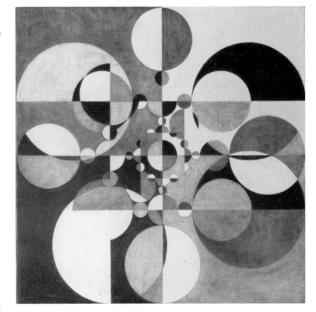

Selected Bibliography

2006 *Gabriel Orozco: The Samourai Tree Invariants*, Verlag Walther König, Cologne

2006 *Gabriel Orozco*, Yve-Alain Bois, Benjamin H.D. Buchloh and interview by Briony Fer, Turner/A&R Press/Conaculta, Mexico City

2005 *Gabriel Orozco*, Museo Nacional Centro de Arte de la Reina Sofia, Madrid

2004 *Gabriel Orozco*, Serpentine Gallery, London/Verlag Walther König, Cologne

2003 *Trabajo*, Molly Nesbit, Angeline Scherf and Jean-Pierre Criqui, Galerie Chantal Crousel, Paris/Verlag Walther Köning, Cologne

Selected Exhibitions

2007 Galerie Chantal Crousel, Paris

2006 Museo del Palacio de Bella Artes, Mexico City

2006 'Blue Orange Prize', Ludwig Museum, Cologne

2006 White Cube, London

2005 Palacio de Cristal, Museo Nacional de Arte Reina Sofia, Madrid

Gabriel **Orozco**

Born 1962
Lives New York/Paris/Mexico

Gabriel Orozco creates lyrical encounters with everyday life in a diversity of media. Early photographs documenting ordinary objects in unexpected situations – for example, five potatoes placed atop five stacks of spiral notebooks in a stationery store in *Five Problems* (1992) – combine the tradition of the ready-made with the Surrealist poetics of chance encounter. Later large-scale sculptures such as *Ping Pond* (1998), a ping-pong table with a lily pond at its centre, enlist the viewer in a surprising, physical confrontation. The artist's newest venture documents molecular structures through the idiom of Geometric Abstraction. The common thread in Orozco's work is the effect of our actions on the surrounding world, a world that proves ever malleable and ever resistant. (CG)

Shown by Galerie Chantal Crousel D3, Marian Goodman Gallery F14, kurimanzutto H3, White Cube/Jay Jopling F13

Adrian **Paci**

Born 1969
Lives Milan

In his video and photographic works Adrian Paci rarely strays far from home. For an Albanian living in Italy this often involves conceptual leaps across the highly policed Adriatic. His subjects have included his infant daughter's memory of civil unrest, a portrait of an academically trained painter-turned-forger in a market stall and day-workers holding globes lit by generators on the steps of a town square. While compelling personal narratives often provide starting-points, Paci's works are meditations on proximity and distance, the representational politics of pointing the lens and how one frames 'documentary'. (DE)

Shown by francesca kaufmann A7, Galerie Peter Kilchmann E2

Selected Bibliography

2007 *Adrian Paci: Per Speculum*, Michael Stanley et al., Milton Keynes Gallery

2006 *Adrian Paci*, Angela Vettese et al., Edizioni Charta, Milan

2006 *Shoot the Family*, Ralph Rugoff, Independent Curators International, New York

2005 *Always a Little Further: 51st Venice Biennale*, ed. Rosa Martinez and Maria de Corral, Venice Biennale

2005 'Strong Current', Dominic Eichler, *frieze*, 94

Selected Exhibitions

2007 'Adrian Paci: Per Speculum', Milton Keynes Gallery

2006 'Adrian Paci: Raccontare', Galleria Civica, Modena

2006 Basis voor Actuele Kunst, Utrecht

2005 PS1 Contemporary Art Center, New York

2005 'Perspective 147: Adrian Paci', Contemporary Arts Museum, Houston

3. *Aktion*
(3rd Action)
1970
Silver gelatin print
24×30cm
Courtesy Galerie Krinzinger

Selected Bibliography

1992 *Rudolf Schwarzkogler: Leben und Werk* (Rudolf Schwarzkogler: Life and Work), Eva Badura-Triska and Hubert Klocker, MUMOK, Vienna

1989 *Aktionsmalerei – Aktionismus* (Action Painting – Actionism), Peter Noever, Museum für Angewandte Kunst, Vienna

1989 *Wiener Aktionismus, Band 2. Wien 1960–1971. Der zertrümmerte Spiegel* (Viennese Actionism, Volume 2. Vienna 1960–1971. The Mirror Cracked), Hubert Klocker, Ritter Verlag, Klagenfurt

1988 *Wiener Aktionismus, Band 1. Von der Aktionsmalerei zum Aktionismus. Wien 1960–1965* (Viennese Actionism, Volume 1. From Action Painting to Actionism. Vienna 1960–1965), Hubert Klocker, Ritter Verlag, Klagenfurt

1976 *Rudolf Schwarzkogler*, Günter Brus, Hermann Nitsch and Peter Weiermair, Galerie Krinzinger, Innsbruck

Selected Exhibitions

2006 'Into Me/Out of Me', PS1 Contemporary Art Center, New York

2004 'Kunst & Revolte –Archiv Wiener Aktionismus', MUMOK, Vienna

2002 'Homage to Rudolf Schwarzkogler', Galerie Krinzinger, Vienna

1998 'Out of Actions: Between Performance and the Object 1949–1979', Museum of Contemporary Art, Los Angeles; MAK, Vienna; MAC, Barcelona; MOCA, Tokyo; NMA, Osaka

1972 documenta 5, Kassel

Rudolf **Schwarzkogler**

Born 1940
Died 1969

By tenacious legend Rudolf Schwarzkogler died from a publicly performed self-castration. The truth is more prosaic: he jumped out of a fifth-floor window during a period of depression. A member of the Vienna Actionist group, alongside Hermann Nitsch, Otto Muehl and Günter Brus, Schwarzkogler avoided the publicity sought by his peers. His intricately orchestrated rituals were performed either in private or before a small group of initiates and usually featured participant actors, the corpses of fish and chickens, surgical gauze and the occasional light bulb. Their dark mortifications have been preserved only as relatively small-format vintage photographs but remain an influence on contemporary art, such as that of Paul McCarthy. (AJ)

Shown by Galerie Krinzinger D17

Untitled
2006
Acrylic and batik process on canvas
200×200cm
Courtesy Andersen_s
Contemporary

Anja **Schwörer**

Born 1971
Lives Berlin

Anja Schwörer sees in her paintings 'a kind of force field' in which 'spatial powers spread out'. Indeed, in each of her mostly black paintings, which are made using a batik process of folding, bleaching and dyeing, there is a visible struggle between a psychedelic handicraft process and a formal painterly language. Expanding black grids or radiating lines appear against accidental splashes of bleach or colour, as though Schwörer intends to tame the chance patterns of the batik with rigid, deliberate gestures. Her works call to mind Frank Stella's 'Black Paintings', made by a hippie who's turned to Heavy Metal, or Rorschach tests that reveal skulls or demons rather than butterflies. (CL)

Shown by Andersen_s Contemporary F17

Selected Bibliography

2007 *Konkretismus: Material, Sprache und Abstraktion seit 1955* (Concretism: Material, Language and Abstraction since 1955), ed. Andreas Pinczewski, Claudia Seidel and Renate Wiehager, Baden-Württembergische Bank, Stuttgart

Selected Exhibitions

2007 Andersen_s Contemporary, Copenhagen

2007 'Group Show', Galerie Almine Rech, Paris

2006 'Konkretismus', Baden-Württembergische Bank, Stuttgart

2006 'exploding white mice', Showroom, Berlin

2006 'irrational thoughts should be followed logically', Elizabeth Dee Gallery, New York

*31st December 1999,
off The Albanian Coast*
2000
Cibachrome
97×247cm
Courtesy Galeria Filomena Soares

Selected Bibliography

2006 *Critical Realism in Contemporary Art: Around Alan Sekula's Photography*, ed. Jan Baetens, University of Leuven

2003 *Allan Sekula: Performance under Working Conditions*, Sabine Breitwieser, Generali Foundation, Vienna

2000 *TITANIC's wake*, Allan Sekula, Camera Austria, Graz/ Maumaus: Escola de Artes Visuais, Lisbon

1997 *Dead Letter Office*, Benjamin H.D. Buchloh et al., Netherlands Foto Instituut, Rotterdam

1995 *Fish Story*, Allan Sekula and Benjamin H.D. Buchloh, Witte de With, Rotterdam

Selected Exhibitions

2007 documenta 12, Kassel

2006 'Allan Sekula: Fish Story Chapter One', FRAC Bretagne, Université du Havre/Maison de l'Etudiant, Le Havre

2004 'Secret Formula: Wealth without Workers', Galeria Filomena Soares, Lisbon

2003 'Performance Under Working Conditions', Generali Foundation, Vienna

2002 documenta 11, Kassel

Allan **Sekula**

Born 1951
Lives Los Angeles

So much contemporary art pretends to be 'about' globalization in some nebulous sense that it is sometimes hard to tell actual analysis from simple aspiration. Allan Sekula is the genuine, assiduous article: an artist unafraid to match his ongoing academic critique of the contemporary image with an often arduous engagement in the real world. From his earliest reflections – in *Aerospace Folktales* (1973) – on his own family's implication in the US military–industrial complex through *Fish Story* (1995), his study of the geopolitical machinery of the container shipping industry, to his recent images of anti-capitalist protest, Sekula has consistently married critical rigour to visual impact. (BD)

Shown by Galeria Filomena Soares H7

Schäferjunge (Gigant)
(Young Shepherd, Giant)
2007
Piezo print on paper
40×34cm
Courtesy Galerie Guido W.
Baudach

Markus **Selg**

Born 1974
Lives Berlin

In his extremely dense and versatile work Markus Selg employs a variety of media – sculpture, installation and computer-generated 'painting' – to create a collage of what he considers the most salient elements of ancient and modern times, interwoven with glimpses of a possible future. Owing a heavy debt to German Expressionism (both painting and film), his installations are like film sets, his sculptures like the protagonists of those films. His focus is on the human figure, but always shattered, displaced and deconstructed; these are the members of a shadow army, knights returning from an ill-fated quest, their hopes and ideals lost. (AC)

Shown by Galerie Guido W. Baudach E20, Galerie Christian Nagel E3

Selected Bibliography

2007 *PAX: Armies and Caravans Brought To Halt*, Lina Launhardt, Ottmann GmbH & Co. Südhausbau KG, Munich

2006 *Chronik: Density, Struggle, Man*, Thomas Groetz, Hatje Cantz Verlag, Ostfildern Ruit

2006 *The Moloch's Laugh*, Zdenek Felix, Guido W. Baudach, Berlin

2006 *Imagination Becomes Reality Part IV: Breaking New Ground: A Conversation with Markus Selg*, Karsten Löckemann, Kunstverlag Ingvild Goetz, Munich

2005 'dead/undead: Retro Mechanismen in der aktuellen Kunst' (dead/undead: Retro Mechanism in Contemporary Art), Cornelia Gockel, *Kunstforum*

Selected Exhibitions

2007 'Imagination Becomes Reality', ZKM Centre for Art and Media, Karlsruhe

2007 'Delphi/The Human Rainbow', Daniel Hug, Los Angeles

2006 'PAX/Lektion in Frieden', Cabinet, London

2006 'MolocH', Kunstverein, Oldenburg

2004 'Amnesia', Galerie Guido W. Baudach, Berlin

Seven Year's Itch
2006
Oil on canvas
203×203cm
Courtesy Burger Collection,
Switzerland/Hong Kong

Shi Xinning

Selected Bibliography

2005 *China: Contemporary Painting*,
Lorenzo Sassoli de Bianchi,
Damiani, Bologna

Selected Exhibitions

2007 'Remixed and Revisited:
New Visions of China', Arndt &
Partner, Zurich

2005 'Mahjong: Contemporary
Chinese Art from the Sigg
Collection', Kunstmuseum, Bern

2005 'Chinese Contemporary
Paintings', Marella Arte
Contemporanea, Bologna

2004 'Landscapes', Gallery of Art,
Shanghai

2001 'Fake Reality: Shi Xinning',
Fan Gallery, Beijing

Born 1969
Lives Beijing

The protean artist Shi Xinning repaints iconic press
photos in oil on canvas, inserting the figure of
Chairman Mao in their black and white, musty
mise-en-scène: he sits between Winston Churchill
and Franklin D. Roosevelt at Yalta; he watches
over Peggy Guggenheim as she sunbathes in
Venice; he faces Joe McCarthy at the Con-
gressional hearings during the USA's Red Scare.
Shi's *Zelig*-like gambit plays on the ubiquity of
Mao, both in images and in recounted stories, and
shows how cheaply half-truths are made – as well
as their potential when transformed into fiction.
(MG)

Shown by Arndt & Partner G21

Leslie **Shows**

Born 1977
Lives San Francisco

Overflowing waste-paper bins and forgotten stationery cupboards provide the materials for Leslie Shows' large-scale collages of social and ecological decline. These visions of washed-out landscapes are acts of recycling in themselves: futile attempts at sustainability, scattered with trodden confetti, magazine off-cuts and half-moons of hole-punched paper. Yet amid the empty fields and ruins Shows' pieces reveal a hallucinatory beauty, all the more affecting for the suspicion that these retro-futurist dystopias could just possibly be snapshots of today. (ST)

Shown by Jack Hanley Gallery A8

Selected Bibliography

2007 'SECA Award Winners', Kenneth Baker, *San Francisco Chronicle*

2006 'Must-See Art', Amra Brooks, *LA Weekly*

2006 'California Above All', Elizabeth Armstrong, *ArtReview*

2005 'Eco: Art About the Environment', Mark Van Proyen, *Artweek*

2005 'Leslie Shows', Glen Helfand, *Artforum.com*

Selected Exhibitions

2007 'SECA Art Award', San Francisco Museum of Modern Art

2006 'Carbon Freeze', Jack Hanley Gallery, Los Angeles

2006 'Californial Biennial', Orange County Museum of Art, Newport Beach

2005 'International Parks', Jack Hanley Gallery, San Francisco

2005 'Murphy/Cadogan Awards Show', Arts Commission Gallery, San Francisco

Untitled (Balls)
2007
Ink and marker on paper
42×30cm
Courtesy Galleri Nicolai Wallner

David **Shrigley**

Born 1968
Lives Glasgow

The characters that live in David Shrigley's world have good reason to be anxious. Theirs is a morally fraught universe, in which the slightest action has the gravest implications, and in which a bumbling god is constantly beset by a scrawny but determined devil. In the celestial sphere above these figures is Shrigley himself, sketching out dilemmas, complaints and warnings in his shaky, amateurish hand or incorporating them into sculptures, paintings, photographs and animations. Despite being frequently hilarious, the voices that emerge through misspelt and unkempt lines of text have a sincerity that hints that perhaps they aren't so very different from our own. (JG)

Shown by BQ B5, Stephen Friedman Gallery D4, Yvon Lambert G5, Galerie Francesca Pia H11, Galleri Nicolai Wallner A4

Selected Bibliography

2005 *The Book of Shrigley*, David Shrigley, Redstone Press, London

2004 *Blocked Path*, David Shrigley, Galleri Nicolai Wallner, Copenhagen

2004 *Kill Your Pets*, David Shrigley, Revolver, Frankfurt

2004 *Joy*, David Shrigley, Chronicle Books, San Francisco

2003 *Who I Am and What I Want*, David Shrigley, Redstone Press, London

Selected Exhibitions

2007 Galleri Nicolai Wallner, Copenhagen

2006 Contemporary Arts, Dundee

2006 'Drawings', The Journal, New York

2006 'New Etchings and Woodcuts', Galleri Nicolai Wallner, Copenhagen

2003 Kunsthaus, Zurich

Probably Eight or Half of Each
2007
Hollow core doors, carpet, staples,
Plexiglass
Dimensions variable
Courtesy Private collection, New
York

Gedi **Sibony**

Born 1973
Lives New York

Gedi Sibony's materials might be more commonly found in a hardware shop: plywood, rubbish bags and hollow-core doors are arranged to appear as staged accidents, but the elegant articulation of space within these compositions of ready-mades betrays their careful conception. *THEIR PROPER PLACES THE ENTITIES FROM WHICH PARTIAL ASPECTS EMERGE* (2006) uses the unexpected allure of grey carpet both to occupy space and to create it. By directing our attention to the most precarious parts of his installations, Sibony foregrounds the slapstick and in doing so finds humour in the stuff that surrounds us. (BB)

Shown by Art : Concept G10, Zero... G3

Selected Bibliography

2006 'Gedi Sibony Interview', Philippe Vergne, *Flash Art International*

2006 'Gedi Sibony', Suzanne Hudson, *Artforum*, November

2006 'Interview', Elizabeth Schambelan, *The Wrong Times*, 2

2004 'Art in Review: Gedi Sibony', Roberta Smith, *The New York Times*

2001 *PS1/Clocktower*, Paulo Herkenhoff, PS1 Contemporary Art Center/Clocktower Gallery, New York

Selected Exhibitions

2007 Kunsthalle, St Gallen

2007 Zero..., Milan

2007 Midway Contemporary Art, Minneapolis

2007 'Unmonumental', The New Museum, New York

2006 'Day for Night', Whitney Biennial, New York

Video Know
2002/2006
Painting (acrylic on canvas), ten
drawings (mixed media), two
sculptures (modelling clay, mixed
media)
Dimensions variable
Courtesy Galerie Barbara Weiss

Selected Bibliography

2007 *Skulptur.Projekte Münster*
(Sculpture Projects Munster),
Brigitte Franzen et al., Skulptur.
Projekte Münster, Cologne

2000 *Aus: Gesellschaft mit
beschränkter Haftung* (From: Limited
Liability Company), Andreas
Siekmann, Verlag Walther König,
Cologne

1999 *Platz der permanenten
Neugestaltung* (Square of Permanent
Reorganization), Andreas
Siekmann and Hubertus Butin,
Verlag Walther König, Cologne

1993 *Wir fahren für Bakunin*
(We're rolling for Bakunin),
Andreas Siekmann and Hubertus
Butin, Verlag Walther König,
Cologne

Selected Exhibitions

2007 documenta 12, Kassel

2007 Sculpture Projects 07,
Munster

2004 'Aus: Die Exklusive – Zur
Politik des ausgeschlossenen
Vierten', Galerie Barbara Weiss,
Berlin

2004 'Ex Argentina: Schritte der
Flucht von der Arbeit zum Tun',
Museum Ludwig, Cologne

1999 'Andreas Siekmann. Aus:
Gesellschaft mit beschränkter
Haftung', Galerie Barbara Weiss,
Berlin

Andreas **Siekmann**

Born 1961
Lives Berlin

Andreas Siekmann's 2005 exhibition at Galerie
Barbara Weiss had a carnivalesque atmosphere:
friezes of tourist-inspired imagery, as well as
maquettes of cars and pedestrians, encircled the
spaces of the gallery. Yet the panoptic shape of
Siekmann's installation, and the curious presence of
model police among the regular civilians, implied a
contentious political agenda within this set-up.
Here public social space was co-ordinated into a
rigid system, and individuals within that space were
subordinated to the powerful control of the state.
(CB)

Shown by Galerie Barbara Weiss G13

The Fold
2007
Ink on paper
203.5×168cm
Courtesy the artist and Regen
Projects

Paul **Sietsema**

Born 1968
Lives Los Angeles

Playing, as ever, with the mutability and mediation of meaning, Paul Sietsema's latest project, *Oceania*, looks at artifacts from the South Pacific and links them to Western art movements such as post-Minimalism or the German collective November Gruppe. Taking the form of a 16mm film as well as silkscreens, mixed-media sculpture, collages and text-based drawings, this anthropological study completes the trilogy of films that began with *Untitled (Beautiful Place)* (1998) and followed with *Empire* (2002). Sietsema's work is fascinated by context – both of place (*Empire*, for example, shows canonical Abstract Expressionist works installed in the formalist critic Clement Greenberg's apartment) and of time – but, above all, by the moment when context unravels. (MG)

Shown by Regen Projects C10

Selected Bibliography

2007 *L'empire de la vision* (The Empire of Vision), Alain Cueff, Centre Georges Pompidou, Paris

2005 *L.A. Artland: Contemporary Art from Los Angeles*, Chris Kraus, Jan Tumlir and Jane McFadden, Black Dog Publishing, London

2003 *Empire: Paul Sietsema*, Chrissie Iles, Whitney Museum of American Art, New York

2003 'Paul Sietsema: Empire', Giovanni Intra, *Flash Art International*

2001 *Construction of Vision*, Paul Sietsema, Sonsbeek, Arnhem

Selected Exhibitions

2007 'Uncertain States of America', Kunstmuseum, Herning

2007 'USA: American Video Art at the Beginning of the 3rd Millennium', 2nd Moscow Biennial

2006 'Le Mouvement des Images', Centre Georges Pompidou, Paris

2005 'Ecstasy: In and About Altered States', Museum of Contemporary Art, Los Angeles

2003 'Paul Sietsema: Empire', Whitney Museum of American Art, New York

Leonora (Death)
Installation view
2006
Permanent marker pen and pencil
on paper
140×470cm
Courtesy the artist, doggerfisher
and Elisabeth Kaufmann

Selected Bibliography

2007 'Lucy Skaer & Anita di
Bianco', Valerie Knoll, *Artforum*

2006 *Try Again. Fail Again. Fail
Better*, Annette Kierulf and Mark
Sladen, Momentum, Moss

2006 *Lucy Skaer: Drawings 2004–
2005*, Benjamin Greenman,
doggerfisher, Edinburgh

2005 *Vitamin D: New Perspectives
in Drawing*, Emma Dexter, Phaidon
Press, London

2004 'Lucy Skaer', Gilda
Williams, *Art Monthly*, 279

Selected Exhibitions

2007 'Scotland and Venice', 52nd
Venice Biennale

2006 'Momentum', Nordic
Festival of Contemporary Art,
Moss

2006 'British Art Show 6',
BALTIC Centre for
Contemporary Art, Gateshead

Lucy **Skaer**

Born 1975
Lives Glasgow and Basel

Often made on Fabriano paper, Lucy Skaer's
drawings in dense graphite, ink and gold leaf
employ found images from various printed sources,
which she combines to mutually destabilizing effect
with abstract passages of pattern. These drawings –
which resemble the tattered banners of routed
regiments – are complemented by the artist's
public actions, which have seen her introduce
moth and butterfly pupae into a London law court
and place a scorpion and a diamond side by side on
an Amsterdam pavement. Juxtaposition, in Skaer's
art, is not about contrasting one thing with another
to pedagogical ends, but about creating strange
dialogues in strange tongues that open up strange
possibilities. (TM)

Shown by doggerfisher G19

The Adventurers
2006
Collage on paper
91.5×35.5cm
Courtesy the artist and Rivington
Arms

Dash **Snow**

Born 1981
Lives New York

The art and the life of Dash Snow are difficult to separate: the Dionysian downtown Manhattan scene he frequents is perhaps the most discernible influence on his Polaroid photographs, assemblages and collages. Works made using cigarette butts, saliva, phlegm and semen, such as the collage series 'Fuck the Police' (2002–5), comprising newspaper clippings sprayed with the artist's semen, attest to the way in which Snow's practice is rooted in his lived existence. His recent sculpture made from hundreds of used counterculture titles *Untitled (Book Fort)* (2006) could also be seen as an indirect portrait, in which the pages touched and the words read by Snow are given as clues to his identity. (SL)

Shown by Contemporary Fine Arts D2, Rivington Arms F29

Selected Bibliography

2007 'Chasing Dash Snow', Ariel Levy, *New York Magazine*

2006 'Dash Snow: Silence is the Only True Friend That Shall Never Betray You', Thomas Micchelli, *The Brooklyn Rail*

2006 'Dash Snow', Holland Cotter, *The New York Times*

2006 'Dash Snow', Michael Wilson, *Artforum*

2006 'Dash Snow', Leo Fitzpatrick, *The Journal*, 6

Selected Exhibitions

2007 'The End of Living, The Beginning of Survival', Contemporary Fine Arts, Berlin

2007 'Jalouse', Palais de Tokyo, Paris

2006 'Silence Is The Only True Friend That Shall Never Betray You', Rivington Arms, New York

2006 'Defamation of Character', PS1 Contemporary Art Center, New York

2005 'Moments Like This Never Last', Rivington Arms, New York

Apparatus (Sony DCR-PC120E Disassembled)
2007
Light-jet print
60.5×90.5cm
Courtesy Galerie Neu

Selected Bibliography

2006 'Über "Untitled (Archive Iraq)" von Sean Snyder' (On "Untitled (Archive Iraq)" by Sean Snyder), Sven Lütticken, *Texte zur Kunst*

2005 *Untitled (Archive Iraq) 2003–2005*, Sean Snyder, Akiyoshidai International Art Village, Japan

2005 *Sean Snyder*, De Appel, Amsterdam/Neue Kunst Halle, St Gallen/Portikus, Frankfurt

2005 *Sean Snyder*, Secession, Vienna

2002 *Bucharest, Slobozia, Dallas, Pyongyang*, DZ Bank Kunststipendium, Künstlerhaus Bethanien, Berlin

Selected Exhibitions

2007 Galerie Neu, Berlin; Stedelijk Museum, Amsterdam

2006 Sala Rekalde, Bilbao

2005 Galerie Neu, Berlin

2005 Secession, Vienna

2005 Portikus, Frankfurt

Sean **Snyder**

Born 1972
Lives Berlin

In a recent series of solo exhibitions Sean Snyder laid out a dense network of interrelations – often among Cold War visual codes and Modernist architectures that have been distributed globally, despite perceived political divisions. He excavates stories such as that of the Balkan town of Skopje, which, under UN supervision, was rebuilt after a 1963 earthquake – using plans originally drawn up for Tokyo Bay. *Analepsis* (2003–4) is a silent montage of oblique, generic spaces and of ways to film them. Snyder is not 'just' an urban sociologist: focusing less on the 'hard' facts than on the 'soft' gaps between them, he extrapolates the aesthetic of a place as much as its social significance. (JöH)

Shown by Galerie Chantal Crousel D3, Lisson Gallery B8, Galerie Neu B4

Untitled (From After)
2006
Marble
10×50×27cm
Courtesy Galeria Fortes Vilaça

Selected Bibliography

2006 *Seduções: Valeska Soares, Cildo Meireles and Ernesto Neto*, Valeska Soares, Hans-Michel Herzog and Rodrigo Moura, Daros Latinamerica/ Hatje Cantz Verlag, Ostfildern Ruit

2006 *Caprichos* (Follies), Marysol Nieves et al., Bronx Museum of the Arts, New York/ Museo de Arte Contemporáneo, Monterrey/ Art Gallery, Hamilton

2005 *Always a Little Further: 51st Venice Biennale*, ed. Rosa Martinez and Maria de Corral, Venice Biennale

2004 *Valeska Soares: Swirl*, Adrian George, Biennial of Contemporary Art, Liverpool

1999 *Ponto de Fuga* (Vanishing Point), Adriano Pedrosa and Vik Muniz, Galeria Camargo Vilaça, São Paulo

Valeska **Soares**

Born 1957
Lives New York

Valeska Soares collects objects such as tiles, pastries and perfume, which she then displaces, rearranges and reconfigures into groups of sculptures, installations, photographs and videos. She combines Minimalism (polished metals and repetition) with a baroque and documentary sensibility – one piece, for example, includes a looped video of footage from the 1940s of a Modernist night-club in Brazil, while another recreates the flowerpots and saucers from a garden the artist once had. Soares has described her work as 'a visit to my private universe […] there's no way to separate where your thoughts come from'. (JH)
Shown by Galeria Fortes Vilaça E7

Selected Exhibitions

2006 'Walk on By', Art Gallery, Hamilton

2006 'Venice–Istanbul', Museum of Modern Art, Istanbul

2005 51st Venice Biennale

2005 'Inverting the Map: Latin American Art from the Tate Collection', Tate, Liverpool

2003 'Follies', The Bronx Museum of the Arts, New York

The Real Estate Broker
2007
Acrylic and black drawing ink on
giltcarved lime wood
40×50×4cm
Courtesy Arndt & Partner

Selected Bibliography

2006 *Nedko Solakov: Earlier Works*,
Lara Boubnova, Kehrer Verlag,
Heidelberg

2006 'The Story Teller. Nedko
Solakov: Nine Objects, Leftovers
and the Collector of Art', Michele
Robecchi, *contemporary*, 80

2006 'Nedko Solakov: Leftovers',
Giovanni Carmine, *frieze*, 96

2005 'Museum-quality Leftovers',
Marc Spiegler, *ArtReview*

2003 *Nedko Solakov: A 12 1/3
(and even more) Year Survey*, Saul
Anton et al., O.K. Centrum für
Gegenwartskunst, Bozen

Selected Exhibitions

2007 Italian Pavilion, 52nd Venice
Biennale

2007 2nd Moscow Biennial

2007 'New Noah's Ark & New
Paintings', Arndt & Partner, Berlin

2006 2nd International Biennial of
Contemporary Art, Seville

2006 'Earlier Works', Kunsthalle,
Mannheim

Nedko **Solakov**

Born 1957
Lives Sofia

Nedko Solakov uses humour like a perverse
emergency aid agency. His ironic interventions
have been brought to bear on crises such as the
Arab–Israeli conflict, which, as Solakov suggested
to the embassies of Israel and Palestine in his video
Negotiations (2003), might be temporarily resolved
for the duration of his visit to the area. His recent
series of drawings 'Fears' (2007) is a more subtle
enterprise – in one work a blob of a black jellyfish
is captioned with the source of her own distress,
'Deep Waters' – which presents the slightest of
humorous gestures as a valuable means through
which individuals can intervene in the structures of
society. (BB)

Shown by Arndt & Partner G21, Galleria
Massimo Minini F11

Sin título. Viento 1
(Untitled. Wind 1)
2003
Video
Courtesy Galería Helga de Alvear

Montserrat **Soto**

Born 1961
Lives Barcelona

The ruins of a 17th-century stone city in Mauritania, fields of abandoned agricultural polytunnels on the Spanish island of Fuerteventura, ancient crosses and communication towers near Santiago de Compostela – the photographs of Montserrat Soto betray humankind's fraught co-existence with landscape in their very lack of direct human presence. Recently, however, the human figure has threaded its way into her work in video, in the form of a collaboration with the poet Dionisio Cañas, who appears in her meditative seven-screen installation *Lugar de Silencios* (Place of Silences, 2007). (MA)

Shown by Galería Helga de Alvear H4

Selected Bibliography

2007 *Archivo de archivos* (Archive of archives), Centre d'Art La Panera, Lleida

2005 *Tracking Madrid*, Museo Nacional Centro de Arte Reina Sofia, Madrid

2004 *Paisaje y memoria* (Landscape and Memory), La Casa Encendida, Madrid

2004 *Paisajes secretos* (Secret Landscapes), Fundación Telefónica, Madrid

2004 *Montserrat Soto: Del umbral al límite* (Montserrat Soto: From the Threshold to the Limit), Museo Koldo Mitxelena, San Sebastián

Selected Exhibitions

2007 'Lugar de silencios', Centre d'Art Santa Monica, Barcelona

2006 'Archivo de archivos', Centre d'Art La Panera, Lleida

2005 'Tracking Madrid', Museo Nacional Centro de Arte Reina Sofia, Madrid

2004 'Paisajes secretos', Fundación Telefónica, Madrid

2002 'BIG SUR: Neue Spanische Kunst', Hamburger Banhof, Berlin

*Enigmas 3 & 4: Tablecloth from
Artforum Dinner, Art Basel Miami,
December 8, 2006*
2006
Tablecloth, stolen and stretched,
diptych
122×92cm each
Courtesy the artist and Galerie
Chantal Crousel

Selected Bibliography

2006 'Reena Spaulings Fine Art',
Katie Stone Sonnenborn, *frieze*, 97

2006 'Reena Spaulings: elle est
douée mais ce n'est pas David
Hammons' (Reena Spaulings: She's
Clever but She Isn't David
Hammons), Anthony Huberman,
Zérodeux, Spring

2005 'Reena Spaulings', Holland
Cotter, *The New York Times*, 4
February

2004 *Reena Spaulings*, Bernadette
Corporation, Semiotext(e), New
York

Selected Exhibitions

2007 'How to Cook a Wolf',
Kunsthalle, Zurich

2006 'Beware of a Holy Whore',
Galerie Chantal Crousel, Paris

2006 'Uncertain States of
America', Serpentine Gallery,
London

2006 'Day for Night', Whitney
Biennial, New York

2006 'Make Your Own Life',
Institute of Contemporary Art,
Philadelphia

Reena **Spaulings**

Founded 2004
Based New York

Reena Spaulings is a 'female 20-something', an art
dealer turned artist with a gallery in downtown
Manhattan. She has produced a series of 'money
paintings' based on international currency, is the
subject of a self-titled novel and has brought out a
CD. She is also, however, a fiction, generated by
Bernadette Corporation, a New York-based
collective who assembled the various writers, artists
and musicians to produce the collectively authored
novel, artwork and music that goes by her name.
Beneath her shape-shifting form, questions of
authorship and authenticity, individualism and
identity, unravel to reveal a subtle investigation
into dominant roles and modes of interaction in
the art world. (KB)

Shown by Galerie Chantal Crousel D3, Sutton
Lane G1

Wegziel
(Path-goal)
2004
Oil on canvas
150×200cm
Courtesy Aurel Scheibler

Peter **Stauss**

Born 1966
Lives Berlin

Peter Stauss' chaotically colourful paintings throw a veritable monkey wrench into the gears of what Giorgio Agamben dubbed the 'anthropological machine', suspending the difference between the human and the animal and engendering a dark, carnivalesque universe populated by grotesque figures and sundry remnants of civilization. A freak show full of the scars of the 20th century, Stauss' panoply of characters – from Buddhas and comic-strip creations to heroes of historical legends, apes and dogs – channel the anarchic impulses of Hieronymus Bosch, Francisco Goya and James Ensor while perpetuating the avant-gardist revolt against narration in favour of deformed, frozen gestures. (AS)

Shown by Galerie Aurel Scheibler G17

Selected Bibliography

2006 'Melancholische Wesen auf dem Platz des himmlischen Friedens' (Melancholic Creatures on Tiananmen Square), Wiebke Huester, *Frankfurter Allgemeine Zeitung*

2006 'Farbig, poppig, frech' (Colourful, Cheerful and Bold), Bertram Müller, *Rheinische Post*, Dusseldorf

2003 *Dirty Ghandi*, Viet Loers, Galerie Crone, Hamburg

1999 *Enigmatic Voices*, Marcus Steinweg, Aurel Scheibler, Cologne

Selected Exhibitions

2006 Casser Grunert, New York

2006 Galerie Crone Andreas Osarek, Berlin

2004 'Happy Days Are Here Again', David Zwirner, New York

2002 'Des Alpes et des Pyrénées', Aurel Scheibler, Cologne

1999 'Kartoffelesser', Aurel Scheibler, Cologne

Speckhouse
2007
Acrylic and oil on canvas
190×220cm
Courtesy Galerie Fons Welters

Selected Bibliography

2006 'Figuratieve suspense en frivool maniërisme' (Figurative Suspense and Frivolous Mannerism), Xandra de Jongh, *De Volkskrant*

2006 *Heart of Paint*, Frank Hoenjet, Kunstcentrum Hengelo/ Galerie Fons Welters, Amsterdam

2004 'Gé-Karel van der Sterren: De schilderkunst leeft!' (Gé-Karel van der Sterren: Painting is Alive!), Xandra de Jongh, *Kunstbeeld*

2002 'New York is een Begin voor Van der Sterren' (New York is a Beginning for Van der Sterren), Arian Reinders, *Het Parool*

2001 *Liquid City*, Paul Groot, Galerie Fons Welters, Amsterdam

Selected Exhibitions

2007 'Jeanne Oosting Prize', Centraal Museum, Utrecht

2006 'Point of View', Galerie Fons Welters, Amsterdam

2003 'How High Can You Fly', Kunsthaus Glarus, Switzerland

2002 'Tricky Twist', Gemeentemuseum, Helmond

2002 'Darker Gardens', Henry Urbach Architecture, New York

Gé-Karel **van der Sterren**

Born 1969
Lives Amsterdam

Gé-Karel van der Sterren specializes in exuberant bafflement. He favours acid-bright colours and heavy impasto, but the confident and outgoing mood they create is undermined by the relentlessly enigmatic nature of the Dutch painter's subject matter. A bandaged figure stumbles through a field of giant cabbages; two astronauts wander across a yellow moonscape beneath jewel-like overhanging fronds. As viewers, we're in *terra incognita* too: the painted surface shifts abruptly between tight figuration and loose gestural strokes, and iconographically these vivacious obscurities won't resolve. It's painting as wild goose chase, suggesting that Van der Sterren's take on how art communicates may be darker than his superficially vivacious aesthetic implies. (MH)

Shown by Galerie Fons Welters G25

Growth
2005-7
Oil on linen
191.5×290.5cm
Courtesy Alison Jacques Gallery

Tim **Stoner**

Born 1970
Lives London/Ronda

In Tim Stoner's painting there is a light that never goes out. Instead it burns with bright, steady ardour behind the silhouetted figures he depicts, who are typically caught up in some shared happy moment (a paddle in the surf or simply holding hands) or in a display of collective health and vigour (synchronized swimming, group exercises or a society dance). While there is a nostalgic feel to these works, which recall, variously, the fantasy worlds of F. Scott Fitzgerald's 'Jazz Age' and Soviet Socialist Realism, they also address the present moment. Stoner has said that his art reaffirms the idea 'that we do have communal ideas, desires and sentiments'. (TM)

Shown by Alison Jacques Gallery D15

Selected Bibliography

2005 *The Triumph of Painting*, The Saatchi Gallery, London

2004 *Britannia Works*, Katerina Gregos, British Council Publications, London

2003 *Nation*, Vanessa Joan Mueller and Nikolas Schafhausen, Kunstverein, Frankfurt

2003 *Tim Stoner*, Martin Herbert, Junge Kunst, Wolfsburg

2002 *Man in the Middle*, Deutsche Bank Collection, Frankfurt

Selected Exhibitions

2007 Alison Jacques Gallery, London

2005 'Daysleepers', BA-CA Kunstforum, Vienna

2003 'Nation', Kunstverein, Frankfurt

2003 'Exploring Landscape: Eight Views from Britain', Andrea Rosen Gallery, New York

2002 'The Power of Partnership', Stedelijk Museum Bureau, Amsterdam

Keep Distance
2007
Acrylic and lacquer on canvas
240×240cm
Courtesy the artist and Galerie
Sfeir-Semler

Selected Bibliography

2007 'Ein Bild wie Weihnachten in Las Vegas: Christine Streuli's "Jackpot"' (A Painting like Christmas in Las Vegas: Christine Streuli's "Jackpot"), Bruno Steiger, *Magazin für Kultur*, 267

2007 'Es Geht um Behauptungen und Sich-Behaupten-Können: Ein Gesprach mit Christine Streuli' (It is a Question of Assertions and to Assert Oneself: An Interview with Christine Streuli), Claudia Spinelli, *Kunst Bulletin*

2006 *Christine Streuli: Bumblebee*, Claudia Jolles et al., Verlag für Moderne Kunst, Nuremberg

Selected Exhibitions

2007 Swiss Pavilion, 52nd Venice Biennale

2007 'Christine Streuli and Bruno Jakob', Kunsthaus, Langenthal

2006 'Swiss ART Awards', Art 37 Basel

2005 'Rainbow', Sfeir-Semler Gallery, Beirut

2005 'Bekanntmachungen/ Bilderstreit', Kunsthalle, Zurich

Christine **Streuli**

Born 1975
Lives Zurich

By removing her hand from the process of painting Christine Streuli demonstrates that, for her, expression resides in colour rather than in touch. Printing, pressing and tracing are all put to use in works such as *Radar* (2005), an uproarious tumult of yellow, blue and black that is at once an abstract play of form and a sun-soaked psychedelic landscape. Streuli has declared that she consciously and explicitly addresses the public in her work and demands their 'full and personal participation'. In so doing, she reveals how intimacy and distance can be made approximate so that the form of colour becomes the work's content. (BB)

Shown by Galerie Sfeir-Semler E16

Aktive Stagnation
2006
Various metals, wood, frame
79×69×7cm
Courtesy Galerie Almine Rech

Katja **Strunz**

Born 1970
Lives Berlin

The work of Katja Strunz relates to neo-Minimalism rather as Batman does to Superman: her art is the broodingly dark counterpoint to slick invincibility. In her sparse installations of sharp-angled shapes and time-worn, scrap-metal echoes of early-20th-century Russian Constructivism are shot through with a Robert Smithson-esque interest in the derelict sites of the modern age, which she tracks with the sensitive vigilance the Romantics reserved for ancient ruins. In 2006 Strunz eloquently translated her approach into a vast installation that responded to Ludwig Mies van der Rohe's spaces of the Krefeld Museum's Haus Esters. (JöH)

Shown by Gavin Brown's enterprise G14, The Modern Institute/Toby Webster B11, Galerie Almine Rech G7

Selected Bibliography

2007 *Katja Strunz*, Suzanne Hudson and Lutz Niethammer, Adolf Luther Stiftung, Krefeld/ Verlag Walther König, Cologne

2006 'Ein Blick ins Atelier von Katja Strunz' (A Visit to the Studio of Katja Strunz), Katrin Wittneven, *Monopol*, 5

2006 'Katja Strunz', Suzanne Hudson, *Artforum*, April

2006 *Strange I've Seen That Face Before*, Suzanne Titz and Toby Webster, Städtisches Museum Abteiberg, Cologne

2006 *Art's Blooming in Berlin*, Elke Buhr, Modern Painters

Selected Exhibitions

2007 Galerie Almine Rech, Paris

2007 Museum Haus Esters, Krefeld

2007 'Roomrobber', Artpace, San Antonio

2007 'Lazy Corner and the Suicide Walls', The Modern Institute, Glasgow

2006 'Whose Garden Was This', Gavin Brown's enterprise, New York

Museo del Prado 5
2005
C-print
166.5×208cm
Courtesy Galerie Rüdiger Schöttle

Selected Bibliography

2007 *The Prado Project*, Thomas Struth, Schirmer/Mosel, Munich

2005 *Thomas Struth: Museum Photographs*, Hans Belting and Walter Grasskamp, Schirmer/Mosel, Munich

2004 *Thomas Struth: Pergamon Museum*, Thomas Struth and Ludger Derenthal, Schirmer/Mosel, Munich

2002 *New Pictures from Paradise*, Ingo Hartmann and Hans R. Reust, Schirmer/Mosel, Munich

2002 *Photographs 1977–2002*, Charles Wylie, Maria Morris Hambourg and Douglas Eklund, Schirmer/Mosel, Munich

Selected Exhibitions

2007 'Thomas Struth: Making Time', Museo Nacional del Prado, Madrid; Galerie Max Hetzler, Berlin
2006 Galerie Meert Rihoux, Brussels
2006 'Click/Doubleclick: das dokumentarische Moment', Haus der Kunst, Munich
2005 'Thomas Struth: Audience', Galerie Rüdiger Schöttle, Munich

Thomas **Struth**

Born 1954
Lives Dusseldorf

While Andreas Gursky, Thomas Ruff and others among the former students of Bernd and Hilla Becher kept to their teachers' austere, frontal compositions, Thomas Struth has framed skewed structures that speak of historical complexity and layers of potential meaning: the organizing principles of a street, a skyline or a family. He recently completed his most resonant work in this line: the series 'Museum Photographs' (1987–2005), where art works and spectators perform highly choreographed dramas of gesture, meaning and address. (BD)

Shown by Galerie Paul Andriesse H8, Marian Goodman Gallery F14, Galerie Rüdiger Schöttle E10

Cluster Wichtelwelt
(Goblin World)
2006
Acrylic resin cast, spray-paint, dyed
denim, dyed calico
184×50×40cm
Courtesy Sorcha Dallas

Michael **Stumpf**

Born 1969
Lives Glasgow

To encounter the work of Mannheim-born
sculptor Michael Stumpf is to delve into the darker
side of Teutonic Romanticism. Stumpf's mixed-
media assemblages combine durable materials such
as denim, steel pipe and tin foil with fragile
elements such as neon tubes, twine, cardboard and
delicate jewellery chains to endow these hybrid
sculptures with a light, ephemeral appearance. The
amalgamation of found objects with simple
bonding elements – rough tape, hot glue, runny
trails of aluminium – conjures thoughts of magic
and alchemy. His unique visual language remains
cryptic, encouraging the viewer to treat his works
as wondrous and mysterious objects stumbled
across in a dark Brothers Grimm forest. (AC)

Shown by Sorcha Dallas F32

Selected Bibliography

2006 'Michael Stumpf', Sarah
Lowndes, *Open Frequency*

2005 'Made in Glasgow', John
Calcutt, *Map*, 4

2005 'Michael Stumpf', Mick
Peter, *frieze*, 90

2004 *At the Edge of the Night a
Fairytale Ties Roses*, Ross Birrell,
State Academy of Fine Arts,
Karlsruhe

Selected Exhibitions

2007 'Obstacle: New UK
Sculpture', Spectacle Gallery,
Birmingham

2006 'International Enquirer', Art
Gene, Barrow-in-Furness

2005 'Like It Matters', Centre for
Contemporary Art, Glasgow

2005 Sorcha Dallas, Glasgow

2005 'Deutantenausstellung', State
Academy of Fine Arts, Karlsruhe

DUCHAMP FRESH WIDOW
1992
Enamel paint on wood, leather,
glass, brass knobs
79×53×13cm
Courtesy Anthony Reynolds
Gallery

Selected Bibliography

2004 *The Brutal Truth*, ed. Udo
Kittelmann and Mario Kramer,
Museum für Moderne Kunst,
Frankfurt

2002 *Shifting Mental Structures*, ed.
Alexander Tolnay, Neuer
Kunstverein, Berlin

1999 *Sturtevant: 1225 Objets à
Casino Luxembourg*, Robert
Rosenblum, Forum d'Art
Contemporain, Luxembourg

1992 *Sturtevant*, ed. Tilman
Osterworld, Württembergischer
Kunstverein, Stuttgart

1989 *Sturtevant: Works from 25
Years*, Galerie Paul Maenz,
Cologne

Selected Exhibitions

2006 'Day for Night: Whitney
Biennial', Whitney Museum of
American Art, New York

2005 'The Brutal Truth', MIT
List Visual Arts Center, Cambridge

2004 'The Brutal Truth', Museum
für Moderne Kunst, Frankfurt

2002 'Shifting Mental Structures',
Neuer Kunstverein, Berlin

1999 'Duchamp: 1200 Coal Bags
et autres pièces', Musée d'Art
Moderne et Contemporain,
Geneva

Sturtevant

Born 1930
Lives Paris

In 1964 Elaine Sturtevant began recreating the
works of her contemporaries, often shortly after
they were first shown. Her first 'Warhol
Flowers' (1965), for instance, were produced only
a year after the originals. Sturtevant took a
complaint commonly levelled against contem-
porary art – 'I could do that!' – and turned it into a
valid question: 'Could I do that? And if so, where
would it lead me?' In 2005 the Museum für
Moderne Kunst, Frankfurt, presented a show
containing 140 of Sturtevant's works spanning over
40 years. The exhibition constituted a museum of
modern art in itself – and was uncannily visionary
in its repetitions of seminal works by Joseph Beuys,
Roy Lichtenstein and Felix Gonzalez-Torres.
(JöH)

Shown by Anthony Reynolds Gallery F8, Galerie
Thaddaeus Ropac B12

Conceptual Forms 0029
2004
Silver gelatin print
149×119.5cm
Courtesy Studio Guenzani

Hiroshi **Sugimoto**

Born 1948
Lives New York/Tokyo

Since turning his large-format camera on the frozen world of the natural history museum diorama in 1975, Hiroshi Sugimoto has been exploring the relationship between photographic vision and human perception. He has similarly focused his lens on cinema screens in old-time movie theatres (Sugimoto left his shutter open for the duration of each screening, capturing a blazing white rectangle rather than the filmic image), wax portraits, seascapes neatly divided into sea and sky, scientific models and artfully framed Buddhist sculptures. Creating surprisingly lifelike images of artificial subjects, Sugimoto's pictures thwart photography's traditional pretension to objective truth and suggest instead the already digested nature of the world we inhabit and see. (CG)

Shown by Gagosian Gallery D7, Marian Goodman Gallery F14, Studio Guenzani E9

Selected Bibliography

2006 *Hiroshi Sugimoto*, David Elliot et al., Hirshorn Museum and Sculpture Garden, Washington/ Mori Art Museum, Tokyo

2005 *Hiroshi Sugimoto: Conceptual Forms*, Fondation Cartier pour l'Art Contemporain, Actes Sud, Paris

2003 *Sugimoto: Architecture*, ed. Francesco Bonami, Hatje Cantz Verlag, Ostfildern Ruit

1995 *Time Exposed*, Thomas Kellein, Thames & Hudson, London

1994 *Hiroshi Sugimoto*, Kerry Brougher, Museum of Contemporary Art, Los Angeles

Selected Exhibitions

2007 Fine Art Museum/De Young Museum, San Francisco

2006 Hirshhorn Museum and Sculpture Garden, Washington; Mori Art Museum, Tokyo

2006 'Hiroshi Sugimoto: Mathematical Forms', Atelier Brancusi, Centre Georges Pompidou, Paris

2005 'Etant donné: Le Grand Verre', Fondation Cartier pour l'Art Contemporain, Paris

2003 'Sugimoto: Architecture', Museum of Contemporary Art, Chicago

Pond
2006
Acrylic, pigment on canvas
177×229cm
Courtesy Nicole Klagsbrun Gallery

Selected Bibliography

2007 *The Age of Micropop: The New Generation of Japanese Artists*, Matsui Midori, Parco, Tokyo

2006 *Talking Pictures*, Sammlung Goetz, Munich

2004 *Under the Shadow: Hiroshi Sugito's Paintings*, Kyuryudo Art Publishing Co., Tokyo

2004 *Over the Rainbow: Yoshitomo Nara and Hiroshi Sugito*, Doris Krystof and Bernhart Schwenk, Hatje Cantz Verlag, Ostfildern Ruit

2002 *Vitamin P: New Perspectives in Painting*, Barry Schwabsky, Phaidon Press, London

Selected Exhibitions

2007 Nicole Klagsbrun Gallery, New York

2007 'Passage to the Sky', Tomio Koyama Gallery, Tokyo

2007 'The Door into Summer', Art Tower Mito, Ibaraki

2006 'Focus', Modern Art Museum, Fort Worth

2006 'April Song', The Sculpture Garden Museum Vangi Museo, Mishima

Hiroshi **Sugito**

Born 1970
Lives Nagoya

Since 1996 the painting of Hiroshi Sugito has been captivating its audience with its delicate palette and combination of light, sparse spaces, rooms or colour fields peppered with intriguing miniatures ranging from animal men and sofas to battleships and rockets. In many of Sugito's works theatre-like curtains frame the edge of the canvas, suggesting that the scenes beyond are dramas of the imagination. In a recent painting, *the dark, mirror* (2006), such drapes are pulled aside to reveal an oyster-like form threatening to engulf the tiny figures and animals on its surface. (DE)

Shown by Arndt & Partner G21, Galeria Fortes Vilaça E7, Marc Foxx A1, Nicole Klagsbrun Gallery E23, Tomio Koyama Gallery A3

Gemma
2004
Limewood, acrylic paint
51cm (height)
Courtesy Corvi-Mora

Tomoaki **Suzuki**

Born 1972
Lives London

Tomoaki Suzuki's knee-high, carved limewood sculptures of hip young things appear to strike attitudes of defiance, although it's hard to tell exactly what they're defying. It's certainly not fashion (each of them is fitted out with a perfectly observed outfit denoting their membership of a particular urban tribe), nor is it their apparent vulnerability (although small, they have an unnerving self-possession). One answer is given by the artist's creation of a Christmas crib for London's Trafalgar Square in 2006. At the centre of this 12-piece Nativity scene lay an infant Jesus – a figure of a future rebel destined to be co-opted by the powers that be. (TM)

Shown by Corvi-Mora E4

Selected Bibliography

2006 'Away with the Manger', Richard Cork, *The Saturday Times*

2004 'New York, New York', Charles G. Beyer, *Flash Art International*, January/February

2003 'Best London Shows', Rachel Campbell-Johnston, *The Times*

2002 'Tokyo Rising', Rose Aidin, *Vogue UK*, November

2002 'RA Modern', Pernilla Holmes, *ArtReview*, September

Selected Exhibitions

2006 'The Youth of Today', Schirn Kunsthalle, Frankfurt

2005 'First We Take Museums', Kiasma, Museum of Contemporary Art, Helsinki

2004 'Lucy and Simba', Corvi-Mora, London

2003 'The Square Show', Bloomberg Space, London

Deser I (Petit Deser)
(Desert I, Small Desert)
1970–1
Assemblage: polyester resin, glass
tray
8×11×13cm
Courtesy Broadway 1602

Selected Bibliography

2004 *Alina Szapocznikow*, Krystyna
Czerni et al., Institute for Art
Historical Research, Krakow

2004 *Flesh at War with Enigma*,
Anke Kempkes et al., Kunsthalle
Basel/Schwabe/Sternberg Press,
Basel

1998 *Alina Szapocznikow: 1926–
1973*, Anda Rottenberg et al.,
Institute for Promotion of Art
Foundation, Galeria Zacheta,
Warsaw

1973 *Alina Szapocznikow*, Pierre
Restany, Musee d'Art Moderne de
la Ville de Paris/ARC/Editions du
dialogue, Paris

Selected Exhibitions

2007 Broadway 1602, New York

2007 Galerie Gisela Capitain,
Cologne

2007 documenta 12, Kassel

2004 'Flesh at War with Enigma',
Kunsthalle, Basel

1998-9 'Alina Szapocznikow:
1926-1973', Galerie Zacheta,
Warsaw

Alina **Szapocznikow**

Born 1926
Died 1973

Influenced by Czech Surrealism and French
Nouveau Réalisme, Alina Szapocznikow used
resin, grass and wax to explore the fragility and
force of the body in such works as *Illuminated Lips*
(1966), curved stalks topped with light-infused
cast-polyester imprints of the artist's lips. Alongside
these sculptures, photographs, reminiscent in style
of Brassaï, of chewed gum and a full-body imprint
of her son, a wax cast completed the year before
her premature death in 1973, celebrate life with
humour and irony. (VR)

Shown by Broadway 1602 G18, Galerie Gisela
Capitain D11

Stadt 12/18 (Berlin)
City 12/18 (Berlin)
2005
Photograph
240×176cm
Courtesy Galería Helga de Alvear

Frank **Thiel**

Born 1966
Lives Berlin

No artist has tracked Berlin's architectural overhaul during the last decade more relentlessly than Frank Thiel. While he shares the stoic sensibilities of the photographers who trained under Bernd and Hilla Becher, Thiel, who was born and brought up in East Germany, stands apart for his peculiar taste in sites where the science fiction of the past clashes with a future tinged with nostalgia, be these Modernist high-rises of the socialist East (torn down or refurbished) or the Reichstag (completely dismantled and then reconstructed). His large-scale images show Berlin as a phoenix whose feathers are a little more ruffled each time it rises from the ashes. (JöH)

Shown by Galería Helga de Alvear H4, Galerie Krinzinger D17

Selected Bibliography

2006 *Frank Thiel: A Berlin Decade 1995-2005*, Hatje Cantz Verlag, Ostfildern Ruit

2005 *Beyond Delirious*, Cisneros Fontanals Art Foundation, Miami

2004 *Enlightening Abstractions: Reason and Emotion*, 14th Sydney Biennial

2003 *La ciudad radiante: 2a Bienal de Valencia* (The Radiant City: 2nd Valencia Biennial), Skira, Milan

2002 *Brasilia: Ruïna e Utopía* (Brasilia: Ruin and Utopia), 25th São Paulo Biennial

Selected Exhibitions

2006 'Berlin-Tokyo/Tokyo-Berlin: A Tale of Two Cities', Mori Art Museum, Tokyo; Neue Nationalgalerie, Berlin

2005 'Gegenwelten: Das 20. Jahrhundert in der Neuen Nationalgalerie', Neue Nationalgalerie, Berlin

2004 14th Sydney Biennial

2003 'Cold Play', Fotomuseum, Winterthur

2001 'Taking Care', SMART Projekt Space, Amsterdam

3WME
2005–6
Oil on canvas
162×120cm
Courtesy Andrew Kreps Gallery

Padraig **Timoney**

Born 1968
Lives Naples

Padraig Timoney often goes to flamboyant lengths for his art. He once flew from the UK to Los Angeles especially to buy a blank videotape (resulting in the sculpture *The Hunter Became the Hunted*, 1997), and he visited Jerusalem to find cobwebs. A native of Northern Ireland, Timoney has been making strategic objects and obstinate paintings since the late 1980s – works whose intractability and murky motivation have garnered frequent comparisons to the political climate of that province. *Bad Reputations Start Fires* (1995), for example, comprises an acid-filled fire extinguisher, while *Plastic Lumps* (2003) is a canvas that sports paint like brightly coloured tumescent turds. (MA)

Shown by Andrew Kreps Gallery C7, The Modern Institute/Toby Webster B11, Galleria Raucci/Santamaria G4

Selected Bibliography

2006 'Padraig Timoney', Damien Duffy, *Circa*

2006 'Padraig Timoney', Filippo Romero, *Artforum*

2006 'Frederic Pradeau/Padraig Timoney', Francesca Boenzi, *Flash Art International*, 101

2004 'Padraig Timoney', Jack Mottram, *The List*

2003 'Padraig Timoney', Emily Pethick, *Artforum*

Selected Exhibitions

2007 Andrew Kreps Gallery, New York

2007 Xavier Hufkens, Brussels

2006 'The Fear of All Sums: Ten Million Dice to Weigh', Void, Derry

2005 'One Year Speaks Clear Some Years' Peaks Clear', Raucci/Santamaria Gallery, Naples

2004 The Modern Institute, Glasgow

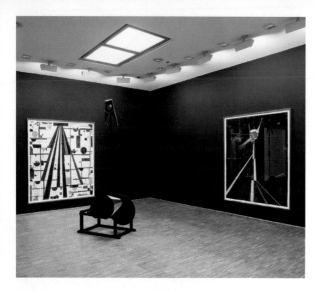

Nichts brennt an nichts kocht über
(Nothing Scorches Nothing Boils
Over)
2007
Installation view
Courtesy Team Gallery

Gert & Uwe **Tobias**

Born 1973
Live Cologne

Romanian-born twins Gert and Uwe Tobias make
large-scale woodcut prints, typewriter drawings,
sculptures and ceramics that, with their macabre
and Gothic air, appear to draw heavily on the
romantic legends of the artists' native Transylvania.
Yet, aside from the dark heritage of Dracula – of
whom they became aware only after relocating to
Germany in 1985 – their visual language also pilfers
vocabulary from a vast range of sources, including
comics, B-movies and 20th-century graphic
design. The close bond between the brothers is
carried through to their work, which is always co-
signed, whether it is collaborative, independently
made, or started by one twin and finished by the
other. (AC)

Shown by The Breeder E17, Team Gallery G23

Selected Bibliography

2006 'L.A. Confidential', Emma
Gray, *artnet Magazine*, September

2006 'Riedels großer Auftritt:
Rüsselsheimer Künstler auf der
Frankfurter Messe', Stephan A.
Dudek, *Main-Spitze*, March 18

2006 'Neues von den Tobias-
Brüdern' (Tobias Brothers: New
Works), *Rhein Main Presse*, 16
September

2004 *Come And See Before The
Tourists Will Do: The Mystery of
Transylvania*, Gert and Uwe
Tobias, Snoeck Verlagsgesellschaft
GmbH, Cologne

Selected Exhibitions

2006 UCLA Hammer Museum,
Los Angeles

2006 'Loveless', Team Gallery,
New York

2005 Kunstverein, Bonn

2005 'Skulls', Galerie Rodolphe
Janssen, Brussels

2003 'Identität schreiben',
Kunstverein, Konstanz

Untitled 5
2006
Tempera on paper
152×104cm
Courtesy Galeria Fortes Vilaça

Selected Bibliography

2006 *Janaina Tschäpe*, Vitória
Daniela Bousso et al., Paço das
Artes, São Paulo

2005 *Landscape Confection*, Helen
Molesworth, Wexner Center for
the Arts/The Ohio State
University, Columbus

2004 *100 Little Deaths*, François
Quintin, Le College Éditions, Frac
Champagne-Ardenne, Reims

2004 *Janaina Tschäpe*, Saint Clair
Cemin, Shelley Rice and Atsushi
Tanigawa, Nichido Contemporary
Art, Tokyo

2001 *Janaina Tschäpe: Sala de
Espera*, Márcia Fortes, Museo
Nacional Centro de Arte Reina
Sofia, Madrid

Selected Exhibitions

2006 'Melantropics',
Contemporary Art Museum, St
Louis

2006 Paço das Artes, São Paulo

2005 'Blood, Sea', University Art
Museum, Buffalo

2005 'Camaleoas', Jeu de Paume,
Paris

Janaina **Tschäpe**

Born 1973
Lives New York

Janaina Tschäpe shares her forename with a
Brazilian water goddess, and, not coincidentally,
her photographs and performances-to-video
feature sumptuously organic, watery, distorted
female figures. Bodies adapted or disguised with
inflated forms and swaths of fabric – a hand
distended by a water-filled condom, or limbs
modified with absurd, yet oddly recognizable,
globular tendrils – intimate personal mythologies of
hybridity and alterity. Although referring to the
primitive beauty of coelenterates, which can
effortlessly curdle into horror when given a sci-fi
twist, Tschäpe's romantic Surrealism emphasizes
the beauty and humour of transformation. (SO'R)

Shown by Galerie Catherine Bastide E12, Galeria
Fortes Vilaça E7

Specter
2006
C-type print
97.5×97.5cm
Courtesy Tomio Koyama Gallery

Mamoru **Tsukada**

Born 1962
Lives Tokyo

In the panoramic photographs in his book *The Fact That We Are Compelled To Look Out Beyond Our Sensible Representations* (2002) Mamoru Tsukada leaves large portions of his compositions blank: lost in shadow or flanked by empty space. The effect is to cause the viewer to imagine whole new photographs made of these eloquent voids, as though there were another visible (if vacant) universe alongside that of his main subject. Which, it turns out, there is: the world of the blind, who were Tsukada's first subjects as a photographer. Further allegorizing photography's play with the visible and invisible, he has recently taken to photographing from behind a mask. (BD)

Shown by Tomio Koyama Gallery A3

Selected Bibliography

2007 *Portrait Session*, Minoru Shimizu, Daiwa Radiator Factory, Hiroshima

2006 'Mamoru Tsukada', Kentaro Ichihara, *Bijutsu Techo*

2003 'Mamoru Tsukada', Miyuki Kondo, *The Asahi Shimbun*, Tokyo, 7 June

2003 'Mamoru Tsukada', Seiichi Tsuchiya, *Bijutsu Techo*

2002 *The Fact That We Are Compelled To Look Out Beyond Our Sensible Representations*, Mamoru Tsukada, Tokyo

Selected Exhibitions

2007 'Portrait Session', City Museum of Contemporary Art, Hiroshima

2006 'Specter', Tomio Koyama Gallery, Tokyo

2005 'Site Graphics', Kawasaki City Museum, Kanagawa

2005 'Zone Poetic Moment', Wonder Site Hongo, Tokyo

2003 'The Fact That We Are Compelled To Look Out Beyond Our Sensible Representations', Tomio Koyama Gallery, Tokyo

Untitled
2007
Oil on canvas
145×120cm
Courtesy Collection Museum
Boijmans Van Beuningen

Selected Bibliography

2007 *The Sorcerer's Apprentice: Late Picasso & Contemporary Painters*, Max Henry, Galleri Faurschou, Copenhagen

2006 'Emerging Artists', Tom Morton, *frieze*, 104

2006 'Phoebe Unwin', Martin Coomer, *Time Out London*, November

Selected Exhibitions

2007 'The Sorcerer's Apprentice', Galleri Faurschou, Copenhagen

2007 'Very Abstract and Hyper Figurative', Thomas Dane, London

2007 'The Contented Heart', W139, Amsterdam

2007 'Saturn Falling', The Corridor, Reykjavik

2006 'The Grand and the Commonplace', Wilkinson Gallery, London

Phoebe **Unwin**

Born 1979
Lives London

Phoebe Unwin's paintings chase down painterly paradoxes. Her works on canvas and paper flirt with the accident of paint, while adhering to the desires of memory to describe a place, a person, an object or a situation. She employs the strident atmospherics of certain colour palettes, shy of neither gloomy greys nor airy pastels, and yet she fragments the image with partial views and transparent layers. Unwin has described her human subjects as 'people who don't really want to be seen', which she herself expresses through an ambivalence towards figuration and a *laissez-faire* attitude to abstraction. (SO'R)

Shown by Wilkinson Gallery E15

Bread Head
2007
Bread, woollen cap
35×25×25cm
Courtesy Galleria Franco Noero

Selected Bibliography

2006 *Visioni dal Paradiso: Un dialogo sull'arte tra Svizzera e Italia* (Visions of Paradise: A Discourse on Art between Switzerland and Italy), Domenico Lucchini et al., Mondadori Electa, Milan

2006 *Costa Vece: Dark Days*, Kunstmuseum, Solothurn

2003 *Costa Vece: Sport Stories: The Truth is I Can't Stand Sports*, Tete Alvarez, Bienal International del Deporte en el Arte, Salamanca

2002 *Costa Vece: The Artist's Fear in Front of the Public*, Rein Wolfs and Claudia Spinelli, ASA Studio Albanese, Vicenza

2002 *Costa Vece: Works from 1992–2002*, Heike Munder et al., Migros Museum, Zurich/Galleria Franco Noero, Turin/Galerie Peter Kilchmann, Zurich

Costa **Vece**

Born 1969
Lives Zurich

Known for politically charged video works projected in installations made from transient materials, Costa Vece first came to international attention with *Videolounge* (1998), which consisted of loops of explosions and immolations screened within a claustrophobia-inducing space constructed from cardboard boxes. The work was widely perceived as a commentary on today's mediated presentation of war; however *Videolounge* is as elegiac as it is critical. *Look Back in Anger* (2001) featured a full-size, single-masted ship with a hole large enough to be a door punched in the hull: inside played a loop from Roberto Rossellini's film *Stromboli* (1950), in which terrified refugees attempt to reach safety. (AJ)

Shown by Georg Kargl G16, Galleria Franco Noero A2, Galeria Filomena Soares H7

Selected Exhibitions

2007 'Entre Fronteras/Between Borders', Museo de Arte Contemporanea, Vigo

2006 'Heaven Can Wait', Kunstmuseum, Solothurn

2005 Galleria Franco Noero, Turin

2003 'G2003: Un villaggio e un borgo accolgono l'arte', Vira Gambarogno

2001 'Look Back in Anger', Migros Museum, Zurich

Chamber
2006
Wood, acrylic paint, enamel,
aluminium leaf, collage
32×47.5×40.5cm
Courtesy Galleria
Raucci/Santamaria

Selected Bibliography

2007 'Torbjörn Vejvi', Laura
Cherubini, *Flash Art International*,
263

2005 'Cheney Thompson and
Torbjörn Vejvi', Simona Barucco,
Flash Art International, 243

2004 'Goofy, Deadpan and
Spiritual', Michael Clifton, *Wrong
Times*

2000 'Opening: Torbjörn Vejvi',
Dennis Cooper, *Artforum*,
December

2000 'Torbjörn Vejvi', Dennis
Cooper, *frieze*, 54

Selected Exhibitions

2007 'New Works', Galleria
Raucci/Santamaria, Naples

2006 'Zane Peach/Torbjörn
Vejvi', Urbis Artium Gallery, San
Francisco

2004 Art Statements, Art 35 Basel

2003 C/O Atle Gerhardsen,
Berlin

2002 Richard Telles Fine Art, Los
Angeles

Torbjörn **Vejvi**

Born 1972
Lives Los Angeles

Torbjörn Vejvi's work has become deceptively
simple. Formerly, appropriated images adorned his
sculptures. Now those images have dispersed for an
almost complete concentration on modern art's
most restrained object: the cube. But Vejvi's cubes
are not of the Minimalist variety. Like a box of
secrets, their play of open peepholes and eclipsed
enclosures confounds us. Vejvi transforms the most
rudimentary materials – cardboard, foam board,
paper – into unknown intersections of modular
structures, composed geometric affairs that efface
our comprehension of them. Their form
gesticulates between unknown and known,
hesitantly revealing obscured compositions. (CB)

Shown by Galleria Raucci/Santamaria G4

Kill Yourself (Twin)
2006
Tinted epoxy, wood, fluorescent
tubes, steel, flight cases and
hardware
Dimensions variable
Courtesy Migros Museum and
Galerie Thaddaeus Ropac

Banks **Violette**

Born 1973
Lives New York

A stark whiteness has emerged in Banks Violette's
recent works. As in his *Untitled* (2005), the ruinous
skeleton of an *ad hoc* chapel installed at the
Whitney Museum, these white works are encased
in salt. While his earlier sculptures usually sported a
trademark glossy black exterior, this new pallid
coarseness heightens the surface tensions implied in
his creations. In *Untitled (Model for a Future Disaster)*
(2003), for instance, monochromatic images of
galloping horses appeared threatened by the
violently dark, black stage they were placed
behind. These stark differences elicit the anxiety of
being, the desolation of teenage melancholia
struggling for identity in a world of superficial
imagery. (CB)

Shown by Maureen Paley D5, Galerie Thaddaeus
Ropac B12, Team Gallery G23

Selected Bibliography

2006 *USA Today*, Norman
Rosenthal, Royal Academy of
Arts, London

2005 *Banks Violette*, Shamin M.
Momin, Whitney Museum of
American Art, New York

2005 'Spotting an Aesthetic
Dispute and Embracing All Sides',
Roberta Smith, *The New York
Times*

2005 'Blackness Is Not a Void',
Power Ekroth, *Artforum.com*

2005 'Banks Violette', Michael
Cohen, *Flash Art International*, 244

Selected Exhibitions

2007 Galerie Thaddaeus Ropac,
Salzburg

2007 Team Gallery, New York

2007 Gladstone Gallery, New
York

2005 'Untitled', Whitney
Museum of American Art, New
York

Hawks
2006
Oil paint on gesso board
122×113cm
Courtesy the artist and doggerfisher

Selected Bibliography

2005 *Hotspots: The Shadow of the Decorative*, Ben Greenman, Sammlung Essl Privatstiftung, Klosterneuburg

2005 *Afterwards: in the Blank Wood*, Hanneline Visnes, Centre for Contemporary Arts, Glasgow

2004 'Hanneline Visnes', Neil Mulholland, *Flash Art International*, 237

Selected Exhibitions

2007 'On Ornaments', arte giani, Frankfurt

2007 doggerfisher, Edinburgh

2006 'The Crow Wants Everything to be Black', Pump House Gallery, London

2006 'Imagine the Universe Bursts into Song', Laura Bartlett Gallery, London

2005 'Hotspots', Museum Essl, Vienna

Hanneline **Visnes**

Born 1972
Lives Glasgow

In the paintings of Hanneline Visnes the geometric tangles of illuminated manuscripts, Chinese lacquer work and Persian tiles are resituated deep within the dark fjords and forests of the artist's native Norway. A magpie-like tendency informs Visnes' nomadic curiosity, as she gathers decorative patterns from far-flung folk traditions and iconography, taking up to a month to complete a single, intricately detailed piece. Yet there is violence in her tight ordering of the natural order: smears of paint rudely obscure gypsy roses and Islamic motifs, while a tension between symmetry and irregularity suffuses this Gothic Baroque, unsettling as much as it charms. (ST)

Shown by doggerfisher G19

1992
Installation view
2007
Architectural models, archival
materials
Courtesy The Breeder

Vangelis **Vlahos**

Born 1971
Lives Athens

Skyscrapers hold a particular ideological fascination for Vangelis Vlahos: the Torre de Atocha in San Sebastián, Spain, and the Athens Tower in the Greek capital, for example, were both constructed during dictatorships: of Francisco Franco and Georgios Papadopoulos respectively. Through his scale models, technical drawings and archival research Vlahos scrutinizes and mirrors the power and diplomacy vested in such totemic architecture. For his latest project, *1992* (2007), he investigated the former Bosnian parliament building, a nondescript tower constructed in 1974 and partially destroyed in the Balkan conflict in the early 1990s, whose renovation has been largely funded by the Greek state. (MA)

Shown by The Breeder E17

Selected Bibliography

2006 *Vangelis Vlahos: Buildings like Politics*, Magali Arriola, Hito Steyerl and Despina Zefkili, The Hellenic Ministry of Culture, Athens

2004 '3rd Berlin Biennial of Contemporary Art', Pablo Lafuente, *ArtReview*

2004 'Manifesta 5: European Biennial of Contemporary Art', Dan Fox, *frieze*, 85

Selected Exhibitions

2007 '1992', The Breeder, Athens

2007 3rd Prague Biennial

2006 27th São Paulo Biennial

2005 'Behind Closed Doors', Centre for Contemporary Arts, Dundee

2004 3rd Berlin Biennial

Adair
2006
Oil on linen, on aluminium
72×56cm
Courtesy the artist and Max
Wigram Gallery

Selected Bibliography

2006 'Preview', Jessica Lack, *The Guardian*

2005 'Faux Realism II', Helen Sumpter, *Time Out London*

2005 'Making an Entrance at Any Age', Roberta Smith, *The New York Times*

2004 'Unpeacable Kingdom', Martin Coomer, *Time Out London*

2003 'Selected Paintings', Sally O'Reilly, *frieze*, 79

Selected Exhibitions

2007 'Old School', Hauser & Wirth, London

2007 L&M Arts, New York

2006 Max Wigram Gallery, London

2004 'Expander', Royal Academy of Arts, London

2004 'Britannia Works', Lleana Tounta Contemporary Art Centre and Xippas Gallery, Athens

Richard **Wathen**

Born 1971
Lives London

Richard Wathen's abstemious application of paint and Wedgwood blue-infused palette recall the academicism of Jean-Auguste-Dominique Ingres. In *Erin* (2005) Wathen takes on tradition, depicting a nude youth with preposterous ringlets clutching a rabbit. Despite the apparent voyeurism of the piece, by rendering his subject slightly out of focus the artist puts this nubile flesh beyond easy consumption. His works are fantastical: *Animalia* (2006) is a pastoral idyll populated by an impossible menagerie of beasts. Wathen has no need to make tradition strange; instead he mines the conventions of painting to find them replete with other-worldly effects. (BB)

Shown by Max Wigram Gallery G20

Airstream Dream
2007
Collage on light-jet print
102×127cm
Courtesy the artist and Patrick
Painter, Inc.

Marnie **Weber**

Lives Los Angeles

In Marnie Weber's darkly glam universe female characters co-exist with bleeding snowmen, lame rabbits or violin-playing bears. Weber places her heroines in greater danger than did Joseph Cornell, though many photo-collages – including one where Little Red Riding Hood gazes at a naked, kneeling giantess – feature women 'rescued' from porn magazines and set amid fairy-tale landscapes. In others, costumed models inhabit doll's house interiors with titles such as *The Snow Room* or *The Trophy Room* (both 2002). Weber began her career performing in a band, and her music, films, videos, performances, installations and collages increasingly intertwine, as in her ongoing series 'The Spirit Girls', about a ghostly, reincarnated 1970s' girl band. (KJ)

Shown by Patrick Painter, Inc. B14, Emily Tsingou Gallery A10

Selected Bibliography

2007 *Sing Me A Western Song*, Annie Buckley, Patrick Painter, Inc., Santa Monica

2006 'Babes in Spiritland', Michael Duncan, *Art in America*

2006 'The Other Left Bank', Michael Ned Holte, *Interview*

2005 'Spirits Rock Among Us', Doug Harvey, *LA Weekly*

2005 *LA Artland: Contemporary Art from Los Angeles*, Chris Kraus, Jan Tumlir and Jane McFadden, Black Dog Publishing, Los Angeles

Selected Exhibitions

2007 'Sing Me A Western Song', Patrick Painter, Inc., Santa Monica

2007 'Variations On A Western Song', Fredericks & Freiser Gallery, New York

2007 'From A Western Song', Emily Tsingou Gallery, London

2005 'From The Dust Room', Luckman Gallery, California State University, Los Angeles

2005 'Ghost Love', Rosamund Felson Gallery, Santa Monica

The Big Giving (Small Group)
Installation view
2006
Scoria, resin and water
Dimensions variable
Courtesy Andrew Kreps Gallery
and Herald St

Selected Bibliography

2006 'Ecstasy: In and About Altered States', Erik Davis, *Artforum*

2005 'A Mind-bending Trip down a Rabbit Hole', Michael Kimmelman, *The New York Times*

2005 'A Portal to a New Berlin', Christopher Knight, *Los Angeles Times*

2004 'Klaus Weber', Sally O'Reilly, *frieze*, 85

2004 'Artists' Picks: Klaus Weber: Unfolding Cul-de-Sac', Elmgreen & Dragset, *Artforum*

Selected Exhibitions

2007 Andrew Kreps Gallery, New York

2007 'The Big Giving', Hayward Gallery, London

2006 'The Big Giving (Small Group)', Herald St, London

2005 'Ecstasy: In and About Altered States', The Geffen Contemporary, Museum of Contemporary Art, Los Angeles

Klaus **Weber**

Born 1967
Lives Berlin

The ingredients of Klaus Weber's scenarios suggest a fascination with the dissolution of human control: mushrooms powerful enough to grow through tarmac, proliferating crickets chirruping at their own preternatural cues and fountains that appear to spurt and quell spontaneously or carry homeopathic levels of LSD. His installations, in the gallery or the world at large, often evoke narratives – a car crashed cinematically into a hydrant, for instance, or a shed apparently evacuated by a cricket- and mushroom-rearing sociopath – that tug at the social imaginary, taking their time to unfold. (SO'R)

Shown by Herald St F1, Andrew Kreps Gallery C7

Silver Surfer
2006
Mixed media on canvas
115×160cm
Courtesy Gabriele Senn Galerie

Hans **Weigand**

Born 1954
Lives Vienna

Aggressive, evocative and self-consciously decorative, Hans Weigand's combines of images cull the stuff of Pop culture to create almost apocalyptic visions. *Helden am Stadtrand* (Hero on the Outskirts of Town, 2005) shows a Richard Prince-style cowboy racing across an eroding landscape, over which loom a teetering acropolis and various imperial-era equestrian statues. Yet Weigand's premise for invoking these subjects is not to empty them of their significance in the collective imagination but rather to amplify their meaning. (BB)

Shown by Gabriele Senn Galerie E24

Selected Bibliography

2005 *Hans Weigand*, Christian Höller, Verlag Walther König, Cologne

2005 *Les Grands Spectacles: 120 Years of Art and Mass Culture*, Roberto Ohrt, Museum der Moderne, Salzburg

2001 *Jerry Cotton*, Roberto Ohrt and Kaspar König, Secession, Vienna/Museum Ludwig, Cologne

1999 *Get Together*, Russell Ferguson, Kunsthalle, Vienna

1997 *Hans Weigand: SAT*, Peter Noever, MAK, Vienna

Selected Exhibitions

2005 'Hans Weigand: Von hier nach dort', Neue Galerie, Graz

2005 Kunstraum, Innsbruck

2003 'Serious Play/Metaphorical Gesture', Gemäldegalerie Akademie der Bildenden Künste, Vienna

2002 'Jerry Cotton', Museum Ludwig, Cologne

2001 'Cotton', Secession, Vienna

Serenade Melancolique (The Collection of the Dead)
2007
Oil on canvas on board
57×36cm
Courtesy Emily Tsingou Gallery

Selected Bibliography

2006 'Mathew Weir', Lillian Davies, *Artforum*

2005 'Don't Look Now', Adrian Searle, *The Guardian*

2005 'Mathew Weir', Michael Glover, *ArtReview*

2005 'Mathew Weir', Tom Morton, *frieze*, 91

2005 'Mathew Weir', Pablo Lafuente, *Flash Art International*, 242

Selected Exhibitions

2006 Emily Tsingou Gallery, London

2006 Johnen Galerie, Berlin

2005 Northern Gallery for Contemporary Art, Sunderland

2004 Roberts and Tilton, Los Angeles

2003 'Breaking God's Heart', 38 Langham Street, London

Mathew **Weir**

Born 1977
Lives London

Mathew Weir's meticulous, intensely chromatic paintings of 19th-century ceramic caricatures of black males are as beautiful as they are politically chafing. Rendered in absolutely flat brushstrokes (Weir's paint looks, in Frank Stella's words, 'as good as it does in the can'), works such as *Shithouse* (2004–5) – in which a figurine of a black boy takes a last, proud peek back through a privy door before he departs – do not so much mount a critique of their motifs as subject them to aesthetic re-habilitation through an indiscriminating painterly all-over-ness. While this is a dangerous game, what emerges, in the end, is the weakness of outmoded racist discourse. (TM)

Shown by Emily Tsingou Gallery A10

Husk
2006
Oil on canvas
259×168cm
Courtesy Guild & Greyshkul

Garth **Weiser**

Born 1979
Lives New York

Garth Weiser's canvases pit tactile paint-handling against the purity of geometric shapes. The two black striated diamonds of *No Good Will* (2007) cast shadows on a background of Yves Klein blue; an orange triangle fits into the shadowy crevices depicted in *Frontier Delay* (2006). Recent canvases working with the motif of painted block backgrounds look like Modernist buildings blackened by coal-mines and corrosion, while *The Couple* (2006), an oil on canvas in a similar palette, resembles the darkened hues of a burnt wooden room. Not everything is set in these earthy colours or blacks and browns: *Something for the Weekend* (2005) summons the lightness of warm spring days, and *Husk* (2006) softens in a late-autumn light. (MG)

Shown by Guild & Greyshkul F19

Selected Bibliography

2007 'Garth Weiser', James Glisson, *Time Out Chicago*

2007 'Weiser's Solo Show Offers Unique Filter', Alan Artner, *The Chicago Tribune*

2005 *Greater New York*, Klaus Biesenbach, PS1 Contemporary Art Center/Museum of Modern Art, New York

Selected Exhibitions

2007 'Paintings from 2007', Kavi Gupta Gallery, Chicago

2006 Guild & Greyshkul, New York

2006 'The Manhattan Project', Frederic Snitzer Gallery, Miami

2006 'Hunch and Flail', Artists Space, New York

2005 'Greater New York', PS1 Contemporary Art Center, New York

C-69
1981
Gelatin silver print
46×36cm
Courtesy Maureen Paley

Selected Bibliography

2007 *James Welling: Flowers*, Lynne Tillman and James Welling, David Zwirner, New York

2001 'Surface Histories: The Photography of James Welling', David Joselit, *Art in America*

2001 'James Welling', Kristin M. Jones, *frieze*, 59

2000 *James Welling's Lock, 1976*, Michael Fried, Wexner Center for the Arts/The Ohio State University, Columbus

1998 'A Slice of Light', Carol Squires, *Artforum*

Selected Exhibitions

2007 Maureen Paley, London

2007 David Zwirner, New York

2006 'Tomorrow Land: CalArts in Moving Pictures', Museum of Modern Art, New York

2006 'The Los Angeles Art Scene, 1955–1985', Centre Georges Pompidou, Paris

2006 'The Gold Standard', PS1 Contemporary Art Center, New York

James **Welling**

Born 1951
Lives Los Angeles

Photographic media retain a degree of mystery in James Welling's work – albeit mystery of a particular kind, stemming from the nature of looking and technological mediation rather than from the nature of what is depicted. Working since the late 1970s in black and white or glowing colour, Welling has created abstract photograms and photographs of subjects such as railway lines, architecture, aluminium foil, hanging curtains or a painter's palette. Preoccupied with the manipulation of light, they are rigorously Conceptual yet sensuous. In the series 'Tricolour Photographs' (1998), for example, black and white negatives shot through red, blue or green filters are digitally superimposed, producing unsettling images of gardens or marshes. (KJ)

Shown by Maureen Paley D5, Regen Projects C10, David Zwirner C8

Martin **Westwood**

Born 1969
Lives London

Martin Westwood fuses the trappings of the
corporate world with the intricate passions of the
handmade. His multi-layered collages, often held
together with map pins, depict generic business
scenes of sales assistants and customers sealing
transactions or employees meeting targets.
Westwood finesses these episodes by deploying
shredded documents or cut-out and stencilled
invoices, for example, which he often decorates
with masked and spray-painted patterns. With
fatfinger (HAITCH. KAY. EKS) (2003),
Westwood's office-bound craft ecology makes a
bid for the built environment, deploying chewing-
gum-dashed blue carpet tiles, logo-festooned
papier-mâché balloons and talismans made from
stationery. (MA)

Shown by The Approach D10

Selected Bibliography

2007 'Martin Westwood', Peter
Suchin, *Art Monthly*, 305

2007 *Art Now*, Tate Britain,
London

2005 *Martin Westwood*, J.J.
Charlesworth, Other Criteria
Publishing, London

2003 *fatfinger (HAITCH.KAY.
EKS)*, Grant Watson, Project Arts,
Dublin

2003 'Best of 2003', Martin
Herbert, *Artforum*

Selected Exhibitions

2007 The Approach, London

2006 'Art Statements', Art 37
Basel

2005 'Art Now: Martin
Westwood', Tate Britain, London

2003 'Hard Pressed Flowers', The
Approach, London

2001 'A Seed is a Stone', The
Approach, London

The Lighting Showroom
2006
Mixed media on board
52×52cm
Courtesy Timothy Taylor Gallery

Selected Bibliography

2007 'Crafty Work', Harriet Lane, *Vogue UK*

2006 'A Brave New Look at Yesterday's Utopias', David Cohen, *The New York Sun*

2006 'Lucy Williams', Gerard Haggerty, *ARTnews Reviews*

2005 'Lucy Williams at McKee Gallery', Steven Vincent, *Art in America*

2005 'Intricate Layers', Molly Molloy, *Cent Magazine*, 5

Selected Exhibitions

2007 Timothy Taylor Gallery, London

2006 'The Day the Earth Stood Still', McKee Gallery, New York

2004 'Stranger than Paradise', McKee Gallery, New York

2003 'Chockerfuckingblocked', Jeffrey Charles Gallery, London

2001 'Graduate 2002', The Kiosk Project, London

Lucy **Williams**

Born 1972
Lives London

Lucy Williams' mixed-media bas-reliefs invest the clean lines of Modernist architecture – Idlewild Airport (*International Arrivals*, 2004) or the facilities built for the 1952 Helsinki Olympics (*Diving Pool*, 2004) – with a home-made intensity. Using needlepoint and collage, and model-making materials such as Artex paper, balsa wood, foam core and polystyrene nodules, Williams produces tactile views of iconic buildings. However, she does more than join 'feminine' handicrafts to 'masculine' architecture: her work also describes the emblematic and atmospheric qualities that buildings hold for individual people. *The Glass-walled House in Summer* (2005) appears to be a building that exists in the mind's eye, as a sanctuary or an imagined place. (SL)

Shown by Timothy Taylor Gallery G9

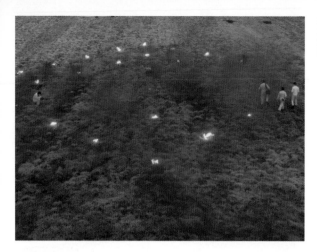

Landscape of Fire
2007
DVD video
Courtesy Johann König

Jordan **Wolfson**

Born 1980
Lives New York

Jordan Wolfson is concerned with the consequences of moments when, as he puts it, 'things are at such an intensity that they either have to reverse or go forward'. In a work from 2005 the artist adapts Charlie Chaplin's final speech from *The Great Dictator* (1940) – the actor's first 'talkie' – in which Chaplin voiced his own political beliefs in response to the rise of fascism in Europe. Wolfson re-silences the actor by filming the speech performed in sign language, while the work's title transcribes the discourse in full, acknowledging, in this work as in others, the power that distant and faded images exert on the present. (JG)

Shown by Johann König D13

Selected Bibliography

2007 *2nd Moscow Biennial*, Joseph Backstein et al., Moscow

2006 'Jordan Wolfson', Andrea Bellini, *Flash Art International*, 247

2006 *Interview with Jordan Wolfson*, Max Andrews, Uovo

2005 'Film Best of 2005', Chrissie Iles, *Artforum*, 11

2005 *Uncertain States of America*, Astrup Fearnley Museum of Modern Art, Oslo

Selected Exhibitions

2007 Johann König, Berlin

2007 GAMec, Bergamo

2007 'Absent without Leave', Victoria Miro Gallery, London

2007 'Learn to Read', Tate Modern, London

2007 2nd Moscow Biennial

Untitled
2007
Enamel on linen
320×244cm
Courtesy the artist and Luhring
Augustine

Selected Bibliography

2006 *Christopher Wool*, Consuelo Cisar Casabian, Marga Paz and DAvid Rimanelli, Institute d'Art Modern, Valencia/ Editions des Musees, Strasbourg

2004 *Christopher Wool*, Luhring Augustine, New York

2003 *Crosstown Crosstown*, Xavier Douroux, Katrina M. Brown and Anne Pontegnie, Contemporary Arts, Dundee/Le Consortium, Dijon

2001 *Christopher Wool*, Secession, Vienna

1998 *Christopher Wool*, ed. Ann Goldstein, Museum of Contemporary Art, Los Angeles/ Scalo, Zurich

Selected Exhibitions

2006 Instituto de Arte Moderno, Valencia; Musée d'Art Moderne et Contemporain, Strasbourg

2004 Camden Arts Centre, London

2004 Luhring Augustine, New York

2002 'Crosstown Crosstown', Le Consortium, Dijon; Contemporary Arts, Dundee

2001 Secession, Vienna

Christopher **Wool**

Born 1955
Lives New York

Christopher Wool has created an art of anti-mastery, of refusal and retraction. Every gesture he makes inspires an equal and opposite withdrawal. Throughout his career he has worked by setting himself problems, then obsessively undermining their premises. This essentially philosophical activity has resulted in elegantly stark paintings and drawings that crackle with unexpected visual energy: snarky block-letter text pieces, abstractions filled with *faux*-spontaneous drips, rubber-stamped patterns and smeary erasures. With a spiky intelligence Wool sifts through the tropes of modern painting, conducting an ongoing inquiry into the possibility (and impossibility) of meaning and communication. (SS)

Shown by Galerie Gisela Capitain D11, Taka Ishii Gallery G8, Luhring Augustine B9, Giò Marconi F6, Galerie Micheline Szwajcer D9

Swan
2007
Marble dust and resin
137×71×84cm (edition of 5)
Courtesy the artist and Frith Street
Gallery

Daphne **Wright**

Born 1963
Lives Bristol

The relation of human to animal, says Daphne
Wright, is 'a peculiarly sentimental conundrum'. It
consists of an apparently ambiguous set of attitudes,
which the artist has explored in several works that
draw on her upbringing on an Irish farm. In the
video *Sires* (2003) the legs of cattle in close-up look
oddly elegant and human. In a series of intaglio
prints from photographs of bulls' heads, one animal
gazes back at us with a look that seems unsettlingly
knowing and familiar. Her porcelain casts of
stillborn calves and lambs draw on symbols so
elemental they stray into pure kitsch – where, for
Wright, profound truths are sometimes plainly
hidden. (BD)

Shown by Frith Street Gallery C1

Selected Bibliography

2007 *Daphne Wright: Home
Ornaments*, Simon Morrissey, The
Artworks Programme, Glasgow

2006 *Profile 23: Daphne Wright*, ed.
John O'Regan, Gandon Editions,
Oysterhaven

2006 *Croon by Daphne Wright +
Johnny Hanrahan*, ed. Johnny
Hanrahan, Gandon Editions,
Oysterhaven

2005 'Cultural Exchange', Peter
Murray, *Irish Arts*, Spring

2003 'Daphne Wright', Susanne
Biebered, *Art Monthly*, December/
January

Selected Exhibitions

2007 'Still Life', Hanbury Hall,
Worcestershire

2006 'Sires', City Gallery of Art,
Limerick

2005 'New Sculpture from
Ireland', The New Art Centre
Sculpture Park and Gallery, Roche
Court, Wiltshire

2004 'After Life', The Bowes
Museum, Barnard Castle, County
Durham

2003 'These Talking Walls',
Crawford Gallery, Cork

From Here To Eternity or Dreaming of the Beginning of the Information Age
2006
Star made out of home-made rocket fuel, vacuum-sealed in plastic to prevent the absorption of water from the air, wire and ignition system consisting of Christmas tree bulb, solder and home-made black powder of potassium nitrate and charcoal
Sculpture: 90×108×100cm; kit: 54×61×29cm
Courtesy Galleria Raucci/Santamaria

Selected Bibliography

2007 'James Yamada', Beatrice Salvatore, *tema celeste*, January/February

2005 'Interview by Myself', James Yamada, *Wrong Times*

2005 'John Pilson and James Yamada', Marco Altavilla, *Flash Art Italia*, 250

2005 *James Yamada*, Amy Smith-Stewart, PS1 Contemporary Art Center/Museum of Modern Art, New York

2003 'Bait: James Yamada', Cay Sophie Rabinowitz, *Boiler Magazine*, 4

Selected Exhibitions

2007 'Idiot Joy Showland', The IFC Center, New York

2006 'Bunch Alliance and Dissolve', Contemporary Arts Center, Cincinnati

2006 'Rainbow Ball', Galleria Raucci/Santamaria, Naples

2005 'Good Ass Job', Andrew Kreps Gallery, New York

2005 'Greater New York', PS1 Contemporary Art Center, New York

James **Yamada**

Born 1968
Lives New York

Working in an array of media, James Yamada orchestrates actions that subtly realign the relationship between nature and technology. One series documented wild animals collecting food from sculptures fitted with a special system designed to attract wildlife. In *From Here to Eternity or Dreaming of the Beginning of the Information Age* (2006) a starfish cast from home-made rocket fuel (of the kind recently used in Katushya rockets in the Israel–Lebanon conflict) rests on a futuristic, landmass-like structure covered with silver fireproof material. Yamada also supplied wire and an 'ignition kit', including a Christmas tree bulb and some home-made black powder, to set the simulated sea creature on fire and send it aloft. (KJ)

Shown by Galleria Raucci/Santamaria G4

American Dollars (detail)
2007
Watercolour on paper
146.5×250cm
Courtesy David Zwirner and
Galleria Massimo de Carlo

Yan Pei-Ming

Born 1960
Lives Dijon

Using a monochrome palette and a formidable form of impasto, Yan Pei-Ming renders Chairman Mao, his own father, various unknown figures and the odd religious icon alike. On entering the world of paint his diverse characters lose their identities; world leaders and Amsterdam prostitutes are severed from life, becoming one and the same. Pei-Ming's decision to take on portrait commissions is based less on commercial reasons than the eradication of artistic intention: 'My choice no longer comes into it'. Despite the expressive nature of his mark-making, Pei-Ming claims his work is 'not gestural painting but an assault, a determination, that has spiritual, moral and also critical meaning'. (BB)

Shown by Galleria Massimo de Carlo F3, David Zwirner C8

Selected Bibliography

2006 *Exécution* (Execution), Lóránd Hegyi, Franck Gautherot, Frabian Stech, et al., Les Presses du Réel, Paris

2006 'Art Martial', Eric Troncy, *Numéro*, September

2005 *Yan Pei-Ming*, Li Xiang Yang et al., Shanghai Art Museum

2005 *The Way of the Dragon*, Rolf Lauter, Kehrer Verlag Heidelberg, Mannheim

1997 *Yan Pei-Ming: La Prisonnière* (Yan Pei-Ming: The Prisoner), Christian Besson, Musée des Beaux-Arts, Rennes and Dôle

Selected Exhibitions

2007 'You maintain a sense of balance in the midst of great success', David Zwirner, New York

2007 10th Istanbul Biennial

2006 'Execution', Musée d'art moderne, Saint-Etienne

2005 'The Way of the Dragon', Kunsthalle, Mannheim

2005 'Inside the Rear Window: Confession', Galleria Massimo de Carlo, Milan

Lock (open)
2006
Ilfochrome transparency, light-box
102×130×16.5cm
Courtesy Alison Jacques Gallery

Selected Bibliography

2007 'Catherine Yass', Martha Schwnedener, *Artforum*

2006 'Catherine Yass: Lock', Roberta Smith, *The New York Times*

2006 *Vitamin Ph: New Perspectives in Photography*, T.J. Demos, Phaidon Press, London

2006 *The Portrait Now*, Sandy Nairne and Sarah Howgate, National Portrait Gallery, London

2005 *Catherine Yass: Filmografía* (Catherine Yass: Filmography), A. Rodriguez Fominaya, Mark Godfrey and Michael Newman, Centro Atlántico de Arte Moderno, Gran Canaria

Selected Exhibitions

2007 'Dateline Israel: Recent Photography and Video', Jewish Museum, New York

2006 4th International Media Biennial, Seoul

2006 6th Shanghai Biennial

2005 'Catherine Yass: Wall', Centro Atlántico de Arte Moderno, Gran Canaria

2005 'Wall', Herzliya Museum of Modern Art, Israel

Catherine **Yass**

Born 1963
Lives London

Catherine Yass' meditative films often concentrate on concrete. Most recently, *Lock* (2006) shows a ship pulling into the concrete-lined lock of the Three Gorges Dam on the Yangtze River in China. Although the film is formally rigorous, the subject is not a neutral site: the dam has displaced millions of Chinese people. Similarly, Yass' film *Wall* (2004) shows the barricade between Israel and Palestine in a close-up tracking shot that leaves the viewer staring at little other than implacable concrete. As the artist says: 'The film itself is like a wall.' The photographic light-boxes that accompany her films employ double-exposure to make feats of engineering and construction seem strangely dematerialized. (CL)

Shown by Alison Jacques Gallery D15

AMERICAN
2005
Charcoal on paper
71×46cm
Courtesy Galerie Micky Schubert
and Hotel

Mark **van Yetter**

Born 1978
Lives New York

Mark van Yetter's small watercolours and oil paintings deftly combine an idyllic, pastoral sensibility rooted in 19th-century landscape painting with a taste for the disturbing and the bizarre. Images of countryside wanderings executed in soft, pastel strokes combine with psychologically probing portraits and pen–and–ink caricatures of anonymous beggars and religious clerics, lawyers and criminal suspects, to create a semi-fantastic, semi-real-world realm in which beauty and ugliness, sensuality and perversion, are shown to be uncomfortably aligned. (CG)

Shown by Hotel H2

Selected Exhibitions

2007 Galerie Micky Schubert, Berlin

2005 'Ein Ding von Schönheit ein Glück auf immer', Corvi-Mora, London

2004 'Direkt from Poconos', Star Ship, Berlin

Untitled
2007
C-print
101.6×82.2cm
Courtesy the artist and Rivington
Arms

Selected Bibliography

2007 'Food for Thought', Ana
Finel Honigman, *Alef Magazine*, 2

2007 *Pinar Yolacan: Perishables*,
Mine Haydaroglu, Yapi Credi
Foundation, Istanbul

2005 'Against the Exotic', Ana
Finel Honigman, *ArtReview*

2005 'Pinar Yolacan at Rivington
Arms', Brian Boucher, *Art in
America*

2004 'A Shelf Life So Short It
Takes The Breath Away', Cathy
Horyn, *The New York Times*

Selected Exhibitions

2007 'Perishables', Yapi Credi
Foundation, Istanbul

2005 'Art-Robe: Women Artists
in a Nexus of Art and Fashion',
UNESCO, Paris

2005 'Surface Tension', Gallery
500, Portland

2004 'Perishables', Rivington
Arms, New York

2004 'Festival of Emerging
Photographers', Art + Commerce,
New York

Pinar **Yolacan**

Born 1981
Lives Brooklyn

Pinar Yolacan's meditations on mortality are made
through the medium of meat. Her series of
photographs depicting ageing Upper East Side
WASP-style women, 'Perishables' (2001–4),
seduces and disgusts in equal measure. Each of the
once elegant figures sports clothing made from raw
tripe, testicles and intestines. Any semblance of
appeal dissolves when, on closer inspection, the
subtly sophisticated cream and tan garments reveal
their deeply repellent origins. These amorphous
offerings hang lifeless, indistinguishable from the
flesh they shroud: Yolacan hints at the fast-
encroaching mortality of her subjects by
reincarnating the already demised – albeit as a
piecrust frill collar. (BB)

Shown by Rivington Arms F29

Studio Sheradaze: Before They Got Their Military Training. Saida Early 1970s
2006
Modern silver prints
30×30cm (each)
Courtesy the artist and Galerie Sfeir-Semler

Akram **Zaatari**

Born 1966
Lives Beirut

Akram Zataari's practice comprises photography, video and archival research. A founder member of the Arab Image Foundation, one of his aims is to salvage the history of his native Lebanon and to counteract the erosion of people's memories as a result of the physical destruction of the country. To this end he collects and preserves prewar images and documents, particularly ones that conflict with the official state version of historical events. Another goal is to explore representations of male sexuality from the Arab region, using both his own works and found objects to create complex installations. Although clearly political, Zataari's pieces are not didactic or polemical: rather, they are charming and intimate, often leading the artist and the viewer on a journey of discovery. (AC)

Shown by Galerie Sfeir-Semler E16

Selected Bibliography

2007 'Akram Zaatari: Objects of Study', Belinda Grace Gardner, *Bidoun Magazine*, Spring

2007 'Akram Zaatari', Nina Moentmann, *Artforum*

2004 *Hashem el Madani: Studio Practices*, Akram Zaatari and Lisa Lefeuvre, Arab Image Foundation/Mind the Gap/The Photographers' Gallery, Beirut

2002 *Mapping Sitting: On Portraiture and Photography*, Akram Zaatari, Karl Bassil and Zeina Maasri, Arab Image Foundation/Mind the Gap, Beirut

Selected Exhibitions

2007 'Objects of Study', Galerie Sfeir-Semler, Hamburg

2007 'Art Statements', Art 36 Basel

2006 14th Sydney Biennial

2006 'Hashem el Madani: Promenades and Studio Practices', La Caixa Forum, Barcelona

2006 6th Gwangju Biennale

Danuta, Halina, Dorota
2006
Still from 3-channel video
installation
Courtesy Galerie Peter Kilchmann

Selected Bibliography

2007 'Artur Zmijewski: Selected Works', Kathrin Becker, *Neuer Berliner Kunstverein*

2006 'Carceral Subjects: The Play of Power in Artur Zmijewski's Repetition', Derek Conrad Murray, *Parachute*

2006 'The Social Turn: Collaboration and its Discontents', Claire Bishop, *Artforum*, 6

2005 *Einmal ist keinmal* (If It Happened Only Once It's As If It Never Happened), Adam Szymczyk, Charles Esche and Jane Farver, Zacheta National, Warsaw/ Kunsthalle, Basel

2004 *Artur Zmijewski: Selected Works: 1998–2003*, Jane Farver, MIT List Visual Arts Centre, Cambridge

Selected Exhibitions

2007 Neuer Berliner Kunstverein, Berlin

2007 documenta 12, Kassel

2006 'A Short History of Performance: Part IV', Whitechapel Art Gallery, London

2005 Kunsthalle, Basel

2005 Polish Pavilion, 51st Venice Biennale

Artur **Zmijewski**

Born 1966
Lives Warsaw

If the video works of Artur Zmijewski are unsettling and even at times difficult to watch, they are also some of the most penetrating meditations currently being produced on state violence, physical pain, individual alienation, the defective and the dysfunctional. Zmijewski's calculated, somatic provocations lend an uncanny visibility to the 'imperfect', the lacking, the abject – to all that is normally relegated to the shadows. Recently, Zmijewski has garnered attention for his recreation of the famous Stanford 'prison experiment' in *Repetition* (2005); here unemployed Poles replace graduate students as they improvise the roles of captors and captives in a mock jail, yet ominously a similar pattern of escalating sadism follows until the participants feel compelled to abandon the project. (AS)

Shown by Foksal Gallery Foundation E6, Galerie Peter Kilchmann E2, Sommer Contemporary Art F18

Contributors

(MA) Max Andrews is a writer and curator. He is co-founder of Latitudes, Barcelona.

(CB) Chris Balaschak is a writer based in Los Angeles, and a PhD candidate in the Visual Studies Program at the University of California, Irvine.

(KB) Kirsty Bell is a writer and curator based in Berlin.

(AB) Andrew Bonacina is a London-based writer and curator and curatorial assistant of Frieze Projects.

(BB) Belinda Bowring is a London-based art historian and writer.

(AC) Amanda Coulson is a writer and curator based in Frankfurt, Germany.

(BD) Brian Dillon is a columnist for *frieze* and author of a memoir, *In the Dark Room*.

(DE) Dominic Eichler is a contributing editor to *frieze* magazine.

(DF) Dan Fox is associate editor of *frieze*. He is also a writer, musician and filmmaker.

(CG) Claire Gilman is an independent curator and writer living in New York.

(JG) Jonathan Griffin is editorial assistant of *frieze* and a writer.

(MG) Melissa Gronlund is Special Projects Editor of *ArtReview* and a London-based writer and critic.

(JH) Jörg Heiser is co-editor of *frieze*. He lives in Berlin and writes for *Süddeutsche Zeitung*.

(MH) Martin Herbert is a writer and critic based in Tunbridge Wells, Kent.

(JH) Jennifer Higgie is co-editor of *frieze* and a writer. Her first novel, *Bedlam*, is published by Sternberg Press. She also wrote the screenplay for the feature length movie, *I Really Hate My Job*.

(AJ) Adam Jasper is a regular contributor to *frieze* and is currently working on an unusual history of aesthetics.

(KJ) Kristin M. Jones is a writer and editor based in New York, and a regular contributor to *frieze*.

(CL) Christy Lange is assistant editor at *frieze*'s Berlin office and a writer.

(SL) Sarah Lowndes is a lecturer at Glasgow School of Art and a writer.

(TM) Tom Morton is contributing editor to *frieze* and curator of Cubitt Gallery, London.

(SR) Sally O'Reilly is a London-based writer and co-editor of *Implicasphere*.

(VR) Vivian Rehberg is an art historian and critic, founding editor of the Journal of Visual Culture, and a lecturer at the School of Fine Arts in Dunkirk.

(AS) Aaron Schuster is a Brussels-based philosopher and art critic, and author of a forthcoming book, *The Trouble With Pleasure*.

(SS) Steven Stern is a New York-based writer and a regular contributor to *frieze*.

(ST) Sam Thorne is website editor of *frieze* and a writer.

(JT) James Trainor is US editor of *frieze* and a writer. He lives and works in New York.

frieze

frieze

frieze

frieze

frieze

frieze

Michael Borremans Carsten Höller Thomas Schütte Andreas Slominski

frieze

Martha Rosler interview
Are art prizes useful?
City report: Istanbul

plus Sharon Lockhart, Matisse, Catherine Sullivan and Konstantin Grcic

frieze

frieze
issue
100

frieze

Paola Pivi
Black Audio Film Collective
Art and the Occult

frieze

Index

Gallery Index

ACME.

Stand D16
Tel +1 323 857 5942

6150 Wilshire Boulevard
Los Angeles CA 90048
USA
Tel +1 323 857 5942
Fax +1 323 857 5864
info@acmelosangeles.com
www.acmelosangeles.com

Contact
Robert Gunderman
Randy Sommer
Dean Anes

Gallery artists
Amy Adler
Kai Althoff
Kristin Baker
Justin Beal
Miles Coolidge
Tomory Dodge
Tony Feher
Chris Finley
Katie Grinnan
Kevin Hanley
Bill Jensen
Kurt Kauper
Martin Kersels
Allison Miller
Aaron Morse
Laura Owens
Monique Prieto
Dario Robleto
Lisa Sanditz
John Sonsini
Jennifer Steinkamp
Neal Tait

Air de Paris

Stand E5
Tel +33 1 44 23 02 77

32 rue Louise Weiss
Paris 75013
France
Tel +33 1 44 23 02 77
Fax +33 1 53 61 22 84
fan@airdeparis.com
www.airdeparis.com

Contact
Florence Bonnefous
Edouard Merino

Gallery artists
Olaf Breuning
Guy de Cointet
François Curlet
Stéphane Dafflon
Brice Dellsperger
Trisha Donnelly
Claire Fontaine
Liam Gillick
Joseph Grigely
Guyton & Walker
Annika von Hauswolff
Carsten Höller
Ann Veronica Janssens
Pierre Joseph
Inez van Lamsweerde &
Vinoodh Matadin
M/M Paris
Sarah Morris
Petra Mrzyk &
Jean-François Moriceau
Philippe Parreno
Bruno Pelassy
Rob Pruitt
Navin Rawanchaikul
Torbjørn Rødland
Allen Ruppersberg
Bruno Serralongue
Shimabuku
Josh Smith
Lily van der Stokker
Jean-Luc Verna

galerie bob van **orsouw**

Stand C12
Tel +41 79 402 76 29

Limmatstrasse 270
Zurich 8005
Switzerland
Tel +41 44 273 1100
Fax +41 44 273 1102
mail@bobvanorsouw.ch
www.bobvanorsouw.ch

Suzie Q Projects
Limmatstrasse 265
Zurich 8005
Switzerland
Tel +41 44 273 0300
Fax +41 44 273 0304

Contact
Bob van Orsouw
Birgid Uccia
Bettina Meier-Bickel
Eveline Baumgartner

Gallery artists
Haluk Akakçe
Philip Akkerman
Nobuyoshi Araki
Hannah van Bart
Marcel van Eeden
Armen Eloyan
Gabríela Fridriksdóttir
Paul Graham
Anton Henning
Lori Hersberger
Teresa Hubbard &
Alexander Birchler
Josephsohn
Atelier van Lieshout
Erik van Lieshout
Edward Lipski
Bjørn Melhus
Daido Moriyama
Claudio Moser
Ernesto Neto
Walter Niedermayr
Julian Opie
Erik Parker

David Reed
Albrecht Schnider
Shirana Shahbazi
Wawrzyniec Tokarski
Bernard Voïta

Patrick **Painter**, Inc.

Stand B14
Tel +1 310 264 5988

2525 Michigan Avenue
A8 & B2
Santa Monica CA 90404
USA
Tel +1 310 264 5988
Fax +1 310 264 5998
info@patrickpainter.com
www.patrickpainter.com

Contact
Patrick Painter
Edward Chu
Heather Harmon
Daniel Congdon

Gallery artists
Estate of Bas Jan Ader
Hope Atherton
Georg Baselitz
Tim Berresheim
Glenn Brown
André Butzer
Liz Craft
Valie Export
Bernard Frize
Francesca Gabbiani
Salomón Huerta
Jörg Immendorf
Larry Johnson
Mike Kelley
Won Ju Lim
Ivan Morley
Albert Oehlen
Philippe Pasqua
Ed Ruscha (works available)
Matthias Schaufler
Christoph Schmidberger
Jim Shaw
Melanie Smith
Marnie Weber
Li Wei
Peter Wu
Toby Zeigler
Ivette Zighelboim
Thomas Zipp

Maureen **Paley**

Stand D5
Tel +44 20 7729 4112

21 Herald Street
London E2 6JT
UK
Tel +44 20 7729 4112
Fax +44 20 7729 4113
info@maureenpaley.com
www.maureenpaley.com

Contact
Susanna Chisholm
Oliver Evans
Maureen Paley

Gallery artists
Kaye Donachie
Dick Evans
Hamish Fulton
Maureen Gallace
Andrew Grassie
Anne Hardy
Sarah Jones
Michael Krebber
Daria Martin
Muntean & Rosenblum
Paul Noble
Saskia Olde Wolbers
Seb Patane
Ruth Root
Maaike Schoorel
Hannah Starkey
David Thorpe
Wolfgang Tillmans
Donald Urquhart
Banks Violette
Rebecca Warren
Gillian Wearing
James Welling
Eric Wesley

Peres Projects Los Angeles Berlin

Stand G22
Tel +1 213 617 1100

969 Chung King Road
Los Angeles CA 90012
USA
Tel +1 213 617 1100
Fax +1 213 617 1141
info@peresprojects.com
www.peresprojects.com

Schlesische Strasse 26
Berlin 10997
Germany
Tel +49 30 6162 6962
Fax +49 30 6162 7066

Contact
Javier Peres
Sarah Walzer
Margherita Belaief
Blair Taylor

Gallery artists
Assume Vivid Astro Focus
Dan Attoe
Chris Ballantyne
Joe Bradley
Dan Colen
Liz Craft
Amie Dicke
Kaye Donachie
Matthew Greene
John Kleckner
Terence Koh
Bruce LaBruce
Paul Lee
Kirstine Roepstorff
Dean Sameshima
Agathe Snow
Mark Titchner

Galerie Emmanuel **Perrotin**

Stand F9
Tel +33 1 42 16 79 79

76 rue de Turenne
Paris 75003
France
Tel +33 1 42 16 79 79
Fax +33 1 42 16 79 74
info-paris@galerieperrotin.com
www.galerieperrotin.com

194 North West 30th Street
Miami FL 33127
Tel +1 305 573 2130
Fax +1 305 573 05 95
info-miami@galerieperrotin.com

Contact
Emmanuel Perrotin
Peggy Leboeuf
Etsuko Nakajima
Nathalie Brambilla

Gallery artists
Chiho Aoshima
Daniel Arsham
Bhakti Baxter
Sophie Calle
Maurizio Cattelan
Peter Coffin
Eric Duyckaerts
Michael Elmgreen &
Ingar Dragset
Lionel Esteve
Naomi Fisher
Bernard Frize
Giuseppe Gabellone
gelitin
Kolkoz
Guy Limone
Keegan Mchargue
Jin Meyerson
Mariko Mori

Mr.
Takashi Murakami
Martin Oppel
Jean-Michel Othoniel
Paola Pivi
Aya Takano
Piotr Uklanski
Chris Vasell
Xavier Veilhan
Peter Zimmermann

Friedrich
Petzel Gallery

Stand B2
Tel +1 212 680 9467

537 West 22nd Street
New York NY 10011
USA
Tel +1 212 680 9467
Fax +1 212 680 9473
maureen@petzel.com
www.petzel.com

535 West 22nd Street
New York NY 10011
USA
Tel +1 212 680 9467

Contact
Maureen Sarro
Andrea Teschke
Sam Tsao

Gallery artists
Cosima von Bonin
Matthew Brannon
Troy Brauntuch
Björn Dahlem
Keith Edmier
Thomas Eggerer
Andrea Fraser
Wade Guyton
Georg Herold
Charline von Heyl
Dana Hoey
Maria Lassnig
Michel Majerus
Allan McCollum
Sarah Morris
Jorge Pardo
Philippe Parreno
Seth Price
Stephen Prina
Jonathan Pylypchuk
Tobias Rehberger
Jeroen de Rijke &
Willem de Rooij
Dirk Skreber
Nicola Tyson

Galerie
Francesca
Pia

Stand H11
Tel +41 79 247 57 52

Limmatstrasse 275
Zurich 8005
Switzerland
Tel +41 44 271 24 44
Fax +41 44 271 24 45
info@francescapia.com
www.francescapia.com

Contact
Francesca Pia
Angelika Hunziker

Gallery artists
Thomas Bayrle
Stéphane Dafflon
Philippe Decrauzat
Hans-Peter Feldmann
Vidya Gastaldon
Aloïs Godinat
Joseph Grigely
Wade Guyton
Jutta Koether
Mai-Thu Perret
David Shrigley
Joanne Tatham &
Tom O'Sullivan
John Tremblay

PKM
Gallery

Stand G2
Tel +82 2 734 9467/8

137–1 Hwa-dong
Jongro-Gu
Seoul 110–210
Korea
Tel +82 2 734 9467/8
Fax +82 2 734 9469
info@pkmgallery.com
www.pkmgallery.com

46-C Cao Chang Di,
Chaoyang Qu,
Beijing 100015
China
Tel +86 10 8456 7429
Fax +86 10 8456 7482

Contact
Kyung-Mee Park
Shi-Ne Oh
Yoewool Kang

Gallery artists
Young-Whan Bae
Bernd & Hilla Becher
Moon Beom
Lee Bul
Ingrid Calame
Cody Choi
Jonas Dahlberg
Olafur Eliasson
Steven Gontarski
Ham Jin
Michael Joo
Byron Kim
Jiwon Kim
Sang-Gil Kim
Noori Lee
Sangnam Lee
Bruce Nauman
Jorge Pardo
Stephen Prina
Wang Quingsong
Wenbo Chen

Galerija
Gregor
Podnar

Stand F20
Tel +386 1 430 4929

Kolodvorska 6
Ljubljana 1000
Slovenia
Tel +386 1 430 4929
Fax +386 1 430 4928
gpodnar@siol.net
www.gregorpodnar.com

Contact
Gregor Podnar
Mara Ambrožic
Bettina Klein
Dragana Radojevic

Gallery artists
Attila Csörgo
Vadim Fiškin
Alexander Gutke
Irwin
Magnus Larsson
Yuri Leiderman
Dan Perjovschi
Goran Petercol
Tobias Putrih
Nika Špan

Galerie Eva
Presenhuber

Stand C3
Tel +41 43 444 7050

Limmatstrasse 270
Zurich 8005
Switzerland
Tel +41 43 444 7050
Fax +41 43 444 7060
info@presenhuber.com
www.presenhuber.com

Contact
Eva Presenhuber
Niklaus Kuenzler
Anna Caruso
Markus Rischgasser

Gallery artists
Doug Aitken
Emmanuelle Antille
Monika Baer
Martin Boyce
Angela Bulloch
Valentin Carron
Verne Dawson
Trisha Donnelly
Maria Eichhorn
Urs Fischer
Peter Fischli & David Weiss
Sylvie Fleury
Liam Gillick
Mark Handforth
Candida Höfer
Karen Kilimnik
Andrew Lord
Hugo Markl
Richard Prince
Gerwald Rockenschaub
Tim Rollins and K.O.S.
Ugo Rondinone
Dieter Roth
Eva Rothschild
Jean-Frédéric Schnyder
Steven Shearer
Beat Streuli
Franz West
Sue Williams

Produzenten-galerie

Stand H8
Tel +49 40 37 82 32

Admiralitätstrasse 71
Hamburg 20459
Germany
Tel +49 40 37 82 32
Fax +49 40 36 33 04
info@produzentengalerie.com
www.produzentengalerie.com

Contact
Jürgen Vorrath
Anna-Catharina Gebbers
Kerstin Niemann
Peter Sander

Gallery artists
Tjorg Douglas Beer
Ulla von Brandenburg
Jonas Burgert
Stephan Craig
Bogomir Ecker
Beate Gütschow
Gustav Kluge
Olaf Metzel
Thomas Scheibitz
Thomas Schütte
Norbert Schwontkowski
Andreas Slominski
Nicole Wermers

The **Project**

Stand H1
Tel +1 212 688 1585

37 West 57th Street, 3rd Floor
New York, NY 10019
USA
Tel +1 212 688 1585
Fax +1 212 688 1589
mail@elproyecto.com
www.elproyecto.com

Contact
Christian Haye
Renaud Proch
Lizzy Cross
Giovanni Garcia-Fenech

Gallery artists
Chen Xiaoyun
José Damasceno
Coco Fusco
Maria Elena González
Barkley Hendricks
Nic Hess
Glenn Kaino
Kimsooja
Daniel Joseph Martinez
Julie Mehretu
Aernout Mik
Kori Newkirk
Yoshua Okon
Geof Oppenheimer
Paul Pfeiffer
William Pope. L
Jessica Rankin
Peter Rostovsky
Tracey Rose
Cristián Silva
Stephen Vitiello

Galleria **Raucci/** Santamaria

Stand G4
Tel +39 081 744 3645

Corso Amedeo di Savoia 190
Naples 80136
Italy
Tel +39 081 744 3645
Fax +39 081 744 2407
info@raucciesantamaria.com
raucciesantamaria.com

Contact
Umberto Raucci
Carlo Santamaria
Mara De Falco
Giorgio Salzano

Gallery artists
Miriam Backstrom
Mat Collishaw
Georg Herold
Evan Holloway
Hervé Ingrand
Ann Lislegaard
Hugo Markl
John Pilson
Frederic Pradeau
Tim Rollins & K.O.S.
Ugo Rondinone
Norbert Schwontkowski
Glenn Sorensen
Cheyney Thompson
Padraig Timoney
Torbjörn Vejvi
Cathy Wilkes
James Yamada

Galerie
Almine **Rech**

Stand G7
Tel +33 1 45 83 71 90

19 rue de Saintonge
Paris 75003
France
Tel +33 1 45 83 71 90
Fax +33 1 45 70 91 30
a.rech@galeriealminerech.com
www.galeriealminerech.com

11 avenue Victoria
Brussels 1000
Belgium
Tel +32 2 648 56 84
Fax +32 2 648 44 84

Contact
Thomas Dryll (Paris)
Renaud Pillon (Paris)
Almine Rech (Brussels)
Bérénice Chef (Brussels)

Gallery artists
Rita Ackermann
Nobuyoshi Araki
Matias Becker
Don Brown
Tom Burr
Damien Cadio
Philip-Lorca diCorcia
Anita Dube
John Giorno
Wenda Gu
Mark Handforth
Gregor Hildebrandt
Peter Joseph
Johannes Kahrs
Joesph Kosuth
Ange Leccia
John McCracken
Kenneth Noland
Sven Pahlsson
Miguel Palma
Tobias Putrih
Nathaniel Rackowe
Anselm Reyle
Zbigniew Rogalski
Ugo Rondinone

Matt Saunders
Taryn Simon
Hedi Slimane
Annelies Strba
Katja Strunz
Vincent Szarek
John Tremblay
Tatiana Trouvé
Gavin Turk
James Turrell
Stephen Vitiello
Miwa Yanagi

Regen
Projects

Stand C10
Tel +1 323 605 72 01

633 North Almont Drive
Los Angeles CA 90069
USA
Tel +1 310 276 5424
Fax +1 310 276 7430
office@regenprojects.com
www.regenprojects.com

Contact
Shaun Caley Regen
Stacy Bengtson
Jennifer Loh
Yasmine Rahimzadeh

Gallery artists
Doug Aitken
Stephan Balkenhol
Matthew Barney
John Bock
Edgar Bryan
John Currin
Thomas Demand
Christian Jankowski
Anish Kapoor
Toba Khedoori
Liz Larner
Glenn Ligon
Scott McFarland
Catherine Opie
Jennifer Pastor
Manfred Pernice
Raymond Pettibon
Elizabeth Peyton
Jack Pierson
Lari Pittman
Richard Prince
Charles Ray
Willem de Rooij
Paul Sietsema
Billy Sullivan
Wolfgang Tillmans
Gillian Wearing
Lawrence Weiner
James Welling
Sue Williams
Andrea Zittel

Daniel **Reich** Gallery

Stand F27
Tel +1 212 924 4949

537a West 23rd Street
New York NY 10011
USA
Tel +1 212 924 4949
Fax +1 212 924 6224
laura@danielreichgallery.com
www.danielreichgallery.com

Contact
Daniel Reich
Laura Higgins

Gallery artists
Scoli Acosta
Hernan Bas
Black Leotard Front
Michael Cline
Sean Dack
Amy Gartrell
Christian Holstad
Anya Kielar
Birgit Megerle
Futoshi Miyagi
Paul P.
Scott Reeder
Tyson Reeder

Anthony **Reynolds** Gallery

Stand F8
Tel +44 20 7439 2201

60 Great Marlborough Street
London W1F 7BG
UK
Tel +44 20 7439 2201
Fax +44 20 7439 1869
info@anthonyreynolds.com
www.anthonyreynolds.com

Contact
Anthony Reynolds
Maria Stathi

Gallery artists
The Atlas Group
David Austen
Richard Billingham
Ian Breakwell
Erik Dietman
Keith Farquhar
Leon Golub
Paul Graham
Lucy Harvey
Georg Herold
Emily Jacir
Kai Kaljo
Andrew Mansfield
Alain Miller
Lucia Nogueira
Walid Raad
Nancy Spero
Sturtevant
Jon Thompson
Amikam Toren
Nobuko Tsuchiya
Mark Wallinger

Rivington Arms

Stand F29
Tel +1 646 654 3213

4 East 2nd Street, 1st Floor
New York NY 10003
USA
Tel +1 646 654 3213
Fax +1 212 475 1801
info@rivingtonarms.com
www.rivingtonarms.com

Contact
Melissa Bent
Mirabelle Marden

Gallery artists
Darren Bader
Mathew Cerletty
John Finneran
Shara Hughes
Lansing-Dreiden
Hanna Liden
Carter Mull
Dash Snow
Pinar Yolacan

Galerie Thaddaeus **Ropac**

Stand B12
Tel +43 662 881 393

Mirabellplatz 2
Salzburg 5020
Austria
Tel +43 662 881 393
Fax +43 662 881 3939
office@ropac.at
www.ropac.net

7 rue Debelleyme
Paris 75003
France
Tel +33 1 42 72 99 00
Fax +33 1 42 72 61 66
galerie@ropac.net

Contact
Thaddaeus Ropac
Elena Bortolotti
Bénédicte Burrus
Jill Silverman van Coenegrachts
Arne Ehmann

Gallery artists
Cory Arcangel
Donald Baechler
Stephan Balkenhol
Georg Baselitz
Jean-Marc Bustamante
Philippe Bradshaw
Marc Brandenburg
Francesco Clemente
Tony Cragg
Richard Deacon
Elger Esser
Sylvie Fleury
Gilbert & George
Antony Gormley
Wang Guangyi
Peter Halley
Lori Hersberger
Ilya Kabakov

Alex Katz
Anselm Kiefer
Imi Knoebel
Wolfgang Laib
Jonathan Lasker
Liza Lou
Robert Mapplethorpe
Fabian Marcaccio
Bernhard Martin
Jason Martin
Yasumasa Morimura
Paul P.
Mimmo Paladino
Jack Pierson
Rona Pondick
Arnulf Rainer
Gerwald Rockenschaub
Ed Ruscha
Lisa Ruyter
Tom Sachs
David Salle
Hubert Scheibl
Julian Schnabel
Sturtevant
Philip Taaffe
Banks Violette
Not Vital
Andy Warhol

Galleria Sonia **Rosso**

Stand A9
Tel +39 011 817 2478

Via Giulia di Barolo 11/h
Turin 10124
Italy
Tel +39 011 817 2478
Fax +39 011 817 2478
info@soniarosso.com
www.soniarosso.com

Contact
Sonia Rosso
Valentina Sina

Gallery artists
Charles Avery
Pierre Bismuth
Massimiliano Buvoli
Alice Guareschi
Scott King
Jim Lambie
Peter Land
Christina Mackie
Jonathan Monk
Scott Myles
Matthew Sawyer
Annika Ström

Salon 94

Stand B13
Tel +1 646 672 9212

12 East 94th Street
New York NY 10128
USA
Tel +1 646 672 9212
Fax +1 646 672 9214
info@salon94.com
www.salon94.com

Contact
Jeanne Greenberg Rohatyn
Fabienne Stephan
David Fierman
Alissa Friedman

Gallery artists
Barry X Ball
Amy Bessone
Huma Bhabha
Carter
Gerald Davis
Francesca DiMattio
Iris van Dongen
Sylvie Fleury
Paula Hayes
Laleh Khorramian
Marilyn Minter
Estate of Carlo Mollino
Aïda Ruilova
Shirana Shahbazi
Lorna Simpson
Wang Qingsong

Galerie Aurel **Scheibler**

Stand G17
Tel +49 30 30 30 13 29

Witzlebenplatz 4
Berlin 14057
Germany
Tel +49 30 30 30 13 29
Fax +49 30 30 11 24 20
office@aurelscheibler.com
www.aurelscheibler.com

Scheibler Mitte
Charlottenstrasse 1–3
10969 Berlin
Germany

Contact
Aurel Scheibler
Rebeccah Blum
Marie Graftieaux
Alexander Hattwig
Dr. Brigitte Schlüter

Gallery artists
Sam Crabtree
Öyvind Fahlström
Anthony Goicolea
Stefan Löffelhardt
Sarah Morris
Ernst Wilhelm Nay
Alice Neel
Jack Pierson
Bridget Riley
Peter Saul
Claudia Schink
Rachel Selekman
Boy & Erik Stappaerts
Peter Stauss
Billy Sullivan
Hideo Togawa
Alessandro Twombly
Christoph Wedding
Erwin Wurm
Joe Zucker

Galerie Rüdiger **Schöttle**

Stand E10
Tel +49 17 01 86 52 52

Amalienstrasse 41, Rgb.
Munich 80799
Germany
Tel +49 89 333 686
Fax +49 89 342 296
info@galerie-schoettle.de
www.galerie-schoettle.de

Contact
Rüdiger Schöttle
Ingrid Lohaus
Sabine Heuser-Hauck
Franziska Fronhöfer

Gallery artists
Janis Avotins
Stephan Balkenhol
Armin Boehm
Rafal Bujnowski
David Claerbout
James Coleman
Martin Creed
Slawomir Elsner
Elger Esser
Günther Förg
Dan Graham
Rodney Graham
Andreas Gursky
Thomas Helbig
Candida Höfer
On Kawara
John Knight
Tim Lee
Jan Merta
Frank Nitsche
Anselm Reyle
Stefan Rinck
Thomas Ruff
Anri Sala
Wilhelm Sasnal
Thomas Schütte
Thomas Struth
Florian Süßmayr
Jeff Wall
Thomas Zipp

Gabriele **Senn** Galerie

Stand E24
Tel +43 664 521 7058

Schleifmühlgasse 1a
Vienna 1040
Austria
Tel +43 1 585 2580
Fax +43 1 585 2606
galerie.senn@aon.at
www.galeriesenn.at

Contact
Gabriele Senn

Gallery artists
Kai Althoff
Abel Auer
Cosima von Bonin
Maria Brunner
Norbert Brunner
André Butzer
Bernhard Fruehwirth
Kerstin von Gabain
Martin Gostner
Georg Herold
Richard Jackson
Dorota Jurczak
Armin Krämer
Kitty Kraus
Dennis Loesch
Marko Lulic
Hans-Jörg Mayer
Albert Mayr
Barbara Mungenast
Johann Neumeister
Josephine Pryde
Michael S. Riedel
Elfie Semotan
Hans Weigand
Amelie von Wulffen

Galerie **Sfeir-Semler**

Stand E16
Tel +49 172 4209668

Admiralitätstrasse 71
Hamburg 20459
Germany
Tel +49 40 3751 9940
Fax +49 40 3751 9637
beirut@sfeir-semler.com
www.sfeir-semler.com

Tannous Building
Street 56, Jisr Sector 77
Beirut
Lebanon
Tel +961 1 566 550
Fax +961 1 566 551

Contact
Andrée Sfeir-Semler
Nathalie Khoury
Anna Grosskopf

Gallery artists
The Atlas Group
Yto Barada
Robert Barry
Daniele Buetti
Balthasar Burkhard
Elger Esser
Ian Hamilton Finlay
Hans Haacke
Christian Hahn
Mona Marzouk
Hiroyuki Masuyama
Stephan Moersch
Rabih Mroué
Moataz Nasreldin
Walid Raad
Khalil Rabah
Marwan Rechmaoui
Ulrich Rückriem
Felix Schramm
Setareh Shahbazi
Wael Shawky
Christine Streuli
Barbara Camilla Tucholski
Akram Zaatari

Stuart **Shave** / Modern Art

Stand D12
Tel +44 788 755 6818

10 Vyner Street
London E2 9DG
UK
Tel +44 20 8980 7742
Fax +44 20 8980 7743
info@stuartshavemodernart.com
www.stuartshavemodernart.com

Contact
Stuart Shave
Jimi Lee

Gallery artists
Bas Jan Ader
David Altmejd
Kenneth Anger
Simon Bill
Tom Burr
Nigel Cooke
Barnaby Furnas
Tim Gardner
Lothar Hempel
Brad Kahlhamer
Phillip Lai
Linder
Barry McGee
Jonathan Meese
Alan Michael
Matthew Monahan
Katy Moran
Clare E. Rojas
Eva Rothschild
Lara Schnitger
Collier Schorr
Steven Shearer
Ricky Swallow
Clare Woods

Galeria Filomena **Soares**

Stand H7
Tel +35 1 96 237 3956

Rua da Manutenção 80
Lisbon 1900-321
Portugal
Tel +35 1 21 862 4122
Fax +35 1 21 862 4124
gfilomenasoares@mail.telepac.pt
www.gfilomenasoares.com

Contact
Sofia Nunes
Manuel Santos

Gallery artists
Pilar Albarracín
Helena Almeida
Vasco Araújo
Art & Language
Inês Botelho
Daniel Canogar
Pedro Casqueiro
José Pedro Croft
Andy Denzler
Dias & Riedweg
Ângela Ferreira
Rui Ferreira
Günther Förg
Pia Fries
Pedro Gomes
Susy Gómez
Katharina Grosse
Susan Hiller
Axel Hütte
Imi Knoebel
Jason Martin
Tracey Moffatt
Antoni Muntadas
Markus Oehlen
António Olaio
Rodrigo Oliveira
João Penalva
Ana Luisa Ribeiro

Jorge Rodrigues
Allan Sekula
António Sena
João Pedro Vale
Costa Vece
Júlia Ventura
Peter Zimmermann

Sommer Contempo- rary Art

Stand F18
Tel +972 3 516 6400

13 Rothschild Boulevard
Tel Aviv 65785
Israel
Tel +972 3 516 6400
Fax +972 3 566 5501
iritms@netvision.net.il
www.sommergallery.com

Contact
Irit Mayer-Sommer

Gallery artists
Darren Almond
Yael Bartana
Rineke Dijkstra
Ofir Dor
Karl Haendel
Alona Harpaz
Michal Helfman
Boyan Lazanof
Itzik Livneh
Muntean & Rosenblum
Adi Nes
Ugo Rondinone
Wilhelm Sasnal
Yehudit Sasportas
Netally Schlosser
Efrat Shvily
Doron Solomons
Eliezer Sonnenschein
Wolfgang Tillmans
Sharon Ya'ari
Rona Yefman
Guy Zagursky
Artur Zmijewski

Monika **Sprüth**, Philomene Magers

Stand B10
Tel +44 78 04 27 42 39

7a Grafton Street
London W1S 4EJ
UK
Tel +44 20 7408 1613
Fax +44 20 7499 4531
fvh@spruethmagers.com
www.spruethmagers.com

Wormser Strasse 23
Cologne 50677
Germany
Tel +49 221 380 415/16
Fax +49 221 380 417

Schellingstrasse 48
Munich 80799
Germany
Tel +49 893 304 0600
Fax +49 893 973 02

Contact
Monika Sprüth
Philomene Magers
Andreas Gegner
Franziska von Hasselbach

Gallery artists
Siegfried Anzinger
Richard Artschwager
John Baldessari
Alighiero e Boetti
Vincenzo Castella
George Condo
Walther Dahn
Thomas Demand
Philip-Lorca diCorcia
William Eggleston
Peter Fischli & David Weiss
Dan Flavin
Sylvie Fleury
Andreas Gursky
Jenny Holzer
Donald Judd
Axel Kasseböhmer
Stefan Kern
Karen Kilimnik
Astrid Klein
Barbara Kruger
Louise Lawler
Michel Majerus
Robert Morris
Paul Morrison
Jean-Luc Mylayne
Richard Prince
Ed Ruscha
Thomas Scheibitz
Andreas Schulze
Cindy Sherman
Frances Sholz
Stephen Shore
Robert Therrien
Rosemarie Trockel

Standard (Oslo)

Stand F25
Tel +47 917 07 429

Hegdehaugsveien 3
Oslo 0352
Norway
Tel +47 22601310
Fax +47 22601311
info@standardoslo.no
www.standardoslo.no

Contact
Eivind Furnesvik

Gallery artists
Tauba Auerbach
Johanna Billing
Gardar Eide Einarsson
Marius Engh
Matias Faldbakken
Ane Graff
Knut Henrik Henriksen
Kim Hiorthøy
David Lieske
Michaela Meise
Are Mokkelbost
Torbjørn Rødland
Josh Smith
Oscar Tuazon

Store

Stand F31
Tel +44 20 7729 8171

27 Hoxton Street
London N1 6NH
UK
Tel +44 20 7729 8171
Fax +44 20 7729 8171
info@storegallery.co.uk
www.storegallery.co.uk

Contact
Louise Hayward
Niru Ratnam

Gallery artists
Chris Evans
Simon Evans
Aurélien Froment
Ryan Gander
Claire Harvey
Dan Holdsworth
Rosalind Nashashibi
Lisa Oppenheim
Pamela Rosenkranz
Dexter Sinister
Matthew Smith
Bedwyr Williams
Roman Wolgin

Galeria Luisa Strina

Stand F12
Tel +55 11 811 10 233

Rua Oscar Freire 502
São Paulo SP 01426-000
Brazil
Tel +55 11 3088 2471
Fax +55 11 3064 6391
info@galerialuisastrina.com.br
www.galerialuisastrina.com.br

Contact
Luisa Malzoni Strina
Cristina Candeloro Quinn
Camila Leme de Mattos

Gallery artists
Keila Alaver
Caetano de Almeida
Juan Araujo
Laura Belém
Alexandre da Cunha
Wim Delvoye
Antonio Dias
Valdirlei Dias Nunes
Marcius Galan
Carlos Garaicoa
Fernanda Gomes
Brian Griffiths
Jenny Holzer
Marcellvs L.
Luisa Lambri
Tonico Lemos Auad
Laura Lima
Armin Linke
Dora Longo Bahia
Jarbas Lopes
Renata Lucas
Jorge Macchi
Marepe
Gilberto Mariotti
Cildo Meireles
Tracey Moffatt
Pedro Motta
Antoni Muntadas
Marina Saleme
Edgard de Souza
Sandra Tucci

Sutton Lane

Stand G1
Tel +44 20 7253 8580

1 Sutton Lane
London EC1M 5PU
UK
Tel +44 20 7253 8580
Fax +44 20 7253 6580
info@suttonlane.com
www.suttonlane.com

6 rue de Braque
Paris 75003
France
Tel +33 1 40 29 08 92

Contact
Gil Presti

Gallery artists
Liz Deschenes
Slawomir Elsner
Henriette Grahnert
Daniel Lefcourt
Justin Lieberman
Camilla Løw
Scott Lyall
Yuri Masnyj
Toby Paterson
Sean Paul
Eileen Quinlan
Blake Rayne
Christoph Ruckhäberle
Nora Schultz
Reena Spaulings
Joanne Tatham &
Tom O'Sullivan
Cheyney Thompson
Michael Wilkinson

Team
Gallery

Stand G23
Tel +1 212 279 92 19

83 Grand Street
New York 10013
USA
Tel +1 212 279 92 19
Fax +1 212 279 92 20
office@teamgal.com
www.teamgal.com

Contact
Jose Freire
Miriam Katzeff
Owen Reynolds Clements

Gallery artists
Cory Arcangel
Pierre Bismuth
Slater Bradley
Brice Dellsperger
Gardar Eide Einarsson
Ross Knight
Jakob Kolding
Maria Marshall
Bernhard Martin
Ryan McGinley
Dawn Mellor
Muntean & Rosenblum
Tam Ochiai
Guillaume Pinard
David Ratcliff
Cristina Lei Rodriguez
Jon Routson
Gert & Uwe Tobias
Banks Violette

Emily
Tsingou
Gallery

Stand A10
Tel +44 7789 265 991

10 Charles II Street
London SW1Y 4AA
UK
Tel +44 20 7839 5320
Fax +44 20 7839 5321
iben@emilytsingougallery.com
www.emilytsingougallery.com

Contact
Emily Tsingou
Iben la Cour

Gallery artists
Michael Ashkin
Henry Bond
Kate Bright
Peter Callesen
Mari Eastman
Paula Kane
Justine Kurland
Won Ju Lim
Dietmar Lutz
Daniel Pflumm
Sophy Rickett
Jim Shaw
Marnie Weber
Mathew Weir

Vilma Gold

Stand G26
Tel +44 20 8981 3344

6 Minerva Street
London E2 9EH
UK
Tel +44 20 8981 3344
Fax +44 20 8981 3355
mail@vilmagold.com
www.vilmagold.com

Contact
Rachel Williams
Sarah McCrory

Gallery artists
Dan Attoe
Nicholas Byrne
Alexandre da Cunha
William Daniels
Vladimir Dubossarsky &
Alexsander Vinogradov
Brock Enright
Brian Griffiths
Daniel Guzman
Sophie von Hellermann
hobbypopMUSEUM
Thomas Hylander
Dani Jakob
Andrew Mania
Alisa Margolis
Aïda Ruilova
Michael Stevenson
Josef Strau
Mark Titchner
Jennifer West

Vitamin
Creative
Space

Stand F28
Tel +86 13 5700 06834

301 29 Hao
Hengyi Jie Chigangxi Lu
Haizhuqu
Guangzhou 510300
China
Tel +86 20 8429 6760
mail@vitamincreativespace.com
www.vitamincreativespace.com

Contact
Zhang Wei
Shen Zudi

Gallery artists
Heman Chong
Liu Chuang
Cao Fei
Zheng Guogu
Duan Jianyu
Xu Tan
Jun Yang
Yangjiang Group
Lin Yilin
Chu Yun

Waddington
Galleries

Stand F15
Tel +44 20 7851 2200

11 Cork Street
London W1S 3LT
UK
Tel +44 20 7851 2200
Fax +44 20 7734 4146
mail@waddington-galleries.com
www.waddington-galleries.com

Contact
Leslie Waddington
Thomas Lighton
Phillida Reid
Ales Ortuzar

Gallery artists
Craigie Aitchison
Josef Albers
Milton Avery
Peter Blake
Patrick Caulfield
John Chamberlain
Giorgio de Chirico
Ian Davenport
Jean Dubuffet
Barry Flanagan
Sam Francis
Peter Halley
Al Held
Patrick Heron
Axel Hütte
Robert Indiana
Donald Judd
Morris Louis
Agnes Martin
Henri Matisse
Fausto Melotti
Joan Miró
Henry Moore
Ben Nicholson
Claes Oldenburg &
Coosje van Bruggen
Mimmo Paladino
Francis Picabia
Pablo Picasso

Robert Rauschenberg
Susan Rothenberg
Lucas Samaras
Frank Stella
Antoni Tàpies
Joe Tilson
William Turnbull
Andy Warhol
Bill Woodrow

Galleri Nicolai **Wallner**

Stand A4
Tel +45 32 57 09 70

Njalsgade 21, Building 15
Copenhagen 2300
Denmark
Tel +45 32 57 09 70
Fax +45 32 57 09 71
nw@nicolaiwallner.com
www.nicolaiwallner.com

Contact
Nicolai Wallner
Claus Robenhagen
Sidsel K. Rasmussen

Gallery artists
Daniel Buren
Mari Eastman
Michael Elmgreen &
Ingar Dragset
Douglas Gordon
Jens Haaning
Jeppe Hein
Chris Johanson
Joachim Koester
Jakob Kolding
Peter Land
Jonathan Monk
Henrik Plenge Jakobsen
Clare E. Rojas
Christoph Ruckhäberle
Christian Schmidt-Rasmussen
David Shrigley
Glenn Sorensen
Gitte Villesen

Galerie Barbara **Weiss**

Stand G13
Tel +49 30 262 4284

Zimmerstrasse 88–91
Berlin 10117
Germany
Tel +49 30 262 4284
Fax +49 30 265 1652
mail@galeriebarbaraweiss.de
www.galeriebarbaraweiss.de

Contact
Barbara Weiss
Anna Enberg
Birgit Szepanski
Peer Golo Willi

Gallery artists
Monika Baer
Heike Baranowsky
Thomas Bayrle
Janet Cardiff &
George Bures Miller
Maria Eichhorn
Nicole Eisenman
Ayse Erkmen
Friederike Feldmann
Christine & Irene Hohenbüchler
Laura Horelli
Jonathan Horowitz
Raoul de Keyser
Boris Mikhailov
John Miller
Rebecca Morris
Mai-Thu Perret
Jean-Frédéric Schnyder
Andreas Siekmann
Roman Signer
Erik Steinbrecher
Niele Toroni
Marijke van Warmerdam

Galerie Fons **Welters**

Stand G25
Tel +31 20 423 3046

Bloemstraat 140
Amsterdam 1016 LJ
The Netherlands
Tel +31 20 423 3046
Fax +31 20 620 8433
mail@fonswelters.nl
www.fonswelters.nl

Contact
Fons Welters
Laura van Grinsven
Laurie Cluitmans

Gallery artists
Eylem Aladogan
Rob Birza
Merijn Bolink
Tom Claassen
Jan De Cock
Yesim Akdeniz Graf
Claire Harvey
Sara van der Heide
Thomas Houseago
Job Koelewijn
Sven Kroner
Gabriel Lester
Atelier van Lieshout
Matthew Monahan
Maria Roosen
Daniel Roth
Gè-Karel van der Sterren
Berend Strik
Jennifer Tee
Monika Wiechowska
Alex Winters

White Cube/
Jay Jopling

Stand F13
Tel +44 20 7930 5373

48 Hoxton Square
London N1 6PB
UK
Tel +44 20 7930 5373
Fax +44 20 7749 7460
enquiries@whitecube.com
www.whitecube.com

25–26 Mason's Yard
St James's
London SW1Y 6BU
UK
Tel +44 20 7930 5373
Fax +44 20 7749 7460

Contact
Jay Jopling
Daniela Gareh
Tim Marlow

Gallery artists
Franz Ackermann
Darren Almond
Ellen Altfest
Miroslaw Balka
Candice Breitz
Koen van den Broek
Jake & Dinos Chapman
Chuck Close
Gregory Crewdson
Carroll Dunham
Tracey Emin
Katharina Fritsch
Gilbert & George
Antony Gormley
Marcus Harvey
Mona Hatoum
Eberhard Havekost
Damien Hirst
Gary Hume
Runa Islam
Sergej Jensen
Mika Kato
Anselm Kiefer

Martin Kobe
Liza Lou
Josiah McElheny
Christian Marclay
Julie Mehretu
Harland Miller
Sarah Morris
Gabriel Orozco
Damián Ortega
Richard Phillips
Marc Quinn
Jessica Rankin
Doris Salcedo
Neal Tait
Sam Taylor-Wood
Fred Tomaselli
Gavin Turk
Jeff Wall
Cerith Wyn Evans

Max
Wigram
Gallery

Stand G20
Tel +44 20 7495 4960

99 New Bond Street
London W1S 1SW
UK
Tel +44 20 7495 4960
Fax +44 20 7495 4930
info@maxwigram.com
www.maxwigram.com

Contact
Max Wigram
Michael Briggs

Gallery artists
Cory Arcangel
Athanasios Argianas
Michael Ashcroft
Slater Bradley
F.O.S.
Tue Greenfort
James Hopkins
Barnaby Hosking
Pearl C. Hsiung
Marine Hugonnier
Mustafa Hulusi
Alison Moffett
John Pilson
Julian Rosefeldt
Christian Ward
Richard Wathen
James White

Wilkinson Gallery

Stand E15
Tel +44 7890 892 851

50–58 Vyner Street
London E2 9DQ
UK
Tel +44 20 8980 2662
Fax +44 20 8980 0028
info@wilkinsongallery.com
www.wilkinsongallery.com

Contact
Amanda Wilkinson
Anthony Wilkinson

Gallery artists
Kevin Appel
Kamrooz Aram
David Batchelor
Tilo Baumgartel
A.K. Dolven
Julie Henry
Matthew Higgs
Nicky Hirst
Paul Housley
Joan Jonas
Jacob Dahl Jürgensen
Thoralf Knobloch
Marcin Maciejowski
Sara MacKillop
Elizabeth Magill
Renzo Martens
Robert Orchardson
Kaz Oshiro
Ged Quinn
Silke Schatz
Dierk Schmidt
George Shaw
Shimabuku
Mike Silva
Johnny Spencer
Martina Steckholzer
Phoebe Unwin
Matthias Weischer
Olav Westphalen

Galleri Christina **Wilson**

Stand F26
Tel +45 32 54 52 06

Sturlasgade 12h
Copenhagen 2300
Denmark
Tel +45 32 54 52 06
Fax +45 32 54 52 04
gcw@christinawilson.net
www.christinawilson.net

Contact
Christina Wilson

Gallery artists
Kaspar Bonnén
Peter Linde Busk
F.O.S.
Piero Golia
Jesper Just
Keisuke Maeda
Ulrik Møller
Kirstine Roepstorff
Les Rogers
Mette Winckelmann

XL Gallery

Stand E13
Tel +7 495 7758373

4 Siromiatnicheski per. 1, str.6
Moscow 105120
Russia
Tel +7 495 775 8373
Fax +7 495 775 8373
info@xlgallery.ru
www.xlgallery.ru

Contact
Elena Selina
Sergey Khripun

Gallery artists
Bluesoup
Aristarkh Chernyshov
Vladimir Dubossarsky &
Alexandr Vinogradov
Lyudmila Gorlova
Tanya Hengstler
Irina Korina
Mikhail Kosolapov
Elena Kovylina
Oleg Kulik
Tanya Lieberman
Igor Makarevich
Vladislav Mamyshev–Monroe
Boris Mikhailov
Igor Moukhin
Irina Nakhova
Boris Orlov
Viktor Pivovarov
Alexei Shulgin
Konstantin Zvezdochetov

Zeno X Gallery

Stand B3
Tel +32 3 216 16 26

Leopold de Waelplaats 16
Antwerp 2000
Belgium
Tel +32 3 216 1626
Fax +32 3 216 0992
info@zeno-x.com
www.zeno-x.com

Zeno X Storage
Appelstraat 37
Borgerhout 2140
Belgium
Tel +32 3 216 16 26
Fax +32 3 216 09 92

Contact
Frank Demaegd
Rose van Doninck
Koen van den Brande
Jelle Breynaert

Gallery artists
Michaël Borremans
Dirk Braeckman
Patrick van Caeckenbergh
Miriam Cahn
Stan Douglas
Marlene Dumas
Kees Goudzwaard
Noritoshi Hirakawa
Yun-Fei Ji
Kim Jones
Johannes Kahrs
Naoto Kawahara
Anne-Mie van Kerckhoven
Raoul de Keyser
John Körmeling
Jan de Maesschalck
Mark Manders
Jenny Scobel
Maria Serebriakova
Luc Tuymans
Cristof Yvoré

Zero...

Stand G3
Tel +39 349 604 41 36

Via Ventura 5
Milan 20134
Italy
Tel +39 02 3651 4283
Fax +39 02 9998 2731
info@galleriazero.it
www.galleriazero.it

Contact
Paolo Zani
Claudia Ciaccio

Gallery artists
Micol Assaël
Cezary Bodzianowski
Hubert Duprat
Christian Frosi
Francesco Gennari
Tue Greenfort
Massimo Grimaldi
Jeppe Hein
Victor Man
Pietro Roccasalva
Michael Sailstorfer
Hans Schabus
Shimabuku
Gedi Sibony

David Zwirner

Stand C8
Tel +1 917 664 4525

525 West 19th Street
New York NY 10011
USA
Tel +1 212 727 2070
Fax +1 212 727 2072
information@davidzwirner.com
www.davidzwirner.com

Contact
David Zwirner
Daelyn Short
Angela Choon
Bellatrix Hubert
Hanna Schouwink

Gallery artists
Tomma Abts
Francis Alÿs
Mamma Andersson
Michaël Borremans
R. Crumb
Stan Douglas
Marcel Dzama
Isa Genzken
On Kawara
Raoul de Keyser
Rachel Khedoori
Toba Khedoori
Estate of Gordon Matta-Clark
John McCracken
Jockum Nordström
Chris Ofili
Raymond Pettibon
Neo Rauch
Estate of Jason Rhoades
Daniel Richter
Michael S. Riedel
Thomas Ruff
Katy Schimert
Yutaka Sone
Diana Thater
Luc Tuymans
James Welling
Christopher Williams
Sue Williams
Yan Pei-Ming
Lisa Yuskavage

Magazine Index

Afterall

Stand M4

London office:
Central St Martins
College of Art and Design
107–109 Charing Cross Road
London WC2H 0DU
UK
Tel +44 20 7514 7212
Fax +44 20 7514 7166
london@afterall.org
www.afterall.org

Los Angeles office:
California Institute of the Arts
24700 McBean Parkway
Valencia CA 91355-2397
USA
Tel +1 661 253 7722
Fax +1 661 253 7738
losangeles@afterall.org

a-n The Artists Information Company

Stand M15

Unit 16
Toynbee Studios
28 Commercial Street
London E1 6AB
UK
Tel +44 20 7655 0390
Fax +44 20 7655 0396
ads@a-n.co.uk
www.a-n.co.uk

1st Floor
7–15 Pink Lane
Newcastle upon Tyne NE1 5DW
UK
Tel +44 191 241 8000
Fax +44 191 241 8001
info@a-n.co.uk

Art + Auction

Stand M8

LTB Media
111 Eighth Avenue, Suite 302
New York NY 10011
USA
Tel +1 646 348 6320
Fax +1 212 627 4175
david.gursky@ltbmedia.com
www.artinfo.com

Art AsiaPacific

Stand M13

245 Eighth Avenue, Suite 247
New York NY 10011
USA
Tel +1 212 255 6003
Fax +1 212 255 6004
info@aapmag.com
www.aapmag.com

Artforum

Stand M23

19th Floor
350 Seventh Avenue
New York NY 10001
USA
Tel +1 212 475 4000
Fax +1 212 529 1257
generalinfo@artforum.com
www.artforum.com

Art in America

Stand M17

575 Broadway
New York NY 10012
USA
Tel +1 212 941 2800
Fax +1 212 941 2870
subtler@brantpub.com
www.artinamericamagazine.com

Art Monthly

Stand M18

4th Floor
28 Charing Cross Road
London WC2H 0DB
UK
Tel +44 20 7240 0418
Fax +44 20 7497 0726
info@artmonthly.co.uk
www.artmonthly.co.uk

The Art Newspaper

Stand M14

70 South Lambeth Road
London SW8 1RL
UK
Tel +44 20 7735 3331
Fax +44 20 7735 3332
subscribe@theartnewspaper.com
www.theartnewspaper.com

Art Nexus

Stand M10

12955 Biscayne Boulevard
Suite 410
Miami FL 33181
USA
Tel +1 305 891 7270
Fax +1 305 891 6408
zroca@artnexus.com
www.artnexus.com

Art Press

Stand M7

8 Rue François Villon
Paris 75015
France
Tel +33 1 53 68 65 65
Fax +33 1 53 68 65 77
servicelecteurs@artpress.fr
www.artpress.com

ArtReview

Stand M19

1 Sekforde Street
London EC1R 0BE
UK
Tel +44 20 7107 2760
Fax +44 20 7107 2761
marketing@artreview.co.uk
www.artreview.co.uk

Bidoun

Stand M21

195 Chrystie Street, Suite 900D
New York NY 10002
USA
Tel +1 212 475 1023
Fax +1 212 475 0110
info@bidoun.com
www.bidoun.com

Cabinet

Stand M3

181 Wyckoff Street
Brooklyn NY 11217
USA
Tel +1 718 222 8434
Fax +1 718 222 3700
info@cabinetmagazine.org
www.cabinetmagazine.org

Flash Art International / Art Diary International

Stand M20

68 Via Carlo Farini
Milan 20159
Italy
Tel +39 02 688 7341
Fax +39 02 6680 1290
info@flashartonline.com
www.flashartonline.com

frieze

Stand M5

3-4 Hardwick Street
London EC1R 4RB
UK
Tel +44 20 7833 7270
Fax +44 20 7833 7271
info@frieze.com
www.frieze.com

Guardian News & Media

Stand M25

119 Farringdon Road
London EC1R 3ER
UK
Tel +44 20 7278 2332
www.guardian.co.uk

International Herald Tribune

Stand M11

40 Marsh Wall
London E14 9TP
UK
Tel +44 20 7510 5727
Fax +44 20 7987 3462
sadams@iht.com
www.iht.com

Modern Painters

Stand M1

LTB Media
111 Eighth Avenue, Suite 302
New York NY 10011
USA
Tel +1 646 348 6320
Fax +1 212 627 4152
david.gursky@ltbmedia.com
www.artinfo.com

Parkett

Stand M2

ParkettVerlag
Quellenstrasse 27
8031 Zurich
Switzerland
Tel +41 44 27 18 140
Fax +41 44 27 24 301
info@parkettart.com
www.parkettart.com

Parkett Publishers
145 Avenue of the Americas
New York NY 10013
USA
Tel +1 212 673 2660
Fax +1 212 271 0704

springerin

Stand M9

Museumplatz 1
Vienna 1070
Austria
Tel +43 15 22 91 24
Fax +43 15 22 91 25
springerin@springerin.at
www.springerin.at

Studio Art Magazine

Stand M22

Ahuzat Bayit St. 4
PO Box 29772
Tel Aviv 61290
Israel
Tel +972 3516 5274
Fax +972 3516 5694
studio1@netvision.net.il
www.studiomagazine.co.il

TATE ETC.

Stand M6

Tate Britain
Millbank
London SW1P 4RG
UK
Tel +44 20 7887 8959
Fax +44 20 7887 3940
tateetc@tate.org.uk
www.tate.org.uk/tateetc

tema celeste

Stand M16

Piazza Borromeo 10
20123 Milan
Italy
Tel +39 02 8901 3359
Fax +39 02 8901 5546
editorial@temaceleste.com
www.temaceleste.com

Texte zur Kunst

Stand M12

Torstrasse 141
Berlin D10119
Germany
Tel +49 30 280 47 910
Fax +49 30 280 47 912
verlag@textezurkunst.de
www.textezurkunst.de

Artists Index

Artists Index

Calderwood Matt
Taxter & Spengemann F19
Callan Jonathan
Nicole Klagsbrun Gallery E23
Calle Sophie
Arndt & Partner G21
Galerie Emmanuel Perrotin F9
Callesen Peter
Emily Tsingou Gallery A10
Calvin Brian
Corvi-Mora E4
Marc Foxx A1
Camargo Tony
Casa Triângulo F23
Lisson Gallery B8
Campanini Pierpaolo
Corvi-Mora E4
francesca kaufmann A7
Campbell Beth
Nicole Klagsbrun Gallery E23
Campbell Duncan
Hotel H2
Campbell Neil
Galleria Franco Noero A2
Camplin Bonnie
Cabinet D14
Canogar Daniel
Galeria Filomena Soares H7
Cantor Mircea
Yvon Lambert G5
Caravaggio Gianni
Galerie Paul Andriesse H8
francesca kaufmann A7
Cardelús Maggie
francesca kaufmann A7
Cardells Joan
Galería Pepe Cobo H10
Cardiff & Miller
Luhring Augustine B9
Galerie Barbara Weiss G13
Carnegie Gillian
Cabinet D14
Galerie Gisela Capitain D11
Carneiro da Cunha Tiago
Galeria Fortes Vilaça E7
Kate MacGarry E18
Caro Anthony
Annely Juda Fine Art G15
Carpenter Merlin
Galerie Christian Nagel E3
Los Carpinteros
Galeria Fortes Vilaça E7
Carre Elodie
L'appartement 22 F34
Carron Valentin

Galerie Eva Presenhuber C3
Carter
Jack Hanley Gallery A8
Hotel H2
Salon 94 B13
Carter Nathan
Casey Kaplan A6
Casebere James
Lisson Gallery B8
Casqueiro Pedro
Galeria Filomena Soares H7
Castella Vincenzo
Galerie Paul Andriesse H8
Monika Sprüth, Philomene
Magers B10
Castro Jota
Massimo Minini F11
Catalano Elisabetta
Massimo Minini F11
Cattelan Maurizio
Galleria Massimo de Carlo F3
Marian Goodman Gallery F14
Galerie Emmanuel Perrotin F9
Catunda Leda
Galeria Fortes Vilaça E7
Caughey Samara
David Kordansky Gallery F22
Caulfield Patrick
Waddington Galleries F15
Cerletty Mathew
Rivington Arms F29
Cerveny Alex
Casa Triângulo F23
Cha Xavier
Taxter & Spengemann F19
Chaimowicz Marc Camille
Cabinet D14
Galerie Giti Nourbakhsch C2
Chamberlain John
Waddington Galleries F15
Chan Paul
Galleria Massimo de Carlo F3
Greene Naftali F4
Chapman Jake & Dinos
White Cube/Jay Jopling F13
Chapman Jesse
Marianne Boesky Gallery F7
Charlton Alan
Konrad Fischer Galerie A5
Annely Juda Fine Art G15
Chen Xiaoyun
The Project H1
Chen Yi
Marianne Boesky Gallery F7
Chernyshov Aristarkh

Breakwell –
Clegg & Guttmann

XL Gallery E13
Chetwynd Spartacus
Herald St F1
Galerie Giti Nourbakhsch C2
Chhachhi Sheba
KHOJ International Artists'
Association F33
Chiasera Paolo
Massimo Minini F11
Chillida Eduardo
Annely Juda Fine Art G15
de Chirico Giorgio
Waddington Galleries F15
Chodzko Adam
Galleria Franco Noero A2
Choi Cody
PKM Gallery G2
Chong Heman
Vitamin Creative Space F28
Choudhury Zuliekha
KHOJ International Artists'
Association F33
Christo & Jeanne-Claude
Annely Juda Fine Art G15
Chu Anne
Victoria Miro Gallery G6
Chuang Liu
Vitamin Creative Space F28
Chun Kwang-Young
Annely Juda Fine Art G15
Chung Jay
Marc Foxx A1
Chung & Takeki Maeda
Andersen_s Contemporary F17
Churm Rob
Sorcha Dallas F32
Cinto Sandra
Tanya Bonakdar Gallery E8
Casa Triângulo F23
Claassen Tom
Galerie Fons Welters G25
Claerbout David
Hauser & Wirth Zürich London
C6
Johnen Galerie Berlin/Cologne
F10
Yvon Lambert G5
Galerie Rüdiger Schöttle E10
Galerie Micheline Szwajcer D9
Clark Larry
Luhring Augustine B9
Claydon Steven
Hotel H2
David Kordansky Gallery F22
Clegg & Guttmann

Artists Index

Regen Projects C10
Curry Aaron
David Kordansky Gallery F22
Czernin Adriana
Galerie Martin Janda H6
Dack Sean
Daniel Reich Gallery F27
Dadson Andrew
Galleria Franco Noero A2
Daems Anne
Galerie Micheline Szwajcer D9
Dafflon Stéphane
Air de Paris E5
Galerie Francesca Pia H11
Dahlberg Jonas
PKM Gallery G2
Dahlem Björn
Galerie Guido W. Baudach E20
Luis Campaña Galerie F24
Friedrich Petzel Gallery B2
Dahn Walter
Yvon Lambert G5
Monika Sprüth, Philomene
Magers B10
Dalgaard Jesper
Andersen_s Contemporary F17
Dalwood Dexter
Gagosian Gallery D7
Damasceno José
Thomas Dane Gallery E1
Galeria Fortes Vilaça E7
The Project H1
Dammann Martin
Georg Kargl G16
Daniels William
Marc Foxx A1
Vilma Gold G26
Darboven Hanne
Konrad Fischer Galerie A5
Darsi Hassan
L'appartement 22 F34
Davar Katja
Iris Kadel G24
Davenport Ian
Waddington Galleries F15
Davenport Nancy
Nicole Klagsbrun Gallery E23
David Enrico
Galerie Daniel Buchholz C4
Cabinet D14
Davies Peter
Gagosian Gallery D7
Davis Gerald
Salon 94 B13
Davis Kate

Sorcha Dallas F32
Dawicki Oskar
The Fair Gallery F21
Dawson Verne
Gavin Brown's enterprise G14
Victoria Miro Gallery G6
Galerie Eva Presenhuber C3
Deacon Richard
Marian Goodman Gallery F14
Lisson Gallery B8
Galerie Thaddaeus Ropac B12
Dean Stephen
Casa Triângulo F23
Dean Tacita
Frith Street Gallery C1
Marian Goodman Gallery F14
Decrauzat Philippe
Galerie Francesca Pia H11
Dedobbeleer Koenraad
Georg Kargl G16
Mai 36 Galerie C12
Galerie Micheline Szwajcer D9
Degaki Rogério
Casa Triângulo F23
Degen Benjamin
Guild & Greyshkul F19
Dejanoff Plamen
Galerie Meyer Kainer F2
Deller Jeremy
Art : Concept G10
Gavin Brown's enterprise G14
The Modern Institute/Toby
Webster B11
Dellsperger Brice
Air de Paris E5
Team Gallery G23
Delvoye Wim
Arndt & Partner G21
Galeria Luisa Strina F12
Demand Thomas
Taka Ishii Gallery G8
Victoria Miro Gallery G6
Regen Projects C10
Monika Sprüth, Philomene
Magers B10
Demmerle Yannick
Arndt & Partner G21
Denzler Andy
Galeria Filomena Soares H7
Derges Susan
Paul Kasmin Gallery E14
Deschenes Liz
Sutton Lane G1
Dias Antonio
Galeria Luisa Strina F12

Dias Nunes Valdirlei
Galeria Luisa Strina F12
Dias & Riedweg
Galeria Filomena Soares H7
Dibbets Jan
Konrad Fischer Galerie A5
Gladstone Gallery D6
Dicke Amie
Peres Projects Los Angeles Berlin
G22
Dickinson Jeremy
Tomio Koyama Gallery A3
diCorcia Philip-Lorca
Galerie Almine Rech G7
Monika Sprüth, Philomene
Magers B10
Diefenbach Andreas
Galerie Christian Nagel E3
Dietman Erik
Anthony Reynolds Gallery F8
Dijkstra Rineke
The Fair Gallery F21
Marian Goodman Gallery F14
Sommer Contemporary Art F18
Dillemuth Stephan
Galerie Christian Nagel E3
DiMattio Francesca
Salon 94 B13
Dion Mark
Tanya Bonakdar Gallery E8
Georg Kargl G16
Galerie Christian Nagel E3
Djurberg Nathalie
Giò Marconi F6
Doberauer Anke
Mai 36 Galerie C12
Dodge Jason
Galleria Massimo de Carlo F3
Taka Ishii Gallery G8
Casey Kaplan A6
Dodge Tomory
ACME. D16
CRG Gallery H5
Alison Jacques Gallery D15
Doherty Willie
Galería Pepe Cobo H10
Kerlin Gallery E11
Galerie Peter Kilchmann E2
Doig Peter
Gavin Brown's enterprise G14
Contemporary Fine Arts D2
Victoria Miro Gallery G6
Dolven A.K.
Wilkinson Gallery E15
Donachie Kaye

Esser Elger
Johnen Galerie Berlin/Cologne F10
Galerie Thaddaeus Ropac B12
Galerie Rüdiger Schöttle E10
Galerie Sfeir-Semler E16
Esteve Lionel
Galerie Emmanuel Perrotin F9
Ethridge Roe
greengrassi D8
Andrew Kreps Gallery C7
Mai 36 Galerie C12
Evans Chris
Store F31
Evans Dick
Maureen Paley D5
Evans Simon
Jack Hanley Gallery A8
Nicole Klagsbrun Gallery E23
Store F31
Export Valie
Patrick Painter, Inc. B14
Galerie Rüdiger Schöttle E10
Fabre Jan
Massimo Minini F11
Fabro Luciano
Gladstone Gallery D6
Galerie Micheline Szwajcer D9
Fagen Graham
doggerfisher G19
Fahlström Öyvind
Galerie Aurel Scheibler G17
Fahlstrom Brian
Marc Foxx A1
Fairhurst Angus
Sadie Coles HQ C9
Galeria Fortes Vilaça E7
Georg Kargl G16
Paul Kasmin Gallery E14
Faldbakken Matias
Standard (Oslo) F25
Farmer Barney
Cabinet D14
Fänge Jens
Galleri Magnus Karlsson G11
Farocki Harun
Greene Naftali F4
Farquhar Keith
Galerie Neu B4
Anthony Reynolds Gallery F8
Farrell Seamus
L'appartement 22 F34
Fast Omer
The Fair Gallery F21
Fauguet Richard

Art : Concept G10
Faust Gretchen
greengrassi D8
Faust Jeanne
Galerie Karin Guenther G12
Meyer Riegger C7
Favaretto Lara
Galleria Franco Noero A2
Fecteau Vincent
Galerie Daniel Buchholz C4
Marc Foxx A1
greengrassi D8
Feher Tony
ACME. D16
Fei Cao
Vitamin Creative Space F28
Feiersinger Werner
Galerie Martin Janda H6
Feinstein Rachel
Marianne Boesky Gallery F7
Corvi-Mora E4
Feintuch Robert
CRG Gallery H5
Feldmann Friederike
Galerie Barbara Weiss G13
Feldmann Hans-Peter
Konrad Fischer Galerie A5
Johnen Galerie Berlin/Cologne F10
Massimo Minini F11
Galerie Francesca Pia H11
Galerie Micheline Szwajcer D9
Fend Peter
Georg Kargl G16
Galerie Christian Nagel E3
Fernandez Teresita
Lehmann Maupin F16
Fernandez Diego
Galerie Christian Nagel E3
Ferreira Ângela
Galeria Filomena Soares H7
Ferreira Rui
Galeria Filomena Soares H7
Ferris Dee
Corvi-Mora E4
Finch Spencer
Yvon Lambert G5
Lisson Gallery B8
Finley Chris
ACME. D16
Finlay Ian Hamilton
Massimo Minini F11
Victoria Miro Gallery G6
Galerie Sfeir-Semler E16
Finneran John

Rivington Arms F29
Fischer Berta
Galerie Krobath Wimmer E22
Galerie Giti Nourbakhsch C2
Fischer Naomi
Galerie Emmanuel Perrotin F9
Fischer Nina
Galerie Eigen + Art Leipzig/Berlin F5
Fischer Urs
Gavin Brown's enterprise G14
Galleria Massimo de Carlo F3
Sadie Coles HQ C9
Galerie Eva Presenhuber C3
Fischl Eric
Jablonka Galerie D1
Fischli & Weiss
Matthew Marks Gallery C5
Galerie Eva Presenhuber C3
Monika Sprüth, Philomene Magers B10
Fisher Kim
China Art Objects Galleries E19
The Modern Institute/Toby Webster B11
Fisher Morgan
Galerie Daniel Buchholz C4
China Art Objects Galleries E19
Fisher Naomi
Galerie Emmanuel Perrotin F9
Fisk Lars
Taxter & Spengemann F19
Fiškin Vadim
Galerija Gregor Podnar F20
Flamm Christian
Alison Jacques Gallery D15
Galerie Neu B4
Flanagan Barry
Paul Kasmin Gallery E14
Galerie Thaddaeus Ropac B12
Waddington Galleries F15
Flannigan Moyna
doggerfisher G19
Flavien Jean-Pascal
Galerie Catherine Bastide E12
Flavin Dan
Monika Sprüth, Philomene Magers B10
Flechtner Thomas
Marianne Boesky Gallery F7
Fletcher Harrell
Jack Hanley Gallery A8
Fleury Sylvie
Galerie Eva Presenhuber C3
Galerie Thaddaeus Ropac B12

Artists Index

Artists Index

Artists Index

Artists Index

Artists Index

Casa Triângulo F23
Matisse Henri
Waddington Galleries F15
Matta-Clark Gordon
David Zwirner C8
Mauss Nick
Galerie Neu B4
Mayer Hans-Jörg
Galerie Christian Nagel E3
Galerie Giti Nourbakhsch C2
Gabriele Senn Galerie E24
Mayer Maix
Galerie Eigen+Art Leipzig/
Berlin F5
Mayr Albert
Gabriele Senn Galerie E24
McBride Rita
Mai 36 Galerie C12
McCarthy Alicia
Jack Hanley Gallery A8
McCarthy Paul
Studio Guenzani E9
Hauser & Wirth Zürich London
C6
Tomio Koyama Gallery A3
McCollum Allan
Friedrich Petzel Gallery B2
McConnell Gareth
Carl Freedman Gallery B1
McCorkle Corey
maccarone B6
McCracken John
Galleria Massimo de Carlo F3
Hauser & Wirth Zürich London
C6
Galerie Almine Rech G7
David Zwirner C8
McDevitt Paul
Stephen Friedman Gallery D4
McDonald Peter
Kate MacGarry E18
McElheny Josiah
White Cube/Jay Jopling F13
McEwen Adam
Art : Concept G10
Jack Hanley Gallery A8
Nicole Klagsbrun Gallery E23
McFarland Scott
Regen Projects C10
McGee Barry
Stuart Shave/Modern Art D12
McGill Melissa
CRG Gallery H5
McGinley Ryan
Team Gallery G23

McHargue Keegan
Jack Hanley Gallery A8
Metro Pictures C11
Galerie Emmanuel Perrotin F9
McKenna Stephen
Kerlin Gallery E11
McKenzie Lucy
Galerie Daniel Buchholz C4
Cabinet D14
Metro Pictures C11
McLane Kelly
CRG Gallery H5
McLaughlin John
Annely Juda Fine Art G15
McMakin Roy
Matthew Marks Gallery C5
McNab Janice
doggerfisher G19
McQueen Steve
Thomas Dane Gallery E1
Marian Goodman Gallery F14
Meadows Jason
Tanya Bonakdar Gallery E8
Corvi-Mora E4
Marc Foxx A1
Studio Guenzani E9
Meckseper Josephine
Arndt & Partner G21
van Meene Hellen
Sadie Coles HQ C9
Marc Foxx A1
Mees Guy
Galerie Micheline Szwajcer D9
Meese Jonathan
Contemporary Fine Arts D2
Galerie Krinzinger D17
Stuart Shave/Modern Art D12
Megerle Birgit
Galerie Neu B4
Daniel Reich Gallery F27
Mehretu Julie
The Project H1
White Cube/Jay Jopling F13
Meireles Cildo
Galeria Luisa Strina F12
Meise Michaela
Greene Naftali F4
Johann König D13
Standard (Oslo) F25
Melee Robert
Andrew Kreps Gallery C7
Melgaard Bjarne
Galerie Guido W. Baudach E20
Galerie Krinzinger D17
Melhus Bjørn

galerie bob van orsouw C12
Mellor Dawn
Team Gallery G23
Mellors Nathaniel
Alison Jacques Gallery D15
Melotti Fausto
Waddington Galleries F15
Mendoza Ryan
Massimo Minini F11
Mercier Mathieu
Jack Hanley Gallery A8
Massimo Minini F11
Merta Jan
Galerie Martin Janda H6
Johnen Galerie Berlin/Cologne
F10
Galerie Rüdiger Schöttle E10
Merz Mario
Konrad Fischer Galerie A5
Gladstone Gallery D6
Merz Marisa
Gladstone Gallery D6
Marian Goodman Gallery F14
Messager Annette
Marian Goodman Gallery F14
Metinides Enrique
kurimanzutto H3
Metzel Olaf
Produzentengalerie H8
Meuser
Galerie Bärbel Grässlin D18
Meyer Riegger C7
Meyer Anna
Galerie Krobath Wimmer E22
Meyerson Jin
Galerie Emmanuel Perrotin F9
Mezzaqui Sabrina
Massimo Minini F11
Michael Alan
Sorcha Dallas F32
Hotel H2
David Kordansky Gallery F22
Stuart Shave/Modern Art D12
Michael Kristine
KHOJ International Artists'
Association F33
Michaeledes Michael
Annely Juda Fine Art G15
Miga Irini
The Breeder E17
Mignone Vania
Casa Triângulo F23
Mik Aernout
Galleria Massimo de Carlo F3
The Project H1

Artists Index

Artists Index

Artists Index

Artists Index

Gallery Index

Contempo-rary FineArts

Stand D2
Tel +49 30 288 78 70

Hinter dem Giesshaus /
Am Kupfergraben
Berlin 10117
Germany
Tel +49 30 288 78 70
gallery@cfa-berlin.com
www.cfa-berlin.com

Contact
Philipp Haverkampf
Nicole Hackert
Bruno Brunnet

Gallery artists
Georg Baselitz
Cecily Brown
Peter Doig
Robert Lucander
Sarah Lucas
Jonathan Meese
Chris Ofili
Raymond Pettibon
Walter Pichler
Tal R
Anselm Reyle
Daniel Richter
Dana Schutz
Norbert Schwontkowski
Dash Snow

Andreas Slominski
Christiana Soulou
Rudolf Stingel
Nicola Tyson
Paloma Varga Weisz
T. J. Wilcox
Andrea Zittel

Corvi-Mora

Stand E4
Tel +44 20 7840 9111

1a Kempsford Road
London SE11 4NU
UK
Tel +44 20 7840 9111
Fax +44 20 7840 9112
tcm@corvi-mora.com
www.corvi-mora.com

Contact
Tommaso Corvi-Mora
Tabitha Langton-Lockton

Gallery artists
Richard Aldrich
Abel Auer
Brian Calvin
Pierpaolo Campanini
Anne Collier
Andy Collins
Rachel Feinstein
Dee Ferris
Liam Gillick
Richard Hawkins
Roger Hiorns
Jim Isermann
Colter Jacobsen
Dorota Jurczak
Aisha Khalid
Armin Krämer
Eva Marisaldi
Jason Meadows
Monique Prieto
Imran Qureshi
Andrea Salvino
Glenn Sorensen
Tomoaki Suzuki
Naoyuki Tsuji

China Art Objects Galleries

Stand E19
Tel +1 213 613 0384

933 Chung King Road
Los Angeles CA 90012
USA
Tel +1 213 613 0384
Fax +1 213 613 0363
info@chinaartobjects.com
www.chinaartobjects.com

Contact
Steve Hanson
Maeghan Reid

Gallery artists
Andy Alexander
Walead Beshty
Mason Cooley
Bjorn Copeland
Kim Fisher
Morgan Fisher
Thomas Helbig
David Korty
Sean Landers
J.P. Munro
Ruby Neri
Andy Ouchi
Seb Patane
Oliver Payne & Nick Relph
Jonathan Pylypchuk
Eric Wesley
Pae White
T.J. Wilcox

Galería Pepe Cobo

Stand H10
Tel +34 91 319 0683

C/Fortuny 39
Madrid 28010
Spain
Tel +34 91 319 0683
Fax +34 91 308 3190
info@pepecobo.com
www.pepecobo.com

Contact
José Cobo

Gallery artists
Lara Almarcegui
Ibon Aranberri
John Baldessari
Stephan Balkenhol
Joan Cardells
Willie Doherty
Pepe Espaliú
Federico Guzmán
Diango Hernández
Cristina Iglesias
Rinko Kawauchi
Zoe Leonard
Juan Muñoz
Augustina von Nagel
Gonzalo Puch
MP & MP Rosado
Glen Rubsamen
Julião Sarmento
Ann-Sofi Sidén
Joel Sternfeld

Sadie Coles HQ

Stand C9
Tel +44 20 7434 2227

35 Heddon Street
London W1B 4BP
UK
Tel +44 20 7434 2227
Fax +44 20 7434 2228
pauline@sadiecoles.com
www.sadiecoles.com,

69 South Audley Steet
London W1K 2QZ
UK
Tel + 44 20 7434 2227

Contact
Sadie Coles
Pauline Daly

Gallery artists
Carl Andre
Matthew Barney
Avner Ben-Gal
Frank Benson
John Bock
Don Brown
Jeff Burton
John Currin
Angus Fairhurst
Urs Fischer
Jonathan Horowitz
David Korty
Jim Lambie
Sarah Lucas
Hellen van Meene
Victoria Morton
J.P. Munro
Laura Owens
Simon Periton
Raymond Pettibon
Elizabeth Peyton
Richard Prince
Ugo Rondinone
Wilhelm Sasnal
Daniel Sinsel

Galerie **Neu**

Stand B4
Tel +49 30 285 7550

Philippstrasse 13
Berlin 10115
Germany
Tel +49 30 285 7550
Fax +49 30 281 0085
mail@galerieneu.com
www.galerieneu.com

Contact
Alexander Schroeder
Thilo Wermke

Gallery artists
Kai Althoff
Cosima von Bonin
Tom Burr
Keith Farquhar
Christian Flamm
Florian Hecker
Ull Hohn
Sergej Jensen
Kitty Kraus
Hilary Lloyd
Nick Mauss
Birgit Megerle
Manfred Pernice
Daniel Pflumm
Josephine Pryde
Andreas Slominski
Sean Snyder
Francesco Vezzoli
Katharina Wulff
Cerith Wyn Evans

Galleria Franco **Noero**

Stand A2
Tel +39 011 88 2208

Via Giolitti 52a
Turin 10123
Italy
Tel +39 011 88 2208
Fax +39 011 1970 3024
info@franconoero.com
www.franconoero.com

Contact
Franco Noero
Pierpaolo Falone
Luisa Salvi Del Pero
Antoine Levi

Gallery artists
Pablo Bronstein
Tom Burr
Jeff Burton
Neil Campbell
Adam Chodzko
Andrew Dadson
Lara Favaretto
Henrik Håkansson
Arturo Herrera
Gabriel Kuri
Jim Lambie
Muntean & Rosenblum
Mike Nelson
Henrik Olesen
Steven Shearer
Simon Starling
Costa Vece
Francesco Vezzoli
Eric Wesley

Galerie Giti **Nourbakhsch**

Stand C2
Tel +49 30 4404 6781

Kurfürstenstrasse 12
Berlin 10785
Germany
Tel +49 30 4404 6781
Fax +49 30 4404 6782
info@nourbakhsch.de
www.nourbakhsch.de

Contact
Adel Halilovic
Silvie Buschmann
Giti Nourbakhsch

Gallery artists
Tomma Abts
Mario Airò
Peter Böhnisch
Susanne Bürner
Marc Camille Chaimowicz
Spartacus Chetwynd
Berta Fischer
Simone Gilges
Karl Holmqvist
Jamie Isenstein
Piotr Janas
Kerstin Kartscher
Bernd Krauß
Udomsak Krisanamis
Sean Landers
Hans-Jörg Mayer
Peter Peri
Vincent Tavenne
Hayley Tompkins
Sue Tompkins
Corrine Wasmuht
Cathy Wilkes

Galerie
Christian
Nagel

Joanne Tatham &
Tom O'Sullivan
Padraig Timoney
Hayley Tompkins
Sue Tompkins
Cathy Wilkes
Michael Wilkinson
Richard Wright

Stand E3
Tel +49 221 257 05 91

Richard-Wagner-Strasse 28
Cologne 50674
Germany
Tel +49 221 257 05 91
Fax +49 221 257 05 92
cn.koeln@galerie-nagel.de
www.galerie-nagel.de

Weydinger Strasse 2/4
Berlin 10178
Germany
Tel +49 30 400 42641
Fax +49 30 400 42642
cn.berlin@galerie-nagel.de

Contact
Christian Nagel
Florian Baron (Cologne)
Isabelle Erben (Berlin)

Gallery artists
Kai Althoff
Kader Attia
Nairy Baghramian
Michael Beutler
Lutz Braun
Tom Burr
Merlin Carpenter
Clegg & Guttmann
Andreas Diefenbach
Stephan Dillemuth
Mark Dion
Peter Fend
Diego Fernandez
Andrea Fraser
Ingeborg Gabriel
Renée Green
Rachel Harrison
Lone Haugaard Madsen
Julia Horstmann
Sven Johne
Kiron Khosla
Kalin Lindena
Hans-Jörg Mayer

John Miller
Christian Philipp Müller
Stefan Müller
Nils Norman
Josephine Pryde
Cornelius Quabeck
Martha Rosler
Sterling Ruby
Jörg Schlick
Hanna Schwarz
Markus Selg
Sarah Staton
Catherine Sullivan
Stephanie Taylor
Jan Timme
Stephen Willats
Joseph Zehrer
Gang Zhao
Heimo Zobernig

Meyer
Riegger

Stand C7
Tel +49 721 821 292

Klauprechtstrasse 22
Karlsruhe 76137
Germany
Tel +49 721 821 292
Fax +49 721 982 2141
thomas@meyer-riegger.de
www.meyer-riegger.com

Contact
Jochen Meyer
Thomas Riegger
Julia Hölz

Gallery artists
Franz Ackermann
Armin Boehm
Jeanne Faust
Sebastian Hammwöhner
Isabell Heimerdinger
Uwe Henneken
Anna Lea Hucht
Dani Jakob
Korpys & Löffler
Kalin Lindena
Meuser
John Miller
Helen Mirra
Jonathan Monk
Daniel Roth
Glen Rubsamen
Silke Schatz
David Thorpe
Gabriel Vormstein
Corinne Wasmuht
Eric Wesley

Massimo
Minini

Stand F11
Tel +39 33 52 33 817

Via Apollonio 68
Brescia 25128
Italy
Tel +39 030 38 3034
Fax +39 030 39 2446
info@galleriaminini.it
www.galleriaminini.it

Contact
Massimo Minini
Daniella Minini

Gallery artists
Carla Accardi
Mario Airò
Ghada Amer
Stefano Arienti
Robert Barry
Vanessa Beecroft
Alighiero Boetti
Daniel Buren
Jota Castro
Elisabetta Catalano
Paolo Chiasera
Jan De Cock
Maurizio Donzelli
Jan Fabre
Hans-Peter Feldmann
Ian Hamilton Finlay
Alberto Garutti
Luigi Ghirri
Piero Gilardi
Dan Graham
Peter Halley
Anish Kapoor
Bertrand Lavier
Sol LeWitt
Eva Marisaldi
Ryan Mendoza
Mathieu Mercier
Sabrina Mezzaqui
Luigi Ontani
Giulio Paolini
Gabriele Picco

Riccardo Previdi
Gerwald Rockenshaub
Serse
Francesco Simeti
Nedko Solakov
Ettore Spalletti
Haim Steinbach
Beat Streuli
Alessandra Tesi
Sabrina Torelli
Didier Vermeiren

Matthew **Marks** Gallery

Stand C5
Tel +1 212 243 0200

522 West 22nd Street
New York NY 10011
USA
Tel +1 212 243 0200
Fax +1 212 243 0047
info@matthewmarks.com
www.matthewmarks.com

Contact
Sabrina Buell
Stephanie Dorsey
Jeffrey Peabody

Gallery artists
Robert Adams
Darren Almond
David Armstrong
Nayland Blake
Peter Cain
Peter Fischli & David Weiss
Lucian Freud
Katharina Fritsch
Robert Gober
Nan Goldin
Andreas Gursky
Jonathan Hammer
Martin Honert
Peter Hujar
Gary Hume
Jasper Johns
Ellsworth Kelly
Willem de Kooning
Inez van Lamsweerde &
Vinoodh Matadin
Brice Marden
Roy McMakin
Ken Price
Charles Ray
Ugo Rondinone
Tony Smith
Rebecca Warren
Terry Winters

Metro Pictures

Stand C11
Tel +1 917 576 1406

519 West 24th Street
New York NY 10011
USA
Tel +1 212 206 7100
Fax +1 212 337 0070
tom@metropicturesgallery.com
www.metropicturesgallery.com

Contact
Tom Heman

Gallery artists
Olaf Breuning
André Butzer
Andreas Hofer
Isaac Julien
Mike Kelley
Martin Kippenberger
Louise Lawler
Robert Longo
Yuri Masnyj
Keegan McHargue
John Miller
Paulina Olowska
Tony Oursler
Sterling Ruby
Jim Shaw
Cindy Sherman
Gary Simmons
Andreas Slominski
Catherine Sullivan
T.J. Wilcox

Galerie **Meyer** Kainer

Stand F2
Tel +43 676 517 3116

Eschenbachgasse 9
Vienna 1010
Austria
Tel +43 1 585 7277
Fax +43 1 585 7539
info@meyerkainer.com
www.meyerkainer.com

Contact
Renate Kainer
Christian Meyer

Gallery artists
Vanessa Beecroft
John Bock
Agata Bogacka
Olaf Breuning
Plamen Dejanoff
gelitin
Liam Gillick
Dan Graham
Mary Heilmann
Siggi Hofer
Christian Jankowski
Marcin Maciejowski
Sarah Morris
Yoshitomo Nara
Walter Niedemayr
Walter Obholzer
Jorge Pardo
Raymond Pettibon
Mathias Poledna
Isa Schmidlehner
Martina Steckholzer
Beat Streuli
Wolfgang Tillmans
Franz West
T.J. Wilcox
Heimo Zobernig

Kate
MacGarry

Stand E18
Tel +44 208 981 9100

7a Vyner Street
London E2 9DG
UK
Tel +44 208 981 9100
Fax +44 208 981 0100
mail@katemacgarry.com
www.katemacgarry.com

Contact
Kate MacGarry
Fabio Altamura

Gallery artists
Tasha Amini
Josh Blackwell
Matt Bryans
Tiago Carneiro da Cunha
Iain Forsyth & Jane Pollard
Dr. Lakra
Goshka Macuga
Peter McDonald
Stefan Saffer
Francis Upritchard

Mai 36
Galerie

Stand C12
Tel +41 76 322 50 24

Rämistrasse 37
Zurich 8001
Switzerland
Tel +41 44 261 6880
Fax +41 44 261 6881
mail@mai36.com
www.mai36.com

Contact
Victor Gisler
Luigi Kurmann
Gabriela Walther

Gallery artists
Franz Ackermann
Ian Anüll
John Baldessari
Stephan Balkenhol
Matthew Benedict
Troy Brauntuch
Pedro Cabrita Reis
Koenraad Dedobbeleer
Anke Doberauer
Jürgen Drescher
Roe Ethridge
Pia Fries
Jitka Hanzlovà
General Idea
Rita McBride
Harald F. Müller
Matt Mullican
Manfred Pernice
Magnus Plessen
Glen Rubsamen
Christoph Rütimann
Thomas Ruff
Paul Thek
Stefan Thiel
Lawrence Weiner
Rémy Zaugg

Giò Marconi

Stand F6
Tel +39 02 29 40 43 73

Via Tadino 15
Milan 20124
Italy
Tel +39 02 29 40 43 73
Fax +39 02 29 40 55 73
carlotta@giomarconi.com
www.giomarconi.com

Contact
Giò Marconi
Carlotta Arlango
Nadia Forloni

Gallery artists
Franz Ackermann
Enrico Baj
John Bock
André Butzer
Nathalie Djurberg
Lucio Fontana
Richard Hamilton
Lothar Hempel
Christian Jankowski
Atelier van Lieshout
Sharon Lockhart
Estate of Robert Mapplethorpe
Maurizio Mochetti
Louise Nevelson
Jorge Pardo
Giulio Paolini
Tobias Rehberger
Markus Schinwald
Elisa Sighicelli
Andreas Slominski
Thaddeus Strode
Catherine Sullivan
Vibeke Tandberg
Grazia Toderi
Luca Trevisani
Francesco Vezzoli
Christopher Wool

Luhring Augustine

Stand B9
Tel +1 212 206 9100

531 West 24th Street
New York NY 10011
USA
Tel +1 212 206 9100
Fax +1 212 206 9055
info@luhringaugustine.com
www.luhringaugustine.com

Contact
Alix Rice
Vanessa Critchell
Natalia Mager Sacasa

Gallery artists
Janine Antoni
Janet Cardiff &
George Bures Miller
Larry Clark
George Condo
Gregory Crewdson
Luisa Lambri
Yasumasa Morimura
Reinhard Mucha
David Musgrave
Albert Oehlen
Pipilotti Rist
Josh Smith
Joel Sternfeld
Tunga
Rachel Whiteread
Steve Wolfe
Christoper Wool

maccarone

Stand B6
Tel +1 212 431 4977

630 Greenwich Street
New York NY 10014
USA
Tel +1 212 431 4977
Fax +1 212 965 5019
kitchen@maccarone.net
www.maccarone.net

Contact
Ellen Langan
Michele Maccarone

Gallery artists
Mike Bouchet
Carol Bove
Christoph Büchel
Anthony Burdin
Chivas Clem
Roberto Cuoghi
Felix Gmelin
Christian Jankowski
David Lamelas
Nate Lowman
Corey McCorkle
Otto Muehl
Claudia & Julia Mueller
Daniel Roth
Steven Shearer
Olav Westphalen

Richard Jackson
Koo Jeong-A
Joan Jonas
Isaac Julien
On Kawara
Idris Khan
Anselm Kiefer
Barbara Kruger
Thierry Kuntzel
Bertrand Lavier
Louise Lawler
Zoe Leonard
Sol LeWitt
Glenn Ligon
Christian Marclay
Melvin Martinez
Jonathan Monk
Damian Moppett
Scott Myles
Melik Ohanian
Kaz Oshiro
Tsuyoshi Ozawa
Guilio Paolini
Pedro Reyes
Charles Sandison
Andres Serrano
David Shrigley
Niele Toroni
Salla Tykkä
Francesco Vezzoli
Ian Wallace
Lawrence Weiner
Tom Wesselmann
Ian Wilson
Sislej Xhafa

Lehmann
Maupin

Stand F16
Tel +1 917 442 42 53

540 West 26th Street
New York NY 10001
USA
Tel +1 212 255 2923
Fax +1 212 255 2924
info@lehmannmaupin.com
www.lehmanmaupin.com

Contact
Rachel Lehmann
David Maupin
Jan Endlich
Courtney Plummer

Gallery artists
Stefano Arienti
Kutlug Ataman
Ashley Bickerton
Ross Bleckner
Tobias Buche
Lee Bul
Tracey Emin
Teresita Fernández
Anya Gallaccio
Gilbert & George
Christian Hellmich
Shirazeh Houshiary
Jonas Lipps
Mr.
Jun Nguyen-Hatsushiba
Tony Oursler
Sergio Prego
Jennifer Steinkamp
Do-Ho Suh
Juergen Teller
Adriana Varejão
Suling Wang

Lisson
Gallery

Stand B8
Tel +44 20 7724 2739

29 & 52–54 Bell Street
London NW1 5DA
UK
Tel +44 20 7724 2739
Fax +44 20 7724 7124
kate@lisson.co.uk
www.lisson.co.uk

Contact
Nicholas Logsdail
Kate Smith
Neil Robert Wenman
Michelle D'Souza
Marc Tutt

Gallery artists
Jennifer Allora &
Guillermo Calzadilla
Francis Alÿs
Art & Language
Pierre Bismuth
Christine Borland
Roderick Buchanan
Daniel Buren
Gerard Byrne
James Casebere
Anthony Cragg
Angela de la Cruz
Richard Deacon
Spencer Finch
Ceal Floyer
Dan Graham
Rodney Graham
Mark Hosking
Shirazeh Houshiary
Christian Jankowski
Anish Kapoor
On Kawara
Igor & Svetlana Kopystiansky
John Latham
Tim Lee
Sol LeWitt
Robert Mangold
Jason Martin
Tatsuo Miyajima
Jonathan Monk

Galerie **Krobath** Wimmer

Stand E22
Tel +43 1 585 7470

Eschenbachgasse 9
Vienna 1010
Austria
Tel +43 1 585 7470
Fax +43 1 585 7472
galerie@krobathwimmer.at
www.krobathwimmer.at

Contact
Helga Krobath
Barbara Wimmer

Gallery artists
Thomas Baumann
Hannah Dougherty
Judith Eisler
Martin Eiter
Berta Fischer
Maria Hahnenkamp
Isabell Heimerdinger
Jiri Kovanda
Brigitte Kowanz
Dorit Margreiter
Anna Meyer
Julian Opie
Fritz Panzer
Florian Pumhösl
Ugo Rondinone
Esther Stocker
Otto Zitko

kuriman- zutto

Stand H3
Tel +52 55 5286 3059

Mazatlán 5, T6
Colonia Condesa
Mexico DF 06140
Mexico
Tel +52 55 5286 3059
Fax +52 55 5256 2408
info@kurimanzutto.com
www.kurimanzutto.com

Contact
Mónica Manzutto
José Kuri

Gallery artists
Eduardo Abaroa
Carlos Amorales
Miguel Calderón
Abraham Cruzvillegas
Minerva Cuevas
Daniel Guzmán
Jonathan Hernández
Gabriel Kuri
Dr. Lakra
Enrique Metinides
Gabriel Orozco
Damián Ortega
Fernando Ortega
Luis Felipe Ortega
Monika Sosnowska
Sofía Táboas
Rirkrit Tiravanija

Yvon **Lambert**

Stand G5
Tel +33 614 272 703

564 West 25th Street
New York NY 10001
USA
Tel +1 212 242 3611
Fax +1 212 242 3920
harry@yvon-lambert.com
www.yvon-lambert.com

108 rue Vieille du Temple
Paris 75003
France
Tel +33 1 42 71 09 33
Fax +33 1 42 71 87 47

Contact
Yvon Lambert
Harry Scrymgeour
Olivier Belot
Severine Waelchli
Emilio Steinberger

Gallery artists
Richard Aldrich
Carlos Amorales
Alice Anderson
Carl Andre
Miquel Barceló
Robert Barry
Pavel Braila
Candice Breitz
Berlinde De Bruyckere
Stanley Brouwn
Mircea Cantor
David Claerbout
Walter Dahn
Spencer Finch
Anna Gaskell
Kendell Geers
Nan Goldin
Douglas Gordon
Loris Gréaud
Jeppe Hein
Candida Höfer
Jenny Holzer
Jonathan Horowitz

Andrew **Kreps** Gallery

Stand C7
Tel +1 212 741 8849

525 West 22nd Street
New York NY 10011
USA
Tel +1 212 741 8849
Fax +1 212 741 8163
liz@andrewkreps.com
www.andrewkreps.com

Contact
Andrew Kreps
Liz Mulholland

Gallery artists
Ricci Albenda
Daniel Bozhkov
Peter Coffin
Roe Ethridge
Jonah Freeman
Uwe Henneken
Jamie Isenstein
Goshka Macuga
Ján Mancuska
Robert Melee
Peter Piller
Ruth Root
Lawrence Seward
Cheyney Thompson
Padraig Timoney
Hayley Tompkins
Klaus Weber

Galerie **Krinzinger**

Stand D17
Tel +43 676 324 8385

Seilerstätte 16
Vienna 1010
Austria
Tel +43 1 513 30 06
Fax +43 1 513 30 06 33

Krinzinger Projekte
Schottenfeldgasse 45
Vienna 1070
Austria
Tel +43 1 512 81 42
galeriekrinzinger@chello.at
www.galerie-krinzinger.at

Contact
Ursula Krinzinger
Thomas Krinzinger

Gallery artists
Nader Ahriman
Siegfried Anzinger
Hans Op de Beeck
Günther Brus
Chris Burden
Angela de la Cruz
Vladimir Dubossarsky &
Alexandr Vinogradov
Ann-Kristin Hamm
Ken Kagami
Zenita Komad
Valerie Koshlyakov
Angelika Krinzinger
Oleg Kulik
Zbigniew Libera
Ulrike Lienbacher
Atelier van Lieshout
Erik van Lieshout
Jonathan Meese
Bjarne Melgaard
Shintaro Miyake
Alois Mosbacher
Otto Muehl
Hermann Nitsch
Meret Oppenheim
Christoph Raitmayr
Werner Reiterer
Eva Schlegel
Rudolf Schwarzkogler
Frank Thiel
Gavin Turk
Jannis Varelas
Martin Walde
Mark Wallinger
Erwin Wurm
Thomas Zipp

David
Kordansky
Gallery

Stand F22
Tel +1 860 214 5556

510 Bernard Street
Los Angeles CA 90012
USA
Tel +1 323 222 1482
Fax +1 323 227 7933
info@davidkordanskygallery.
com
www.davidkordanskygallery.
com

Contact
David Kordansky
Natasha Garcia-Lomas

Gallery artists
Markus Amm
Amy Bessone
Matthew Brannon
Samara Caughey
Steven Claydon
Aaron Curry
Mark Flores
Will Fowler
Patrick Hill
Violet Hopkins
Thomas Houseago
William E. Jones
Alan Michael
David Noonan
Anthony Pearson
Brett Cody Rogers
Lesley Vance
Nicolau Vergueiro

Tomio
Koyama
Gallery

Stand A3
Tel +81 90 91 03 23 29

1–3–2–7f Kiyosumi
Koto-ku, Tokyo 135-0024
Japan
Tel +81 3 3642 4090
Fax +81 3 3642 4091
info@tomiokoyamagallery.com
www.tomiokoyamagallery.com

Contact
Tomio Koyama

Gallery artists
Franz Ackermann
Masako Ando
Benjamin Butler
Jeremy Dickinson
Jeanne Dunning
Tom Friedman
Atsushi Fukui
Daisuke Fukunaga
Rieko Hidaka
Satoshi Hirose
Tamami Hitsuda
Dennis Hollingsworth
Mika Kato
Hideaki Kawashima
Naoki Koide
Makiko Kudo
Masahiko Kuwahara
Toru Kuwakubo
Mitsue Makitani
Yoshino Masui
Paul McCarthy
Shintaro Miyake
Mr.
Takashi Murakami
Yoshitomo Nara
Ernesto Neto
Mika Ninagawa
Tam Ochiai
Satoshi Ohno
Jonathan Pylypchuk

Tom Sachs
Yuko Someya
Kishio Suga
Hiroshi Sugito
Vibeke Tandberg
Jason Teraoka
Mamoru Tsukada
Richard Tuttle
Peter Wu
Keisuke Yamamoto
Liu Ye
Bruce Yonemoto

Peter
Kilchmann

Stand E2
Tel +41 79 205 5286

Limmatstrasse 270
Zurich 8005
Switzerland
Tel +41 44 440 3931
Fax +41 44 440 3932
info@peterkilchmann.com
www.peterkilchmann.com

Contact
Peter Kilchmann
Claudia Friedli
Annemarie Reichen
Cynthia Krell

Gallery artists
Rita Ackermann
Francis Alÿs
Maja Bajevic
Michael Bauer
John Coplans
Willie Doherty
Jochen Kuhn
Zilla Leutenegger
Hanna Liden
Jorge Macchi
Teresa Margolles
Fabien Marti
Claudia & Julia Müller
Lucy & Jorge Orta
Adrian Paci
Santiago Sierra
Melanie Smith
Javier Téllez
Andro Wekua
Artur Zmijewski

Nicole
Klagsbrun
Gallery

Stand E23
Tel +1 212 243 3335

526 West 26th Street, No. 213
New York 10001
USA
Tel +1 212 243 3335
Fax +1 212 243 1059
gallery@nicoleklagsbrun.com
www.nicoleklagsbrun.com

Contact
Nicole Klagsbrun
Ruth Phaneuf
Carolyn Ramo

Gallery artists
Ryoko Aoki
Jonathan Callan
Beth Campbell
Nancy Davenport
Echo Eggebrecht
Simon Evans
Jacob El Hanani
Alona Harpaz
Dennis Hollingsworth
Ezra Johnson
Barney Kulok
Rosilene Luduvico
Adam McEwen
Mitzi Pederson
John Pilson
Elaine Reichek
Mika Rottenberg
Peter Schuyff
Dylan Stone
Hiroshi Sugito
Billy Sullivan
Andrzej Zielinski

Johann
König

Stand D13
Tel +49 30 2610 3080
Dessauer Strasse 6–7
Berlin 10963
Germany

Tel +49 30 2610 3080
Fax +49 30 3088 2690
info@johannkoenig.de
www.johannkoenig.de

Contact
Johann König
Timo Kappeller
Kirsa Geiser

Gallery artists
Micol Assaël
Manuel Graf
Tue Greenfort
Jeppe Hein
Annette Kelm
Manfred Kuttner
Lisa Lapinski
Kris Martin
Michaela Meise
Natascha Sadr Haghighian
Johannes Wohnseifer
Jordan Wolfson
David Zink Yi
Andreas Zybach

Kerlin
Gallery

Stand E11
Tel +353 1 670 90 93

Anne's Lane
South Anne Street
Dublin D2
Ireland
Tel +353 1 670 90 93
Fax +353 1 670 90 96
david@kerlin.ie
www.kerlin.ie

Contact
David Fitzgerald
Darragh Hogan
John Kennedy
Eimear O'Raw

Gallery artists
Phillip Allen
Varda Caivano
Phil Collins
Dorothy Cross
Willie Doherty
Mark Francis
Maureen Gallace
David Godbold
Siobhán Hapaska
Callum Innes
Jaki Irvine
Merlin James
Elizabeth Magill
Stephen McKenna
Isabel Nolan
Kathy Prendergast
Norbert Schwontkowski
Paul Seawright
Tony Swain
Paul Winstanley

KHOJ
International Artists' Association

Stand F33
Tel +41 79 205 5286

KHOJ Studios
S-17 Khirkee Village Extension
Behind Malviya Nagar
New Delhi 110017
India
Tel +91 11 65 65 58 74/3
khojinteract@gmail.com
www.khojworkshop.org

Contact
Peter Kilchmann
Claudia Friedli
Annemarie Reichen
Cynthia Krell

Gallery artists
Ravi Agarwal
Shaina Anand
Atul Bhalla
Sheba Chhachhi
Zuliekha Choudhury
Anita Dube
Chatarapati Dutta
Sanchayan Ghosh
Abhijit Gupta
Shilpa Gupta
Subodh Gupta
Arunkumar H. G.
N.S. Harsha
Sonal Jain
Suresh Jayaram
Ramesh Kalkur
Amar Kanwar
Bharti Kher
Riyaz Komu
Anusha Lall
Mriganka Madhukaillya
Kristine Michael
Prasantha Mukherjee
Kausik Mukhopadhyay
Manisha Parekh
Prajakta Potnis

Sumedh Rajendran
Raghavendra Rao
Kallat Reena Saini
Gigi Scaria
Paula Sen Gupta
Surekha
Asim Waqif

Galleri Magnus **Karlsson**

Stand G11
Tel +46 86 60 43 53

Fredsgatan 12
Stockholm 111 52
Sweden
Tel +46 86 60 43 53
info@gallerimagnuskarlsson.com
www.gallerimagnuskarlsson.com

Contact
Magnus Karlsson
Anna Pettersson

Gallery artists
Mamma Andersson
Roger Andersson
Lars Arrhenius
Bianca Maria Barmen
Amy Bennett
Mette Björnberg
Thomas Broomé
Marcel Dzama
Niklas Eneblom
Jens Fänge
Carl Hammoud
Tommy Hilding
Kent Iwemyr
Richard Johansson
Johanna Karlsson
Klara Kristalova
Petra Lindholm
Ulf Lundin
Jockum Nordström
Susanne Simonson
Anna Strid
Per Wennerstrand

Paul **Kasmin** Gallery

Stand E14
Tel +1 212 563 4474

293 10th Avenue
New York NY 10001
USA
Tel +1 212 563 4474
Fax +1 212 563 4494
inquiry@paulkasmingallery.com
www.paulkasmingallery.com

511 West 27th Street
New York NY 10001
USA
Tel + 1 212 563 4474
Fax +1 212 563 4494

Contact
Paul Kasmin
Clara Ha

Gallery artists
Christopher Bucklow
Susan Derges
Angus Fairhurst
Barry Flanagan
Caio Fonseca
Walton Ford
Al Held
David Hockney
Robert Indiana
Mark Innerst
Deborah Kass
Claude &
Francois-Xavier Lalanne
Morris Louis
Santi Moix
James Nares
Jules Olitski
Elliott Puckette
Nancy Rubins
Kenny Scharf
Frank Stella
Andy Warhol
Xu Bing
Joe Zucker

francesca **kaufmann**

Stand A7
Tel +39 02 7209 4331

Via dell'Orso 16
Milan 20121
Italy
Tel +39 02 7209 4331
Fax +39 02 7209 6873
info@galleriafrancesca
kaufmann.com
www.galleriafrancesca
kaufmann.com

Contact
Francesca Kaufmann
Chiara Repetto
Julia Koropoulos

Gallery artists
Candice Breitz
Pierpaolo Campanini
Gianni Caravaggio
Maggie Cardelùs
Edi Hila
Kori Newkirk
Kelly Nipper
Tam Ochiai
Yoshua Okon
Adrian Paci
Eva Rothschild
Aïda Ruilova
Roberta Silva
Lily van der Stokker
Billy Sullivan
Pae White

Casey
Kaplan

Stand A6
Tel +1 917 415 64 09

525 West 21st Street
New York NY 10011
USA
Tel +1 212 645 7335
Fax +1 212 645 7835
info@caseykaplangallery.com
www.caseykaplangallery.com

Contact
Casey Kaplan
Chana Budgazad
Joanna Kleinberg
Loring Randolph

Gallery artists
Henning Bohl
Jeff Burton
Nathan Carter
Miles Coolidge
Jason Dodge
Trisha Donnelly
Pamela Fraser
Liam Gillick
Annika von Hausswolff
Carsten Höller
Brian Jungen
Jonathan Monk
Diego Perrone
Julia Schmidt
Simon Starling
Gabriel Vormstein
Johannes Wohnseifer

Georg **Kargl**

Stand G16
Tel +43 1 585 4199

Schleifmühlgasse 5
Vienna 1040
Austria
Tel +43 1 585 4199
Fax +43 1 585 41999
office@georgkargl.com
www.georgkargl.com

Contact
Georg Kargl
Pilar Alcala
Evelyn Appinger
Fiona Liewehr

Gallery artists
Richard Artschwager
Carol Bove
Clegg & Guttmann
Chuck Close
Martin Dammann
Koenraad Dedobbeleer
Mark Dion
Angus Fairhurst
Peter Fend
Andreas Fogarasi
Vera Frenkel
Franz Graf
Renée Green
Jitka Hanzlová
Herbert Hinteregger
Chris Johanson
Sanna Kannisto
Herwig Kempinger
Elke Krystufek
Thomas Locher
Christian Phillip Müller
Matt Mullican
Muntean & Rosenblum
Max Peintner
Paul de Reus
Gerwald Rockenschaub
Lisa Ruyter
Julia Scher
Markus Schinwald

Rudolf Stingel
Gabl Trinkaus
Rosemarie Trockel
Nadim Vardag
Costa Vece
John Waters
Ina Weber
Cerith Wyn Evans

Annely **Juda** Fine Art

Stand G15
Tel +44 78 02 46 15 76

23 Dering Street
London W1S 1AW
UK
Tel +44 20 7629 7578
Fax +44 20 7491 2139
ajfa@annelyjudafineart.co.uk
www.annelyjudafineart.co.uk

Contact
David Juda
Laura Henderson

Gallery artists
Roger Ackling
Anthony Caro
Alan Charlton
Eduardo Chillida
Christo and Jeanne-Claude
Kwang-Young Chun
Prunella Clough
Gloria Friedmann
Katsura Funakoshi
Naum Gabo
Stefan Gec
Alan Green
Nigel Hall
Werner Haypeter
David Hockney
Sigrid Holmwood
Peter Kalkhof
Tadashi Kawamata
Leon Kossoff
Darren Lago
Edwina Leapman
Catherine Lee
Estate of Kenneth &
Mary Martin
John McLaughlin
Michael Michaeledes
Francois Morellet
David Nash
Alan Reynolds
Yuko Shiraishi

Janos Sugar
Suzanne Treister
Georges Vantongerloo
Friedrich Vordemberge-
Gildewart
Graham Williams

Iris **Kadel**

Stand G24
Tel +49 721 909 16 72

Viktoria Strasse 3–5
Karlsruhe 76133
Germany
Tel: +49 721 909 16 72
Fax: +49 721 467 28 00
www.iris-kadel.de
info@iris-kadel.de

Contact:
Iris Kadel

Gallery artists:
Matthias Bitzer
Shannon Bool
Katja Davar
Henry VIII´s Wives
Benedikt Hipp
Myriam Holme
Skafte Kuhn
Philipp Morlock
Riccardo Previdi
Olaf Quantius
Mathilde Rosier
Karoline Walther

Galerie Martin **Janda**

Stand H6
Tel +43 664 233 5429

Eschenbachgasse 11
Vienna 1010
Austria
Tel +43 1 585 7371
Fax +43 1 585 7372
galerie@martinjanda.at
www.martinjanda.at

Contact
Martin Janda
Elisabeth Konrath

Gallery artists
Martin Arnold
Adriana Czernin
Milena Dragicevic
Werner Feiersinger
Giuseppe Gabellone
Asta Gröting
Christine & Irene Hohenbüchler
Christian Hutzinger
Raoul de Keyser
Jakob Kolding
Július Koller
Jan Merta
Roman Ondák
Peter Pommerer
Allen Ruppersberg
Joe Scanlan
Lara Schnitger
Ene-Liis Semper
Roman Signer
Xavier Veilhan
Johannes Vogl
Maja Vukoje
Corinne Wasmuht
Lois & Franziska Weinberger
Jun Yang
Jakub Julian Ziolkowski
Gregor Zivic

Johnen Galerie Berlin / Cologne

Stand F10
Tel +49 172 210 1434

Schillingstrasse 31
Berlin 10179
Germany
Tel +49 30 2758 3030
Fax +49 30 2758 3050
mail@johnen-schoettle.de
www.johnengalerie.de

Contact
Jörg Johnen
Markus Lüttgen
Tan Morben

Gallery artists
Janis Avotins
Stephan Balkenhol
Roger Ballen
Armin Boehm
Martin Boyce
Michal Budny
Rafal Bujnowski
David Claerbout
James Coleman
Martin Creed
Slawomir Elsner
Elger Esser
Hans-Peter Feldmann
Francesco Gennari
Dan Graham
Rodney Graham
Stefan Hablützel
Candida Höfer
Olaf Holzapfel
Martin Honert
Robert Kusmirowski
Victor Man
Jan Merta
Yoshitomo Nara
Pietro Roccasalva

Thomas Ruff
Anri Sala
Wilhelm Sasnal
Tino Sehgal
Helmut Stallaerts
Florian Süßmayr
Jeff Wall
Liu Ye

Taka **Ishii** Gallery

Stand G8
Tel +81 3 5646 6050

1-3-2-5f Kiyosumi Koto-ku
Tokyo 135-0024
Japan
Tel +81 3 5646 6050
Fax +81 3 3642 3067
tig@mui.biglobe.ne.jp
www.takaishiigallery.com

Contact
Jeffrey Ian Rosen
Nahoko Yamaguchi
Elisa Uematsu
Tsuguko Kano

Gallery artists
Amy Adler
Doug Aitken
Nobuyoshi Araki
Slater Bradley
Jeff Burton
Thomas Demand
Jason Dodge
Michael Elmgreen &
Ingar Dragset
Tomoo Gokita
Kevin Hanley
Naoya Hatakeyama
Tomoki Imai
Naoto Kawahara
Yuki Kimura
Sean Landers
Daido Moriyama
Kyoko Murase
Silke Otto-Knapp
Jorge Pardo
Erik Parker
Jack Pierson
Hiroe Saeki
Dean Sameshima
Kei Takemura
Kara Walker
Christopher Wool
Cerith Wyn Evans

Jablonka Galerie

Stand D1
Tel +49 22 12 40 34 26

Kochstrasse 60
Berlin 10969
Germany
Tel +49 17 15 11 48 47
Fax +49 30 21 23 68 91
info@jablonka.net
www.jablonkagalerie.com

Lindenstrasse 19
Cologne 50674
Germany
Tel +49 221 240 3426
Fax +49 221 240 8132

Contact
Rafael Jablonka
Christian Schmidt
Uta Flick

Gallery artists
Nobuyoshi Araki
Ron Arad
Miquel Barceló
Francesco Clemente
Eric Fischl
Alex Katz
Mike Kelley
David LaChapelle
Sherrie Levine
David Salle
Andreas Slominski
Philip Taaffe
Andy Warhol
Terry Winters

Alison **Jacques** Gallery

Stand D15
Tel +44 20 7631 4720

16–18 Berners Street
London W1T 3LN
UK
Tel +44 20 7631 4720
Fax +44 20 7631 4750
info@alisonjacquesgallery.com
www.alisonjacquesgallery.com

Contact
Alison Jacques
Laura Lord
Tom Harrisson

Gallery artists
Uta Barth
André Butzer
Liz Craft
Tomory Dodge
Stef Driesen
Christian Flamm
Mark Flores
Ian Kiaer
Graham Little
Robert Mapplethorpe
Nathaniel Mellors
Paul Morrison
Michael van Ofen
Hélio Oiticica
Tom Ormond
Jack Pierson
Jon Pylypchuk
Alessandro Raho
Sam Salisbury
Tim Stoner
Hannah Wilke
Catherine Yass
Thomas Zipp

Herald St

John McCracken
Caro Niederer
Raymond Pettibon
Michael Raedecker
Estate of Jason Rhoades
Pipilotti Rist
Anri Sala
Wilhelm Sasnal
Christoph Schlingensief
Roman Signer
Tony Smith
Diana Thater
Estate of André Thomkins
Zhang Enli
David Zink Yi
Jakub Julian Ziolkowski

Stand F1
Tel +44 20 7168 2566

2 Herald Street
London E2 6JT
UK
Tel +44 20 7168 2566
Fax +44 20 7613 0009
mail@heraldst.com
www.heraldst.com

Contact
Nicky Verber
Ash Lange

Gallery artists
Markus Amm
Alexandra Bircken
Pablo Bronstein
Spartacus Chetwynd
Peter Coffin
Thomas Houseago
Scott King
Cary Kwok
Christina Mackie
Djordje Ozbolt
Oliver Payne & Nick Relph
Tony Swain
Donald Urquhart
Klaus Weber
Nicole Wermers

Hotel

Stand H2
Tel +44 20 7729 3122

53a Old Bethnal Green Road
London E2 6QA
UK
Tel +44 20 7729 3122
Fax +44 20 7739 4045
email@generalhotel.org
www.generalhotel.org

Contact
Darren Flook
Christabel Stewart

Gallery artists
Rita Ackermann
Michael Bauer
Carol Bove
Agnieszka Brzezanska
Duncan Campbell
Carter
Steven Claydon
Luke Dowd
Richard Kern
Alastair MacKinven
Alan Michael
David Noonan
Peter Saville
Torsten Slama
Mark van Yetter
Alexis Marguerite Teplin

Jack **Hanley**
Gallery

Stand A8
Tel +1 415 522 1623

395 Valencia Street
San Francisco CA 94103
USA
Tel +1 415 522 1623
Fax +1 415 522 1631
info@jackhanley.com
www.jackhanley.com

945 Sun Mun Way
Los Angeles CA 90012
USA
Tel +1 213 626 0403

Contact
Jack Hanley
Ava Jancar
Dina Pugh

Gallery artists
Tauba Auerbach
Michael Bauer
Carter
Anne Collier
Simon Evans
Harrell Fletcher
David Godbold
Jo Jackson
Colter Jacobsen
Piotr Janas
Chris Johanson
Saskia Leek
Camilla Løw
Euan Macdonald
Andrew Mania
Alicia McCarthy
Adam McEwen
Keegan McHargue
Mathieu Mercier
Muntean & Rosenblum
Scott Myles
Shaun O'Dell
Bill Owens
Jon Pylypchuk
Aurie Ramirez
Scott Reeder

Tyson Reeder
Will Rogan
Michael Sailstorfer
Leslie Shows
Hayley Tompkins
Donald Urquhart
Chris Ware
Erwin Wurm

Hauser &
Wirth Zürich
London

Stand C6
Tel +44 207 486 44 64

Limmatstrasse 270
Zurich 8031
Switzerland
Tel +41 44 446 8050
Fax +41 44 446 8055
zurich@hauserwirth.com

196a Piccadilly
London W1J 9DY
UK
Tel +44 20 7287 2300
Fax +44 20 7287 6600
london@hauserwirth.com
www.hauserwirth.com

Contact
Iwan Wirth
Gregor Muir
Florian Berktold
Marc Payot
Cornelia Providoli

Gallery artists
Louise Bourgeois
Berlinde De Bruyckere
Christoph Büchel
David Claerbout
Martin Creed
Ellen Gallagher
Isa Genzken
Dan Graham
Rodney Graham
David Hammons
Mary Heilmann
Estate of Eva Hesse
Andreas Hofer
Richard Jackson
Estate of Allan Kaprow
On Kawara
Rachel Khedoori
Guillermo Kuitca
Maria Lassnig
Estate of Lee Lozano
Paul McCarthy

Galerie
Bärbel
Grässlin

Stand D18
Tel +49 69 299 24 670

Schäfergasse 46b
Frankfurt am Main 60313
Germany
Tel +49 69 299 24 67 0
Fax +49 69 299 24 67 29
mail@galerie-graesslin.de
www.galerie-graesslin.de

Contact
Bärbel Grässlin

Gallery artists
Herbert Brandl
Werner Büttner
Helmut Dorner
Günther Förg
Asta Gröting
Georg Herold
Ika Huber
Hubert Kiecol
Martin Kippenberger
Imi Knoebel
Meuser
Reinhard Mucha
Stefan Müller
Christa Näher
Manuel Ocampo
Albert Oehlen
Markus Oehlen
Tobias Rehberger
Thomas Werner
Franz West

Greene
Naftali

Stand F4
Tel +1 212 463 7770

508 West 26th Street
New York NY 10001
USA
Tel +1 212 463 7770
Fax +1 212 463 0890
info@greenenaftaligallery.com
www.greenenaftaligallery.com

Contact
Carol Greene
Alex Tuttle
Jay Sanders

Gallery artists
Julie Becker
Paul Chan
Tony Conrad
Jim Drain
Harun Farocki
Michael Fullerton
Lucy Gunning
Guyton& Walker
Rachel Harrison
Richard Hawkins
Sophie von Hellermann
Jacqueline Humphries
Joachim Koester
David Korty
Michael Krebber
Michaela Meise
Daniel Pflumm
Daniela Rossell
Gedi Sibony
Josef Strau
Katharina Wulff
Amelie von Wulffen

greengrassi

Stand D8
Tel +44 20 7840 9101

1a Kempsford Road
London SE11 4NU
UK
Tel +44 20 7840 9101
Fax +44 20 7840 9102
info@greengrassi.com
www.greengrassi.com

Contact
Cornelia Grassi
Megan O'Shea
Lindsay Jarvis

Gallery artists
Tomma Abts
Stefano Arienti
Jennifer Bornstein
Henry Coleman
Roe Ethridge
Gretchen Faust
Vincent Fecteau
Giuseppe Gabellone
Joanne Greenbaum
Ellen Gronemeyer
Sean Landers
Simon Ling
Margherita Manzelli
Aleksandra Mir
David Musgrave
Kristin Oppenheim
Silke Otto-Knapp
Alessandro Pessoli
Lari Pittman
Charles Ray
Karin Ruggaber
Allen Ruppersberg
Anne Ryan
Frances Stark
Jennifer Steinkamp
Pae White
Lisa Yuskavage

Gladstone
Gallery

Stand D6
Tel +1 212 206 9300

515 West 24th Street
New York NY 10011
USA
Tel +1 212 206 9300
Fax +1 212 206 9301
info@gladstonegallery.com
www.gladstonegallery.com

Contact
Barbara Gladstone
Rosalie Benitez
Angela Brazda
Maxime Falkenstein

Gallery artists
Jennifer Allora &
Guillermo Calzadilla
Kai Althoff
Miroslaw Balka
Stephan Balkenhol
Matthew Barney
Robert Bechtle
Alighiero e Boetti
Bruce Conner
Jan Dibbets
Carroll Dunham
Luciano Fabro
Gary Hill
Thomas Hirschhorn
Huang Yong Ping
Anish Kapoor
Sharon Lockhart
Sarah Lucas
Mario Merz
Marisa Merz
Dave Muller
Jean-Luc Mylayne
Shirin Neshat
Catherine Opie
Walter Pichler
Lari Pittman
Magnus Plessen
Richard Prince
Gregor Schneider
Rosemarie Trockel
Paloma Varga Weisz
Andro Wekua

Marian
Goodman
Gallery

Stand F14
Tel +1 207 486 66 21

24 West 57th Street
New York NY 10019
USA
Tel +1 212 977 7160
Fax +1 212 581 5187
goodman@mariangoodman.
com
www.mariangoodman.com

79 rue du Temple
Paris 75003
France
Tel +33 1 48 04 70 52
Fax +33 1 40 27 81 37

Contact
Marian Goodman
Rose Lord
Agnes Fierobe
Andrew Richards

Gallery artists
Eija-Liisa Ahtila
Chantal Akerman
Giovanni Anselmo
John Baldessari
Lothar Baumgarten
Dara Birnaum
Christian Boltanski
Marcel Broodthaers
Maurizio Cattelan
James Coleman
Anthony Cragg
Thierry de Cordier
Richard Deacon
Tacita Dean
Rineke Dijkstra
Yang Fudong
David Goldblatt
Dan Graham
Pierre Huyghe
Cristina Iglesias
William Kentridge
Sol LeWitt

Steve McQueen
Marisa Merz
Annette Messager
Juan Muñoz
Maria Nordman
Gabriel Orozco
Giulio Paolini
Giuseppe Penone
Gerhard Richter
Anri Sala
Thomas Schütte
Tino Sehgal
Thomas Struth
Hiroshi Sugimoto
Niele Toroni
Jeff Wall
Lawrence Weiner
Francesco Woodman

Gagosian Gallery

Stand D8
Tel +44 20 7841 9960

6–24 Britannia Street
London WC1X 9JD
UK
Tel +44 20 7841 9960
Fax +44 20 7841 9961
info@gagosian.com
www.gagosian.com

17–19 Davies Street
London W1K 3DE
UK
Tel +44 20 7493 3020

980 Madison Avenue
New York NY 10021
USA
Tel +1 212 744 2313

555 West 24th Street
New York NY 10011
USA
Tel +1 212 741 1111

522 West 21st Street
New York NY 10011
USA
Tel +1 212 741 1717

456 North Camden Drive
Beverly Hills CA 90210
USA
Tel +1 310 271 9400

Via Francesco Crispi 16
00187 Rome
Italy

Contact
Millicent Wilner
Stefan Ratibor
Robin Vousden

Gallery artists
Ghada Amer
Richard Artschwager
Georg Baselitz
Cecily Brown
Glenn Brown
Chris Burden
Francesco Clemente
Michael Craig-Martin
John Currin
Dexter Dalwood
Tom Friedman
Ellen Gallagher
gelitin
Alberto Giacometti
Douglas Gordon
Arshile Gorky
Damien Hirst
Sir Howard Hodgkin
Carsten Höller
Rachel Howard
Mike Kelley
Anselm Kiefer
Martin Kippenberger
Willem de Kooning
Jeff Koons
Vera Lutter
Walter de Maria
Takashi Murakami
Marc Newson
Ed Ruscha
Jenny Saville
Richard Serra
Elisa Sighicelli
David Smith
Hiroshi Sugimoto
Philip Taaffe
Mark Tansey
Robert Therrien
Cy Twombly
Piotr Uklanski
Andy Warhol
Franz West
Rachel Whiteread
Richard Wright
Elyn Zimmerman

Annet Gelink Gallery

Stand E21
Tel +31 61 063 97 67

Laurierstraat 187–189
Amsterdam NL 1016 PL
The Netherlands
Tel +31 20 330 20 66
Fax +31 20 330 20 65
geer@annetgelink.com
www.annetgelink.com

Contact
Geer Oskam

Gallery artists
Rita Ackermann
Carlos Amorales
Armando Andrade Tudela
Yael Bartana
Delphine Courtillot
Ed van der Elsken
Alicia Framis
Ryan Gander
Anya Gallaccio
Carla Klein
Kiki Lamers
David Maljkovic
Victor Man
Jenny Perlin
Liza May Post
Muzi Quawson
Glenn Sorensen
Robert Suermondt
Barbara Visser
Erik Wesselo

Galeria **Fortes** Vilaça

Stand E7
Tel +55 11 3032 7066

Rua Fradique Coutinho 1500
São Paulo SP 05416–001
Brazil
Tel +55 11 3032 7066
Fax +55 11 3097 0384
galeria@fortesvilaca.com.br
www.fortesvilaca.com.br

Contact
Ticiana Correa
Alexandre Gabriel
Márcia Fortes
Alessandra d'Aloia

Gallery artists
Franz Ackermann
Efrain Almeida
John Bock
Tiago Carneiro da Cunha
Los Carpinteros
Leda Catunda
Gil Heitor Cortesão
José Damasceno
Iran do Espirito Santo
Angus Fairhurst
José Antonio Hernández-Diez
Alejandra Icaza
Beatriz Milhazes
Gerben Mulder
Vik Muniz
Paulo Nenflídio
Ernesto Neto
Rivane Neuenschwander
Damián Ortega
Osgemeos
Mauro Piva
Sara Ramo
Nuno Ramos
Julie Roberts
Julião Sarmento
Valeska Soares
Hiroshi Sugito
Janaina Tschäpe
Adriana Varejão
Érika Verzutti
Cerith Wyn Evans
Luiz Zerbini

Marc **Foxx**

Stand A1
Tel +1 323 857 5571

6150 Wilshire Boulevard
Los Angeles CA 90048
USA
Tel +1 323 857 5571
Fax +1 323 857 5573
gallery@marcfoxx.com
www.marcfoxx.com

Contact
Marc Foxx
Rodney Hill

Gallery artists
Richard Aldrich
Ryoko Aoki
Cris Brodahl
Brian Calvin
Jay Chung
Anne Collier
Andy Collins
William Daniels
Stef Driesen
Olafur Eliasson
Brian Fahlstrom
Vincent Fecteau
Ryan Gander
Sophie von Hellermann
Roger Hiorns
Jim Hodges
Evan Holloway
Makiko Kudo
Luisa Lambri
Kris Martin
Jason Meadows
Hellen van Meene
Carter Mull
David Musgrave
Philippe Perrot
Alessandro Pessoli
Richard Rezac
Matthew Ronay
Sterling Ruby
Frances Stark
Hiroshi Sugito
Jan Timme
Nicola Tyson
Karlheinz Weinberger
Jennifer West

Konrad **Fischer** Galerie

Stand A5
Tel +49 17 26 41 13 60

Platenenstrasse 7
Dusseldorf 40233
Germany
Tel +49 211 68 59 08
Fax +49 211 68 97 80
office@konradfischergalerie.de
www.konradfischergalerie.de

Lindenstrasse 34–35
Berlin 10969
Germany
Tel +49 171 47 30 272

Contact
Dorothea Fischer
Daniel Marzona
Ulla Wiegand
Thomas W. Rieger
Claudia Pasko

Gallery artists
Carl Andre
Giovanni Anselmo
Bernd & Hilla Becher
Guy Ben-Ner
Stanley Brouwn
Matthew Buckingham
Daniel Buren
Alan Charlton
Tony Cragg
Hanne Darboven
Jan Dibbets
Helmut Dorner
Hans-Peter Feldmann
Gilbert & George
Cristina Iglesias
Zon Ito
Stephen Kaltenbach
On Kawara
Harald Klingelhöller
Jannis Kounellis
Wolfgang Laib

Jim Lambie
Sol LeWitt
Richard Long
Robert Mangold
Mario Merz
Bruce Nauman
Claes Oldenburg
Giuseppe Penone
Manfred Pernice
Magnus Plessen
Wolfgang Plöger
Robert Ryman
Gregor Schneider
Thomas Schütte
Yuji Takeoka
Paloma Varga Weisz
Lawrence Weiner
Petra Wunderlich
Jerry Zeniuk

Foksal Gallery Foundation

Stand E6
Tel +48 22 826 5081

Gorskiego 1a
Warsaw 00-033
Poland
Tel +48 22 826 5081
Fax +48 22 826 5081
mail@fgf.com.pl
www.fgf.com.pl

Contact
Andrzej Przywara

Gallery artists
Pawel Althamer
Cezary Bodzianowski
Piotr Janas
Katarzyna Jozefowicz
Edward Krasinski
Robert Kusmirowski
Anna Niesterowicz
Wilhelm Sasnal
Monika Sosnowska
Jakub Julian Ziolkowski
Artur Zmijewski

Galerie Eigen +Art Leipzig / Berlin

Stand F5
Tel +49 341 960 7886

Spinnereistrasse 7, Halle 5
Leipzig 04179
Germany
Tel +49 341 960 7886
Fax +49 341 225 4214
leipzig@eigen-art.com
www.eigen-art.com

Auguststrasse 26
Berlin 10117
Germany
Tel +49 30 280 6605
Fax +49 30 280 6616
berlin@eigen-art.com

Contact
Gerd Harry Lybke
Kerstin Wahala
Elke Hannemann

Gallery artists
Akos Birkas
Birgit Brenner
Martin Eder
Tim Eitel
Nina Fischer
Stella Hamberg
Jörg Herold
Christine Hill
Uwe Kowski
Rémy Markowitsch
Maix Mayer
Carsten Nicolai
Olaf Nicolai
Neo Rauch
Ricarda Roggan
Maroan el Sani
Yehudit Sasportas
David Schnell
Annelies Strba
Matthias Weischer

The **Fair** Gallery

Stand F21
Tel +49 163 871 11 54

Frieze Art Fair
Regent's Park
London NW1 4NR
UK
Tel +49 163 871 11 54
office@thefairgallery.com
www.thefairgallery.com

Contact
GB Agency, Paris
Jan Mot, Brussels
Raster, Warsaw
Aurélie Voltz, Berlin (curator)

Gallery artists
Mac Adams
Sven Augustijnen
Azorro
Pierre Bismuth
Manon de Boer
Agata Bogacka
Robert Breer
Elina Brotherus
Michal Budny
Rafal Bujnowski
Oskar Dawicki
Rineke Dijkstra
Slawomir Elsner
Omer Fast
Mario Garcia Torres
Dominique Gonzalez-Foerster
Douglas Gordon
Aneta Grzeszykowska
Alban Hajdinaj
Joachim Koester
Július Koller
Jiri Kovanda
David Lamelas
Zbigniew Libera
Sharon Lockhart
Marcin Maciejowski
Przemek Mateckl
Bartek Materka
Deimantas Narkevicius
Roman Ondák

Dominique Petitgand
Pratchaya Phintongh
Zbigniew Rogalski
Pia Rönicke
Wilhelm Sasnal
Tino Sehgal
Jan Smaga
Ian Wilson

Thomas **Dane** Gallery

Stand E1
Tel +44 77 48 63 71 62

11 Duke Street
St James's
London SW1Y 6BN
UK
Tel +44 20 7925 2505
Fax +44 20 7925 2506
info@thomasdane.com
www.thomasdane.com

Contact
Thomas Dane
François Chantala
Martine d'Anglejan-Chatillon
Leigh Robb
Alice Chubb

Gallery artists
Hurvin Anderson
José Damasceno
Michel François
Anya Gallaccio
Arturo Herrera
Stefan Kürten
Luisa Lambri
Michael Landy
Glenn Ligon
Steve McQueen
Jean-Luc Moulène
Albert Oehlen
Paul Pfeiffer
Jorge Queiroz

Dicksmith Gallery

Stand F30
Tel +44 20 7253 0663

10–12 Baches Street
London N1 6DN
UK
Tel +44 20 7253 0663
info@dicksmithgallery.co.uk
www.dicksmithgallery.co.uk

Contact
Thomas Hanbury
Rodolphe von Hofmannsthal

Gallery artists
Joel Croxson
Benjamin Alexander Huseby
Edward Kay
Meiro Koizumi
George Henry Longly
Duncan Marquiss
Rupert Norfolk

doggerfisher

Stand G19
Tel +44 77 90 56 90 90

11 Gayfield Square
Edinburgh EH1 3NT
UK
Tel +44 131 558 7110
Fax +44 131 558 7179
susanna@doggerfisher.com
www.doggerfisher.com

Contact
Susanna Beaumont
Pauline Hanson

Gallery artists
Charles Avery
Claire Barclay
Nathan Coley
Graham Fagen
Moyna Flannigan
Franziska Furter
Ilana Halperin
Alexander Heim
Louise Hopkins
Janice McNab
Rosalind Nashashibi
Sally Osborn
Jonathan Owen
Lucy Skaer
Hanneline Visnes

CRG Gallery

Stand H5
Tel +1 212 229 2766

535 West 22nd Street
Third Floor
New York NY 10011
USA
Tel +1 212 229 2766
Fax +1 212 229 2788
info@crggallery.com
www.crggallery.com

Contact
Carla Chammas
Richard Desroche
Glenn McMillan
Glen Baldridge

Gallery artists
Robert Beck
Rhona Bitner
Russell Crotty
Tomory Dodge
Robert Feintuch
Pia Fries
Ori Gersht
Joana Hadjithomas &
Khalil Joreige
Lyle Ashton Harris
Jim Hodges
Butt Johnson
Tonico Lemos Auad
Siobhan Liddell
Graham Little
Melissa McGill
Kelly McLane
Stephanie Pryor
Sam Reveles
Jeffrey Saldinger
Lisa Sanditz
Sandra Scolnik
Mindy Shapero
Frances Stark

Galerie Chantal Crousel

Stand D3
Tel +33 1 42 77 38 87

10 rue Charlot
Paris 75003
France
Tel +33 1 42 77 38 87
Fax +33 1 42 77 59 00
galerie@crousel.com
www.crousel.com

Contact
Chantal Crousel
Niklas Svennung

Gallery artists
Jennifer Allora &
Guillermo Calzadilla
Darren Almond
Fikret Atay
Tony Cragg
Claire Fontaine
Wade Guyton
Fabrice Gygi
Mona Hatoum
Thomas Hirschhorn
Hassan Khan
Michael Krebber
Wolfgang Laib
Jean-Luc Moulène
Moshe Ninio
Melik Ohanian
Gabriel Orozco
Jeroen de Rijke &
Willem de Rooij
Anri Sala
Alain Sechas
José Maria Sicilia
Sean Snyder
Reena Spaulings
Rirkrit Tiravanija
Wang Bing

Sorcha Dallas

Stand F32
Tel +44 78 1260 5745

5–9 St Margaret's Place
Glasgow G1 5JY
UK
Tel +44 141 589 0607
Fax +44 141 553 2662
info@sorchadallas.com
www.sorchadallas.com

Contact
Sorcha Dallas
Jo Charlton

Gallery artists
Rob Churm
Henry Coombes
Kate Davis
Alex Frost
Charlie Hammond
Fiona Jardine
Sophie Macpherson
Alan Michael
Craig Mulholland
Alex Pollard
Gary Rough
Clare Stephenson
Michael Stumpf

BQ

Stand B5
Tel +49 17 27 87 95 51

Jülicher Strasse 14
Cologne 50674
Germany
Tel +49 221 285 8862
Fax +49 221 285 8864
boetnagel.quirmbach@netco-
logne.de

Contact
Joern Bötnagel
Yvonne Quirmbach
Anna Grande

Gallery artists
Dirk Bell
Alexandra Bircken
Matti Braun
Owen Gump
Andrew Kerr
Ferdinand Kriwet
Friedrich Kunath
Bojan Sarcevic
David Shrigley
Reinhard Voigt
Richard Wright

The **Breeder**

Stand E17
Tel +30 2103 31 75 27

6 Evmorfopoulou Street
Athens 10553
Greece
Tel +30 2103 31 75 27/8
Fax +30 2103 31 75 27
gallery@thebreedersystem.com
www.thebreedersystem.com

Contact
Stathis Panagoulis
George Vamvakidis
Natasha Adamou

Gallery artists
Markus Amm
Athanasios Argianas
Marc Bijl
Matt Connors
Iris van Dongen
Stef Driesen
Vasso Gavaisse
Uwe Henneken
Dionisis Kavallieratos
Irini Miga
Scott Myles
Ilias Papailiakis
Mindy Shapero
Gert & Uwe Tobias
Alexandros Tzanis
Jannis Varelas
Vangelis Vlahos

Broadway
1602

Stand G18
Tel +1 212 481 03 62

1182 Broadway, Suite 1602
New York NY 10001
USA
Tel +1 212 481 03 62
Fax +1 212 481 03 62
gallery@broadway1602.com
www.broadway1602.com

Contact
Anke Kempkes

Gallery artists
Cezary Bodzianowski
Agnieszka Brzezanska
Martin Soto Climent
Ryan Doolan
Edwin Laliq
Babette Mangolte
Megan Sullivan
Alina Szapocznikow
Lucy Stein
Manuela Viera Gallo

Gavin **Brown's** enterprise

Stand G14
Tel +1 212 627 5258

620 Greenwich Street
New York NY 10014
USA
Tel +1 212 627 5258
Fax +1 212 627 5261
gallery@gavinbrown.biz
www.gavinbrown.biz

Contact
Gavin Brown
Corinna Durland
Kelly Taylor

Gallery artists
Franz Ackermann
James Angus
Thomas Bayrle
Dirk Bell
Jennifer Bornstein
Martin Creed
Verne Dawson
Jeremy Deller
Peter Doig
Urs Fischer
Dara Friedman
Mark Handforth
Jonathan Horowitz
Tony Just
Christopher Knowles
Udomsak Krisanamis
Mark Leckey
Victoria Morton
Silke Otto-Knapp
Laura Owens
Oliver Payne & Nick Relph
Elizabeth Peyton
Steven Pippin
Rob Pruitt
Anselm Reyle
Katja Strunz
Spencer Sweeney
Rirkrit Tiravanija

Galerie Daniel **Buchholz**

Stand C4
Tel +49 170 430 0153

Neven-Dumont Strasse 17
Cologne 50667
Germany
Tel +49 221 257 4946
Fax +49 221 253 351
post@galeriebuchholz.de
www.galeriebuchholz.de

Contact
Daniel Buchholz
Christopher Müller

Gallery artists
Tomma Abts
Henning Bohl
Cosima von Bonin
Tony Conrad
Enrico David
Lukas Duwenhögger
Thomas Eggerer
Vincent Fecteau
Morgan Fisher
Isa Genzken
Jack Goldstein
Julian Göthe
Richard Hawkins
Jochen Klein
Jutta Koether
Nina Könnemann
Michael Krebber
Mark Leckey
David Lieske
Lucy McKenzie
Henrik Olesen
Paulina Olowska
Silke Otto-Knapp
Mathias Poledna
Florian Pumhösl
Jeroen de Rijke &
Willem de Rooij
Frances Stark
Josef Strau

Stefan Thater
Cheyney Thompson
Wolfgang Tillmans
T.J. Wilcox
Katharina Wulff
Cerith Wyn Evans

Cabinet

Stand D14
Tel +44 20 7251 6114

20a Northburgh Street
London EC1V OEA
UK
Tel +44 20 7251 6114
Fax +44 20 7608 2414

Apartment 6
49–59 Old Street
London EC1V 9HX
UK
art@cabinetltd.demon.co.uk

Contact
Martin McGeown
Andrew Wheatley

Gallery artists
Tariq Alvi
Bonnie Camplin
Gillian Carnegie
Marc Camille Chaimowicz
Cosey Fanni Tutti
Enrico David
Lukas Duwenhögger
Barney Farmer
Julian Göthe
Lee Healey
Mark Leckey
Lucy McKenzie
Paulina Olowska
Lily van der Stokker
J.D. Williams

Luis **Campaña** Galerie

Stand F24
Tel +49 221 256 712

An der Schanz 1a
Cologne 50735
Germany
Tel +49 221 256 712
Fax +49 221 256 213
info@luis-campana.de

Contact
Luis Campaña

Gallery artists
Monica Baer
Katie Barath
Ralph Berger
Jan De Cock
Björn Dahlem
Wim Delvoye
Kendell Geers
Bethan Huws
Seb Koberstädt
Takeshi Makishima
Wilhelm Mundt
Tatzu Nishi
Matthieu Ronsse
Gregor Schneider
Qui Shi-Hua
Dirk Skreber
Jorg Wagner

Galerie Gisela **Capitain**

Stand D11
Tel +49 221 355 701 00

St.-Apern-Strasse 20–26
Cologne 50667
Germany
Tel +49 221 355 701 00
Fax +49 221 355 701 29
fiorito@galeriecapitain.de
www.galeriecapitain.de

Contact
Regina Fiorito
Nina Kretzschmar

Gallery artists
Maria Brunner
Gillian Carnegie
Anna Gaskell
Wade Guyton
Uwe Henneken
Georg Herold
Charline von Heyl
Margarete Jakschik
Martin Kippenberger
Rachel Khedoori
Zoe Leonard
Albert Oehlen
Laura Owens
Jorge Pardo
Seth Price
Stephen Prina
Sam Samore
Monika Sosnowska
Alina Szapocznikow
Franz West
Christopher Williams
Johannes Wohnseifer
Christopher Wool

Galleria Massimo de **Carlo**

Stand F3
Tel +39 02 7000 3987

Via Giovanni Ventura 5
Milan 20134
Italy
Tel +39 02 7000 3987
Fax +39 02 7492 135
info@massimodecarlo.it
www.massimodecarlo.it

Contact
Massimo de Carlo
Ludovica Barbieri
Elena Tavecchia
Anna Maria Soverini
Sara Cappelletti

Gallery artists
Amy Adler
Mario Airò
Haluk Akakçe
John Armleder
Assume Vivid Astro Focus
Massimo Bartolini
Simone Berti
Chris Burden
Maurizio Cattelan
Paul Chan
Roberto Cuoghi
Jason Dodge
Michael Elmgreen &
Ingar Dragset
Urs Fischer
Roland Flexner
Rainer Ganahl
Ryan Gander
Anna Gaskell
gelitin
Felix Gonzalez-Torres
Thomas Grünfeld
Carsten Höller
Christian Holstad
Ian Kiaer
Annika Larsson
Bertrand Lavier

Armin Linke
John McCracken
Eva Marisaldi
Aernout Mik
Matt Mullican
Steven Parrino
Diego Perrone
Paola Pivi
Jonathan Pylypchuk
Sam Samore
Julia Scher
Gregor Schneider
Tino Sehgal
Jim Shaw
Ettore Spalletti
Rudolf Stingel
Piotr Uklanski
Laurence Weiner
Franz West
Yan Pei-Ming
Andrea Zittel

Casa Triângulo

Stand F23
Tel +55 11 3167 5621

Rua Paes de Araujo 77
São Paulo 04531 090
Brazil
Tel +55 11 3167 5621
Fax +55 11 3168 1640
info@casatriangulo.com
www.casatriangulo.com

Contact
Ricardo Trevisan

Gallery artists
Daniel Acosta
Albano Afonso
Assume Vivid Astro Focus
Felipe Barbosa
Tony Camargo
Alex Cerveny
Sandra Cinto
Carlito Contini
Stephen Dean
Rogério Degaki
Adrianne Gallinari
Raquel Garbelotti
Max Gomez Canle
Silvia Gurfein
Kaoru Katayama
Lúcia Koch
Rubens Mano
Rodrigo Matheus
Vania Mignone
Nazareth Pacheco
Mariana Palma
Pazé
Mauro Restiffe
Gustavo Rezende
Rosana Ricalde
Sergio Romagnolo
Pier Stockholm
Juan Tessi
Joana Vasconcelos
Paulo Whitaker
Marcia Xavier

Dennis Scholl
Shi Xinning
Nedko Solakov
Hiroshi Sugito
Miroslav Tichý
Tim Trantenroth
Susan Turcot
Veron Urdarianu
Wang Du

Art : Concept

Stand G10
Tel +33 61 96 08 894

16 rue Duchefdelaville
Paris 75013
France
Tel +33 1 53 60 90 30
Fax +33 1 53 60 90 31
info@galerieartconcept.com
www.galerieartconcept.com

Contact
Olivier Antoine
Daniele Balice
Caroline Maestrali

Gallery artists
Martine Aballéa
Pierre-Olivier Arnaud
Julien Audebert
Francis Baudevin
Whitney Bedford
Jean-Luc Blanc
Michel Blazy
Ulla von Brandenburg
Anne-Lise Coste
Jeremy Deller
Hubert Duprat
Richard Fauguet
Vidya Gastaldon
Geert Goiris
Lothar Hempel
Nathan Hylden
Andrew Lewis
Jacques Lizène
Adam McEwen
Philippe Perrot
Pietro Roccasalva
Gedi Sibony
Roman Signer

Galerie Catherine Bastide

Stand E12
Tel +32 2 646 2971

62 rue Chaussée de Forest
Brussels 1060
Belgium
Tel +32 2 646 2971
Fax +32 2 640 0694
info@catherinebastide.com
www.catherinebastide.com

Contact
Catherine Bastide
Marc Perennes

Gallery artists
Jacques Andre
David Colosi
Jean-Pascal Flavien
Monique van Genderen
Geert Goiris
T. Kelly Mason
William Pope L.
Ola Rindal
Josh Smith
Catherine Sullivan
Janaina Tschäpe
Kelley Walker

Galería Helga de **Alvear**

Stand H4
Tel +34 1 468 0506

Doctor Fourquet 12
Madrid 28012
Spain
Tel +34 91 468 0506
Fax +34 91 467 5134
joaquin@helgadealvear.net
www.helgadealvear.net

Contact
Helga de Alvear
Joaquin Garcia
Monique Lambie

Gallery artists
Helena Almeida
Slater Bradley
Jean-Marc Bustamante
José Pedro Croft
Michael Elmgreen &
Ingar Dragset
Alicia Framis
Katharina Grosse
Axel Hütte
Prudencio Irazabal
Isaac Julien
Jürgen Klauke
Imi Knoebel
Mitsuo Miura
Jesus Palomino
Ester Partegas
Dan Perjovschi
Karin Sander
Santiago Sierra
DJ Simpson
Montserrat Soto
Frank Thiel
Javier Vallhonrat

Andersen_s Contempo- rary

Stand F17
Tel +45 26 36 92 35

Islands Brygge 43
Copenhagen 2300
Denmark
Tel +45 46 97 84 37
info@andersen-s.dk
www.andersen-s.dk

Contact
Claus Andersen
Scot Surdez
Nina Nørgaard Jensen

Gallery artists
Kaucyila Brooke
Jay Chung & Q Takeki Maeda
Jesper Dalgaard
Olafur Eliasson
Ingen Frygt
Søren Jensen
Malene Landgreen
Daniel Lergon
Henrik Olesen
Anselm Reyle
Thiago Rocha Pitta
Pia Ronicke
Mia Rosasco
Tomas Saraceno
Anja Schwörer

Galerie Paul **Andriesse**

Stand H8
Tel +31 20 623 62 37

Detroit Building 8
Withoedenveem
Amsterdam 1019 HE
The Netherlands
Tel +31 20 623 62 37
Fax +31 20 639 00 38
info@paulandriesse.nl
www.galeries.nl/andriesse

Contact
Paul Andriesse
Milka van der Valk Bouman
Adriana González Hulshof

Gallery artists
Jo Baer
Bert Boogaard
Jean-Marc Bustamante
Gianni Caravaggio
Vincenzo Castella
Charlotte Dumas
Marlene Dumas
Keith Edmier
Christine & Irene Hohenbüchler
Britta Huttenlocher
Henri Jacobs
Rob Johannesma
Natasja Kensmil
Johan van der Keuken
Jan Koster
Luisa Lambri
Ann Lislegaard
Willem Oorebeek
Jan van de Pavert
Antonietta Peeters
Giuseppe Penone
John Riddy
Thomas Struth
Lidwien van de Ven
Stephen Wilks

L'apparte-ment 22

Stand F34
Tel +212 6359 8288

279 avenue Mohamed V
Rabat
Morocco
Tel +212 6359 8288
abdellah@appartement22.com
www.appartement22.com

Contact
Abdellah Karroum
Sophia Akhmisse

Gallery artists
Doa Aly
Liliana Basarab
Elodie Carre
Hassan Darsi
Mohamed El-Baz
Seamus Farrell
Chourouk Hriech
Fabrice Hyber
Amal Kenawy
Faouzi Laatiris
Catherine Poncin
Younès Rahmoun
Hani Rashed
Jerôme Schlomoff
Pascal Semur
Batoul S'himi
Jean-Paul Thibeau
Sislej Xhafa

The Approach

Stand D10
Tel +44 20 8983 3878

1st Floor 47 Approach Road
London E2 9LY
UK
Tel +44 20 8983 3878
Fax +44 20 8983 3919
info@theapproach.co.uk
www.theapproach.co.uk

The Reliance
2nd Floor
336 Old Street
London EC1V 9DR
Tel +44 (0)207 729 2629
info@thereliance.co.uk
www.thereliance.co.uk

Contact
Jake Miller
Emma Robertson
Mike Allen
Vanessa Carlos

Gallery artists
Haluk Akakçe
Phillip Allen
Cris Brodahl
Patrick Hill
Evan Holloway
Inventory
Germaine Kruip
Rezi van Lankveld
Dave Muller
Jacques Nimki
Michael Raedecker
Brett Cody Rogers
John Stezaker
Mari Sunna
Evren Tekinoktay
Gary Webb
Martin Westwood
Tom Wood
Shizuka Yokomizo

Arndt & Partner

Stand G21
Tel +49 160 964 33 307

Zimmerstrasse 90–91
Berlin 10117
Germany
Tel +49 30 280 8123
Fax +49 30 283 3738
arndt@arndt-partner.com
www.arndt-partner.com

Lessingstrasse 5
Zurich 8002
Switzerland
+41 43 817 6780/81
+41 43 817 6782

Contact
Matthias Arndt
Thorsten Albertz
Julie Burchardi
Anna Duque y González

Gallery artists
Adam Adach
Jules de Balincourt
Sue de Beer
Sophie Calle
Joe Coleman
William Cordova
Wim Delvoye
Yannick Demmerle
Gabi Hamm
Mathilde ter Heijne
Anton Henning
Thomas Hirschhorn
Jon Kessler
Henning Kles
Douglas Kolk
Karsten Konrad
Yayoi Kusama
Josephine Meckseper
Muntean & Rosenblum
Tam Ochiai
Erik Parker
Julian Rosefeldt
Charles Sandison